A PORTRAIT OF
FASHION

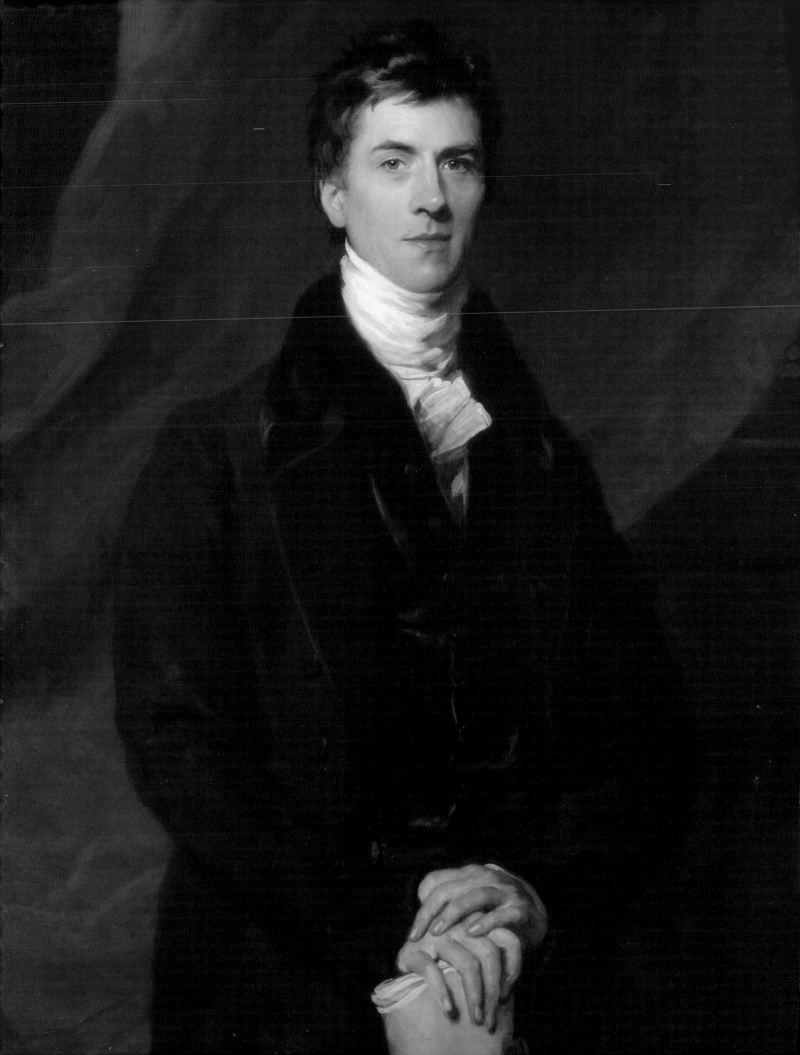

A PORTRAIT OF
FASHION

SIX CENTURIES OF DRESS
AT THE NATIONAL PORTRAIT GALLERY

AILEEN RIBEIRO
WITH CALLY BLACKMAN

NATIONAL PORTRAIT GALLERY, LONDON

CONTENTS

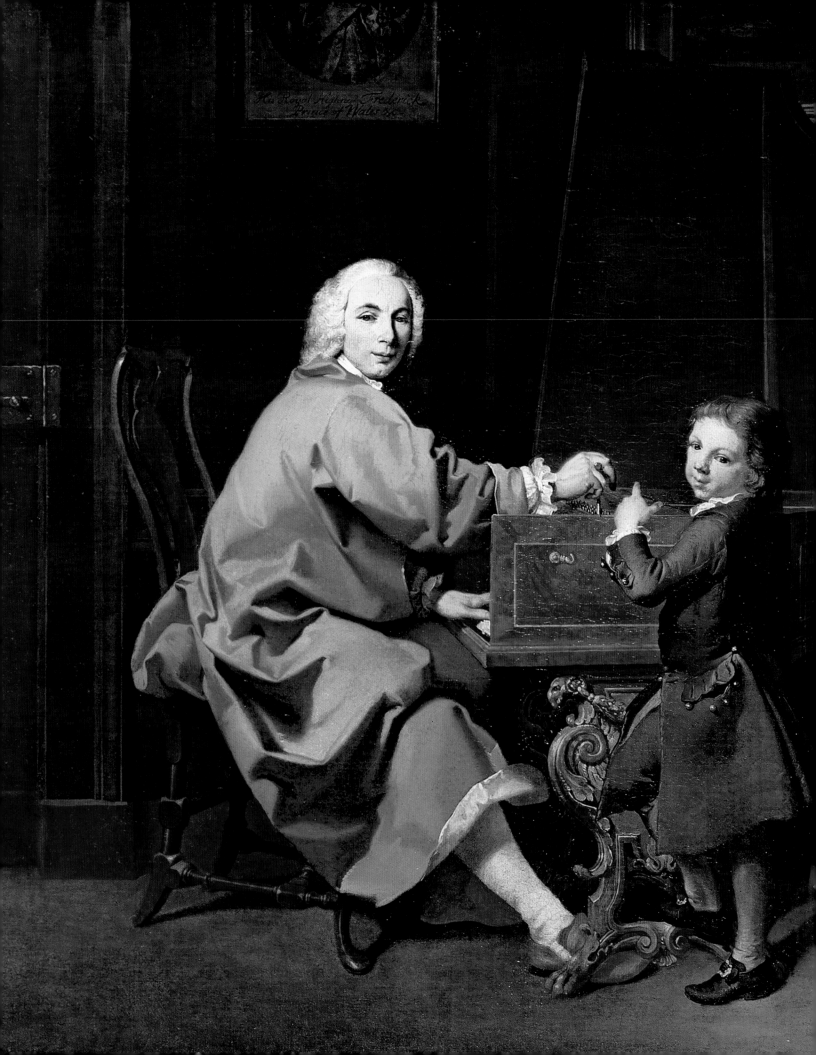

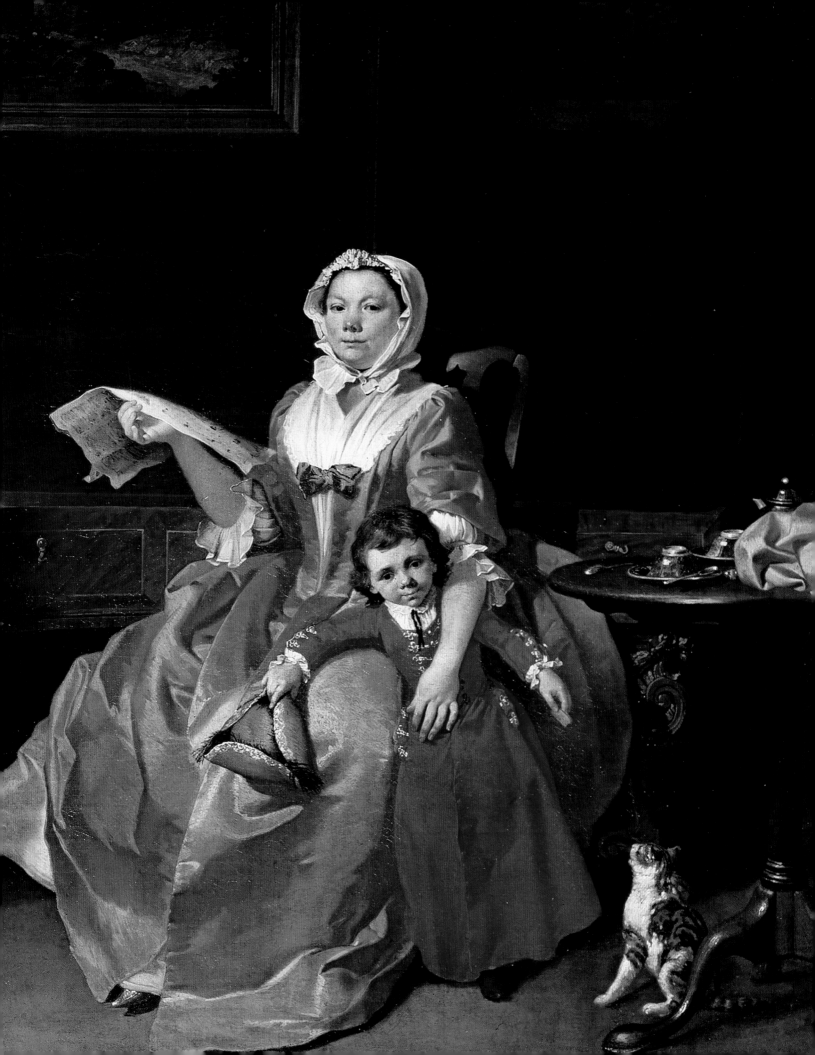

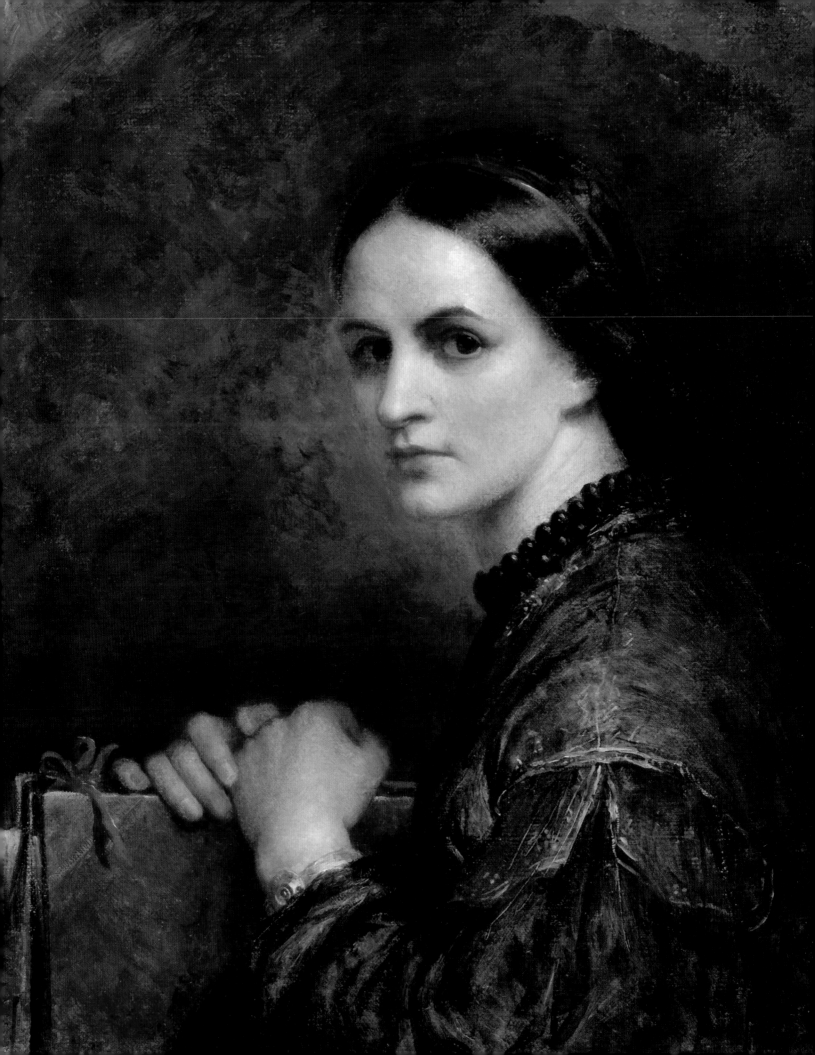

ACKNOWLEDGEMENTS

AILEEN RIBEIRO

In 1997, I was asked by the National Portrait Gallery to write a book on clothing in their portrait images, a prospect not only daunting, given the scope and extent of the Collection, but exhilarating as well. Portraiture is where art and fashion meet, and *The Gallery of Fashion* (the book's original title, taken from that of a famous fashion magazine), reflected this link. With regard to *The Gallery of Fashion*, I would like to reiterate my thanks to the staff at the Gallery, to the sitters in a number of late-twentieth-century portraits in the Collection, and to all the museums, galleries, art dealers and collectors who provided images and information about the complementary material in the book.

Almost twenty years later, invited to produce a new edition, the task was even more of a challenge, given the extended time frame into the present day, during which a wealth of innovative portraits appeared, and the greater choice of images from a rapidly growing collection. The perfect solution to the challenge of updating the book, as far as I was concerned, proved to be Cally Blackman, who had worked with me on *The Gallery of Fashion* and whose knowledge of late-twentieth-century clothing and contemporary fashion is far greater than mine. Furthermore, my interests lie more in how dress is represented in art, within a historical context, and Cally's in fashion per se. This book has been effectively restructured by Cally's input: not only has she added many new images from the late 1990s onwards but she has also considerably rethought the twentieth century and has incorporated new portraits and complementary material into the earlier periods. In addition, she has written brief introductions to each century. So this newly titled edition, *A Portrait of Fashion*, is a joint effort – our book.

CALLY BLACKMAN

Aileen has done more than any other academic to raise the profile of our discipline within the realms of art history: her scholarship is legendary, and so it was with some apprehension that I accepted her invitation to work as researcher on *The Gallery of Fashion* soon after leaving The Courtauld Institute, where she led the History of Dress programme. Nearly twenty years later, working with her on *A Portrait of Fashion*, as co-author, has been not only a huge privilege but also immensely enjoyable. I am grateful for everything she has taught me and for being given the chance to work again on the wonderful collection at the National Portrait Gallery.

• • •

At the National Portrait Gallery, our primary thanks are due to Nicola Saunders, who proposed the idea of *A Portrait of Fashion*, and to Sarah Ruddick for her responsive and thorough editing; their enthusiasm and patience have been exemplary. We would also like to thank Kathleen Bloomfield for her help with the picture research, and Lizzie Ballantyne for designing the book. The staff at the Heinz Archive have been, as ever, welcoming and unstinting in their knowledge. Clare Freestone, Associate Curator of Photographs, should also be thanked for her invaluable assistance. Both authors are also indebted to the curators at the National Portrait Gallery for their comments and suggestions on the text.

For their help with colour reproductions, the National Portrait Gallery would like to thank Ruth Slaney, the Gallery's art handling technicians and Mark Fairman from DL Imaging Ltd.

INTRODUCTION

Portraiture is one of the most accessible forms of art, and the one perhaps most generally appreciated. It has dual appeal both as art and as the representation of people we know of and know. At its best a good portrait provides a creative tension between the art object (painting, drawing, statue and so on) and the image that signifies a particular person. We can, of course, appreciate visual depictions of unidentified people (figs 29.1 and 40.1), but knowing who a portrait represents adds to our enjoyment of the image; portraiture is unique in its commitment to character. We are, as Robin Gibson remarks, fascinated by 'the special relationship possible between the creative artist and the object of his interest'; 'as long as there is humanity, portraiture in one form or another will continue to be a primary force in the visual arts'.[1] A gallery of portraits evokes a range of responses from the spectator. These may include immediate recognition of famous personalities of past and present, as well as an admiration of colour and form in the construction of the image. Dress and appearance in portraiture work also in these two ways: they signify and underline the identity of the person portrayed; and act as a kind of abstract art form, in which style and texture, fashion and fabric can be appreciated in their own right. The recognition of the part played by appearance and costume in a portrait leads to questions of identity, status and gender, all of which are explored in this book.

Portraiture may be as close as we can get (along with a piece of clothing or other possession of the sitter portrayed) to the reality of the past, to the living image that triumphs over the inexorable march of time. Through a gallery of portraits we can see time's progress reflected in images of the famous and the not-so famous. We can also see, within different images of the same person, how their appearance, deportment, character (and clothing) change and develop as time passes. My example here is Florence Nightingale, who – in William White's charming c.1836 portrait, *Florence and her sister Parthenope* (fig. i) – we first glimpse as a demure teenager, dressed in pink silk and engaged in embroidering a piece of white linen. Some twenty years later the artist Jerry Barrett (see fig. 58.1), commissioned by the art dealer Thomas Agnew to paint the famous Miss Nightingale in Scutari, as the heroine of a modern history painting, depicted in July 1856 (when the Crimean War had just ended) a woman of grim determination, hair simply and practically styled under a plain bonnet (fig. ii). After her return from the Crimea, illness contracted there confined her to bed, from which she wrote letters and reports campaigning for reforms in nursing, in hospital design, in the approach to soldiers' health and so on. In a rare photograph, taken in later life (fig. iii), Nightingale, a crochet shawl over her shoulders, lace-edged cap and scarf over her head, is an older but recognisable version of White's sketch, with the unlined face characteristic of some invalids and looking younger than her real age, at work on the letters lying on her lap.

As the art historian Richard Brilliant points out in his perceptive study of the genre, portraiture of necessity has to be centred on the self, on the humanity and individuality of each sitter, whatever the circumstances of the commission, by or for the person depicted. When, however, Brilliant argues that portraits must be about people and not things, he is only half right.[2] An essential element in the presentation of personality must be through such external objects as

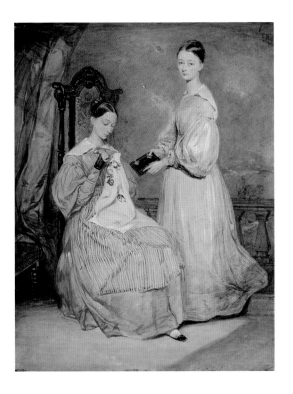
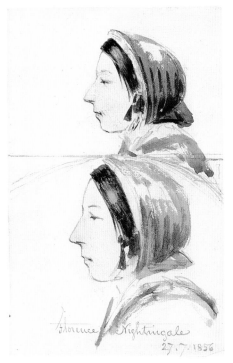
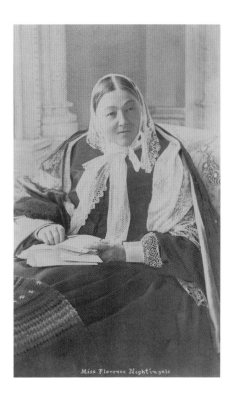

fig. i (above, left)
Florence Nightingale
and her sister Frances
Parthenope, Lady Verney
William White c.1836
NPG 3246

fig. ii (above, centre)
Florence Nightingale
Jerry Barrett, 1856
NPG 2930

fig. iii (above, right)
Florence Nightingale
After S.G. Payne & Son,
1891
NPG x132535

clothing and accessories, which confirm and delineate identity and character. Costume in portraiture is usually (there are exceptions) specific to the sitter and an essential part of his or her identity. Because we too express our individuality through the clothes we wear – although they may be far less grand and expensive than those worn by elite sitters in the past – we can understand and appreciate this shared facet of human existence.

When we contemplate portraits of famous figures of the past and present, their images are largely constructed – indeed created – by the clothing they wear. Costume is the most tactile of the applied arts; in certain portraits it can be apprehended almost physically, creating the impression that we can enter the frame to touch the fabrics, furs and jewellery as though they were the real thing and not merely a simulacrum. It is for this reason that many of the illustrations in this book are of surviving clothes and accessories very similar to those worn by the sitters in the National Portrait Gallery's Collection.

Until fairly recently our culture has yearned for physical likeness in a portrait; many people might still assert that this is the principal point of the exercise. In a general sense, issues of reality and truth must lie behind all depictions of the human form, even if such definitions are difficult to pin down. The artist's idea of likeness is sometimes influenced by a contemporary artistic style, which may override notions of the literal truth or generalise the sitter's clothes. 'Likeness', as Shearer West remarks, 'is subject to the quirks of artistic style, and, for the viewer, is a slippery and subjective notion.'[3] This is true even with contemporary portraiture, and is much harder to ascertain with regard to images of people in the past; how can we know if a portrait by, say, Van Dyck or Reynolds, reveals a real likeness, as the sitter perceives it, or a more 'philosophical' depiction as seen by the artist?

If we are familiar with a person, it is possible to recognise them from the back, by the way they walk and by the clothes they wear. This knowledge with regard to a figure in the past may be lost to us later, unless the information has been recorded, as, for example, in Edwin Landseer's portrait of Princess Victoire of Saxe-Coburg-Gotha (fig. iv), where her cousin Queen Victoria commented on the 'lovely sketch in oils Landseer has done of Victoire's back, as a surprise for me, it is so like'.[4] Dressed in embroidered or sprigged white muslin, standing by a balustrade on the terrace at Windsor, Victoire's appearance has the fashionable drooping look of the late 1830s, very sloping shoulders, low-set sleeves and the shoulder-length ringlets that the artist likens to the ears of the spaniel who keeps her company.

There may be a slightest element of exaggeration in Landseer's humorous 'sketch' (the word is inscribed on the balustrade), suggesting that this is not a formal, posed portrait. It is sometimes forgotten that clothing can be funny, which is why caricaturists home in as much on the clothes worn by those they depict as on their figures, gestures and mannerisms. Lytton Strachey's lanky, etiolated figure was a favourite subject for portraiture and caricature in the early twentieth century; there is a memorable image by Nicolas Clerihew Bentley of Strachey in the late 1920s, in which his beard merges into an immensely long tweed suit (fig. 68.1).

In our own individual ways we create the personality of the sitter in a portrait out of our own experiences as well as from our perception of the person depicted and the meaning of the image. The portrait becomes a kind of palimpsest built up of layers of 'readings' or viewings that our attitudes create. Looking at a portrait leads us to contemplate the idea behind this particular image: does it represent one moment (possibly significant) in the life of the individual, or is it a synthesis of a life's achievement? If the former, then a photograph with its greater sense of immediacy – even spontaneity – might do just as well as a painted portrait. But, it can be argued, we expect more of a good portrait than a mere photographic likeness; that very term has a slight air of disdain about it, implying only a record of surface details, although a great photograph has more insight than many a conventional descriptive portrait. A great portrait – whether painting or photograph – acknowledges and salutes the sitter's humanity and achievements, and records the life of the mind as well as the physical appearance. It usually incorporates the general as well as the particular; it has to be timeless as well as being – inevitably – of its own time. In the hands of some artists (I use the word here to refer to all creators of portrait images) this can present problems when a desire to explore identity imaginatively conflicts with the factual record of physical phenomena and sartorial appearance. As Brilliant comments: 'The extraordinary attempts made by portrait artists over the centuries to fix the image of persons by visualising their appearance and/or character, and at the same time to produce an accessible and acceptable object of art reveals the enormity of the task.'[5]

Clothing in a portrait can be double-edged. The minutiae of fashion detail in some works can overwhelm the image and create an effect little better than a costume portrait (fig. 11) or make it appear like a fashion plate (fig. 62). But if clothing is selected and depicted with intelligence and perception,

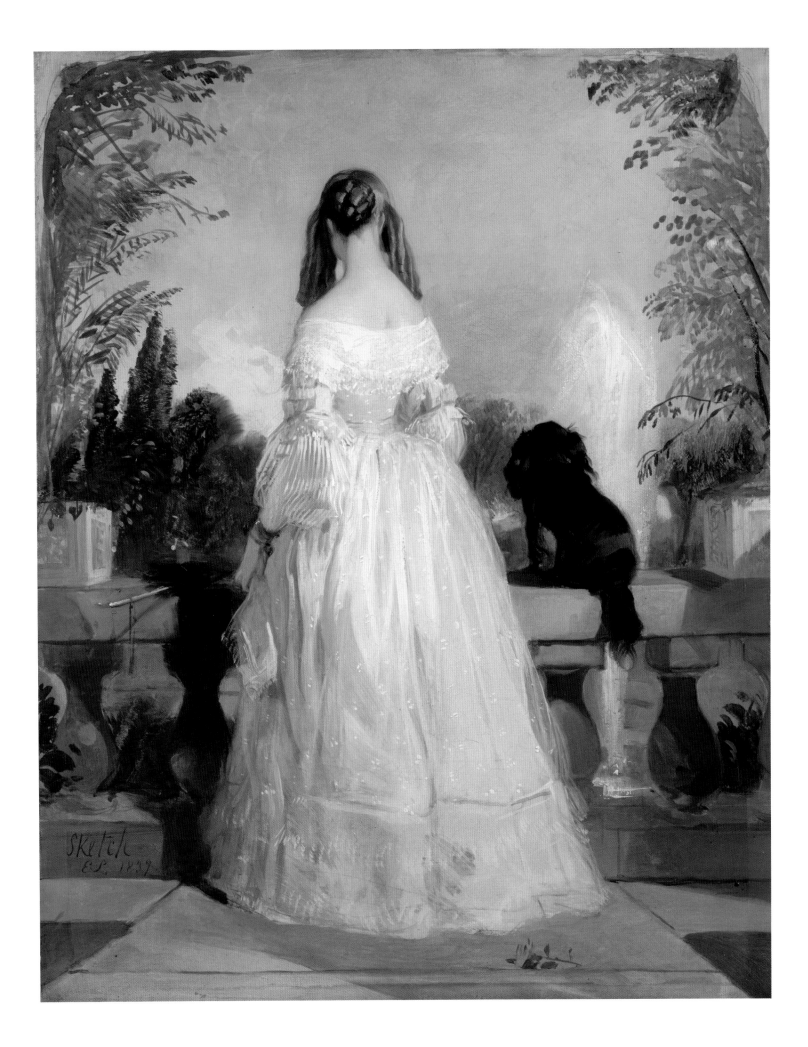

it can reveal psychological insights as well as presenting the obvious in terms of sex, age and status. Examples that come to mind include Thomas Lawrence's portrait of Henry Brougham (fig. 54), where the bravura painting of the black 'colours' that represent the different fabrics of the fashionable male wardrobe emphasises the mercurial and intelligent character of the sitter. Here the skill lies in the way the artist paints the clothing.

In Charles Buchel's portrait of Radclyffe Hall (fig. 71), on the other hand, we see how the choice of costume can indicate personality – in this case how the stylish masculine-influenced ensemble underlines the sitter's firmness of character and steely determination as well as indicating her sexual orientation. In the slightly more liberated social climate of the post-First World War period, Hall's clothes were a defiant statement of her sexual inclinations. Does, for example, the knowledge that the military historian and strategist Sir Basil Liddell Hart had a considerable interest in women's clothes[6] (he was a founder-member of the Costume Society in 1965) influence the way we look at his portrait by the German artist and theatre–film designer Hein Heckroth (fig. v), painted on the eve of the Second World War? What we can see is a stylishly dressed man in a striped shirt, dark red tie, and fine tweed jacket and waistcoat, in a typical Surrealist dream-like landscape (influenced by Dalí and Magritte), and with references to the conflict that was on the horizon, such as Europe clouded over and in a bubble, and the 'listening' ears of the Secret Services.

The link between artist and sitter was (and is) often intimate – a bit like the relationship between priest and confessor – and we do not always know what went on in the studio. Who, for example, decided costume and pose? What did the studio contain in the way of props, draperies, clothing, lay figures (mannequins, usually of wood, which could display clothes and accessories, and create a pose) and pattern books to inspire artist and sitter? How interesting and informative it would be if we could interrogate great artists of the past, such as Holbein, Lely, Reynolds or Lawrence, to find out how they coped with their sitters; what lay behind the choice of clothing in the portraits they painted. Even our knowledge of the live model in the English studio, especially in the early modern period, is relatively slight. What we can say is that most studios were in London, the centre of power and fashion, and that the studios of society artists, in particular, were places where the elite gathered; where people wished to look – both in pose and costume – like those depicted in portraits painted by fashionable artists.

To some extent the choice of costume was determined by the nature of the commission, whether public or private. If a public commission, then the clothing might be official – knightly or aristocratic robes, uniform, clerical or academic gowns – and would be the sitter's deliberate decision. If non-occupational clothing were involved, either mainstream fashion or fanciful costume, then it could be chosen either by artist or sitter, possibly in a process of collaboration. If the sitter was very grand – for example monarchs and their consorts – their clothing would usually be meticulously depicted in all its splendour, for it reflected the honour and status of the princely house; in this context Tudor kings and queens come first to mind. Later, and particularly for non-royal sitters, artists could allow themselves greater licence in the depiction

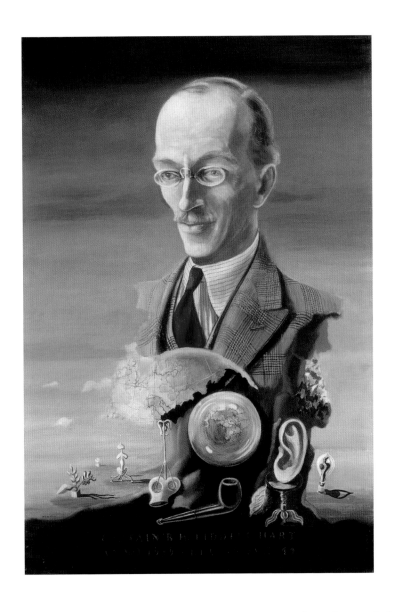

of fashionable dress by possibly altering the colour and decoration of a garment or even generalising the style of dress so as to create the line rather than the detail. From the mid-seventeenth century onwards, many sitters were portrayed in draperies or fancy dress, and therefore we cannot assume that what we see in a portrait is always the literal truth.

But in the sixteenth century, which is where the sequence of contemporary portraits in the National Portrait Gallery begins, the literal truth is what we do see. Portraits of princes and potentates, exchanged between European courts, were ever-present reminders of power and prestige and became the person depicted in another sphere. In this context, although a likeness was important, especially when a royal or aristocratic marriage was under consideration, the artist's reputation rested largely on the ability to paint all the details of rich clothing and jewellery, and to convey the dignity and deportment of the sitter, which to a considerable extent was dictated by the lavish clothing and accessories. This was particularly the case under Henry VIII, the first great Renaissance prince in England. After the relative restraint in costume evidenced by Henry VII (fig. 1), his son's reign saw the appearance of an opulent and extravagant style of dress, exemplified by the King himself, whose larger-than-life image – padded-and-slashed doublet and hose, and huge fur-trimmed coat – was one of exaggerated masculinity and conspicuous consumption (fig. 2). Images of women – even of royalty – pale beside those of Henry VIII; the King's wives are richly jewelled, but their clothing is, on the whole, fairly sombre (particularly in the National Portrait Gallery) until we reach the portrait of Catherine Parr (fig. 4), the first full-length portrait here. The Queen is superb in her fur-trimmed brocade and velvet costume: its widening, triangular-shaped skirt, created by the new hooped underskirt called the farthingale, was to be a dominant feature of elite female dress for more than fifty years. Triangular shapes were the leitmotiv of fashionable female dress during the second half of the sixteenth century. Top 'triangles' were created by a tight, stiffened bodice and by wide sleeves tapering to the wrist, and a lower, reversed 'triangle' was formed by the vast farthingale skirt. In the 1590s this pyramid-shaped skirt was replaced by the square French farthingale of the kind that, for example, Queen Elizabeth I wears in the 'Ditchley' portrait (fig. 9.1), a strange and regal image partially constructed by her clothes and cosmetics; it is only because we know her identity that this painting is more than just a portrait of a dress. The male equivalent of this body-distorting clothing was a tight-fitting padded 'peascod'

doublet (stuffed to resemble a pea-pod at the front) and round, padded trunkhose (figs 10 and 10.1).

The rich, icon-like splendour of formal costume – huge ruffs and sleeves, stiffened bodices and doublets, spreading skirts and cumbersome hose – restricted movement and limited poses in portraiture: arms rest on the clothing and hands clasp fashionable accessories, such as gloves and jewelled chains. Jewellery plays such an important part in the formal Tudor and Jacobean appearance that a number of extant examples have been included as complementary images to the portraits. The richly complex nature of elite clothing in the Elizabethan and Jacobean period, assemblages of luxury fabrics and accessories – what Henry James refers to as 'the glory of costume, the gospel of clothes'[7] – makes it hard at times to recall that the portraits we see are images of flesh and blood; not mere 'costume-portraits', representations of wealth and status.

Less adept artists have always found it easier to depict the physical reality of clothing, with equal emphasis being given to all the constituent parts of the costume, than select and make value judgements as to what kind of dress emphasises character; to create a painting as well as a portrait. By the accession of Charles I (1625) competent journeymen–artists, whose stock-in-trade was the meticulous rendition of fashion and fabric, were no longer so much in demand. A new mood of simplicity in clothing – under the aegis of a stylish king and a young French queen – came gradually into vogue, aided and abetted in the 1630s by the genius of Anthony van Dyck, whose portraits reflected and popularised this trend. Fabrics became plainer and styles of dress more closely followed the natural shape of the body; restraint and dignity were the hallmarks of Caroline court costume (figs 21 and 22). Van Dyck was the first major artist working in England since Holbein to use costume as a sophisticated complement to character, although with a very different approach, turning away from the sensitivity of detail that is such a feature of Holbein's work (especially his drawings) towards a simplification of the main lines of clothing – the essence of dress – and even, in his later years, to the fanciful costume of an Arcadian idyll.

No doubt the new ease in clothes (in art and in life) that Van Dyck sought to depict, and – to some extent – to promote, which was so evident by the middle of the seventeenth century, helped to create more relaxed postures in portraiture. Towards the end of his life, in his last self-portrait (fig. 24), Van Dyck concentrates on the face, and not on the clothes, aware that his exalted status, as one of the greatest artists of his day, requires no finery: the painting of the doublet and shirt are rough and scumbled, the clothing itself limited to basic lines, with no decoration and a plain linen collar. Increasingly, men and women were happy to be depicted *en déshabille* (in undress), in loose gowns and draperies. The 'disengaged' style of male clothing of the middle decades of the century – a voluminous shirt barely held together by a short bolero-style doublet and baggy, loose breeches – turned by the end of the 1660s, after various experimental combinations of coat/tunic, vest (waistcoat) and knee-breeches, into the three-piece suit. This staple of the masculine wardrobe – coat, waistcoat and breeches – remained relatively unchanged until, at the end of the eighteenth century, knee-breeches were replaced by trousers.

During the second half of the seventeenth century there was a growing rivalry in fashion between the courts of France and England, led by Louis XIV and Charles II respectively. It is particularly irritating that Charles, a man of fashion as his accounts testify, was rarely portrayed in contemporary clothing but often in official costume, such as Garter robes, and even antique Roman attire. In terms of classical dress Charles II followed the dictates of those artists who decreed that Roman costume gave dignity and decorum to the sitter thus habited, as well as an air of timelessness; many of his subjects were also painted in this way. Restoration portraits show men wearing loose gowns, which also evoked the notion of timelessness and reflected the relaxed informality of the court of Charles II. Such a costume was, in real life, also a comfortable alternative to the formal structured suit made of heavy fabrics, elaborately trimmed, and the large full-bottomed wig of the period. Samuel Pepys tells us in his diary entries for March 1666 that, for his portrait that year by John Hayls (fig. vi), he hired a brown silk 'Indian gowne'; although he found the pose uncomfortable – he had to look 'over my shoulders to make the posture for him to work by' – he declared himself two months later 'very well satisfied' with the result.

Pepys could not afford Peter Lely, who was the most fashionable artist of the period, particularly in his painting of fanciful costume and draperies. Lely established a new aesthetic in his portraits, especially those of women, where a delight in nacreous flesh and the gleam of satin and taffeta prevailed over likeness – Pepys claimed that Lely's portraits were 'good but not like'.

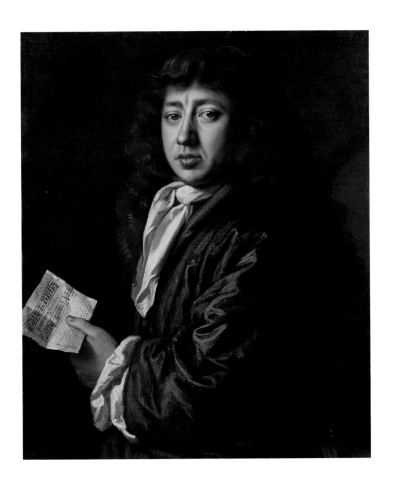

fig. vi
Samuel Pepys
John Hayls, 1666
NPG 211

As Andrew Wilton aptly noted, 'Lely was highly gifted at expressing glamour', a word, with its modern connotation of film-star glossiness, that is especially appropriate in this context.[8] Lely's female sitters are usually lightly clothed and without stays; their draperies seem about to slide off their polished shoulders, giving them an air of sexual availability (fig. 29.1). This was certainly true about court favourites such as Nell Gwyn (fig. 29), painted in just her shift, a visual evocation of the famous lines from 'Delight in Disorder' by poet Robert Herrick: 'A sweet disorder in the dresse/ Kindles in cloathes a wantonnesse'.

It was Van Dyck who began the vogue for painting his sitters (usually women) in generalised romantic versions of fashionable costume. The painter was also the first major and successful artist to adopt the workshop system in England, whereby studio assistants were used to paint clothing and accessories so that more than one hand worked on a portrait. This way of working became de rigueur for most portrait artists from the mid-seventeenth century and lasted until well into the eighteenth century. It was a system calculated to promote the simplified costume and draperies approved by theorists but producing

portraits of little specificity in terms of dress. The *Spectator* for 1711 noted how 'Great Masters in Painting never care for drawing People in the Fashion', in the belief that contemporary clothes 'will make a very odd Figure and perhaps look monstrous in the Eyes of Posterity'. So artists such as Sir Godfrey Kneller often depicted sitters in vague and ill-defined draperies, no longer with the sexual appeal so evident in the work of Lely. This was not for lack of skill, for Kneller did sometimes depict the detail of fashion, as in his portrait of Henrietta Cavendish, Lady Huntingtower (fig. vii), in her cream-coloured camlet riding habit trimmed with gold braid. This is an early example of women raiding the male wardrobe to adapt garments from it for their own use: the coat, cravat and three-cornered hat, and – in this case – the periwig. This costume is clearly worn for the purpose, but by the middle of the eighteenth century women wore such outfits for outdoors and a range of informal occasions; two elegant riding habits can be seen in Johann Zoffany's *The Sharp Family* (fig. 46).

These riding habits anticipated the tailored suits of the late nineteenth century, and they, in their turn, became the trouser suits, either fitted or loose (fig. 92.1), that many professional women started to wear a hundred years later.

On the whole, however, Kneller's preference, and that of many of his contemporaries, was for 'timeless' simplicity in a portrait; a number of his male sitters are painted in loose gowns or classical Roman 'vests' (tighter-fitting, knee-length gowns). These garments often sit oddly with the large wigs dictated by

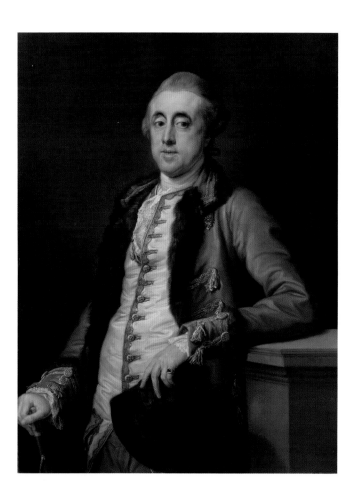

fashion that invalidate a sense of timelessness (figs 34 and 34.2); an alternative was to paint informal costume, such as the open-necked shirt and simple velvet coat that William Congreve (fig. 33) wears in his portrait. An air of grandeur and solidity imbues clothing of the early eighteenth century. The fashionable male silhouette was dictated by the towering periwig, the stiffened coat with flaring side skirts, a waistcoat almost as long as the coat and heavy square-toed shoes (fig. 34.1). Gradually, masculine clothing lost its 'Baroque' heaviness, and by the middle of the century it had become more streamlined, with a less bulky coat and a shorter waistcoat; smaller, neater wigs were in vogue. Foreign travel, especially the Grand Tour, enabled men with a taste for finery to indulge it, for Italian costume was brighter in colour, richer in materials (including furs) and more decorated (with lace and gold-and-silver braid) than the styles worn in England. Artists such as Pompeo Batoni delighted in the detail of clothing for its own sake, because he saw that this was what his patrons (milordi in Rome on the Grand Tour) wished for. Batoni's *John Scott* (fig. viii) is elegantly and expensively dressed in a blue silk coat lined with sable, his right hand resting on the amber top of his cane.

At home British taste tended increasingly

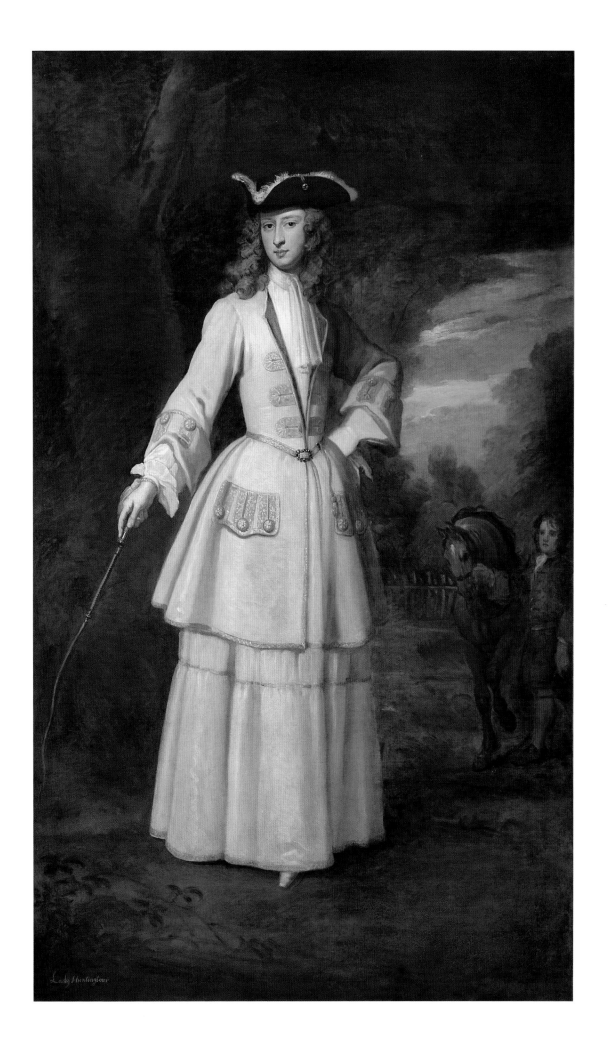

towards less formal clothing, reflected also in portraiture, for it was thought that a relative simplicity in dress could more accurately reveal character in portraiture. Perhaps this is why we can relate better to Joshua Reynolds's fine portrait of a rather distrait Warren Hastings (fig. 41), with his lightly disordered hair and simple dark frock coat, than we can to the aloof formality of John Scott's silk suit and powdered wig. By the later eighteenth century Englishmen were noted for modest simplicity in their everyday clothing, with a preference for woollen cloth (silk being reserved for more formal occasions) with minimal trimming and decoration. This kind of costume – widely worn by an aristocratic elite as well as the middle class – reflected an increasingly commercial society and a new emphasis on talent, whether cultural, scientific or mercantile; professional men, scientists, inventors, bankers, writers and doctors, for example, were increasingly portrayed in art (figs 44 and 46).

The developing story of women's clothing in the eighteenth century could all too easily become a litany of constantly changing styles, a naming of names encouraged by the appearance of the first regularly published fashion plates towards the end of the eighteenth century. Female costume is more complex and difficult to pin down than men's wear of the period. At the beginning of the century formal costume was dominated by the mantua (fig. 31.2), an open gown with stylised back drapery, revealing an elaborately trimmed underskirt ('petticoat' was the contemporary name). By the end of the first decade of the century hoops had reappeared; initially, they were a relatively modest pyramid shape, but they gradually became larger, first rounded, and then, by the 1740s,

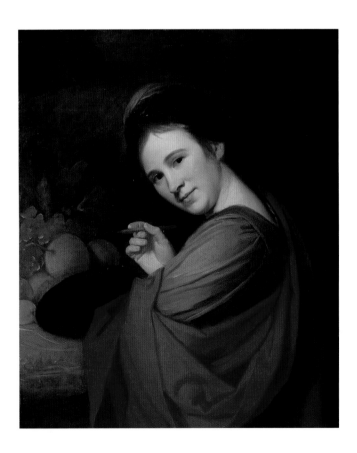

fig. ix
Mary Moser
George Romney, c.1770–1
NPG 6641

square (fig. 40.1), a gift to the caricaturist and to satirical artists like Hogarth. By the middle of the century the elegant lines of French fashion made an impact on English dress; many women, on more formal occasions, adopted the *sacque* dress or *robe à la française*, characterised by flowing back drapery from neck to hem. Later in the century, Englishwomen returned to closer-fitting gowns in plainer fabrics, less adorned with trimming; the *robe à l'anglaise* became one of the mainstays of the feminine wardrobe and can be seen worn by Frances Sharp in Zoffany's painting of the music-making Sharp family (fig. 46).

Running alongside portraits depicting fashion were those where more abstract and intellectual ideas could be expressed, as a number of English artists from the 1760s onwards, first Reynolds and, later, George Romney, began to depict their female sitters in loosely draped gowns, some vaguely 'classical' in style, others less so, but all intended to be 'timeless' in character. Romney's image of the artist Mary Moser (fig. ix), painter of fruit and flowers, and one of the founder-members of the Royal Academy of Arts, London, is such a portrait.

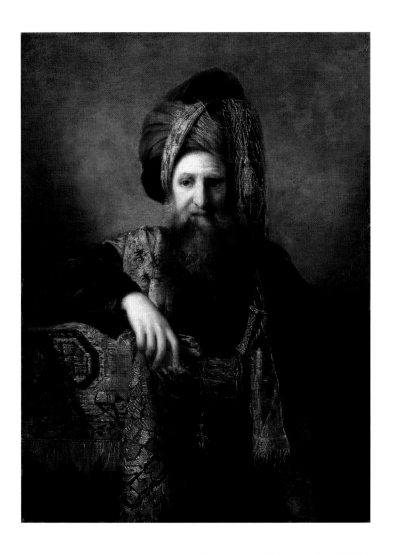

The sitter's hair, far from the elaborate high coiffure of fashion, is simply coiled in a plait round her head and held in place with a gauzy scarf; her 'dress' (indeterminate in style, and possibly concocted in the studio) is mainly hidden beneath a large asymmetrically draped red mantle, again probably a studio prop.

The portrait not only signifies a disdain for the excesses of fashion (a view certainly held by Romney) but also serves to underline Moser's status as an artist: her art – like her appearance – is meant to be timeless. Unusually in such works of art, however, the face is painted with honesty and affection; in spite of the generalised costume, we feel that this is a real person.

From the late sixteenth century to the present day, portraits have depicted the English love of fancy dress, both real and as an artistic conceit; role-playing and fantasy have always been a theme in art and in life. In the eighteenth century the vogue for the masquerade (figs 42 and 42.1) was reflected in the popularity of fancy dress in portraiture. Favourite costumes were historical and oriental, the latter inspired by the versions of Turkish costume that many Britons adopted in their travels in the Levant. One such traveller was Edward Wortley Montagu (fig. x), the eccentric son of the famous Lady Mary Wortley Montagu (who had travelled to Constantinople early in the eighteenth century and was painted *à la turque* (NPG 3924)). Soldier, politician, linguist, oriental traveller and confidence trickster, Edward Wortley Montagu loved, throughout his chequered career, to wear Eastern costume. Towards the end of his life he was portrayed, Rembrandt-style, in a fanciful and highly theatrical 'oriental' costume dominated by a huge tasselled turban.

Turbans, ever since the Renaissance, have been signifiers of the oriental to the western mind. They have sometimes made an appearance in European fashion, most obviously, in the late eighteenth and early nineteenth century (fig. 50.2), as part of the widespread taste for turquerie, which had manifested itself earlier in fancy dress and in the theatre. The idea of the fabled Orient – the turban and the loosely draped clothes – can be seen in Dean Marsh's impressive portrait of psychotherapist and charity founder Camila Batmanghelidjh (fig. xi), the founder, in 1996, of Kids Company, which was set up to give practical and educational help, along with emotional support, to vulnerable and damaged inner-city children in London and Bristol. But, like many portraits, the appearance of the person depicted is as much a construct of the artist's imagination as what the sitter really wears; a portrait is a complex process of selection and elision. Batmanghelidjh was born into a wealthy Iranian family, uprooted by the revolution of 1979, but what she habitually wears, brightly coloured 'clothes

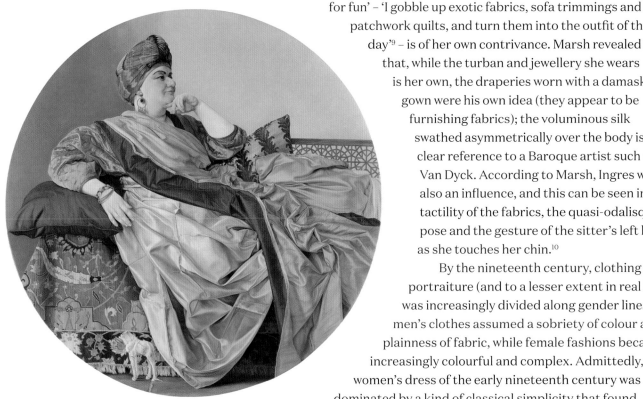

fig. xi
Camila Batmanghelidjh
Dean Marsh, 2008
NPG 6845

for fun' – 'I gobble up exotic fabrics, sofa trimmings and patchwork quilts, and turn them into the outfit of the day'[9] – is of her own contrivance. Marsh revealed that, while the turban and jewellery she wears is her own, the draperies worn with a damask gown were his own idea (they appear to be furnishing fabrics); the voluminous silk swathed asymmetrically over the body is a clear reference to a Baroque artist such as Van Dyck. According to Marsh, Ingres was also an influence, and this can be seen in the tactility of the fabrics, the quasi-odalisque pose and the gesture of the sitter's left hand as she touches her chin.[10]

By the nineteenth century, clothing in portraiture (and to a lesser extent in real life) was increasingly divided along gender lines: men's clothes assumed a sobriety of colour and plainness of fabric, while female fashions became increasingly colourful and complex. Admittedly, women's dress of the early nineteenth century was dominated by a kind of classical simplicity that found much favour with artists (fig. 50), but at the same time as white muslins (fig. 48.2) were all the rage, a romantic historicising impulse (always close to the English heart) also manifested itself, taking the form of velvet dresses à la Renaissance with high collars or ruffs, the type of costume we see in Thomas Lawrence's portrait of Caroline of Brunswick of 1804 (fig. 51).

What was perceived by many moralists as a restless desire for novelty in the progress of female dress was unfavourably compared with the relative uniformity and slower pace of change seen in men's clothes. Revolutions, both industrial and political, encouraged a new masculine ideal in clothing – simple utilitarian suits and coats of woollen cloth – a style founded on the concept of work, self-discipline and economic reliability. Within the limited palette of masculine costume, however, a great artist such as Lawrence could still work wonders. Lawrence was the only early nineteenth-century British artist with a genuine feel for costume and an ability to render fabrics to perfection; a far lesser artist, James Northcote, attempted to disparage him by his reference to 'a sort of man-milliner painter – a meteor of fashion'.[11] Occasionally, it is true, Lawrence invested his sitters with more glamour than they possessed: his portraits of the Prince of Wales, for example, were more flattering than the reality suggested by James Gillray's caricatures (fig. 47). On the whole, however, Lawrence succeeded brilliantly in conveying the subtle sophistication of the male dress of his time: 'He revelled in the deep unmodulated blacks and the sharp white or cream of well-laundered collars and cravats. The sartorial austerities of dandyism were a source of inspiration.'[12]

Black and white came increasingly to be thought of as the colours of modernity and feature prominently in portraiture. Informally, men could wear

more colourful and even patterned clothing, but convention dictated that when having their portrait painted they would deliberately choose the almost 'timeless' quality of black-and-white formal wear over more casual attire. On the whole, portraits of this period show men of the upper and middle classes, whose lives involved the wearing of formal clothes; it is rare to come across a portrait of a working-class man, such as that of the poet John Clare in 1820 (fig. 53.1) in his brown coat, buff-coloured waistcoat and the printed-silk neckerchief that was a cherished mark of individual finery for the working man. It is fairly unusual also in a painted portrait to see casual clothing worn for leisure pursuits and informal occasions; lighter outfits (both in terms of weight and colour) were permissible, but even so the colour palette was usually limited to shades of grey, blue, buff, muted checks or tweeds. Informal clothing of this kind is more likely to be recorded in the portrait photograph or in caricatures.

Masculine clothing in general was suitable to underscore character in a painted portrait, but was especially apt for photography, which from the middle of the nineteenth century provided images of a far wider range of people and variety of costume than formal portraiture could encompass. The direct predecessor of the photograph was the silhouette, a likeness cut in black paper and stuck on to card, which was popular from the last quarter of the eighteenth century. Quite sophisticated images could be created, even down to the details of dress and accessories as well as physical features (fig. 55.1). The fashion for silhouettes lasted until the middle of the nineteenth century, extending the franchise of image-making and creating a link between the portrait and the photograph; when photography became established (the first photographic studio in England opened in Regent Street, London, in 1841), portraits proved to be most popular.[13] Inevitably, painting provided models and inspiration for the portrait photographer (in its turn photography was an invaluable aid to the Victorian artist). Photography had its limitations: in one 'sitting' there was only a single chance to assess the character of the person and no time to discuss, for example, what clothes were to be worn; women, in particular, constrained by their fashionable costume and conventional poses, often look passive and lacking in personality. On the other hand, the speed of the photographic process and the modernity of the image it created could catch character and result in penetrating portraits, such as those by Robert Howlett of the great civil engineer Isambard Kingdom Brunel in 1857,[14] as he prepared to launch the *Great Eastern* (fig. xii), the largest ship in the world at that time. Second from the right, in his rumpled woollen suit and overcoat, he stands with a self-confident air, smoking his trademark cigar, surrounded by a group of similarly clothed men (including the ship's captain on the left); although

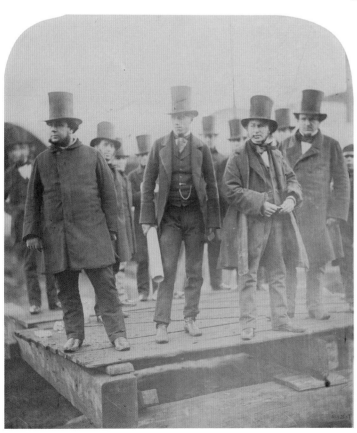

fig. xii
Isambard Kingdom Brunel preparing the launch of the
Great Eastern
Robert Howlett, 1857
NPG P663

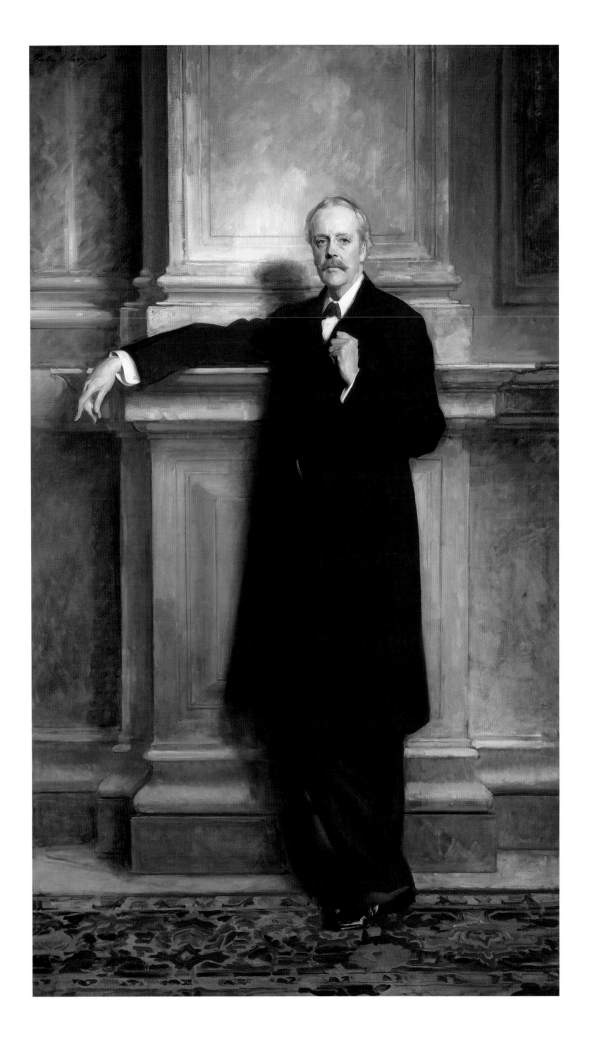

fig. xiii (opposite)
Arthur James Balfour, 1st
Earl of Balfour
John Singer Sargent, 1908
NPG 6620

fig. xiv (below)
John Elliott Burns
John Collier, 1889
NPG 3170

they wear their muddy working clothes, the top hats indicate their status – they work hard, sometimes physically, but these are powerful and important men who shape the industrial destiny of Victorian England.

The three-piece suit, which Brunel and his companions wear, was the mainstay of everyday masculine clothing until well into the twentieth century (and still exists, usually in the reduced form of a matching jacket and trousers); it could be made of tweed for the country, lighter wools for town.

Mostly, however, portraiture demanded more formal clothes, which for men in the second half of the nineteenth century meant a dark (usually black) suit; in the middle and upper layers of society, a frock coat with straight-edged skirts to the knee or just below. Hardly changing in style, the frock coat was the formal daywear of the Establishment, and remained so until the early twentieth century. In John Singer Sargent's monumental 1908 portrait of the Conservative statesman and former Prime Minister Arthur James Balfour (fig. xiii), the artist presents an image of attenuated elegance in clothing (well-tailored frock coat and patent-leather shoes) and languid pose, as befits the leader of the 'Souls' (a group of mainly aristocratic intellectuals and aesthetes in the late-Victorian and Edwardian period).

Lady Colin Campbell declared that men presented 'a sombre, not to say a gloomy appearance ... [with] no scope for variety from year to year, except in the shape and cut'.[15] Other commentators, however, disagreed with such critics who found male formal attire too funereal and uniform; Max Beerbohm claimed that male dress was a celebration of pared-down and austere elegance, declaring: 'Is not the costume of today, with its subtlety and sombre restraint, its quiet congruities of black and white and grey, supremely apt a medium for the expression of modern emotion and modern thought?'[16] In the portrait of Beerbohm himself in his fashionable Chesterfield coat (fig. 63.3) we can see something of the decorative and formalist elements of male costume so celebrated by aesthetic writers and artists. Formal coats like these were not worn by the middle-class intelligentsia or working-class men; the left-wing politician John Elliott Burns, who led a dock strike in 1889, was portrayed by John Collier (fig. xiv) in a short double-breasted dark coat, a soft turned-down collar and a red tie. Clothing has always reflected class, and from the late nineteenth century onwards this became a language of political affiliation, reflected in portraiture; along with the rise of the Labour Party (founded in 1900), the other important movement of the period was that of female suffrage, the militant Christabel Pankhurst wearing a sash in the green, purple and white of the Women's Social and Political Union (fig. 66).

fig. xv
Mrs Bischoffsheim
Sir John Everett Millais, 1873

Political references can be fairly discreet, such as the red tie worn by Burns (and by prominent members of the Labour Party into the new millennium), or more confrontational, for example, the T-shirt with an anti-nuclear message, worn as a vehicle of protest by the fashion designer Katharine Hamnett at a reception in Downing Street in 1984 (fig. 86.2).[17]

The relative simplicity and sobriety of men's clothing in the nineteenth century is a striking contrast to the complex layers of women's clothing in the Victorian period. By the 1830s, fashion had thrown off any lingering vestiges of simplicity to assume forms that stressed individual areas of the body rather than the harmony of the whole. We see, for example, curious segmented hairstyles, inflated sleeves (figs 55, 55.1 and 55.2) and skirts that gradually widened – first through layers of petticoats and then with the cage crinoline of the mid-1850s. Not until the late 1860s did the crinoline, which some might think gave women the appearance of highly decorated lampshades (fig. 58), disappear, giving way to a flatter-fronted dress with complex back drapery often arranged over a bustle (fig. 59). This was a period of highly skilled dressmaking (aided by the invention of the sewing machine in the mid-nineteenth century); when one looks at the elaborate toilettes of the 1870s and 1880s (fig. 62), it is not altogether surprising that many artists found it difficult to rise above the myriad details of fashionable ensembles and ended up producing what the artist and art critic John Ruskin called 'mere coloured photographs of vulgar society'.[18] It was important, as the artist Francis Grant opined in 1873, that in portraiture 'truth to nature should be combined with taste and refinement'.[19] But how could this best be achieved when artists were obsessed by the factual detail of women's clothing (no doubt encouraged by the majority of their fashionable sitters), which often prevented a discriminating analysis of personality?

One possible solution was to incorporate a sense of the historical in portraiture, for artists were encouraged to build on the achievements of the past, on the work of the Old Masters. Although the vogue for fanciful dress in portraiture as an artistic convention had largely died out by the nineteenth century, historical costume (from classical antiquity to more modern times) remained popular for fancy-dress balls, and as subject matter for artists specialising in historical genre scenes. Such artists would often have actual costume in their studios; William Powell Frith's self-portrait of 1867 (NPG 1738) shows the interior of his studio and, in the background, on a chair, an eighteenth-century-style coat trimmed with silver braid. The eighteenth century became a source of inspiration both in portraiture and in fashion during the later decades of the following century; in John Everett Millais' *Mrs Bischoffsheim* (fig. xv), we see an interpretation of the polonaise gown of the 1770s (fig. 45.2) with its bundled-up back drapery, worn over a skirt of pale pink silk that matches the lining of the over-gown. Clarissa Bischoffsheim was married to a prominent Dutch financier, and the couple had an art collection, including works by Gainsborough and Reynolds, at their Mayfair house; perhaps it was Millais who chose her brocade gown, which imitates an eighteenth-century silk and which is decorated in blonde (silk) lace of seventeenth-century inspiration, a somewhat eclectic historical combination.[20] Opinions on the portrait were mixed, some critics admiring the bravura of presentation and

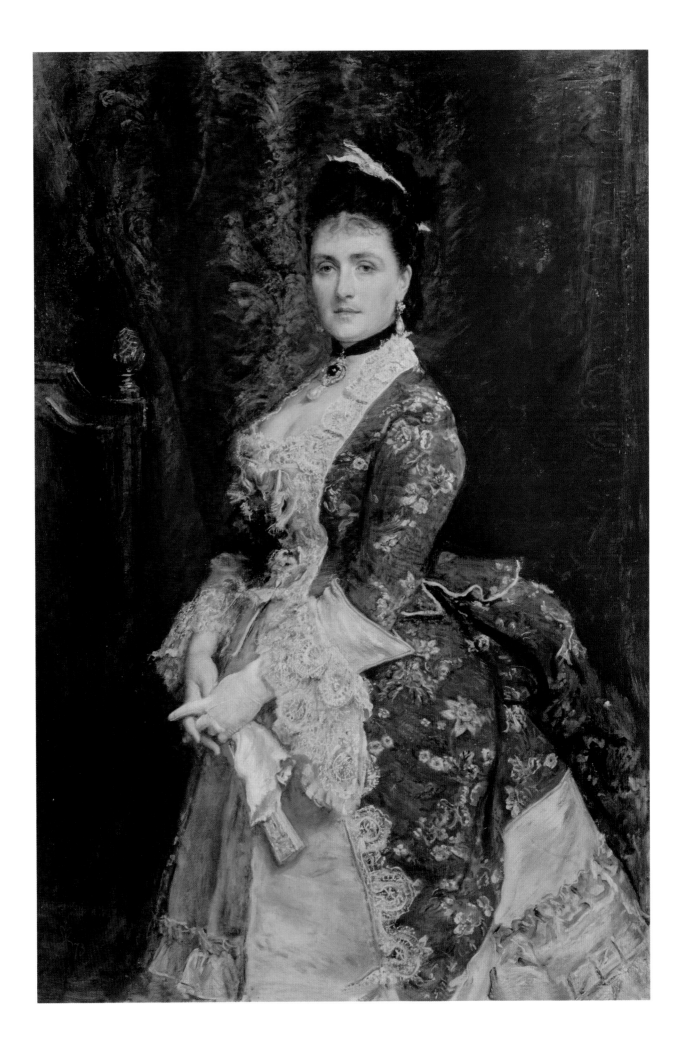

technique, others finding it completely lacking in the 'taste and refinement' that Francis Grant admired.

As a reaction to the prevailing materialism in society, evidenced by the conspicuous consumption of fashion, from the middle of the nineteenth century many artists and 'artistically' inclined women encouraged the wearing of simpler styles of dress, sometimes with 'historical' overtones (fig. 60.1). Although it is often stated that modern dress for women appeared only at the end of the 'long' nineteenth century, in other words with the First World War, it is equally plausible to see earlier signs of sartorial emancipation. The first serious experimentations with practical clothing came with the tailor-made suit, the blouse and skirt (fig. 67); even – in the 1890s – the first tentative steps were made towards the wearing of trousers, after Amelia Bloomer's premature attempt in 1851 to popularise bifurcated garments in England, with her eponymous suit, comprising a tunic worn over trousers. It is in this light, then, that the Edwardian period appears – like the later New Look – to be the last gasp of an outmoded order, using clothing to emphasise breast and buttocks in what appears at times to be almost a parody of the female body. Images of fashionable women at the turn of the twentieth century show a silhouette where the full bosom (aided by corsetry) is pushed forward and the dress clings to the hips, flaring out in a trumpet shape at the hem (fig. 65).

By the end of the first decade of the twentieth century a more natural line for women was beginning to emerge, evident in Joseph Southall's *The Agate* (fig. xvi), a self-portrait with his wife Bessie, who wears a fairly simply styled dress in an artistic purplish-brown colour, although with a fashionably large 'Gainsborough' hat, typical of the period. Southall's socialist sympathies (note the red tie), neomedievalist painting with flat planes of colour and links to the Arts and Crafts movement demonstrate the influence of William Morris.[21] He wears a kind of reform dress (in fig. 63, Oscar Wilde had worn a more aesthetic version), a plain dark-brown woollen jacket, knee-breeches and a trilby.

By the First World War, some women had begun to wear shorter skirts and even had their hair cut short, a hitherto unheard-of feature of feminine appearance. During the War, women took over many traditional masculine jobs, such as operating public transport, munitions work and agricultural employment, and some even joined the armed forces. Such jobs meant that women had to wear practical and hard-wearing clothing; corduroy breeches, for example, which actor Wendy Hiller wears in a portrait of *c*.1935 (fig. 75), were the kind first worn by the Women's Land Army (usually known as Land Girls), working as farm labourers, during the First World War. Whole new worlds of opportunity and previously unknown freedoms – political, social, cultural, sartorial – began to be opened up, and the heavy mortality rate among fighting men meant that many women found themselves the family bread-winner. New freedoms in dress in the post-war period also resulted from the emancipation of female talents, especially in the arts and in education. Women signalled this emancipation by wearing short, simple tubular dresses and adopting the masculine suit and tie (and trousers); they expressed their femininity by the wearing of cosmetics – hitherto make-up had been worn only very discreetly, as it had overtones of impropriety. Many society artists,

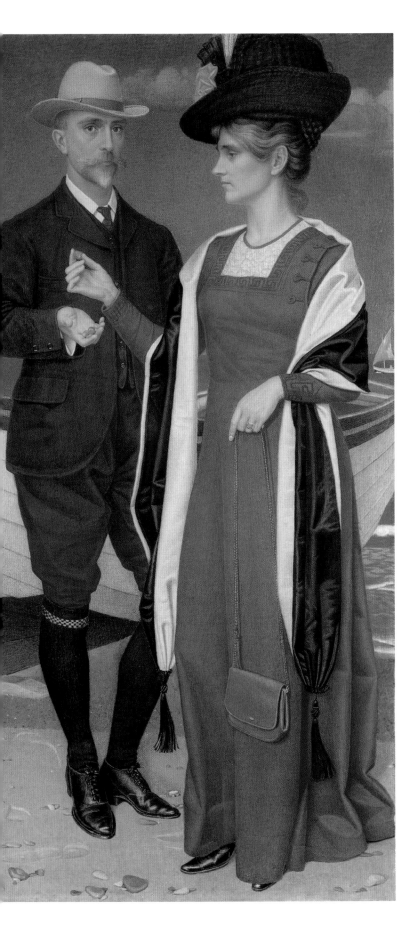

in particular, found it difficult to come to terms with such revolutionary images of women, preferring to hark back to the safety of the past. Many men were challenged (and often daunted) by the modern young woman, but the new practicalities of feminine dress had an impact on men's wear. True, men retained the suit (although summer jackets were of lighter, washable fabrics), but they gradually incorporated more colour in their clothing; from sporting costume and working-class clothing came the knitted sweater, corduroy trousers and the coloured shirt. After the Second World War, further items of casual clothing, such as denim jeans and T-shirts (derived also from working-class dress), entered the male wardrobe, and this move towards the demotic is one of the main themes of contemporary men's wear, allied to the ease and comfort of such sports-influenced garments as trainers and track-suits. Sport and leisure pursuits had – and still have – a major influence on the trend towards casual clothing.

In a century when women's lives changed out of all recognition, the same desire for change was reflected in the clothes they wore. 'Plus ça change, plus c'est la même chose', the cynical critic might say, pondering the notion that there might be in the feminine soul an innate sense of delight in novelty, a feeling continually exploited by the vast fashion industry, which itself is promoted by an explosion of visual media. In the first half of the twentieth century we can, through portraiture, see the main changes in fashion after the opulence of Edwardian dress: the geometric lines of the 1920s, the fluid ultra-feminine styles of the 1930s, the crypto-Victorian revival, the sharp, boxy functional clothing dictated by the exigencies of the Second World War, and the New Look of 1947 that led into the groomed gentility of the 1950s. During the second half of the twentieth century there was a bewildering variety of styles and trends – sporting and leisure clothes, new synthetic fabrics, the acceptance of the sexually provocative in dress, the input of sub-cultures, ethnic dress and a variety of alternative fashions. No longer, after the Second World War, was it possible to say (as might have been the case 300 or so years earlier) that there was one main stream of

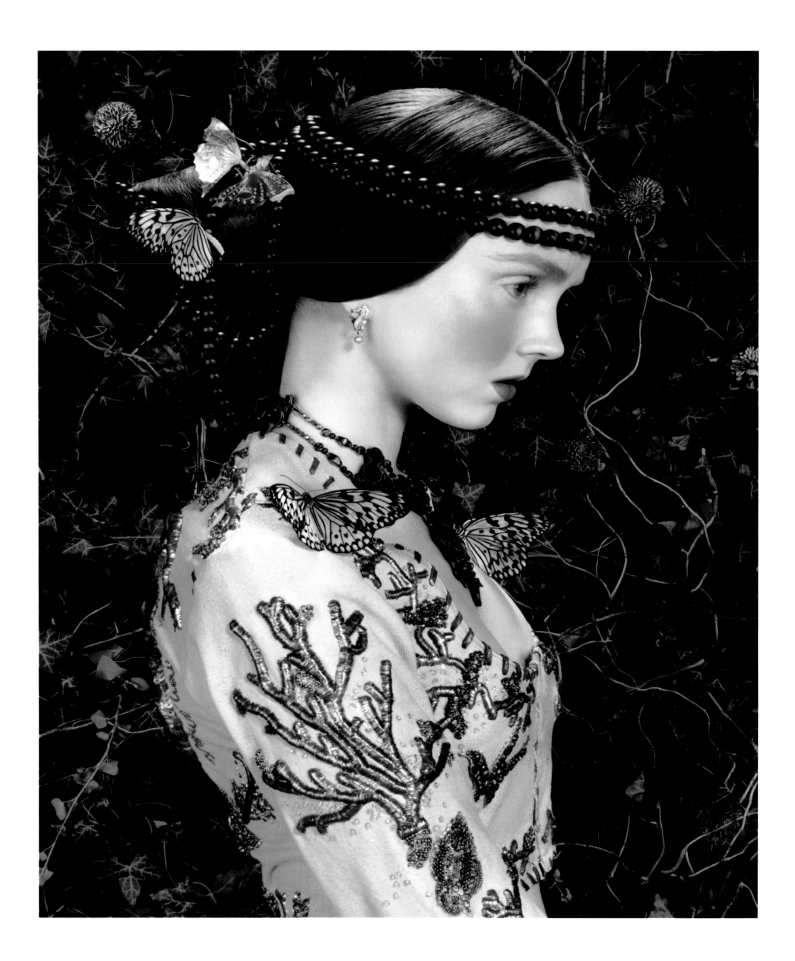

fashion to be followed to a greater or lesser degree in different levels of society, according to age, class, economic considerations and personal inclination. We begin to understand how complex and nuanced clothing was in the past and remains, perhaps even more so, in the present. How do we assess the clothing of our own times and make judgements as to what in future will be seen as crucial shifts of emphasis and defining moments in the story of fashion? Fashion can all too easily appear like a kaleidoscope, constantly fragmenting and changing. Even a definition of what constitutes fashion itself has become debatable; there appears to be far less homogeneity now than in the past.

Post-war trends in society – changing notions of who and what we are, and our place in the world, fluid and shifting personal relationships and employment, a far less formal and structured existence – are reflected both in how we dress and how we appear in portraiture. While the painted portrait still has primacy, it has to contend with such other media as photomontage and video; this makes walking round the displays of contemporary portraiture at the National Portrait Gallery a stimulating but sometimes unnerving experience. No longer do we see the elite portrayed in all their finery, but a series of informal 'snapshots' of a much wider range of people, men and women who no longer dress up for the artist or camera. On the whole, there appears to be little debate, either by artist or sitter, as to the costume worn in contemporary portraits. For Paula Rego's portrait of the writer Germaine Greer (fig. 85.1) the sitter noted that the artist 'did not make suggestions about my clothing', and in the case of Humphrey Ocean's 1996 portrait of the Labour politician and former minister Tony Benn (NPG 6371) the sitter seemed genuinely surprised to be asked about the clothes in which he is shown, saying, 'I don't think we even discussed what I should wear for the portrait.'[22] It has been argued that the painted portrait in the twenty-first century is often marginalised, lacking the 'mystery and power' of earlier periods, and achieving its 'traditional magic' only in 'the hands of very considerable artists'.[23] Even in royal portraiture, 'it is fairly usual for the artist to supply a sense of immediate access to the sitter through casual presentation'.[24] This we can easily see, for example, in Bryan Organ's portrait of Diana, Princess of Wales (fig. 87), and in Paul Emsley's portrait of Catherine, Duchess of Cambridge (fig. 95.1).

During the twentieth century and into the new millennium, notions of identity and likeness have undergone a number of revisions, created, as Richard Brilliant remarks, by such forces as 'psychology's dissolution of the concept of the rational human being ... sociologists' and social historians' insistence on the social rather than the personal nature of identity, philosophers' doubts about the nature or reality of the self'.[25] Our concerns are just as much with psychological perception and the changing nature of truth as with the factual analysis of a person's appearance, whether in life or in art. We no longer want art to be on its best behaviour in the stillness of a painted portrait; rightly or wrongly, some people think they can discern inner truth in a less formal work of art, with the sitter depicted in casual and comfortable clothing. Portraits, so the argument goes, should be images of intimacy and explorations of character, not signifiers of status, wealth and authority, although these latter qualities, perhaps, can still be useful in the portrayal of identity.

This book is less a history of dress in portraiture; more a discussion of dress in selected portraits in the Gallery, set within a chronological narrative. At the beginning of this introduction I referred to the importance of art in the way we perceive fashion; art reflects fashion, and in return fashion makes use of art. *Vogue Italia* (February 2005) published a series of photographs by Miles Aldridge of the English model Lily Cole, inspired by the work of Pisanello, although the text was about the cosmetics used. *Like a Painting* (fig. xvii), clearly influenced by the portrait of Ginevra d'Este in the Louvre,[26] although lacking the pale quattrocento face of the original, depicts Cole (in a Roberto Cavalli short jacket of suede embroidered in Swarovski crystals) with the refinement and delicacy characteristic of the Italian International Gothic artist.

Portraits were (and are) collected for a variety of reasons, which do not include the provision of subject matter for the historian of dress; thus they do not always incorporate the major themes in the history of dress. Furthermore, it is as well to remember that artists are not dressmakers or tailors, and it is not always appropriate to expect an informed knowledge of the properties of textiles and how clothes 'work' on the body. In earlier periods, inevitably, images of royalty and the elite dominate the genre; even as centuries progress it is not always easy to provide equal exposure for all sections of society. This book aims to strike a balance between portraits of famous people, who wear clothing typical of their status, and images of less-well-known men and women, whose costume is of particular interest in furthering the story of fashion's development. For this reason complementary images have been added, including photographs of surviving examples of contemporary costume, relevant both to the main Gallery portraits and the chronology of clothing. The narrative of fashion is liberally interpreted here to include men and women who have not necessarily affixed this label to their appearance. Limitations of space and the fact that this book covers a period of more than 500 years have precluded reference to specialist clothing, such as uniform or occupational dress – the Gallery is, nevertheless, rich in such images, and this could easily form the basis for another book.

The National Portrait Gallery's Collection, like those of many other public institutions, does not always provide a complete and comprehensive survey of art. However, it offers an unparalleled sequence of portrait images for the study of British costume. For anyone interested in social and cultural history, in the human condition in the widest sense and in the character of individuals in particular, images of people and their clothing demand detailed study. The portraits selected here help to tell us who we were and who we are, and how we wished to look; fashion fixes a portrait in time and anchors us to a living past in a continuum with the present day.

Aileen Ribeiro

1. Robin Gibson, *20th Century Portraits* (National Portrait Gallery Publications, London, 1978), pp.8–9.
2. Richard Brilliant, *Portraiture* (Reaktion Books, London, 1991), pp.7 and 14.
3. Shearer West, *Portraiture* (Oxford University Press, 2004), p.22.
4. Queen Victoria's *Journal*, 10 September 1839, vol.12, p.150: www.queenvictoriasjournals.org
5. Brilliant, 1991, op. cit., p.30.
6. Liverpool John Moores University has Liddell Hart's 'highly personal library of fashion' and his archive, which includes newspaper cuttings, patterns and fashion plates; his collections mainly focus on the nineteenth century and are a valuable source for historians of fashion.
7. John L. Sweeney (ed.), *The Painter's Eye: Notes and Essays on the Pictorial Arts by Henry James* (University of Wisconsin Press, Madison, WI, 1989), p.261.
8. Andrew Wilton, *The Swagger Portrait* (Tate Publishing, London, 1992), p.30.
9. *Guardian*, 28 September 2013.
10. See, for example, Ingres' famous portrait of *Madame Moitessier* (National Gallery, London) and the portrait of *Delphine Ramel, Madame Ingres* (Oskar Reinhart Collection, Winterthur, Switzerland).
11. David Piper, *The English Face*, M. Rogers (ed.) (National Portrait Gallery Publications, London, 1992), p.179.
12. Wilton, 1992, op. cit., p.52.
13. Audrey Linkman, *The Victorians: Photographic Portraits* (Tauris Parke, London, 1993), p.20.
14. Howlett's photographs (including the famous one where Brunel stands before the iron launching chains of the *Great Eastern*, NPG P112) are more direct and impressive than the painted portrait by John Callcott Horsley, also of 1857 (NPG 979), which shows Brunel in the black suit of a businessman, sitting at his desk with plans in front of him.
15. Lady Colin Campbell (ed.), *Etiquette of Good Society* (Cassell & Co., London, 1893), p.87.
16. Max Beerbohm, *Dandies and Dandies* (Bodley Head, London, 1896), p.19.
17. On the political aspects of clothing, including the encounter between Mrs Thatcher and Katharine Hamnett, see Aileen Ribeiro, 'If the slogan fits, wear it; the origins of activist fashion', *The Times*, 14 August 1984.
18. Piper, 1992, op. cit., p.234; Ruskin was referring in particular to the glossy 'costume artist' James Tissot.
19. Christopher Newall, 'The Victorians, 1830–1880', in Roy Strong, Frances Spalding, John Wilson *et al., The British Portrait, 1660–1960* (Antique Collectors' Club, Woodbridge, Suffolk, 1991), p.351.
20. I am grateful to Clare Browne from the Furniture, Textiles and Fashion Department at the Victoria and Albert Museum, for her help regarding the lace in Millais' portrait, which she suggests is possibly Maltese bobbin lace, which was sometimes influenced, as here, by patterns in Genoese bobbin lace of the seventeenth century.
21. Southall was a member of the Birmingham School of Artist-Craftsmen, an informal organisation of artists and craftsmen, established in the 1890s; he revived the medieval art of painting in tempera (coloured pigments mixed with egg yolk).
22. In both cases the information came in letters to me from the sitters.
23. Robin Gibson, *The Portrait Now* (National Portrait Gallery Publications, London, 1993), p.10.
24. Frances Spalding, 'The Modern Face, 1918–1960', in Strong *et al.*, 1991, op. cit., p.419.
25. Brilliant, 1991, op. cit., p.171. He also refers, in a rather sweeping way, to 'the anxious decentring and fragmentation of human experience in the modern age, characterised by the disruptive force of world wars, atom bombs, mass culture and the broken hegemony of the West over world politics'.
26. The identity of the sitter is not definite; a Gonzaga princess is another possibility. The rather clumsy headdress of black beads in the photograph may have been inspired, in a general way, by Leonardo da Vinci's painting, *Lady with an Ermine* (National Museum, Kraków).

THE
SIXTEENTH
CENTURY

THE
POWER OF
CLOTHES

There is no other century in English history during which clothes have played a comparable role in signifying the power and wealth of royalty and its attendant court than the sixteenth. The reigns of Henry VIII (1509–47) and Elizabeth I (1558–1603), its most dominant monarchs, divide the century in two, not only in a temporal sense but also in a sartorial one, demarcating changes in the fashionable silhouette of both sexes that mirrored the transfer of power, albeit temporary, from a male to a female sovereign. During Henry's reign, the bulky horizontality of men's clothing overwhelmed the stiff, triangular shape of women's dress; with the advent of the Elizabethan period, the reverse is true: men's dress lacked the impact of the extravagantly decorated and bizarrely distorted appearance of the female figure. This gendered reversal of dominance in fashion is hardly surprising, as both monarchs fully appreciated how dress and adornment could express their rank, and made full use of it. Lustrous silks and velvets in rich colours, glittering gold and silver embroidery, sumptuous furs, gossamer linen and lace, and glowing jewels were deployed lavishly in the creation of their imposing images.

During this period, as Henry and Elizabeth were only too well aware, dress created a symbolic language that could be decoded like a text. Clothing was both valuable and valued as a signifier of class rank and profession across the social spectrum: the monarchs' splendid appearance visually affirmed their power and wealth to the world and to their subjects. The nobility spent vast sums on clothing in order to maintain their position at court, including kitting out their servants in livery, a kind of uniform, also worn by members of City companies. Professional men such as doctors, lawyers and teachers were indentified by their long gowns. Attempts were made through sumptuary legislation to keep the gentry (untitled landowners) and the burgeoning merchant classes in their place by regulating what fabrics, furs and trimmings could be worn by each rank, though this was difficult to enforce and largely unsuccessful. Working people, while not necessarily uninterested in appearance, would have had overriding economic and practical concerns regarding their clothes. Their clothing consisted of some of the same basic elements as those of the upper classes, but were made from plainer fabrics such as homespun linen and cloth (a synonym for woollen cloth), sheepskin and leather. The lower down the order of social rank, the coarser the fabrics from which items of looser, more functional clothing were made.

On his accession in 1509, Henry VIII established a magnificent court equal to any in France or Italy. It attracted artists, craftsmen and scholars from across Europe in search of patronage; it is through the work of the German artist Hans Holbein the Younger, appointed court painter in 1536, that we have a unique record of the King's appearance and an invaluable insight into the fashions worn during this period. Like many great artists, Holbein had a deep interest in and engagement with dress, evident from the annotations on his portrait drawings of members of the Tudor court, his designs for jewellery (fig. 2.1) and the detailed studies he made for his own interest (fig. 3.1).

Henry's increasing corpulence was partly responsible for his massive silhouette in Holbein's depictions of him; emphasised by the multiple layers of clothing deemed necessary at the time. The basics of male dress during the first half of the century constituted: a long linen shirt worn next to the skin, often decorated with intricate 'blackwork' (black silk embroidery on white linen) at the neck and cuffs (and red was also used); a sleeved knee-length, skirted doublet, open at the front from the waist down, allowing a prominent codpiece to be displayed; an equally long sleeveless jerkin, open above and below the waist to display the garments underneath, and a voluminous, sleeved over-gown, lined with fur or contrasting fabric. From waist to

mid-thigh, the legs were covered by trunk hose, upper stocks or breeches (the terminology varies a great deal), which were attached to hose, or nether stocks, that encompassed the feet, shod in square-toed, flat leather shoes. Heavy gold chains and hanging pendants, including those pertaining to chivalric orders, such as the Greater George of the Order of the Garter (fig. 5), indicated rank and position.

In contrast, in the first half of the century, women's dress was characterised by its triangular silhouette, the smaller inverted triangle of the torso set above a larger one created by the skirt below. A fine linen shift usually decorated with embroidery like the male shirt was always worn next to the skin to protect the upper garments. Over the shift and stays, a kirtle, a united bodice and skirt, was worn. In the second half of the century, the kirtle separated into two: a tight bodice (derived from 'a pair of bodyes' as it was made of two parts joined at the sides) and a skirt (derived from 'kirtle'); variations of the gown could be worn over these for extra warmth or formality, according to the occasion. Separate sleeves were tied or pinned to the bodice, the gap concealed by 'wings'; in the 1540s sleeves reached vast proportions and were turned back to display costly fur linings (fig. 4) in turn revealing ornate undersleeves, through which puffs of the shift were pulled for decorative effect. These undersleeves sometimes matched a contrasting triangular panel called a forepart, visible when the skirt was open at the front. The most singular element of Englishwomen's dress during Henry's reign was the angular gable hood, worn over a linen coif, (a small undercap), covering most of the hair. The gable hood was outmoded in the 1530s by the more flattering, rounded French hood, set further back on the head, exposing the hair. The Spanish farthingale, a hooped underskirt that created a bell-like shape, was first recorded in use at the English court in 1545. It was later replaced by the French wheel, or drum, farthingale, and, like the Spanish cloak adopted by men in the second half of the century, is indicative of the cross-cultural influences on fashion during the century.

By Elizabeth's accession in 1558, male clothing had lost much of its bulk: the cloak replaced the heavy over-gown, and a short doublet, padded to a curved point (a 'peascod belly') at the centre of the waist, was worn with leg coverings that varied considerably in shape and form, from the Earl of Leicester's padded trunkhose (figs 10 and 10.1), the outer layer constructed with vertical strips of fabric called panes, to Sir Francis Drake's more streamlined knee-length breeches (fig. 12). By this time, for both sexes, the frilled collar of the shirt and shift had evolved into a separate ruff, trimmed with lace, starched and moulded into shape using heated goffering irons, often requiring some support beneath. Decorative effects, such as slashing, pinking (where small cuts in the fabric created a pattern), paning, guarding (contrasting braid stitched over seams or round hems and edges to create visual interest) and embroidery, covered every surface: contrasts of texture and colour were provided by pulling puffs of the shirt or linings through the upper layers; jewelled pins ('ouches'), brooches and clasps embellished every slash and seam. Luxury accessories such as fans and perfumed gloves, frequently given as gifts, were increasingly important commodities, which could be purchased at Sir Thomas Gresham's Royal Exchange in the City of London, opened by the Queen in 1571 and a fashionable meeting place for Elizabethan society.

Like her father, Elizabeth dressed magnificently, fully aware of the impact of her appearance. Depicted (fig. 9.1) in a gown of white and gold encrusted with jewels, her figure is distorted by swollen sleeves padded with bombast (a stuffing made from cotton, wool or horsehair), and a huge drum farthingale. Her head, with its wig pinned with rubies, pearls and diamonds, is framed by a delicate lace ruff and a silken veil; her painted face is a mask that almost disappears against her fabulous costume. She shimmers as she stands on a map of the country she rules. No wonder a contemporary observer at court went so far as to say: 'It is more thee have seen Elizabeth than thee have seen England.' **CB**

HENRY VII

(1457–1509)

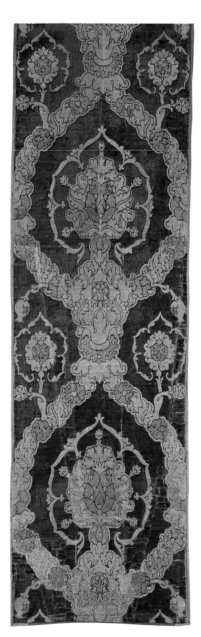

This portrait of the shrewd and calculating founder of the Tudor dynasty, which was established after the defeat of Richard III at the Battle of Bosworth in 1485, is a nicely judged image of substance and symbol. It was painted when Henry VII came on the marriage market for the second time, seeking the hand of Margaret of Savoy, daughter of the Holy Roman Emperor Maximilian I (the marriage never took place). This is possibly why the King wears round his neck the collar and badge of the Golden Fleece (premier order of chivalry of the Holy Roman Empire), to which he was elected in 1491. The rose in Henry's hand is a symbol of love, but it also refers to the unity of the previously warring houses of York and Lancaster, which was cemented by the King's first marriage, to Elizabeth of York (1465–1503).

Henry's clothes indicate modest luxury allied to comfort. Over a black doublet he wears a coat of brocaded red velvet fabric (fig. 1.1) lined with white squirrel fur. The sleeves of this coat reach almost to his knuckles; an alternative way of wearing this garment was to push the hand through the slits on the upper arm, thus forming hanging sleeves. Such a slit, hinted at in this portrait, can be seen more clearly in the fur-lined coat worn by Henry in Pietro Torrigiano's painted-and-gilded terracotta bust (fig. 1.2). The face of the bust was taken from the King's death-mask, but with the signs of death smoothed out.

Both these images of the King show him wearing a biretta-type hat of blocked (or moulded) felt; such hats later became part of academic and clerical dress. Torrigiano's bust shows the King with a flattering and youthful hairstyle, falling in soft waves to his shoulders, whereas the painted portrait indicates – more realistically – that he had thinner and more grizzled hair. Either to hide a wrinkled neck or to keep out the cold, the elderly King (fairly aged by the standard of his time) wears a collar or tippet of sable, then, as now, the richest and most sumptuous of furs.

1 (opposite)
King Henry VII
Unknown Netherlandish
artist, 1505. NPG 416

1.1 (above)
Italian velvet
late fifteenth century

1.2 (right)
Portrait bust of King Henry VII
Pietro Torrigiano, 1509–11

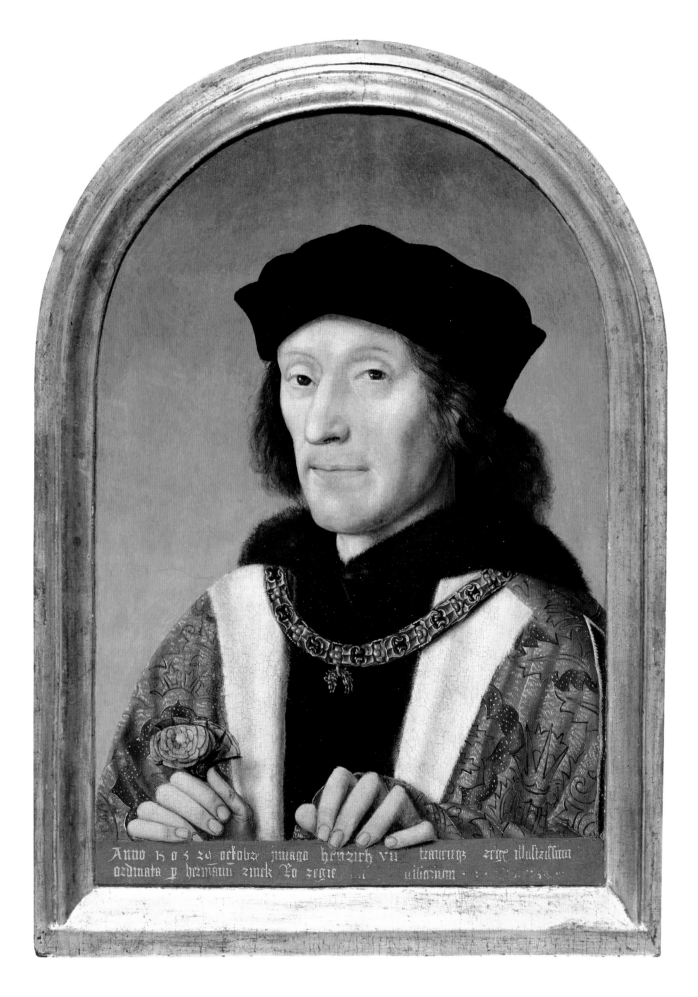

Anno 1505 29 octobre jmago henrich vii francieg zege walltzellam ozdinata p herman zinck Ro zegie ... villarium ·

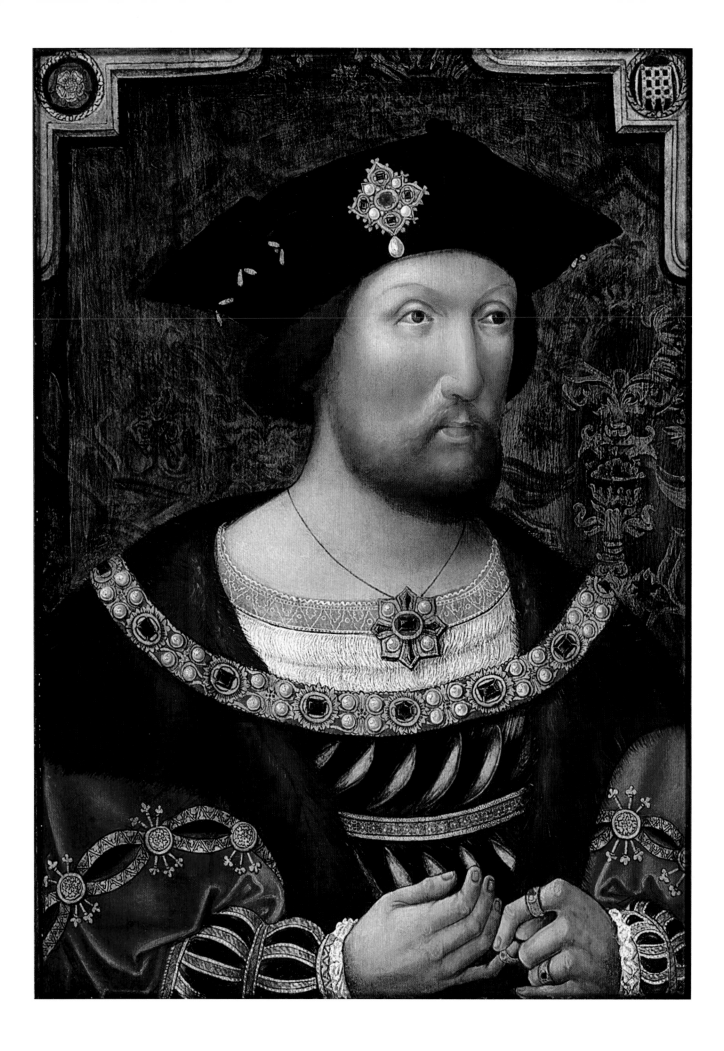

2 HENRY VIII
(1491–1547)

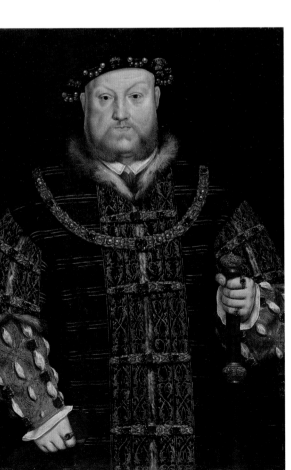

Although not a particularly accomplished portrait in comparison with Holbein's work, this painting gives some idea of a Renaissance monarch's love of luxury and display. Henry was also a major patron of the visual arts and gave lavish entertainments at court. Already impressive in his physical appearance, the King's impassive and watchful face is adorned with a reddish-brown beard, which – according to the Venetian ambassador in 1519 – he grew in emulation of his great rival, Francis I of France.

Expensive fabrics with rich ornamentation make up the King's costume. He wears a doublet of black velvet, with slashes ('ventes' in contemporary accounts) revealing a lining of yellow silk. Gold braid decorates the doublet sleeves, as it does his coat of crimson satin lined with sable. Henry spent a great deal on furs, including many sable-lined gowns, and during his reign a series of sumptuary laws limited expensive furs, as well as costly fabrics such as cloth of gold and silver, to the royal family and the aristocratic elite. Gold-embroidered shirts, such as that of fine pleated linen worn by the King, were also forbidden to those under the degree of knight.

Henry wears on his head a Milan bonnet, a felt hat with a turned-up and stiffened brim, which is decorated with gold 'aglets' (decorative jewelled tags) and a hat brooch of a ruby surrounded with sapphires and pearls set in gold. This brooch is similar in design to a pendant contained in a volume of drawings now in the British Museum, attributed to Hans Holbein the Younger, that may have been the 'paper booke conteyninge diverse paternes for Jewelles' once kept in a coffer in the secret Jewel-house at the Tower of London, possibly as a visual record of Henry VIII's jewels (fig. 2.1). Vast quantities of jewellery feature in images of the King and his court: here Henry displays a pendant at his neck and, round his shoulders, a large collar of pearls and diamonds in gold.

Even more jewels can be seen in the image (fig. 2.2) of Henry VIII taken from a portrait-type of some twenty years later. Nearly every part of his intimidating and monumental figure is covered in lavish ornamentation, from his richly jewelled cap to the gold-figured doublet sleeves, the openings of which are held together with large rubies. The huge loose-fitting 'Turkey gown' (the better to contain the King's corpulence) of pink satin lined with lynx fur is trimmed with gold-and-silver braid and fastened with ruby and diamond clasps.

KATHERINE OF ARAGON
(1485–1536)

3 (opposite)
Katherine of Aragon
Unknown artist, early
eighteenth century
NPG 163

3.1
*Two Views of a Woman
wearing an English Hood*
Hans Holbein the Younger
1535

Initially married to the eldest son of Henry VII, Prince Arthur (d.1502), Katherine became the first wife of Henry VIII in 1509, the year of his accession to the throne. It was the custom for royal brides to relinquish their own fashions in favour of those belonging to their newly adopted country, and here Katherine wears English dress, most notably the unbecoming gable hood with its stiff black understructure and rigid perpendicular 'billiment' (decorative jewelled edging to the hood). Gold-brocade 'lappets' (pendants in the form of long rectangular strips or tubes of fabric) are pinned up over a black velvet fall of drapery, which could be either a single or double backdrop. Holbein's drawing of an unknown woman of the mid-1530s (fig. 3.1) shows how the back of the hood has a box-like structure, with two wide hanging tubes of material. In the mid-1530s it was fashionable to throw one side of the hood up over the head and pin it in place.

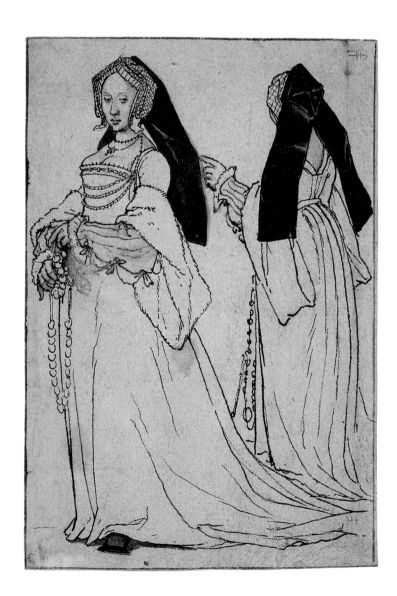

Katherine's black velvet dress reveals little of the natural body shape. The breast is flattened under the tight bodice (corsets, or 'stays', first appear as an essential part of female underwear in the early sixteenth century). The large upper sleeves of the gown, trimmed with fur, reveal gold undersleeves.

The Queen's jewellery is somewhat old-fashioned in its late Gothic simplicity, especially the charming heart-shaped pendant – possibly of garnet – set in gold, at her bosom. Katherine was a fervent Catholic, and the three pearls on the pendant round her neck may be a reference to the Trinity. Pearls decorate the jewelled band or 'square' that outlines the top of her dress, and above this there is a glimpse of the fine blackwork embroidery that edges her linen shift.

A later portrait, *c.*1540 (fig. 3.2), of an unknown woman (once thought to be Catherine Howard, she has been tentatively identified as Elizabeth Seymour, who married Gregory, Lord Cromwell, in 1537/8), depicts the now fashionable French hood, set further back on the head and shaped on the top and sides with a curving gold band. It is worn over a stiffened white undercap, trimmed with gold gauze and braid, which fastens under the chin.

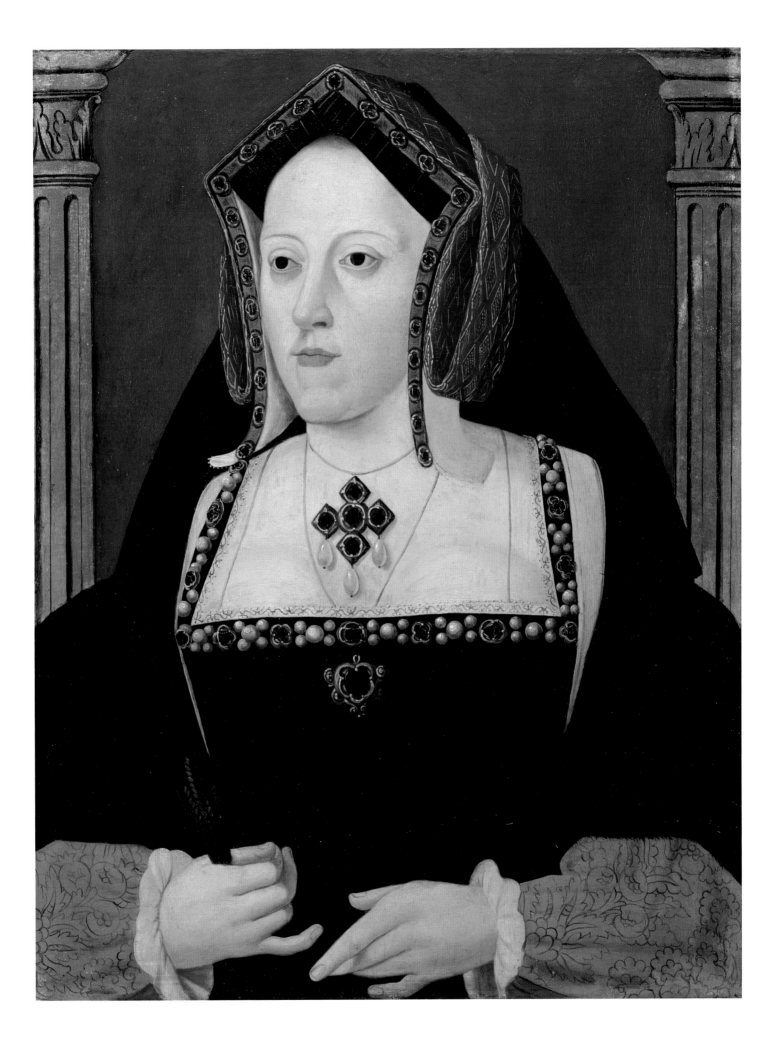

3.2
**Unknown woman,
formerly known as
Catherine Howard**
After Hans Holbein the
Younger, late seventeenth
century. NPG 1119

The sitter is dressed with taste and luxury in a black satin gown, which has a yoke or a shoulder mantle of black velvet open at the neck and lined with white silk. This style of dress was a modest alternative to the low, square-necked gowns worn on more formal occasions. The dress has a plain bodice, which sets off the wide sleeves laid with thick gold braid and aglets; also focusing our attention on the sleeves are beautiful cuffs of fine blackwork. By this time the skirt is open at the front, and we glimpse a chequered black- and-gold forepart that forms a backdrop to a large pendant attached to the jewelled waist girdle. Renaissance jewellery often had religious or mythological motifs that could be 'read' like portable works of art (indeed, some were just as expensive); here, the sitter's bodice pendant shows Lot's family being led away from Sodom, relating, perhaps, to a similar design by Holbein in the same volume in the British Museum, as is mentioned in fig. 2 above.

3.3 (below)
Detail showing the sitter's blackwork cuff

4 KATHERINE PARR
(1512–48)

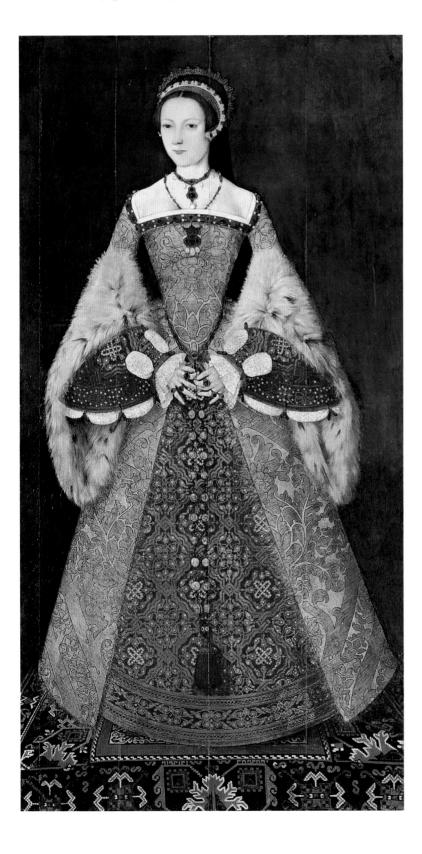

Last wife to Henry VIII (they married in 1543), Katherine was renowned for her learning and religious knowledge; after the King's death in 1547 she married Lord Thomas Seymour and died the following year in childbirth.

This is one of the most detailed and sumptuous costume portraits of the mid-sixteenth century. The artist has taken great pains in the depiction of the French gown of stiff silver brocade, paying particular attention to the lustrous lynx fur that lines the skirt and adorns the sleeves (fig. 4.1). The huge padded undersleeves (which appear to distort the arms) and the forepart of the skirt are of red velvet richly embroidered in intricate designs made from gold thread and pearls, some in the shape of stylised lovers' knots. The bodice of the gown is long and pointed, and the jewelled 'square' holding the neckline in place prevents the heavy sleeves from sliding off the shoulders.

4 (left)
Katherine Parr
Attributed to 'Master John', c.1545. NPG 4451

4.1 (below)
Detail showing lynx-fur lining and embellishment

Jewellery gilds the lily of the intense patterning of this costume. We see rubies and pearls in the billiment of the French hood, and at the Queen's breast is a gold crown-shaped brooch, possibly a gift from Henry to his new bride. Falling from her waist is a long chain of antique cameos, perhaps once belonging to Catherine Howard, who may also have owned the diamond, ruby and pearl pendant attached to the necklace at the Queen's throat. A similar example in the V&A collection is made up of a sapphire, a hessonite garnet and a peridot, the two latter stones surrounded on the reverse of their settings with engraved invocations (ANNANISAPTA+DEI and DETRAGRAMMATA IHS MARIA respectively) (fig. 4.2). These talismanic texts, combined with the long-held belief in the healing properties of precious stones, were transmitted more easily to the wearer by open settings enabling contact with the skin. The prevalence of these types of prophylactic jewels in contemporary portraits indicates not only their popularity but also the continuing overlap of ancient superstitious beliefs with religion.

Like fur linings and borders (which could be moved from one garment to another), items of jewellery were interchangeable, and the pendant shown in fig. 4 can be seen – as part of an ensemble – in another portrait of Katherine Parr of about the same time (fig. 4.3). In this portrait, the Queen wears a less formal costume, a dress of red satin damask trimmed with gold braid and jewelled aglets; among the designs on the gold embroidery is a stylised Tudor rose. The collar is a beautifully observed example of 'drawn-thread work', where the threads are drawn from the linen to create geometric patterns, then oversewn to give further richness of detail; this kind of embroidery was one of the forerunners of lace. Women have often borrowed from the male wardrobe for less formal wear, and here Katherine Parr wears a masculine bonnet (quite close in style to the ones worn by Henry VIII (fig. 2) and Edward VI (fig. 5)) of black velvet studded with gold aglets and pearl pins, adorned with a white ostrich plume beautifully worked with gold and sequins.

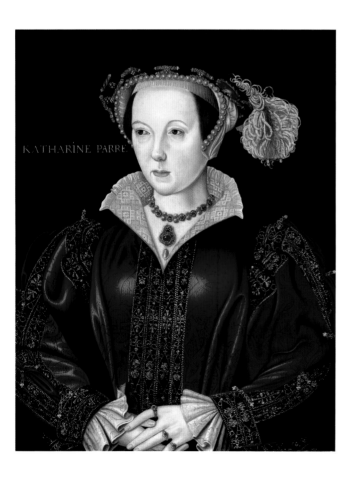

4.2 (above)
Prophylactic pendant
Unknown producer, England
c.1540–60

4.3 (left)
Katherine Parr
Unknown artist, late sixteenth century
NPG 4618

<u>5</u> EDWARD VI
(1537–53)

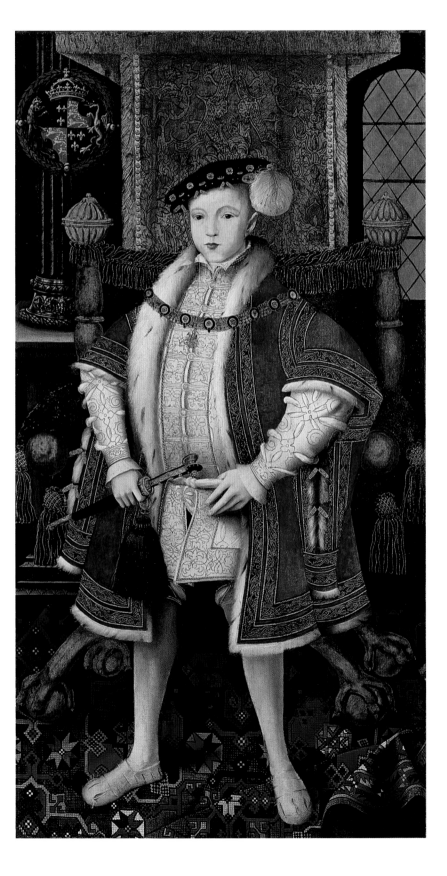

Henry VIII had set a trend for the kind of four-square, solid horizontality that one sees especially in his later portraits, and here the young Edward VI, king at about the age of nine, seems in his pose and costume to be a pale mimic of his father. The formality of the costume (the Greater George, or large jewelled and enamelled pendant of St George vanquishing the dragon, of the Order of the Garter, is worn over his shoulders (fig. 5.1)) seems almost to overwhelm the rather sickly looking boy, his legs braced to keep his balance under the weight of an embroidered red-velvet coat lined with lynx.

Like Nature, Tudor costume abhorred a vacuum, and every surface of clothing is decorated – with slashes, with embroidery and with jewelled ornamentation. Slashing, or cutting into the fabric, usually to reveal a contrasting lining, was very popular, and here the gold-embroidered doublet is slashed, as are the barely visible breeches of cream silk trimmed with gold twist. On his feet the King wears slashed white-leather shoes.

Edward's flat black-velvet cap is trimmed with hat brooches and gold aglets; the latter also appear holding together the openings of the coat's hanging sleeves.

5 (left)
King Edward VI
Workshop associated with 'Master John', c.1547
NPG 5511

5.1
Detail showing the collar of the Order of the Garter, with the Greater George

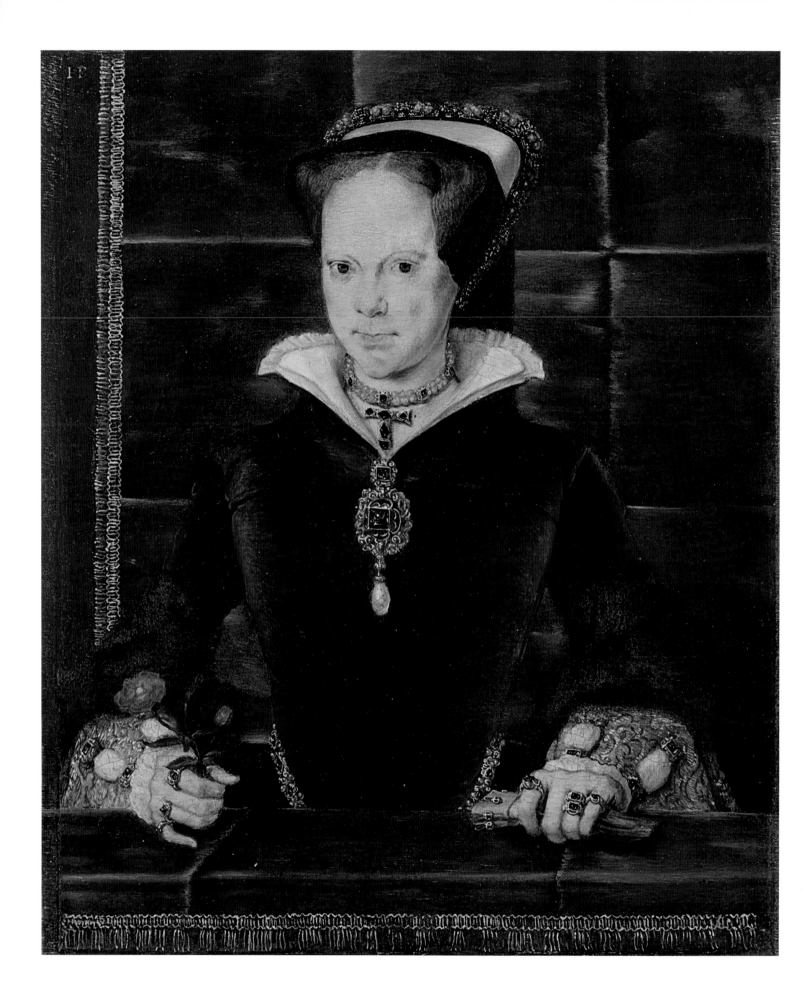

<u>6</u> MARY I
(1516–58)

Something of Mary's determination and vulnerability – inherited, respectively, from her father, Henry VIII, and her mother, Katherine of Aragon – can be seen in this small portrait, which was painted at the time of her marriage to Philip II of Spain. She holds a rose, signalling her love for her husband.

Mary's dress is a French gown of murrey-coloured velvet, the upper sleeves of which are trimmed with sable. The undersleeves are made of cloth of gold with fake slashes of white silk and set with diamond and gold clasps. Murrey (mulberry) was a purplish-red colour much in fashion in the mid-sixteenth century, especially for velvet. In Mary's 'Wardrobe of Robes' for the year 1554 (National Archives, Kew, Richmond, Surrey) there is a reference to a 'Frenche Gowne of Murrey vellat', and on the day before her marriage, at a reception to mark the approaching nuptials, the Queen wore a tight-bodied murrey-velvet gown lined with brocade.

In this portrait, Mary wears a large amount of jewellery, from the diamonds and pearls of her girdle and billiment to the many rings on her fingers. But these pale in comparison to the massive pendant at her breast, a table-cut diamond set in an ornate gold surround with a colossal tear-shaped pearl hanging from it; these are attached to a diamond cross, in turn suspended from a diamond-and-pearl carcanet, or high necklace. This pearl was once thought to be the Peregrina, which was acquired in the late 1960s by Richard Burton as a gift for his wife, Elizabeth Taylor.

However, recent research has established that the Peregrina was brought to Seville from Panama in 1579, twenty-one years after Mary's death. In 1972 the Burtons commissioned Cartier to replace the original setting of the Peregrina pearl with a new necklace based on the one worn by Mary I (fig. 6.1). In the same year they, among others, contributed towards the purchase of the portrait by the Gallery, in the belief that it depicted their famous pearl. At the sale of Taylor's jewellery collection after her death in 2011, the Peregrina pearl, together with its necklace, fetched nearly $12 million.

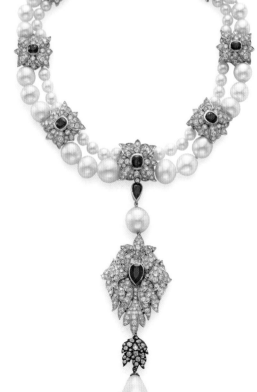

MARY NEVILLE and GREGORY FIENNES
Lady Dacre (1524–c.1576) and 10th Baron Dacre (1539–94)

7 (below)
**Mary Neville, Lady Dacre;
and Gregory Fiennes,
10th Baron Dacre**
Hans Eworth, 1559
NPG 6855

This powerful double portrait is thought to have been commissioned to mark the restitution of the Dacre family's titles and honours after the execution for murder of Lady Mary's first husband, Thomas, 9th Baron Dacre, in 1541. Described as one of the finest works to be painted in England in the mid-sixteenth century, Hans Eworth's portrait is a visual statement of success, a declaration of the family's triumphant return to grace, a return symbolised by the extreme richness of the clothing that mother and son are wearing. In the hands of a lesser artist the meticulous depiction of every intricate stitch of embroidery, every pearl, every link of a golden chain and every strand of fur might have veered towards pedantry, yet Eworth's outstanding technical skill is balanced by restraint and does not allow the sumptuousness of their clothing to overpower the personalities of his sitters, the redoubtable Lady Mary and her 'Crack-brain'd' son, Gregory Fiennes, the new Lord Dacre.

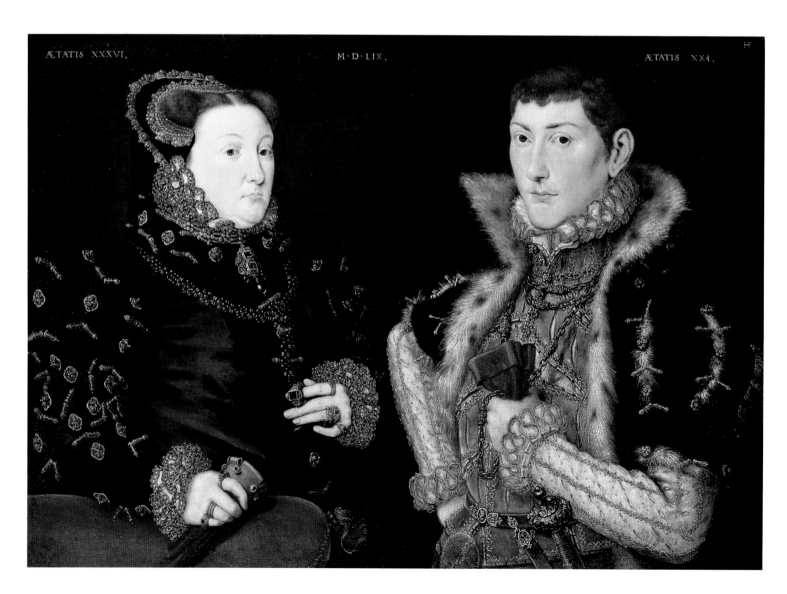

The colour of Lady Mary's black satin-and-velvet gown does not necessarily relate to mourning for her first husband, as by this date she had remarried twice and had borne at least six more children. The plain gown acts as a foil for the gold aglets and ouches sewn to her sleeves, round the neckline and down the centre front and sets off the furled edges of her figure-of-eight ruff and cuffs, embroidered with blackwork and glinting gold overstitching. Her French hood is set well back over her auburn hair (arranged in two horns echoing the hood's shape), its billiment encrusted with gold-and-pearl decoration. A triple rope of black pearls, the most precious type of all, hangs down her front, leading the eye to the dynastic ring at the tip of her finger (fig. 7.2), one of eight on her hands. Even her gloves are studded with square, table-cut jewels on the gauntlets.

Gregory's outfit is, if anything, even more lavish than his mother's: his shirt's high ruff and cuffs are edged with red-and-gold embroidery (fig. 7.1); over this a white silk doublet is worn, pinked and diagonally slashed with stripes of gold embroidery going down the sleeves. Next, a jerkin is worn, possibly of buff leather, slashed across the chest to display the doublet beneath – the edges of the slashes whipped with silver thread and outlined with silver-and-gold lace. His over-gown with high standing collar is lined with spotted lynx, the fur creating a decorative effect on the sleeves as it pokes through the slashes, which are fastened with gold aglets. The ensemble is completed by a linked gold chain, looped three times round his neck and an ornate sword on an equally ornate hanger, below which the panes of the jerkin frame his prominent codpiece. This affirmation of the Dacre dynasty, underscored by the matching hair colour, could not have been more successfully realised in one of the most extraordinary images of conspicuous consumption created during this period.

7.1 (below, left)
Lord Dacre's cuffs and glove

7.2 (below, right)
Dynastic ring at the tip of Lady Mary's finger

8 SIR HENRY LEE
(1533–1611)

8 (opposite)
Sir Henry Lee
Anthonis Mor, 1568
NPG 2095

8.1 (below)
Lee's white linen shirt,
embroidered in black

This portrait, painted when Lee was in Antwerp, reveals something of the sitter's interests and allegiances; such images are not always easy to 'read' and need to be deciphered and interpreted, just like some Elizabethan poetry. Lee held a unique place at the Elizabethan court. He was the Queen's Champion from 1559 to 1590. In about 1571 he initiated the Accession Day Tilts – annual tournaments to celebrate the accession of Elizabeth I (17 November 1558). By the 1580s these had become spectacular entertainments, in which knights in fancy dress on richly caparisoned horses and with lavishly costumed entourages took part in elaborate jousts in honour of the Queen. Lee's costume probably alludes to his relationship with Elizabeth.

In a display of carefully contrived informality, Sir Henry wears a black jerkin over a white shirt. Black and white – which often signified despair and hope in contemporary symbolism – were favoured by Elizabeth, whose honour the Queen's Champion defended. The jerkin, probably of fine leather, is slashed into vertical strips on the chest (and probably at the back), and 'pinked' on the shoulders. The collar is high and supports the ruff, which by now has become a separate item of clothing, quite divorced from the shirt out of whose ruffled collar it originated. Lee's shirt (fig. 8.1) is of fine white linen embroidered in black, with true lovers' knots and armillary spheres (celestial orbs that represent the harmony of the sun and the planets in orbit round the

earth), motifs that might symbolise the wearer's dedication to the Queen – and his wife or mistress. In her portrait by Marcus Gheeraerts the Younger (known as the 'Ditchley' portrait), Elizabeth I wears an earring in the shape of an armillary sphere in her left ear (fig. 9.2); Lee, who owned Ditchley Park in Oxfordshire, commissioned the painting.

Another reference to Lee's attachment to the Queen may be signalled by the jewellery he wears – diamond rings on ribbons round his sleeve, and another ring, a ruby set in gold, on a long red-silk cord round his neck. Medieval tournaments were the inspiration behind the Accession Day Tilts, and traditionally knights wore their lady's token, a mark of favour (a glove, scarf, ribbon or jewel), either in their helmet or on their sleeve. The colour red indicates passion and sacrifice; when worn, as in this portrait, with Elizabeth's black and white, it may refer to Lee's attachment to the Queen.

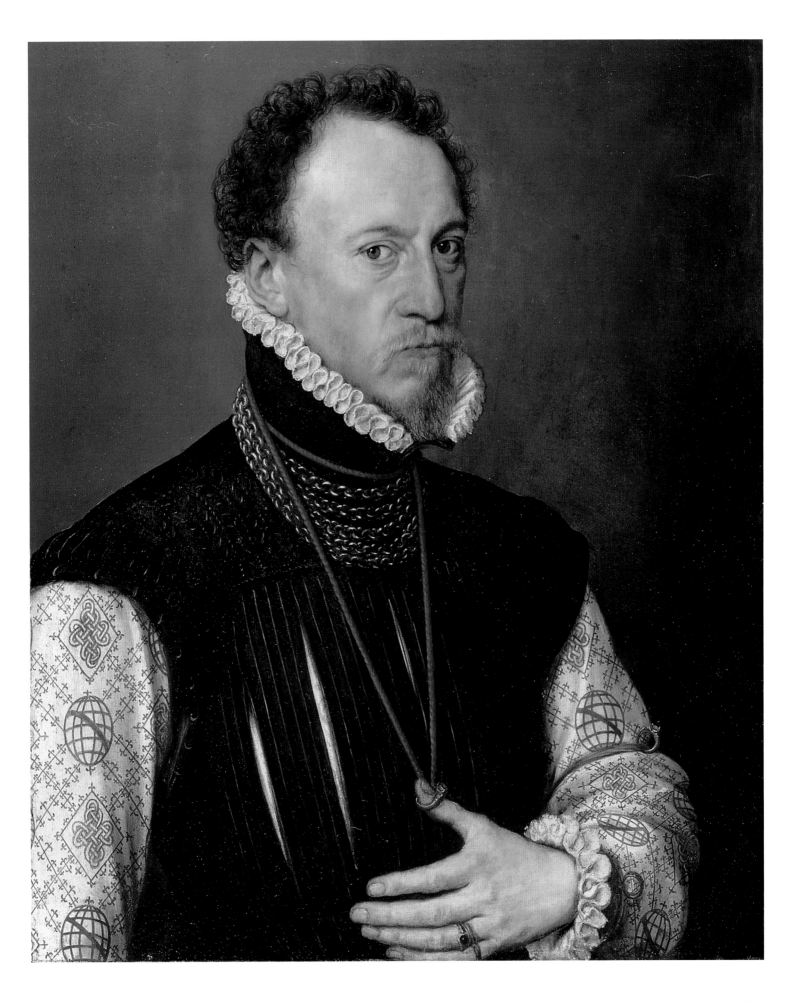

9 ELIZABETH I
(1533–1603)

This is one of the few portraits of Elizabeth I taken directly from life, emphasising the Queen's taut, high-boned face and her hooded, slightly sunken eyes. By this time in her life cosmetic aids to beauty were necessary; here they include a red wig, artificially whitened skin and reddened lips. Elizabethan face paint (paint was the contemporary word for make-up) included a variety of

9 (right)
Queen Elizabeth I
(the 'Darnley' portrait)
Unknown Continental artist,
c.1575. NPG 2082

9.1 (opposite, above)
Queen Elizabeth I
(the 'Ditchley' portrait)
Marcus Gheeraerts the
Younger, c.1592. NPG 2561

9.2 (opposite, below)
Detail of the 'Ditchley'
portrait, showing an earring
in the shape of an armillary
sphere

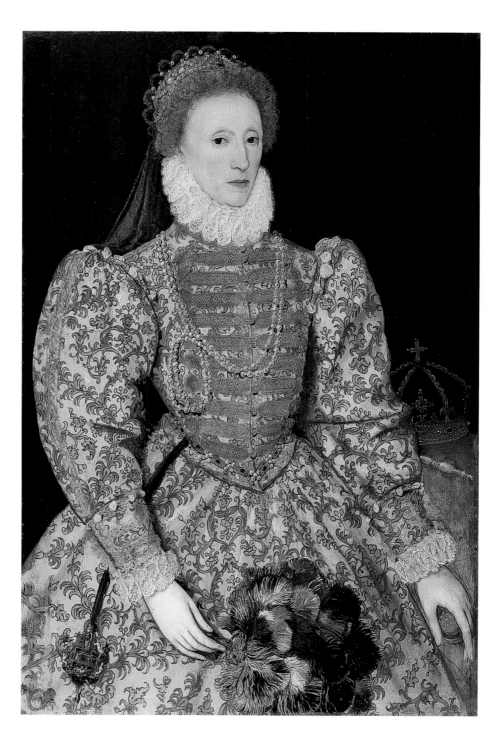

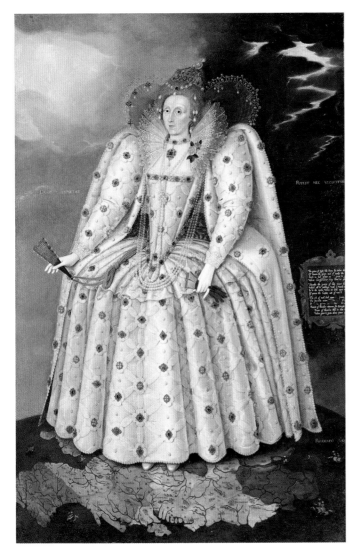

substances to whiten the skin, some of which (lemon, sulphur and borax) were safe, whereas others (white lead, for example) were dangerous to the health as well as to the complexion. Rouge and lip salves usually took the form of fabric and papers impregnated with reddish dyes, which came from ochre, henna, cochineal and the wood of the East Indian brazil tree; there was also vermilion, an injurious rouge made from mercuric sulphide.

The Queen wears a day dress comprising a matching bodice and skirt of brocaded white silk, worn over the pyramid-shaped Spanish farthingale. The bodice is cut rather like a man's doublet, fastening down the centre front and trimmed with horizontal rows of red-and-gold braid that end in tassels. This somewhat martial decoration may indicate that she wears a Polish gown – the sixteenth century was a period when styles of dress from all over Europe were popular at the English court, a form of role-playing that sometimes also reflected changes in foreign policy. A slight air of the masque can be seen in the Queen's pearl diadem holding her black veil in place and the large fan of coloured ostrich plumes that she holds in her right hand.

For all its rich and jewelled luxury, this dress is modest when set beside the extremes of late-Elizabethan costume, exemplified in the portrait of the Queen from the early 1590s by Marcus Gheeraerts the Younger (fig. 9.1). In this, the 'Ditchley' portrait, Elizabeth is depicted in a vast drum-shaped French farthingale, over which is a long pointed bodice with large padded under-sleeves,

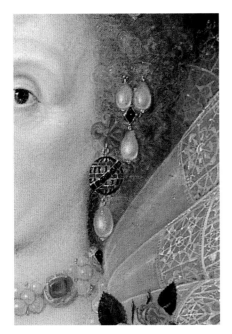

on top of which are extravagant hanging sleeves that almost reach the ground. The overskirt, just visible at the back of her waist, is of textured gold brocade. She wears an open French ruff, partly supported by a wired gauze collar edged with pearls, and on her head is a golden wig piled high with jewels. The dress is of white satin, decorated with a latticework of ruched trimming, interspersed with pearls and embellished at each intersection with a ruby or diamond jewel set in gold. A plethora of pearls decorates the hem of her petticoat and the edges of the sleeves as well as hanging in ropes from her neck. The vibrant coral red of the silk cord, from which her fan hangs, complements the colour of her wig and the numerous rubies on her headdress and her dress, almost swamping the delicate pink of the rose, symbol of England, pinned to her ruff.

Commissioned by Sir Henry Lee (fig. 8), who had fallen out of favour with the Queen, and on whose estate in Oxfordshire her feet are placed, the portrait is thought to symbolise forgiveness and reconciliation. Elizabeth, as the sun after the storm, stands resplendent in all her glory, the icon-like Virgin Queen of legend, an image created, to a large extent, by her extraordinary, unearthly costume and appearance.

ROBERT DUDLEY
1ST EARL OF LEICESTER (1532?–88)

10 (opposite)
**Robert Dudley,
1st Earl of Leicester**
Unknown Anglo-
Netherlandish artist, c.1575
NPG 447

10.1 (below)
**Robert Dudley,
1st Earl of Leicester**
Unknown English workshop,
c.1575
NPG 247

From a family with close links to the Crown, Dudley was the typical Elizabethan courtier, rising to great heights on the strength of his personality and physical presence, rather than on merit (he was not a particularly successful military commander). In spite of his tortuous marital history (his first wife, Amy Robsart, was found dead in mysterious circumstances in 1560, and his two further marriages were shrouded in secrecy and controversy), he captivated Elizabeth I, who made him Master of the Horse, Knight of the Garter and – in 1564 – Earl of Leicester. He entertained the Queen with great magnificence at Kenilworth Castle, Warwickshire, in 1575.

Leicester's sense of style (and self-esteem, perhaps) can be seen in this portrait, where he shows off a suit of dark reddish-pink satin trimmed with silver lace (possibly the 'suit of russet satin' described in a contemporary inventory). It comprises the newly fashionable peascod-fronted doublet and the padded trunk hose, which served to emphasise a slim waist. The doublet is pinked (a play on words of the kind the Elizabethans appreciated), and the trunk hose are slashed over a lining of pink and silver brocade. The high collar and the starched ruff give an air of hauteur to the image, reinforced by the conventional and dignified pose of hand on hip, and the Lesser George of the Order of the Garter on a jewelled chain. Dudley's cap of black velvet has a band of gold set with diamonds and pearls, and – echoing the theme of clothing as the pink of perfection – he has added an ostrich feather of the same colour as his suit.

Slightly later in date is another portrait of Dudley (fig. 10.1), in which a similar elegance of costume is apparent. The doublet is of white satin, trimmed with bands of gold braid, and the trunkhose are made from panes (ribbon-like strips of material) of cream silk, decorated with white braid and laid over gold satin. The Greater George of the Order of the Garter indicates a slightly more formal and conservative costume, and, instead of the fashionable cloak, Dudley wears a short coat richly lined with sable and with jewelled clasps all along the upper seam of the sleeve, matching his hat brooches.

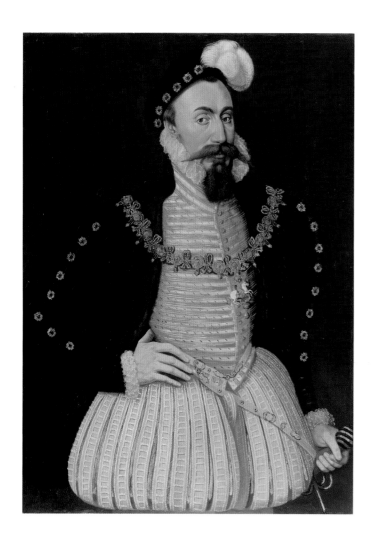

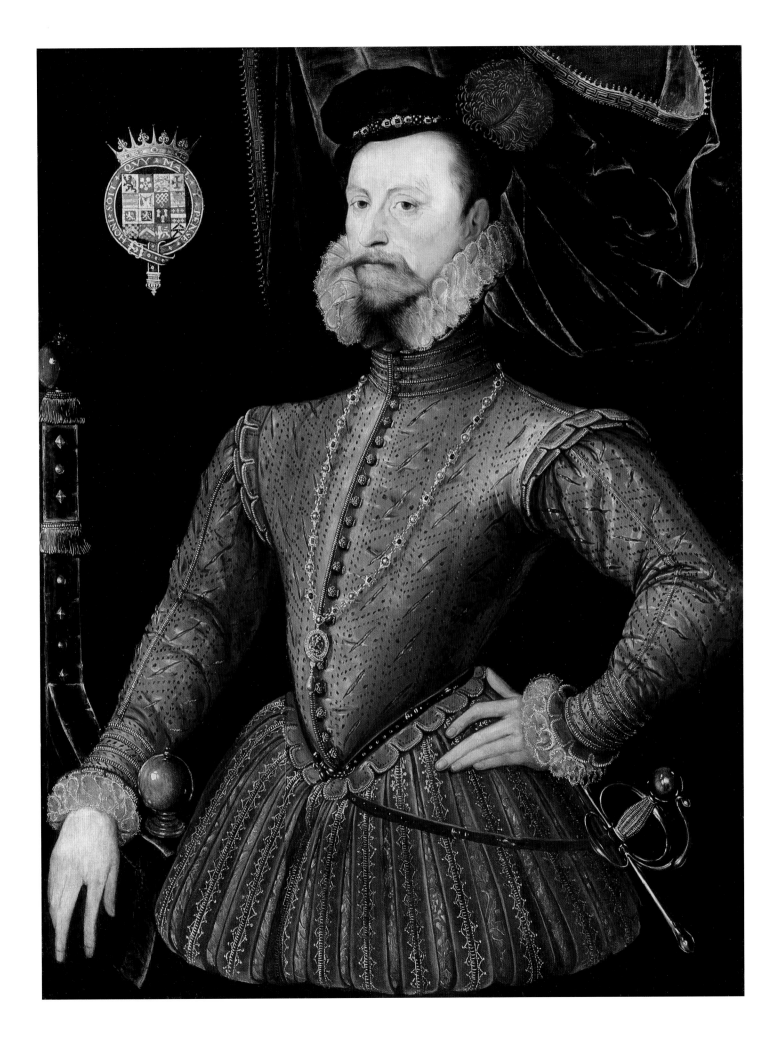

11 (opposite)
Unknown woman,
formerly known as Mary,
Queen of Scots
Unknown artist, c.1570
NPG 96

11.1 (below, left)
Detail showing the pendant,
possibly a wheel of fortune,
that hangs from the
woman's waist

11.2 (below, right)
**Women's gloves, with
elongated fingers and
separately worked
gauntlets**
c.1610–30

This is a problematic portrait, both from the point of view of the identity of the sitter (who was once thought to be Mary, Queen of Scots), and from the condition of the painting, which has suffered from clumsy conservation, including some repainting. However, the details of the costume provide useful information in a period that, as far as the National Portrait Gallery's Collection is concerned, has fewer portraits of women.

What this unknown sitter wears is a charming and sophisticated summer ensemble of black and white. The dress consists of an overdress of black silk, the fabric cut open over white silk to form a decorative pattern on the bodice and down the side fronts of the skirt. The sleeves and forepart are of white silk with a design of small black rectangles (a later addition), perhaps suggesting contemporary embroidery. Above the bodice is a delicately embroidered linen 'partlet' (a decorative infill, sometimes attached to a ruff, which covers the neck and bosom); the translucent effect of the fine, embroidered linen is a subtle contrast to the matte silk of the skirt and sleeves.

This was a period when carefully chosen accessories added to the rich complexity of clothing. Here the sitter wears a small white cap covered with gold net and decorated with puffs of white silk and gold ornaments. Among the gold and pearl chains looping over her shoulders is a cameo set in gold at her breast, and an intriguing pendant (possibly a wheel of fortune) hangs from her waist (fig. 11.1), matching a similar item pinned to her bodice. The delicacy of the dress is complemented by the gold-embroidered ruffs at neck and wrists, and by a pair of pale grey leather gloves decorated with turquoise silk tassels and gold embroidery; such gloves were often perfumed and were popular as lovers' gifts (fig. 11.2).

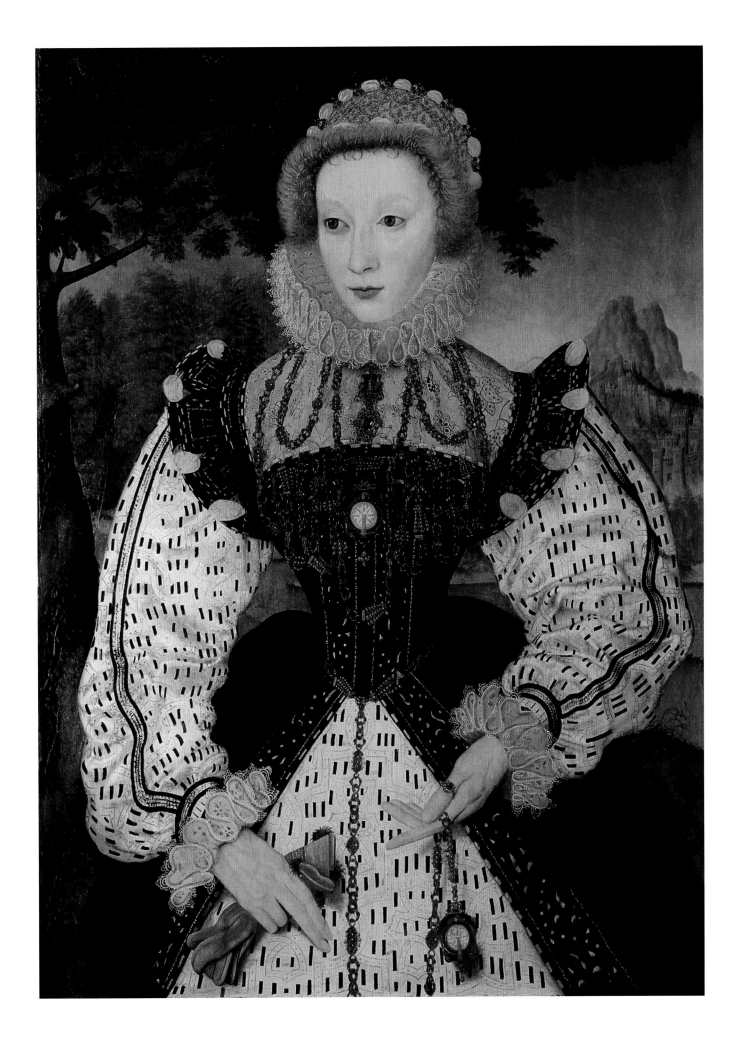

12 SIR FRANCIS DRAKE

(1540?–96)

12 (opposite)
Sir Francis Drake
Unknown artist, c.1580
NPG 4032

12.2 (below)
**Design for an aigrette
with three plumes,
from an album of
designs for jewellery**
Arnold Lulls, c.1585–1640

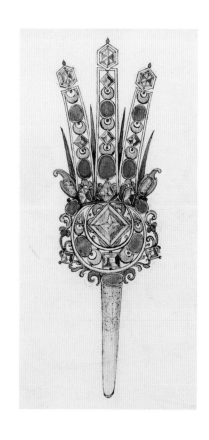

The quintessential Elizabethan adventurer – sailor, pirate and explorer – Drake is portrayed here with a globe that draws attention to his exploits, notably his famous voyage round the world (1577–80), after which he was knighted by the Queen on his ship, the *Golden Hind*, at Deptford.

But it is also as a man of fashion that we see him here, adopting the exaggerated peascod line, so popular in the period, and which aroused criticism from a number of moralists. In *The Anatomie of Abuses* of 1583 the Puritan Philip Stubbes denounced the wearing of 'monstrous' doublets and jerkins for 'being so hard quilted, stuffed, bombasted and sewed, as [men] can neither woorke nor yet well plaie in them through the excessive heate thereof'. Furthermore, Stubbes continued, such garments made their wearers look 'inclined ... to gluttonie, gourmandice, riotte and excesse'. Stubbes also attacked the vogue for wearing the kind of large ruff that we see in Drake's portrait, a costly item of dress that he said led to vanity, and – on more practical grounds – made it difficult to move the head freely. Proclamations were passed (in 1577 and 1580) against excessive size and depth of ruffs, but – like nearly all sumptuary legislation – they were ignored.

Drake's costume consists of a doublet of slashed cream silk under a red jerkin trimmed with silver-gilt braid. His knee-length breeches (known as 'Venetians') match the jerkin. Ironically, considering his lifetime career of attacking Spanish ships, he wears a fashionable short Spanish cloak of pink lined with sage-green velvet. Such cloaks, a number of which survive from this period (fig. 12.1), were usually worn over one shoulder, the better to show off the lining. He carries a soft black-velvet hat, trimmed with pearls, and has a silver hat jewel in the shape of a heron's feather, or aigrette, set with diamonds and cabochon (that is, rounded, not faceted) rubies. Feather motifs were popular in jewellery and can be seen, for example, in designs by the Fleming Arnold Lulls (fig. 12.2).

Drake's extraordinarily long sword is not a misrepresentation by the artist but a reflection of the fashionable reality; edicts were passed, unsuccessfully, to limit the length of such weapons. A more practical touch in Drake's appearance is his choice of black leather 'pattens' (overshoes), which protect his white leather shoes patterned with small diagonal cuts.

Another soldier and explorer, whose buccaneering qualities were exploited by Elizabeth I, was Sir Walter Ralegh, who was famed for his style and sex appeal – qualities that won the attention of the Queen. Ralegh was especially fond of pearls, as is evident from this portrait (fig. 12.3); as well as signifying natural perfection, wealth and taste, they were one of the attributes of virginity, so wearing them was a pledge of devotion to the Queen, as was the wearing of her colours, black and white. Pearls hang from his ear and decorate every surface of his outfit, covering his trunk hose and forming large buttons on his doublet of white ruched and cut silk. Ralegh's sheer silk collar (known as

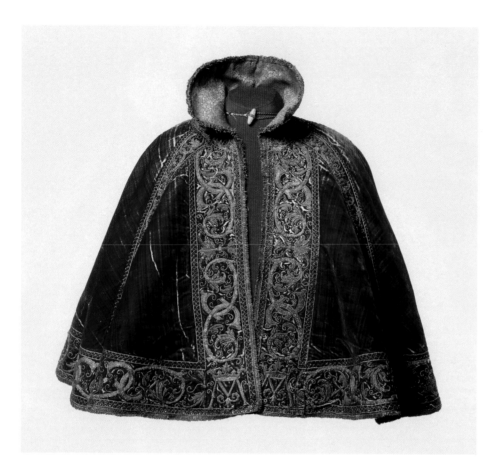

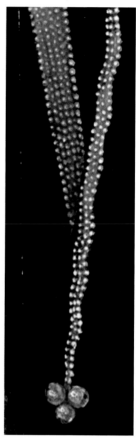

12.1 (above, right)
Front of a crimson silk velvet cloak
1560–75

12.3 (opposite)
Sir Walter Ralegh
Unknown English artist, 1588
NPG 7

12.4 (above, left)
Detail showing pearl embellishment on cloak

a falling band) reveals a pale pink underlayer – on such an outfit a ruff might have been excessive. His short, sable-lined cloak has an almost abstract design of pearls that may be a play on the heraldic device of the sun in splendour, or may represent rays of moonlight, ending in a trefoil (fig. 12.4). Queen Elizabeth was sometimes referred to as Diana (or Cynthia), goddess of the moon, and a crescent moon appears in the top-left corner of the painting.

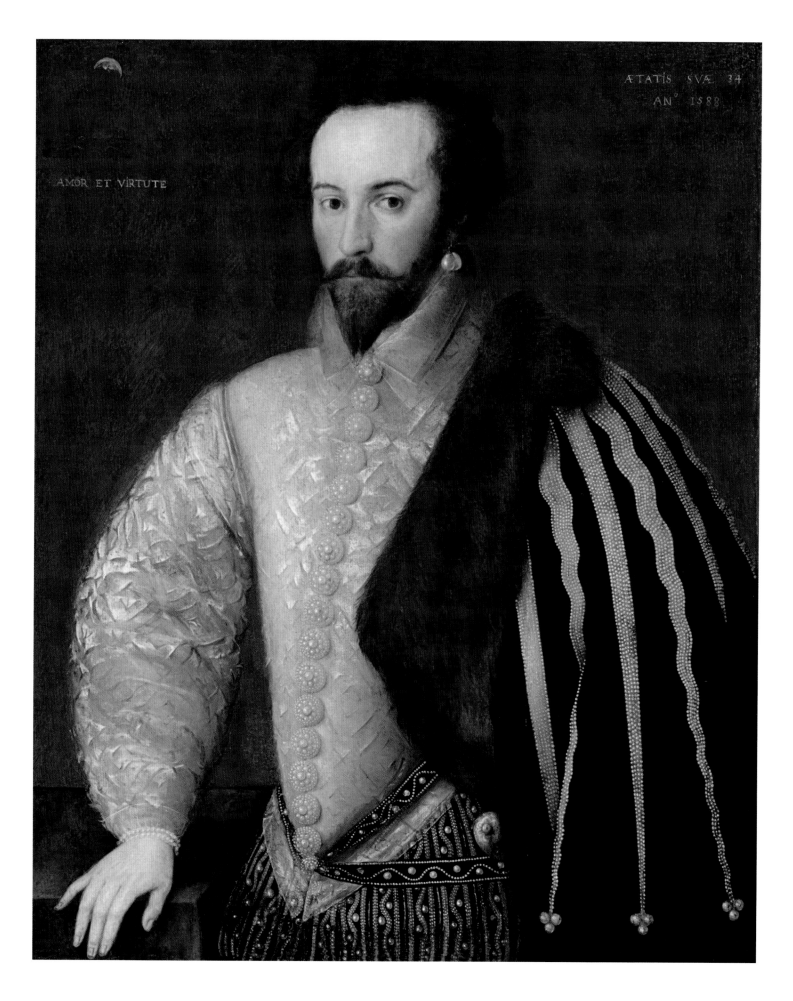

AMOR ET VIRTUTE

ÆTATIS SVÆ 34
AN' 1588

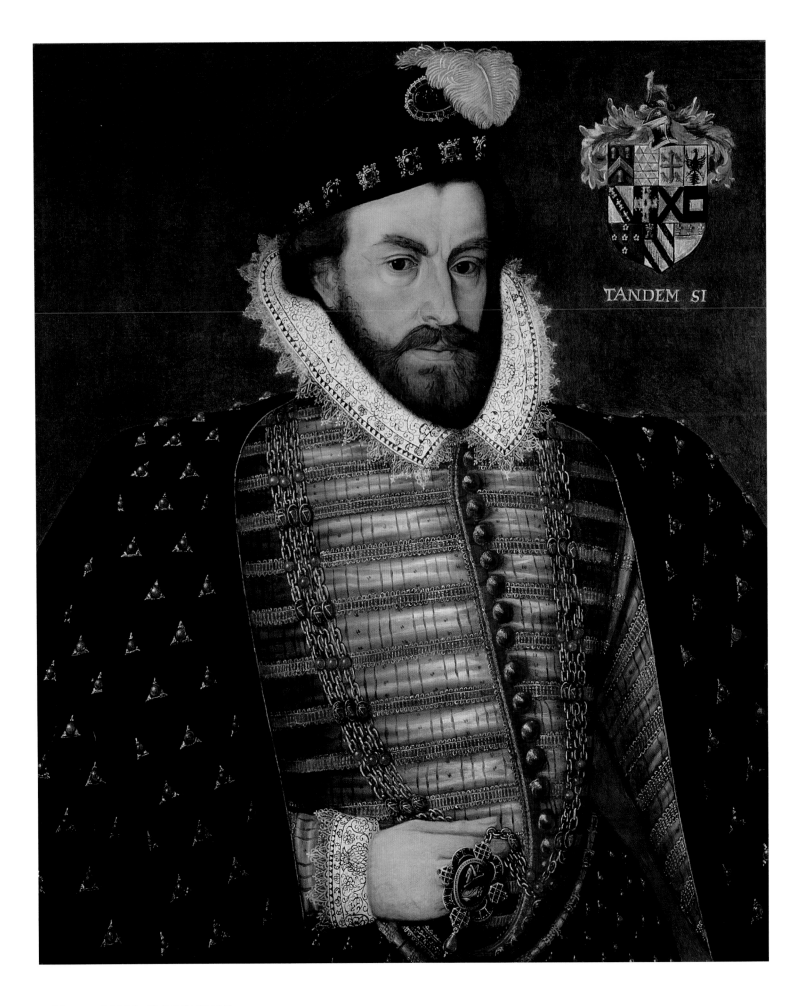

SIR CHRISTOPHER HATTON
(1540–91)

Courtier and lawyer, Hatton is portrayed here more as the former than the latter, although he became Lord Chancellor in 1587. The late sixteenth century is a period of extremes in male dress – stuffed peascod doublets with wide padded sleeves, balloon-like trunk hose and short flaring cloaks – and Hatton follows the fashionable silhouette. His doublet is of white satin, with tiny pinked cuts, and overlaid with horizontal bands of red silk trimmed with gold lace; it fastens down the front with large gold buttons. His cloak and breeches are of black satin with an unusual decoration of pearls set in gold (or possibly cloth of gold), forming equilateral triangular shapes. His collar (an increasingly fashionable alternative to the ruff towards the end of the century) and his cuffs are of blackwork with a scrolling design of fruit and flowers; such embroidery patterns were probably inspired by the popular herbals of the period.

Hatton's black velvet hat is lavishly trimmed with jewelled ornaments – black pearls and rubies set in gold – and a large cameo brooch holds the ostrich feather in place. He draws our attention to another cameo, attached to a gold chain; the image is that of Queen Elizabeth I. A contemporary cameo (fig. 13.1) shows a bust portrait of Hatton (less flattering than the painted portrait), with an image of a golden hind on the reverse. This was his personal crest, and it is possible that Drake named his famous ship in honour of Hatton, one of the backers for his circumnavigation of the globe.

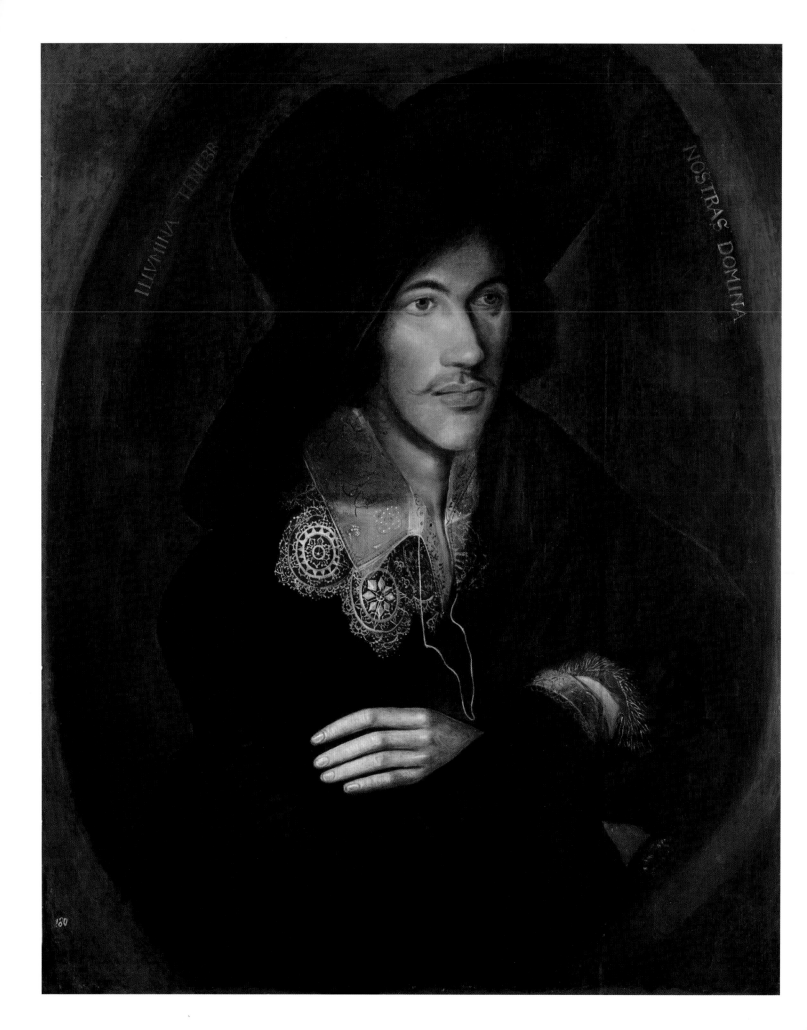

14 JOHN DONNE
(1572–1631)

14 (opposite)
John Donne
Unknown English artist,
c.1595. NPG 6790

14.1 (below)
*A Young Man Seated
Under a Tree*
Isaac Oliver, c.1590–5

Described by Sir Roy Strong as 'the most famous of all melancholy love portraits', this unusual work depicts the sitter deep in the shadows, from which it is only just possible to distinguish his dark clothing, consisting of a chestnut-brown doublet laced with black braid and a black cloak worn in the fashionable manner over one shoulder and wrapped around his upper body; a wide-brimmed round black hat that frames his face. The gloom is only alleviated by the gleam of the metal fringe on the gauntlet of his glove and the bright white of the spiky reticella lace under his almost transparent white-gauze shirt collar, the strings of which are left undone to underline his distracted emotional state. Melancholy was the humour, or mental and physiological trait, most closely associated with intellectual and artistic characteristics, and befits John Donne, the metaphysical poet, playwright and man of letters, 'a great visitor of Ladies, a great frequenter of Playes, a great writer of conceited Verses', as he was described by a 'friend'. The Latin inscription around his head, translated as 'O Lady lighten our darkness', is thought to be a misquotation of a line from Psalm 17, indicating that his melancholy is induced by a lover, and his full, slightly parted red lips are perhaps meant to express his longing and unrequited ardour.

The depiction of male sitters in the fashionable attitude of melancholy, indicated by their dishevelled clothing and 'careless' posture, was a common artistic trope during the Elizabethan period that can also be seen in a miniature by Isaac Oliver (fig. 14.1), painted at the same time as Donne's portrait. Despite its size, every detail of the unknown sitter's clothing is clearly visible, from his black-and-yellow doublet (colours that symbolised sadness at the departure of a loved one) to the embroidery on his shirt and his black trunk hose with their tight-fitting thigh extensions (canions). The soft leather of his unusually high boots wrinkles over his legs in the same way that knitted hose would; wrinkled or ungartered stockings often signified perturbation of the mind. The broad-brimmed round hat worn in both portraits is a new style replacing the bonnet, while the (relative) lack of facial hair and informal poses underline both men's youthful affectation and fashionability.

15 SIR HENRY UNTON

(1557?–96)

15 (below)
Sir Henry Unton
Unknown artist, c.1596
NPG 710

15.1 (opposite)
Detail showing a masque
in progress

This unique narrative painting (probably commissioned by Unton's wife Dorothy) gives us a detailed record of the public and private life of an Elizabethan gentleman, soldier and diplomat, from cradle to grave. On the right, is Unton as a baby in his bearing mantle (a rich and decorative cloth worn for christenings and other ceremonial occasions), being held by his mother, who wears black and the fashionable open French ruff of the 1590s (the clothing makes no attempt at historical accuracy and is completely of the period when painted). On the left is Unton's effigy, in armour, in Faringdon Church, Oxfordshire.

The painting is dominated by a portrait of Unton in a plain black doublet, over which is a 'cassock' trimmed with gold braid. The cassock was a short coat, usually with open, hanging sleeves, and it can also be seen worn by our protagonist during his travels in Italy and France. After studying at Oxford, Unton spent some time in Italy and is depicted (in the top right-hand corner

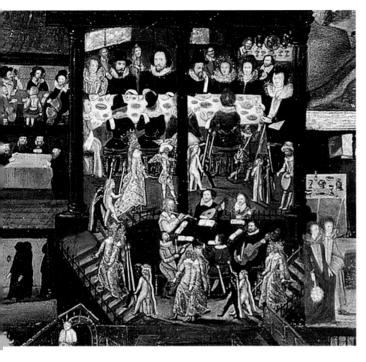

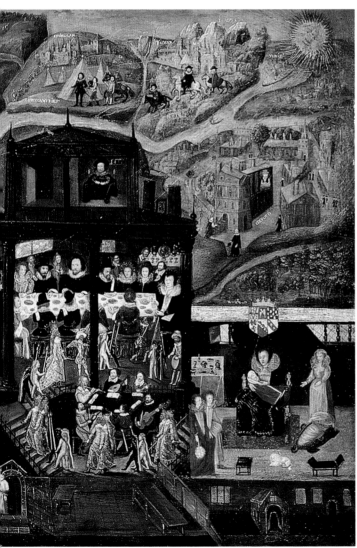

of the painting) riding on horseback under the shade of a white parasol. This is certainly one of the earliest images of an Englishman carrying such an accessory. Parasols and umbrellas (the latter word derives from the former, meaning protection against the sun, rather than the rain, as in the English meaning) were for many years derided by Englishmen as effeminate and were accepted only in the late eighteenth century.

Unton served in the Earl of Leicester's military expedition to the Netherlands (1585–6) and is shown in the top right of the painting wearing armour, with his servant holding his helmet. He was knighted at the Battle of Zutphen (1586), famous for being the occasion of the death of the poet and courtier Sir Philip Sidney. In the 1590s, Unton went on a number of diplomatic missions to France, where he died in 1596. His death-bed scene shows him in a white linen night-shirt and coif, attended by servants and a doctor in the customary long black gown (such gowns, medieval in origin, were long retained by professional men – doctors, lawyers, clerics, academics).

One of the most interesting scenes is a rare depiction of a masque (fig. 15.1) held at Unton's home, Wadley House in Faringdon. Masques were elite entertainments, which took the form of mimed *tableaux vivants* accompanied by music; presentations of allegorical and mythological themes that were put on in honour of ceremonial events, such as marriages or the arrival of exalted visitors. Under the early Stuarts, and in the hands of the court architect Inigo Jones, the masque developed into a sophisticated court entertainment. In Unton's masque the theme is explained to the guests by way of a written text handed to Lady Dorothy Unton by Mercury, messenger of the gods, in a winged helmet. The female masquers, led by the goddess Diana in her crescent-moon headdress, are dressed *all'antica* (or, rather, an Elizabethan notion of the antique), in silver bodices and skirts (without 'unpoetic' farthingales) embroidered with flowers. Their long blonde wigs and red face masks were traditional masque costume, and as such are listed in the accounts of the Office of Revels, which was responsible for all the theatrical entertainments performed at court. Interspersed among the masquers are children as cupids, taking their customary role as torch-bearers; they wear all-in-one black or white garments, possibly of knitted silk.

THE
SEVENTEENTH
CENTURY

DECORATION AND DISORDER

In sartorial terms, the first quarter of the seventeenth century can be seen as an extension of the previous one: dress for both sexes at the Jacobean court continued along its extraordinary journey, eventually becoming so elaborate and overdecorated that an inevitable tipping point was reached. Puritan moralists condemned the goings-on at James I's court as well as, among many other fashions, the craze for young gallants to wear lovelocks (a long curl of hair falling over one shoulder) and women (Queen Anne included) to display large expanses of bosom. The accession of Charles I and his French queen Henrietta Maria in 1625 was the catalyst for change, the abandonment of the *horror vacui* that previously dictated the embellishment of every surface with decorative embroidery (an English speciality (fig. 16.2)), lace, spangles, fringing and ribbons; the destruction of costly fabrics by pinking and slashing in a mania of overt conspicuous consumption. Dress was increasingly equated with religious and moral virtue, and, despite their relative simplicity and restraint, the new styles introduced to the Caroline court by the Catholic queen came under fire for exposing the arms, for being too masculine (fig. 22.1) or, conversely, too unstructured and loose.

As with Henry VIII and Holbein in the previous century, our image of Charles I and his court is provided by a foreign artist. The Flemish painter Anthony van Dyck's flattering depictions of the royal family and the aristocracy not only introduced a new style of portraiture but also provided the consummate representations of the beauty of gleaming silks and satins, augmented only by a little jewellery and a lot of costly Italian or Flemish lace; he may indeed have influenced what became the more sophisticated fashionable aesthetic. Women's dress consisted of a boned bodice and skirt, as always worn over the shift and stays. Farthingales went out of fashion by the 1620s, and with the waistline now at a higher level, the silhouette became softer and more rounded. The ruff also disappeared during this decade. It was replaced by a lace-edged falling collar for both sexes, producing a sloping shoulder line that encouraged the wearing of long hair. In the case of women, this was arranged in ringlets on either side of the face with a small bun at the back of the head. In the late 1660s loose wrapping gowns were introduced (fig. 27); along with the addition of fluid drapery in the form of scarves and mantles, the unprecedented exposure of shoulders, arms and bosoms resulted in a more informal look, if only in painting. A contrived negligence was the fashion, the 'sweet disorder' described by Robert Herrick in his poem, 'Delight in Disorder', published in 1648 although probably written in the 1630s.

It was fashionable for men also to adopt an air of negligence during the middle years of the century, although during the Civil War many would have added items of military dress to their wardrobe. The romantic style we associate with the Royalist 'Cavaliers', with their flowing locks, plumed hats and silk doublets and lace collars, was also worn by men on the Parliamentarian side, just as high style continued to be worn by women on both sides of the conflict. The ensuing Interregnum did little to halt the march of fashion, and by the Restoration in 1660, men's doublets had become so short at the waist and wrists that the shirt billowed out from beneath them, mirroring the loose shift seductively draped around the arms and shoulders of women portrayed in 'undress' including Eleanor 'Nell' Gwyn (fig. 29). Breeches, which had assumed an easy elegance in Charles I's reign, expanded dramatically into voluminous divided skirts, trimmed at the waist and knee with bunches of ribbon loops (fig. 27). Another tipping point was reached, and it was in 1666 with the simultaneous introduction at court by Charles II and Louis XIV of the 'Persian vest' – or knee-length, buttoned waistcoat, worn under an equally long coat – that men entered into an enduring relationship with that most adaptable of all outfits, the three-piece suit (fig. 32), a relationship that continues today.

As is often the case in fashion, garments that begin life as informal wear gradually become more formal: the mantua, originally a loose, unstructured wrapping gown, became the most fashionable type of formal dress for women (fig. 30.1) by the end of the century. It was worn over stays rather than having integrated boning in the bodice, and an ornately decorated petticoat, the complex drapery at the back created by the skirt on either side, could be extended into a train for court wear. It was worn with a headdress composed of wired tiers of lace and long streamers, or lappets, which hung down on either side of the head. The masculine-style riding habit also became popular towards the end of the century and followed the fashions in men's coats, replacing breeches with a habit skirt. The fashionable silhouette fluctuated throughout the century, from the distortion and elaboration of the Jacobean period and the softly rounded romance of the Caroline court to an elongated, more structured line, a process mirrored by men's dress.

The expansion of London outwards from the City established new sites of consumption where fashionable commodities could be purchased, such as the New Exchange on the Strand, and later, after the Restoration, which boosted demand, Pall Mall and St James's. Silk mercers (merchants) and drapers sold fabrics to be made up into garments; trimmings and smaller items of clothing, such as embroidered nightcaps, bed jackets, linen shirts and shifts, lace collars and cuffs, were obtainable ready-made from the haberdashers. Milliners supplied accessories such as feathers, fans, gloves and muffs; also available were the extremely expensive, luxuriant 'full-bottomed' periwigs (from the French word for 'wig', *perruque*), that were introduced for men in the 1650s. Tailors made men's outer clothing and women's riding habits and stays; women's clothing was made by seamstresses who, by the end of the century, were known as mantua makers (from *manteau*, French for 'mantle'). Linen, from which underclothing, some working and sporting dress and household furnishings were made, was traditionally a domestic product; needlework was a highly valued skill that for centuries had been the preserve of women of all classes, although a great household might employ professional itinerant 'drawers' to provide the patterns for the exquisite English vernacular embroidery applied to many clothes and furnishings. The demand for luxury goods, the exchange of fashion information and the increasingly rapid dissemination of new styles were enabled by gradually improving transport and the burgeoning of print media that saw the first fashion plates, per se, published from the 1670s; the consumption of fashion gathered momentum and began to resemble a system recognisable today. **CB**

16 SIR WALTER RALEGH and his son Walter

(1552?–1618) and (1593–1618)

16.2 (above)
Men's linen cap
Seventeenth century

16.1
Phineas Pett
Unknown artist, c.1612
NPG 2035

This is not a particularly skilful portrait of the relationship between father and son, but rather an image of two individuals inhabiting the same space. Nonetheless, it is useful for the contrast between the generations in terms of costume, and the detail with which the clothing is depicted. Sir Walter Ralegh and his son Walter were close, and both died in the same year: the son was killed during his father's disastrous Orinoco expedition to find gold, and Ralegh himself, long out of royal favour, was executed by order of James I.

Ralegh, described by the seventeenth-century diarist John Aubrey in his *Brief Lives* as 'a tall, handsome and bold man', may have chosen his costume as a tribute to the Virgin Queen, as in the earlier portrait (fig. 12.3). He wears a white suit, comprising a pinked satin doublet and trunk hose with diagonal slashes to the panes of silk. Attached to these padded breeches are canions of white watered silk. Over the doublet is a fine leather jerkin embroidered in silver and pearls; a pendant pearl adorns his ruby hat jewel.

The son copies his father's pose, standing with hand on hip. As was often the case, the style of dress worn by the boy is less formal and more up-to-date than that of his father; new trends usually first appear in informal clothing. The young Ralegh wears a suit of dark turquoise silk, decorated with tiny cuts and silver braid; the full breeches fastening under the knee are more fashionable than trunkhose, which were increasingly reserved for very formal, ceremonial wear (fig. 17).

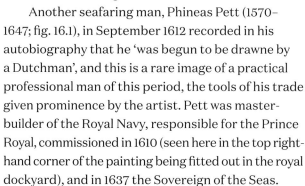

Another seafaring man, Phineas Pett (1570–1647; fig. 16.1), in September 1612 recorded in his autobiography that he 'was begun to be drawne by a Dutchman', and this is a rare image of a practical professional man of this period, the tools of his trade given prominence by the artist. Pett was master-builder of the Royal Navy, responsible for the Prince Royal, commissioned in 1610 (seen here in the top right-hand corner of the painting being fitted out in the royal dockyard), and in 1637 the Sovereign of the Seas.

Pett is also portrayed as a man with a taste for modest finery in dress: a doublet of white silk decorated with diagonal slashes, tiny peppercorn buttons down the centre front and silk ribbon bows on the sleeves. The standing collar, rather Spanish in style, is of plain linen, but is superimposed on pink silk and matches the cuffs. The most beautifully observed item of Pett's costume is his linen cap, embroidered with flowers and trimmed with gold lace; such caps were worn indoors but rarely appear in portraiture, although a number of examples are extant (fig. 16.2).

17 HENRY, PRINCE OF WALES

(1594–1612)

17 (opposite)
Henry, Prince of Wales
Robert Peake the Elder,
c.1610. NPG 4515

17.1 (right)
The Lesser George
Badge of the Order of
the Garter
England, c.1640

17.2 (below)
Detail showing the Prince's
decorative shoe-rose

This portrait may have been painted to commemorate the creation of Henry, eldest son of James I and Anne of Denmark, as Prince of Wales in 1610. The Prince was given the Order of the Garter (the premier order of English chivalry) soon after his father's accession to the throne of England in 1603, and he wears the Lesser George, on a ribbon round his neck, and the Garter itself below his left knee. The Lesser George is a small oval gold or jewelled pendant of St George and the dragon, encircled by the Garter (fig. 17.1). Hung on a chain or, more usually, a blue ribbon, it is worn on non-ceremonial occasions. The cream-coloured beaver hat on the table has a jewel of pearls and enamelled gold that forms the letters HP (Henricus Princeps) and holds in place a panache, or spray, of white ostrich plumes, which refers to the three Prince of Wales feathers as well as to the feathered headdress associated with the Order of the Garter; the white plumes were also very fashionable.

Something of Henry's style and charm can be seen even within the confines of a formal portrait; he was a true Renaissance prince, athletic and cultivated and – even in his early youth – a patron of the arts. His doublet is of brocaded silk, over which he wears a jerkin of cream silk embroidered in red. Red embroidery also decorates the panes of cream silk that form the top layer of his padded trunk hose. This style of costume, which could all too easily look clumsy, especially on an older man, gives Prince Henry a balletic grace, an impression reinforced by his long, slim legs in their red silk stockings.

Grace and delicacy appear in the accessories to the Prince's costume. Like many young men of fashion, he wears a standing collar, lightly starched and edged with fine reticella lace, which matches that on his cuffs. Reticella was an embroidered lace made of fine plaited or needle-woven strands of linen, producing a light, geometric and gossamer fabric, which features prominently in Jacobean portraits. Also popular in this period, for formal wear in particular, were 'shoe-roses' of the kind that Henry wears – puffball confections of metal lace and spangles; the Prince's are made of silver with a central pearl, and they decorate shoes of pinked white leather (fig. 17.2).

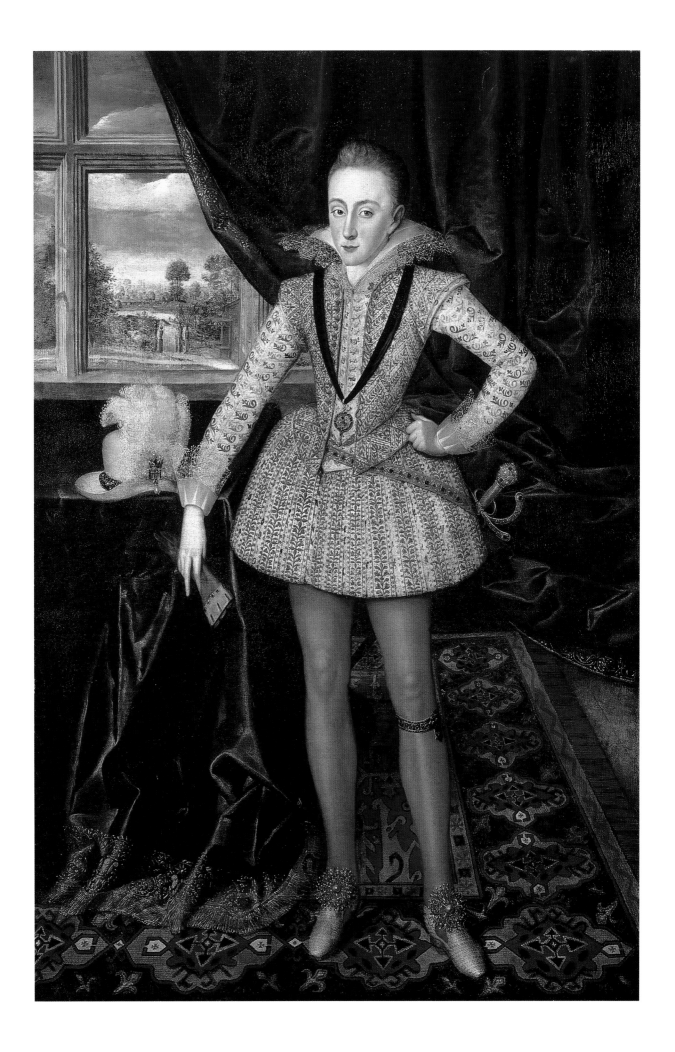

18 ANNE OF DENMARK
Queen of James I (1574–1619)

The new Stuart rulers were keen to assert continuity with the Tudor dynasty, and it was decided that court dress should continue the same as that worn by Elizabeth I. Magnificently attired, Anne of Denmark, a stickler for correct sartorial protocol, wears the French drum farthingale that she insisted on retaining for court (a style only ended by her death in 1619), even though by the time this portrait was painted it was no longer in high fashion. Her tightly boned bodice and sleeves are made of striped brocade featuring carnations and irises. The main body of the white satin overskirt is slashed and pinked, and it is bordered (guarded) with the same stripes, in Spanish style, slightly open at the centre front to reveal a carnation-pink petticoat underneath, hemmed with metal fringe. Pink linings enhance the visibility of the intricate designs in the reticella lace at her wrists and neckline, while her magnificent standing collar is laid on to another of plain gauze, so transparent that the motifs on the wallcovering behind her are visible through it. Pink-and-blue puffs of silk ribbon embellish the 'wings' or pickadils around the top of her arms and are interspersed with table-cut diamonds. Despite Anne's love of jewellery, she shows relative restraint in this portrait: a halo of pearls frames her high hairstyle, three huge drop pearls hang at her forehead and ears, a double strand around her neck and a triple rope twisted diagonally across her chest. A single table-cut diamond is pinned in her hair.

18.1
Elizabeth, Queen of Bohemia
Unknown artist, 1613
NPG 5529

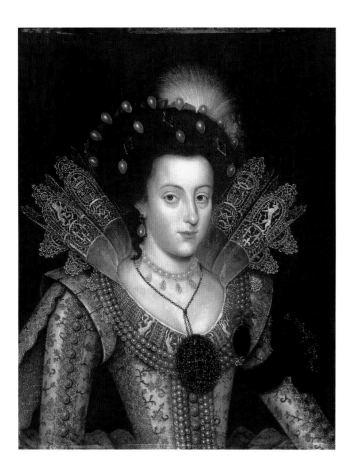

The portrait of Anne's daughter, Princess Elizabeth (1596–1662; fig. 18.1), probably painted at about the time of her marriage in 1613 to Frederick V, Elector Palatine, shows a suitably sumptuous costume and lavish use of jewellery. Her standing lace collar (reticella again) incorporates the royal coat of arms and the heraldic lion and unicorn. Some of this lace, a unique commission, is placed over a red silk partlet, which partly covers the low neckline of her dress. Ropes of pearls, possibly from the famed collection of Elizabeth I, adorn the bodice of the dress; pearls stud her hair like cloves in an orange, and in her right ear is a pearl, attached to which is a lock of hair (probably her own) tied with a black ribbon. A small panache of feathers completes her headdress. An enormous pendant of table-cut diamonds hangs from a chain around her neck (a similar breast ornament can be seen in fig. 18.2), and three large specimens are pinned into her hair between the pearls: until the invention of the brilliant cut in the late seventeenth century all diamonds appear in art as matte and sometimes black. Elizabeth was very close to her

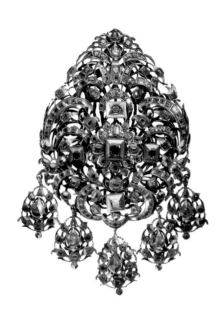

18 (right)
Anne of Denmark
John de Critz the Elder,
c.1605–10. NPG 6918

18.2 (above)
**Enamelled gold and
diamond breast ornament**
Netherlands, c.1630

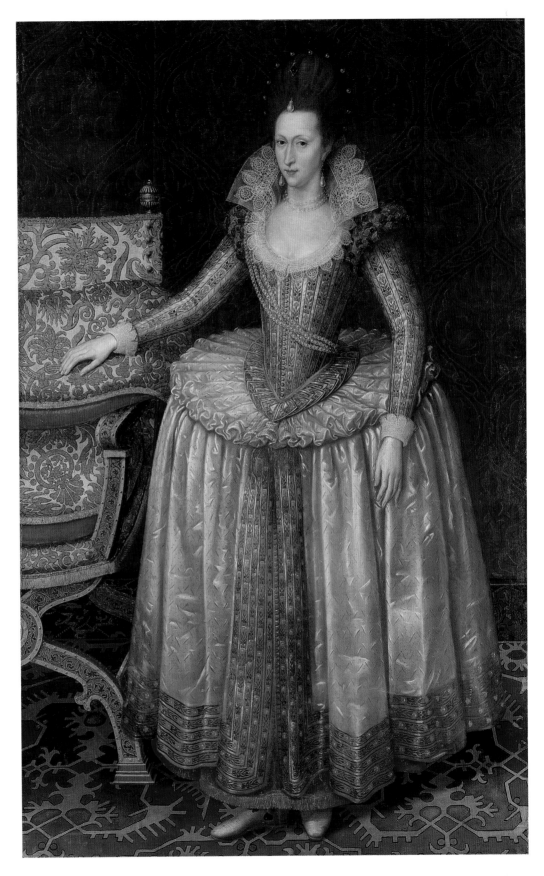

brother, Prince Henry (fig. 17), who died of typhoid in 1612. Possible references to her loss may be seen in the black silk armband and the gold-and-black enamelled locket, which probably contains his miniature, pinned to her dress.

19 ANNE, COUNTESS OF PEMBROKE

Lady Anne Clifford (1590–1676)

19 (opposite)
Anne, Countess of Pembroke (Lady Anne Clifford)
William Larkin, c.1618
NPG 6976

19.1 (below)
Detail of yellow needle-lace collar
Genoa, Italy, c.1620–30

Lady Anne Clifford has come to be regarded as a proto-feminist because of her widely publicised campaign to claim the entirety of her father George Clifford, 3rd Earl of Cumberland's estate. On the deaths of her uncle and cousin, she became one of the wealthiest women in England. As a young woman she was a favourite at court, taking part in several masques; highly educated and intellectual, she became a patron of the arts and a noted diarist (she recorded sitting for this portrait at the age of twenty-eight). She was a conscientious custodian of her family estates in Yorkshire and Cumbria, and became the Sheriff of Westmoreland.

At the time that William Larkin painted this portrait, c.1618, Lady Anne was married to the first of her two husbands, Richard Sackville, 3rd Earl of Dorset, a notoriously extravagant spendthrift, whose portrait Larkin had painted several years before, which is now on display at Kenwood House, London. In comparison to the flamboyant ensemble worn by her husband, Lady Anne's costume is restrained yet discreetly luxurious, consisting of an open green over-gown couched with gold and silver strapwork embroidery, worn over a plain white-silk bodice. A drop pearl hangs from her ear by a black silk cord; another cord, emphasising her white skin, perhaps weighted by a ring, plummets between her breasts into her bodice, close to her heart. The lack of jewellery is compensated for by the quantity of saffron-dyed reticella lace with which she accessorises her outfit: it edges her neckline and frames her 'thick brown hair', as she described it in her diary; a stiff, tilted figure-of-eight ruff, starched and goffered to stay in shape, seems almost to separate her head from her body.

Yellow lace was especially fashionable at this time (fig. 19.1). It became notorious, owing to a court case of 1616, in which Frances Howard, Countess of Somerset (also portrayed by Larkin, see NPG 1955), was found guilty of murdering a friend of her husband's with the aid of an accomplice, Anne Turner, a skilled yellow starcher. Despite this association with immorality, or perhaps because of, it was immensely popular – so much so that, in 1620, James I tried to ban it. In any case, it went out of fashion in the early 1620s.

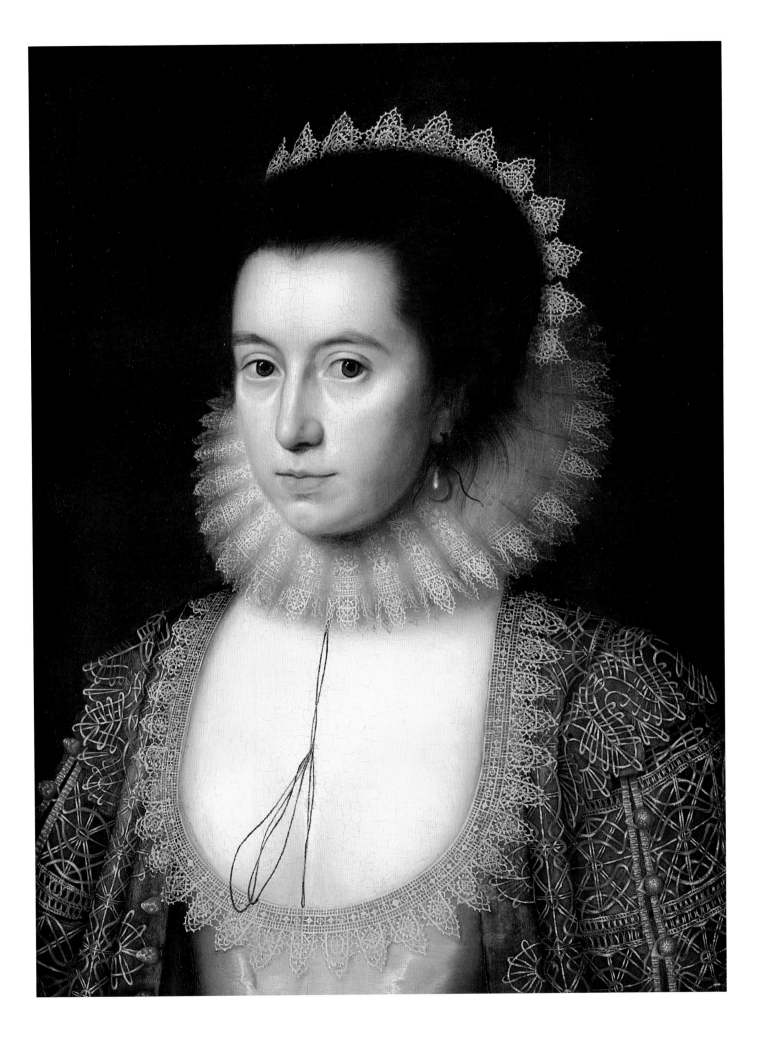

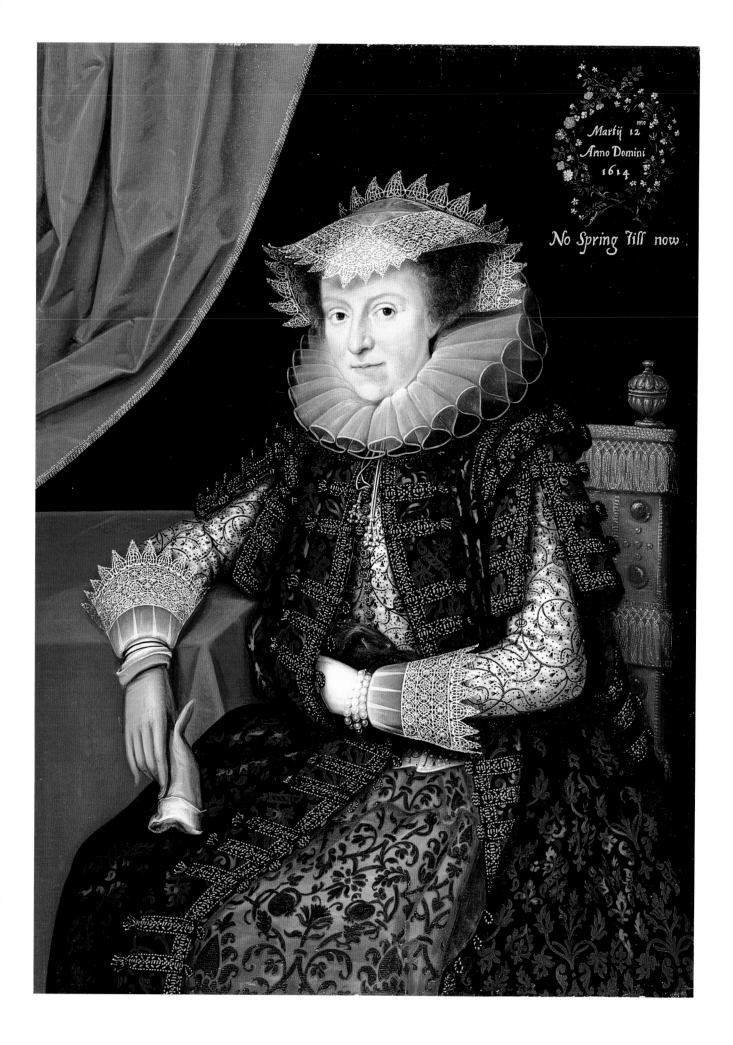

Martij 12^{mo}
Anno Domini
1614

No Spring Till now.

20 MARY, LADY SCUDAMORE

(d.1632)

20 (opposite)
**Probably Mary
(née Throckmorton),
Lady Scudamore**
Marcus Gheeraerts the
Younger, 1615
NPG 64

Little is known about this sitter, except that she was probably the daughter of Sir Thomas Throckmorton and in 1599 married, as her second husband, Sir John Scudamore. The inscription on the portrait probably refers to the marriage of her son John, on 12 March 1614 (Old Style –1615 by today's reckoning), to Elizabeth Porter. It seems likely that the portrait was commissioned both to celebrate this event and for Lady Scudamore to show off the patterned complexity of her costume.

She is seated in conventional pose at a table, one hand gloved and the other inserted in a fold of her fur-lined over-gown. Her gloves are of fine kid lined with white silk, the fingers elongated to mimic the same effect in the hand – long, tapering fingers were counted a sign of elegance and good breeding. She wears a spiky reticella-lace cap (starched or wired to hold its shape) and matching lace edges her cuffs (fig. 20.1). Linking the costly luxury of her headdress and her richly decorated costume is a plain ruff of semi-transparent linen, tied at the centre front with tasselled strings.

Lady Scudamore's costume is a harmonious combination of red, black and white. Her over-gown with hanging sleeves is made of red and black damask, with a design of stylised leaves, flowers and stems; it is decorated with black-and-gold braid, and the fastenings (loops and buttons) are arranged alternately from neck to hem. Such elegant yet comfortable loose gowns were usually worn with a bodice and skirt; here the skirt is of cut velvet, black on red, and the jacket is of white silk embroidered in black and gold thread and tiny gold spangles known as 'oes'. These jackets (some of which survive in museum collections, see fig. 20.2) were sometimes made by the wearer herself or professionally embroidered.

20.1 (left, top)
Detail showing the lace on the sitter's cuff

20.2 (left, below)
Woman's close-fitting long-sleeved linen jacket, embroidered in fine black wool in a pattern of barberries
c.1610–20

21 CHARLES I
(1600–49)

It is clear from this portrait how Charles I valued the notion of kingly dignity and restrained elegance in his clothing. He is portrayed here with the appurtenances of royalty – crown, orb and sceptre – and with the sash of the Order of the Garter, which symbolised for him the traditional chivalric ideals of duty, piety and obedience. Inflexible in politics, ascetic in his private life, he was a cultivated and intelligent patron of the arts; perhaps his highly developed aesthetic sense filtered through into the understated style and subtle colour combinations seen in his costume. In terms of fashion, the age of Charles I is one of simpler styles, where the beauty of plainer fabrics was more highly considered than those that were patterned or overdecorated. In contrast to the often crude finery of James I's appearance, Charles's wardrobe accounts reveal a fondness for suits of one colour, sometimes with contrasting linings to the doublet, as in this portrait, where we see a sophisticated combination of ash grey trimmed with silver braid and aglets, the doublet lined with pale yellow.

An equally stylish sense of colour can be seen in an earlier image of the King by Gerrit van Honthorst (fig. 21.1), where Charles is shown, less formally, in pensive mood, wearing a doublet of sage-green figured silk lined with carnation-coloured silk. The doublet is rather like one listed in the King's wardrobe for the year 1633/4: 'a suite of greene Tabie [tabby, a watered-silk taffeta] lined with Carnation Tabie cutt with and upon Carnation Taffatie … the doublet cutt in panes'.

In both these portraits Charles follows the dictates of fashion by wearing his hair long, a virtual impossibility when starched ruffs and high collars were the rule; it was the vogue also to have the hair slightly longer on one side (a lovelock). The Honthorst portrait depicts a soft, falling ruff, made of layers of lace-edged linen, while Daniel Mytens shows Charles wearing a collar of needle-lace (needle-lace, or needlepoint, is lace made with a needle and thread on a parchment pattern). In the full-length image of the King, it is worth noting how the fine leather gauntlet gloves match his floppy boots; the most highly prized leather came from Cordoba in Spain.

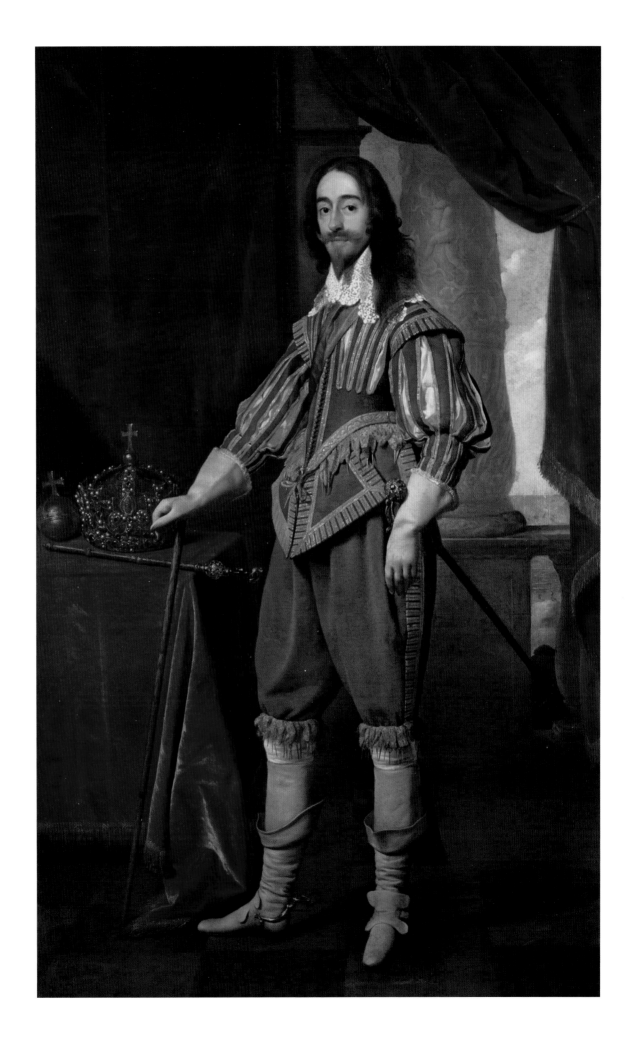

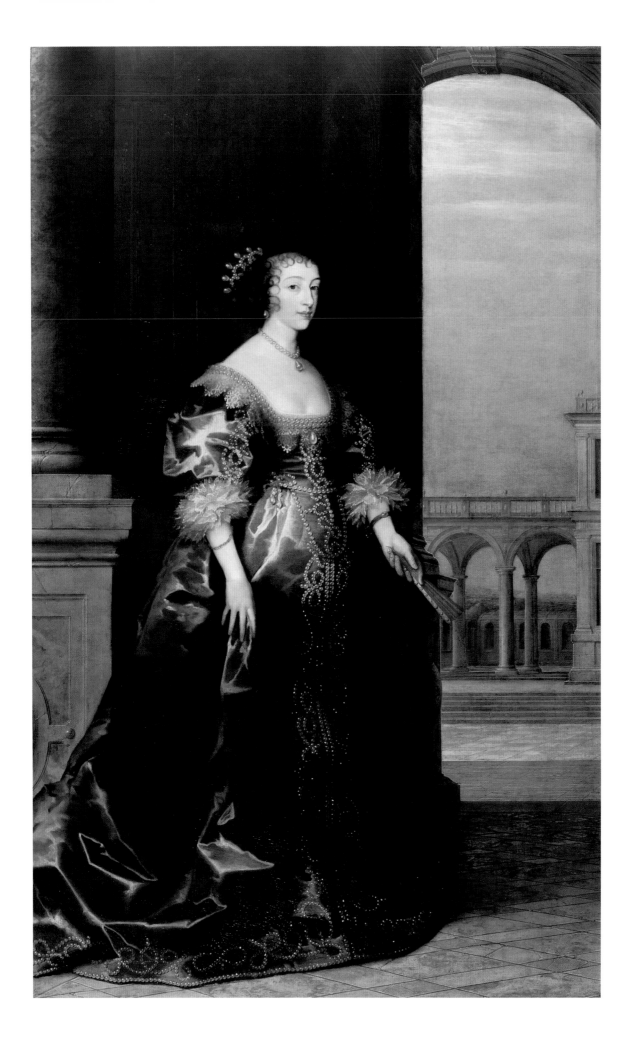

22 QUEEN HENRIETTA MARIA

(1609–69)

22 (opposite)
Henrietta Maria
Unknown artist
(background by Hendrik
van Steenwyck), c.1635
NPG 1247

22.1 (below)
**Queen Henrietta Maria
with Sir Jeffrey Hudson**
Sir Anthony van Dyck, 1633

The stylish elegance of Caroline female costume lay in the beauty of relatively unadorned fabrics, most notably the shining silk taffetas and lustrous satins painted by the court artist Anthony van Dyck and his contemporaries. In this portrait the Queen wears a dress of sage-green satin; green was the colour of true love and features prominently in the royal-wardrobe accounts, an indication, perhaps, of the mutual devotion of Charles I and Henrietta Maria. This beautiful dress, with its low neckline and full, rounded sleeves, is decorated with arabesques of pearls. Pearls also form the Queen's coronet, necklace and earrings; they stud the mount of her coral-coloured fan, which echoes the red ribbons on her bodice.

On her left wrist is a black silk bracelet (fastened with another pearl), through which a gold ring is threaded. Such bracelets – holding small items of personal jewellery – were worn by both men and women (figs 24.1 and 24.3). Women also wore them to show off the whiteness of their skin and to draw attention to a beautiful arm and hand. In one of Robert Herrick's poems, 'Upon a black twist rounding the arme of the Countess of Carlile' (Lucy Percy, Countess of Carlisle, was a close friend of the Queen), we read:

> I saw about her spotlesse wrist
> Of blackest silk, a curious twist,
> Which, circumvolving gently there
> Enthrall'd her Arme, as Prisoner.

Also worth noting is that here, for the first time since classical antiquity, the forearms are bare.

The beautiful costume and elegance of Henrietta Maria's portrait make it fit to be placed alongside any image of the Queen by Van Dyck, the artist most associated with her. Although he preferred to paint her in white, with its connotations of neo-Platonic love and purity, there are other portraits where the Queen wears dresses of the intense but subtle colours also in fashion, such as can be seen in his painting of Henrietta Maria and her dwarf Jeffrey Hudson, which dates from 1633 (fig. 22.1). Here her costume of blue satin, decorated with tiny pinked cuts and gold braid (Van Dyck was as adept with patterns as with plain fabrics), comprises a doublet-style bodice and skirt. With the addition of what her accounts for 1635 refer to as 'a fine black beaver hatt' of the kind worn by men, the Queen is dressed for outdoors, probably about to go riding. Such masculine elements in feminine attire, especially when worn by the Queen, attracted adverse comment, particularly from Puritan moralists, which reflected the increasingly critical attitude towards the court in the country at large.

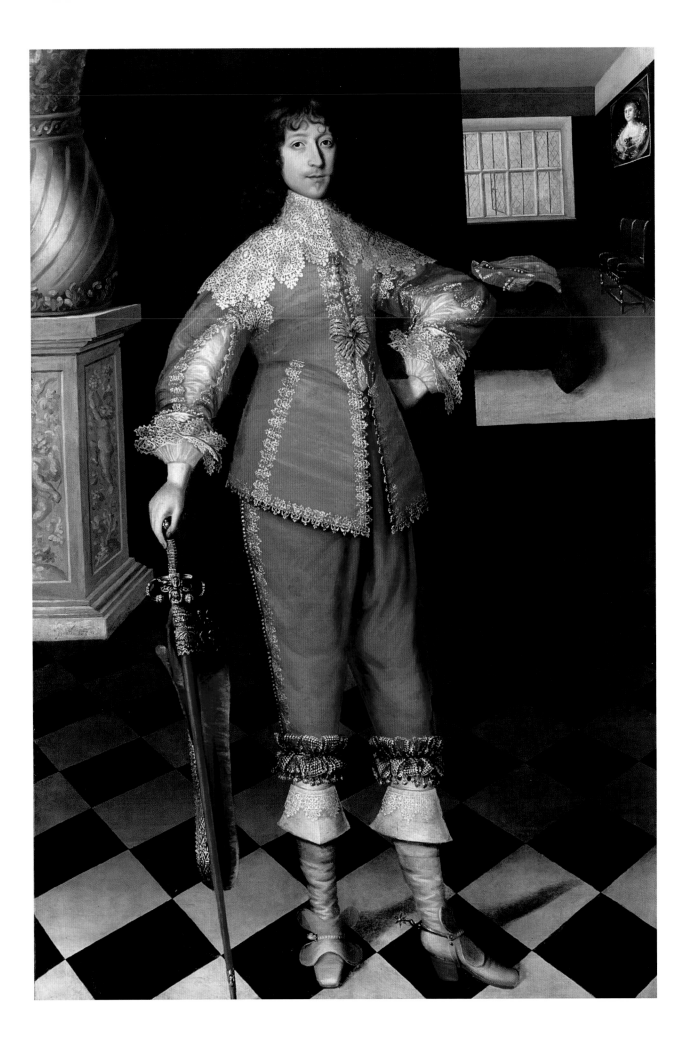

23 JOHN BELASYSE

1st Baron Belasyse (1614–89)

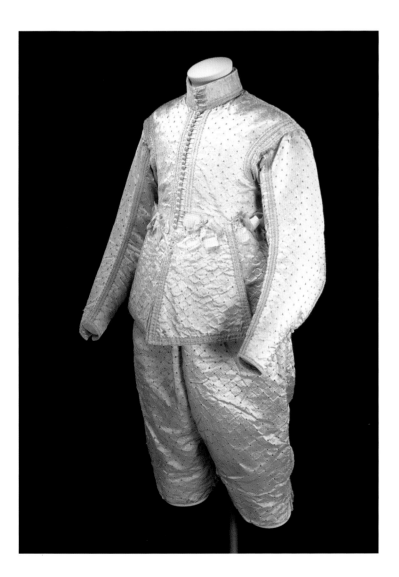

Provincial painters are often better than more sophisticated artists in their recording of costume, even though their figures can be awkwardly posed and placed in oddly perspectived interiors. There is a naive charm about Gilbert Jackson's masterpiece, his portrait of Belasyse, painted in 1636, possibly to commemorate the sitter's marriage of that year – a portrait of his wife hangs in the background.

Belasyse was a Catholic and a Royalist, who fought for Charles I in the Civil War. His finery might indicate his political convictions, if we see (as W. C. Sellar and R. J. Yeatman stated in their comic masterpiece *1066 and All That*, 1930) Cavaliers as 'Wrong but Wromantic', as distinct from Roundheads, characterised as 'Right but Repulsive'. The truth, as always, was more complicated, but popular conceptions of the Royalists – then and now – saw them as rather dashing, ultra-fashionable young men of the kind painted by Van Dyck and other court artists. Belasyse's red silk suit (similar in cut to that in fig. 23.1), trimmed with silver lace, is a good example of the relaxed and unstructured look of fashionable male costume of the 1630s, a style largely deriving from France. The breeches are long and tubular, trimmed with ribbon bows of silk gauze; the doublet is open from mid-chest, allowing a glimpse of the shirt, more of which is revealed by the open sleeve seams. A wide lace collar drapes over his shoulders, and the same lace, possibly English needlepoint, edges his cuffs and his boothose – socks with decorative borders turned down over the boots. Belasyse's boots are of light brown Spanish leather, lined with yellow silk, and with red soles and heels; his silver spurs are buckled on with butterfly-shaped leathers, which also help to protect the ankle from the stirrups.

Provincial artists did not, on the whole, select or filter costume, as did more adept painters, but depicted everything they saw with equal emphasis, often in quirky detail. This can be useful to the dress historian, for a greater range of less usually depicted garments can sometimes be seen. For example the coat draped on a table in the background matches Belasyse's doublet and breeches, and here we have in essence a three-piece suit, forerunner of the fashions of some thirty years later.

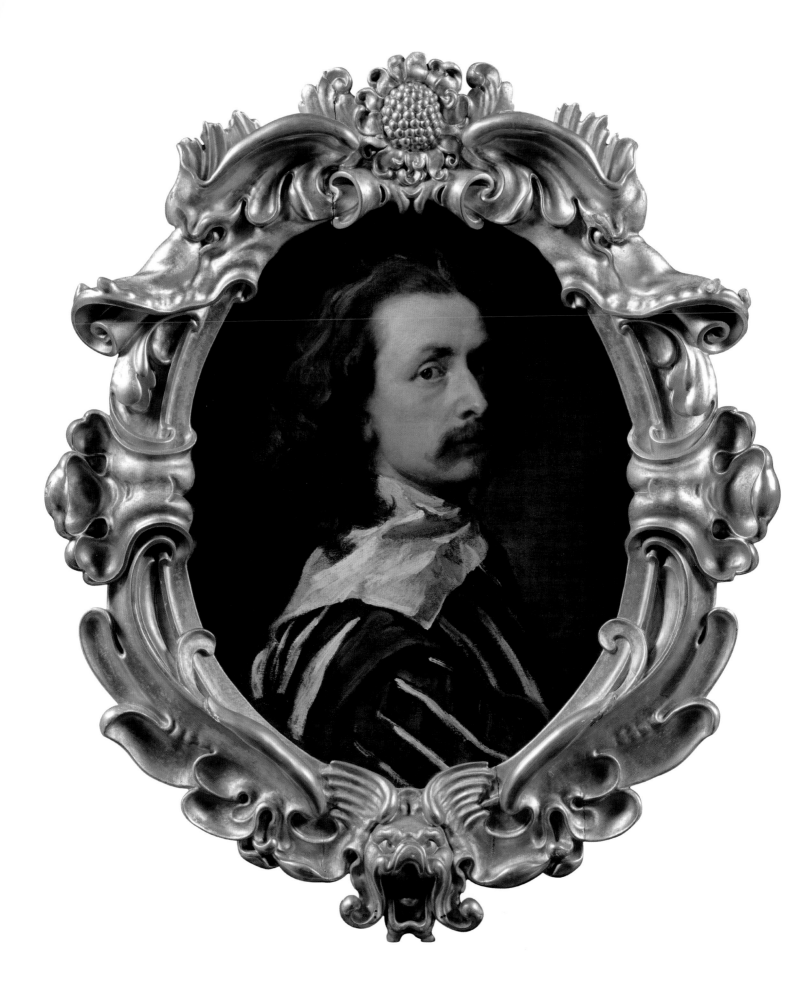

24 SIR ANTHONY VAN DYCK

(1599–1641)

The Flemish painter Sir Anthony van Dyck must be regarded as not only the most influential painter working in England in the seventeenth century but also one of the greatest painters of fashion of any period. The formal aspects of his style, his expansive compositions, sweeping brushstrokes and shimmering surfaces outmoded the decorative, icon-like images painted by artists, working a couple of decades earlier, such as William Larkin, just as Jacobean elaboration in dress gave way to Caroline simplicity.

In this self-portrait, one of three surviving self-portraits painted in Britain, he poses as both an artist and a man of fashion, dressed in a slashed black-silk doublet and a somewhat rumpled plain linen collar, his luxuriant hair tossed behind him as he returns his (and the viewer's) gaze. This casual elegance (and use of black clothing) can also be seen in Van Dyck's double portrait of Sir Thomas Killigrew (1612–83) and another man, thought to be Killigrew's nephew-by-marriage, William, Lord Crofts (fig. 24.1). Both men wear black doublets with plain linen, a style that was both fashionable and appropriate for mourning. That this is an image of grief is confirmed by the wedding ring attached to Killigrew's left wrist by a black silk ribbon (Killigrew's wife Cecilia Crofts died

24 (opposite)
Sir Anthony van Dyck
Sir Anthony van Dyck,
c.1640. NPG 6987

24.1 (right)
**Sir Thomas Killigrew;
possibly with William,
Lord Crofts**
Sir Anthony van Dyck, 1638

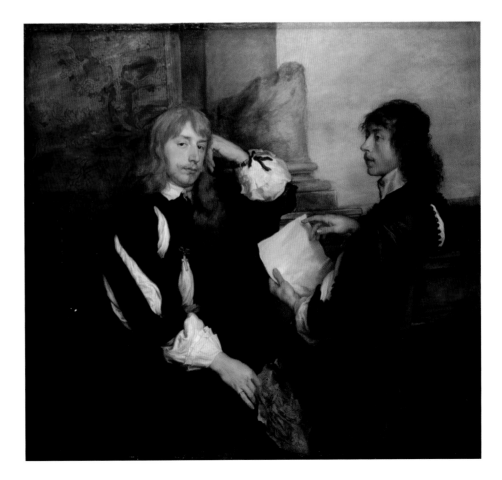

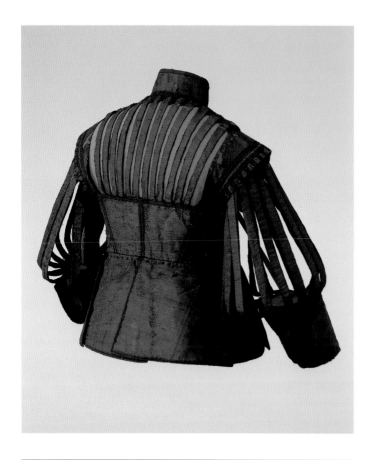

in 1638), the silver cross at his chest inscribed with her initials and the sketch for a funerary monument he holds in his right hand. Crofts's doublet seam is open down the back, revealing the shirt; although he would have been in mourning for his aunt, this is not a gesture towards the rending of clothes as a sign of grief, but an indication of the new fashion for elegant negligence in male costume. This development can be seen in a rare surviving paned doublet of black silk (fig. 24.2) from Darmstadt, Germany, of about the same date, which, like Van Dyck's, is so reduced as a covering for the body, as barely to exist.

Twelve years later (fig. 24.3), Killigrew still wears his wife's ring as well as a memento mori (either a seal or a miniature) around his wrist: the latter may relate to the recent demise of Charles I, in whose household Killigrew had been a page (a portrait of the recently executed monarch hangs on the wall, and among the books is *Eikon Basilike*, the King's supposed spiritual autobiography).

The sitter was famed for his licentious wit, and he was a convivial companion of Charles II in exile; during the Interregnum he was the King's Resident in Venice, where this portrait was painted. After the restoration of the monarchy, Killigrew held court office as a Groom of the Bedchamber, but his prime interest was the theatre: he was a prolific playwright (a pile of his plays can be seen in the portrait), and he built and managed the Theatre Royal in Drury Lane, London.

It is as a man of letters that we see him here in a comparatively rare portrait of what contemporaries called 'undress' – the kind of loose-fitting, comfortable clothing worn by a gentleman in his study: a white satin 'vest' (a knee-length gown buttoning down the front) tied round the waist with a striped silk sash, with three-quarter-length sleeves with fur cuffs (the same fur lines his white satin nightcap).

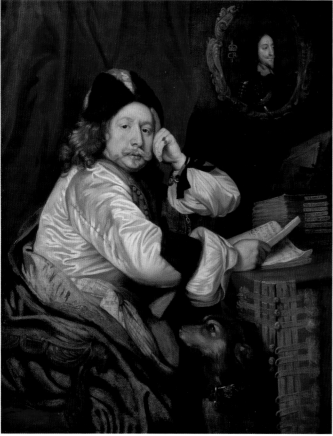

24.2 (left, top)
Darmstadt doublet
1630–5

24.3 (left, below)
Thomas Killigrew
William Sheppard, 1650
NPG 3795

25 ARTHUR CAPEL

1st Baron Capel (1604–49), and his family

25.1 (below, left)
Man's collar
Linen, edged with bobbin lace and tassles of knotted line thread.
Honiton, Devon, England, c.1630–50

25.2 (below, right)
Coral teething ring and rattle, whistle and bells
Marked by Jane Dorrell and Richard May, London, active 1766–71

This family portrait, clearly inspired by Van Dyck's first great royal group of 1632 but minus the courtly bravura, is a sympathetic study by Cornelius Johnson of the modest costume of the gentry class, in an identified setting – the formal garden of the Capels' home, Little Hadham in Hertfordshire.

Arthur Capel, raised to the peerage in 1641, was a Royalist general in the Civil War and was executed shortly after Charles I in 1649. He is shown wearing a black satin suit with collar and cuffs of English bobbin lace (fig. 25.1), made by the twisting, plaiting and interweaving of threads attached to bobbins, and – somewhat unexpectedly – hose of an intense green. His black beaver hat lies on the table behind him. His eldest son, Arthur, clutches his own hat, similar in style (these hats, signifiers of incipient manhood, often look far too large for their young owners), against his pale pink doublet. Until the age of about four or five, when they were 'breeched', small boys wore frocks of the kind we see here; the baby Henry, seated on his mother's lap, has a teething coral on a ribbon round his waist – a traditional belief held that coral protected children from evil (fig. 25.2).

For women, the late 1630s and early 1640s was a period of relative simplicity in costume, and everyday dress consisted of bodice-and-skirt styles, particularly well depicted in Wenceslaus Hollar's beautifully detailed fashion etchings (fig. 25.3). In Johnson's portrait, Lady Capel wears a blue silk bodice and matching skirt; the bodice has yellow ribbons laced over a stomacher (an

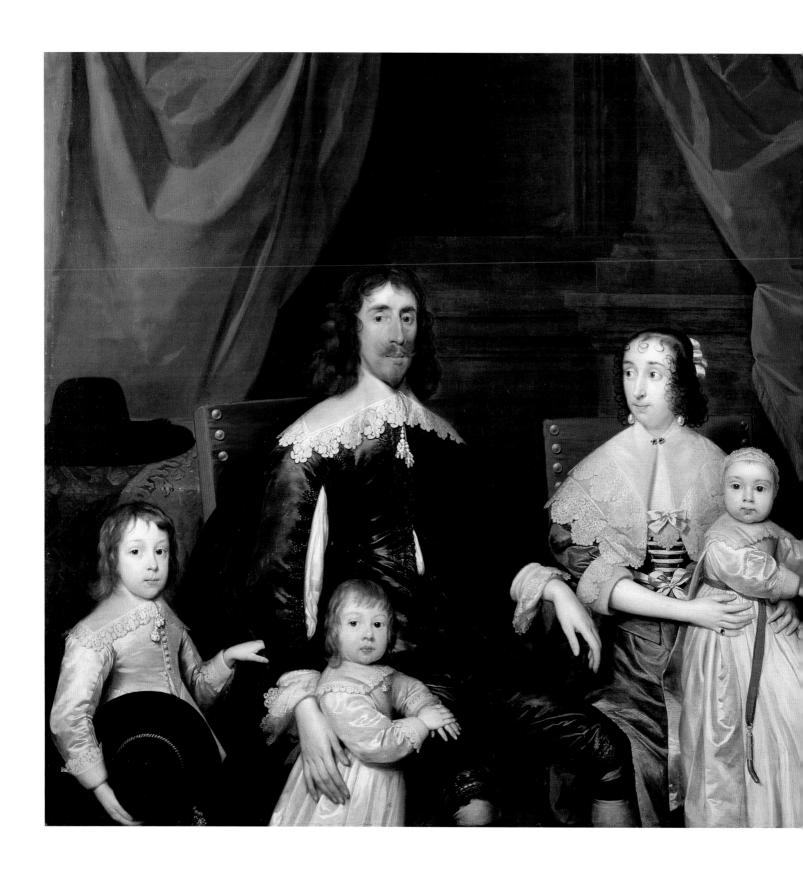

infill of fabric between the front edges of the bodice), and the neckline is covered by a lace-edged kerchief, pinned with a small jewelled brooch at the neck. The two girls are identically dressed (sisters close in age often were) in yellow silk. The elder daughter, Mary, has flowers in her hair, and the younger, Elizabeth, has a basket of roses, one of which she holds out to her tiny brother. Flowers were a conventional attribute of youth and beauty, but here there may be specific reference to the family interest in horticulture.

25 (above)
The Capel Family
Cornelius Johnson, c.1640
NPG 4759

25.3 (above, right)
English Noblewoman
(etching)
Wenceslaus Hollar, 1643

26 FRANCES JENNINGS

Duchess of Tyrconnel (1647/9–1730)

'La belle Jennings' first appeared at court, aged fifteen, as a Maid of Honour to Anne Hyde, Duchess of York. She was famed for her 'dazzlingly fair' complexion, her blonde hair and her perfect figure.

The low-cut, tight-bodiced gown of the kind worn by the sitter had first appeared – ironically – in the 1650s during the Interregnum, at which time Thomas Hall, a Puritan clergyman, had inveighed against the 'laying out of naked Breasts' as a 'temptation to Sinne' in his 'Divers Reasons Against Painting, Spots, naked Backs, Breasts, Arms &c' (1654). It was a style, however, particularly associated with the beauties who flourished in the free-and-easy sexual climate of the court of Charles II. Such a costume was not only sexually appealing because the breasts were on display, unhidden by any lace, but also – perhaps – because the wearer was captive within the confines of a tightly boned bodice, the low-set sleeves restricting the movements of her arms. An extant garment of about the same period, a bodice of blue watered silk (fig. 26.1), bears out the veracity of Samuel Cooper's depiction; it has a concealed front fastening and is well-boned, even in the upper sleeve – this was to keep the shape taut and to prevent the bodice falling too far off the shoulders.

The famous contemporary letter-writer Dorothy Osborne noted that 'There is a beauty in youth that everyone has once in their lives.' Here we see Frances Jennings in the first flush of her beauty, dressed very cleverly in an unadorned dress of plain silk, her skin complemented by pearls at her ears and round her neck, and her fair hair arranged in curls over her forehead and falling in artful ringlets over her shoulders.

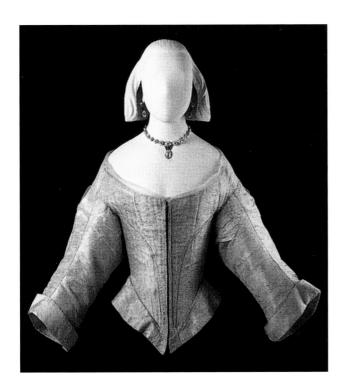
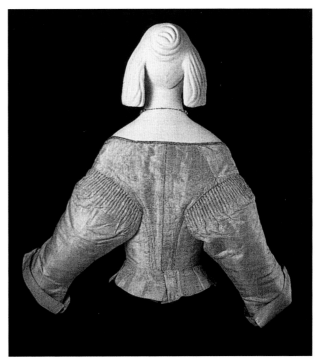

27 SIR ROBERT VYNER

(d.1688) and his family

27
The Family of
Sir Robert Vyner
John Michael Wright, 1673
NPG 5568

Compared to the generalised costume and vague draperies of so much English painting in the second half of the seventeenth century (see fig. 29.1), John Michael Wright's portraits provide welcome information on the details of fashionable clothing. Vyner was a banker and goldsmith, who made the regalia for the coronation of Charles II (he eventually went bankrupt as a result of the Crown's failure to repay money he had lent). When we look at this portrait, which shows the family in the garden of their house in Middlesex, we see an image of relaxed and civilised prosperity. Vyner himself dominates the canvas in his fashionable loose gown of Italian silk (similar to that in fig. 27.1), worn over a fine shirt trimmed with Milanese bobbin lace and with small diamond-and-gold

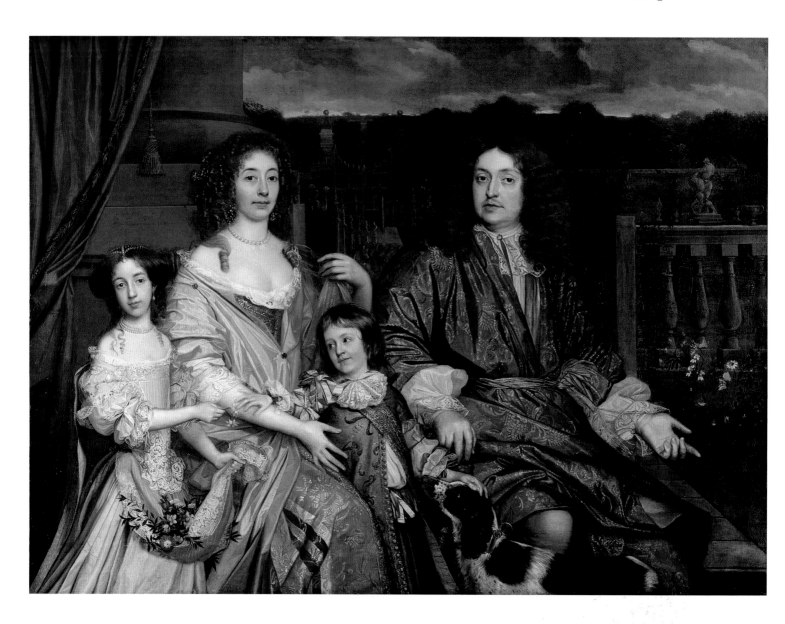

brooches at neck and wrists. Even in undress, however, the now fashionable full-bottomed wig was a necessary part of masculine appearance among the elite. It was in the 1650s that the vogue for wigs began, a fashion lasting well over a hundred years. Long hair of any kind – whether the wearer's own or someone else's – had attracted some hostility during the Interregnum, being linked to those with Royalist sympathies. A flavour of such criticism can be gained from the title of a contemporary tract, *The Loathsomnesse of Long Haire*, published in 1653 by Thomas Hall, in which 'these Periwigs of false-coloured haire which begin to be rife' were singled out for attack.

Vyner's son Charles is more formally dressed than his father, in a short-sleeved coat of blue brocade and wide breeches (known as 'petticoat' breeches because they were very full and open-ended like a woman's skirt); his costume is fashionably trimmed with bunches of blue and yellow ribbons. As a contrast to this splendour – it is probably his first grown-up suit ,and he even wears a sword hanging from a handsome baldric trimmed with gold-and-silver fringe – his hair is casually arranged, falling naturally to his shoulders.

In 1665, Vyner married Mary Hyde, a wealthy widow, whose daughter Bridget stands by her mother in a dress of pale blue silk. Bridget's status as a child is confirmed by her apron and the streamers falling from her shoulders; these long fabric pendants were partly an echo of old-fashioned hanging sleeves and partly related to the leading strings worn by babies and young children to control their movements. They were retained in the costume of young girls – as a sign of dependence – until their mid-teens.

Lady Vyner's own dress is a clever mingling of the ornate – a stiffened gold-brocade bodice and a skirt of striped coral silk – and the fashionably informal – a loose French over-gown, called a *sacque*, of pale grey taffeta lined with blue; early in March 1669 Pepys refers in his *Diary* to his wife putting on 'her French gown called a Sac'. Lady Vyner's hair is tightly frizzed all over – perhaps aiming at an effect complementary to her husband's wig – with the exception of long ringlets (possibly false), which fall over her shoulders and draw attention to her décolletage and bare shoulders. As well as the ubiquitous pearls round her neck, she wears unusual earrings of gold and silver filigree, rather Spanish in style and perhaps commissioned by the husband as a gift to his wife.

27.1
Italian brown figured silk brocaded in silver
Late seventeenth century

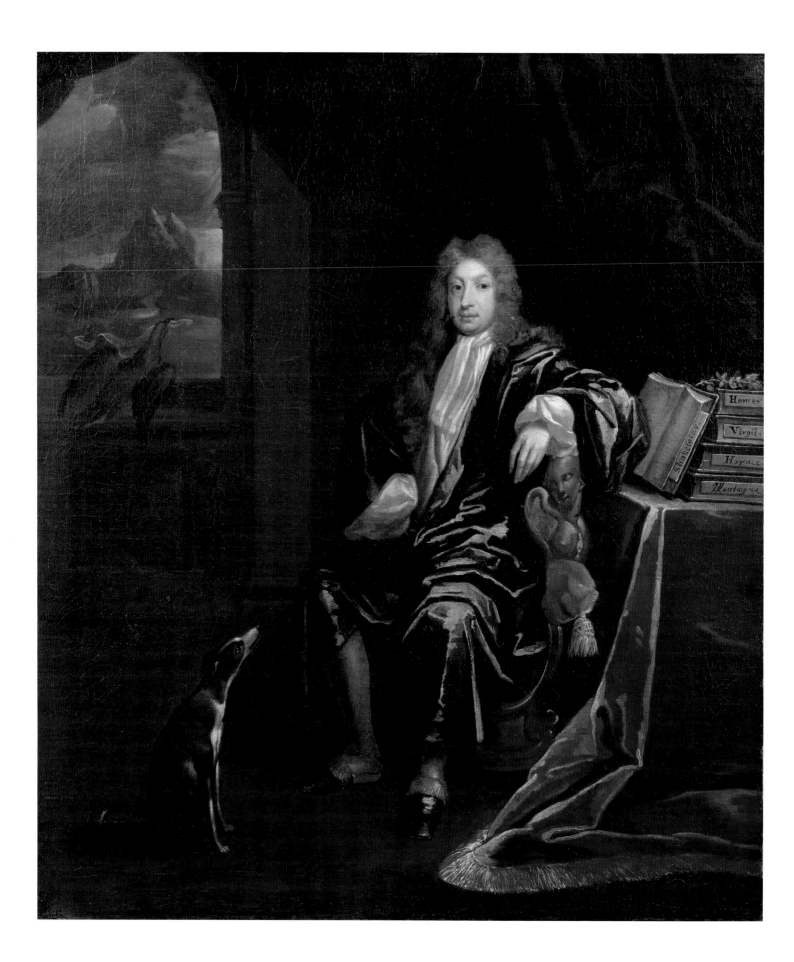

28 JOHN DRYDEN

(1631–1700)

28 (opposite)
John Dryden
James Maubert, c.1695
NPG 1133

28.1 (below)
**Unknown man, formerly
known as Daniel Purcell**
Unknown artist, 1690s
NPG 1463

By the late seventeenth century, it had become a well-established (even hackneyed) convention for artists, men of letters and musicians to be painted in loose gowns. These could be draped around the body in vaguely 'classical' folds, thus avoiding the necessity for depicting in detail contemporary fashion, which supposedly rendered a portrait the reverse of 'timeless'. Such gowns were the usual working costume of writers and scholars, so it is appropriate that Dryden (poet and author of heroic verse plays) should be shown in this instance, in this portrait by James Maubert, dressed in a gown of yellow-lined blue silk. Fashion, however, does make an appearance here, for he wears rather stylish indoor footwear and the periwig which was de rigueur by now, even when the sitter was informally dressed.

An alternative to Dryden's loose gown was the slightly more fitted vest, fastened with buttons or decorative clasps down the centre front; an example can be seen in the portrait of Thomas Killigrew (fig. 24.3). A number of artists turned this vest into a fanciful, invented garment that was intended to look Roman; as the periwig added decorum to the individual, so the vest gave him a kind of classical dignity. The playwright Richard Flecknoe referred to it as a 'civil vest', and in the preface to his 1661 tragicomedy *Erminia* he described it as 'wide-sleev'd and loosely flowing to the knees'. This is what we see in a portrait of the late 1690s, by an unknown artist (fig. 28.1), of an unknown composer, once thought to be Daniel Purcell.

29 ELEANOR 'NELL' GWYN

(1650–87)

29 (opposite)
Eleanor ('Nell') Gwyn
Simon Verelst, c.1680
NPG 2496

29.1 (below)
Unknown woman,
formerly known as Eleanor
('Nell') Gwyn
Studio of Sir Peter Lely,
c.1675
NPG 3976

Eleanor 'Nell' Gwyn – Pepys, in his *Diary*, called her a 'mighty pretty creature' – was a light comedy actress; among the first wave of women on the stage in England, she made her debut in 1665 at the Theatre Royal, Drury Lane, London. Shortly afterwards she took on a more famous role, that of mistress to Charles II, and appropriately she is portrayed by Simon Verelst wearing only a shift, the basic female undergarment, closest to the body, that had the greatest erotic potential of the whole female wardrobe. The fabric is gathered in a drawstring round the neckline, looped up on one shoulder and open down the centre front, allowing one nipple to be seen. It is clearly an image in a direct line from those of Renaissance courtesans, who are depicted in nothing more than a little jewellery and shifts that seem about to slide off their shoulders.

It was no wonder that so much flesh on display prompted attacks from such critics as the littérateur Abbé Jacques Boileau (1636–1711), whose 1675 treatise on the subject was translated into English in 1678 under the title *A Just and Seasonable Reprehension of naked Breasts and Shoulders*. Breasts were the prime erogenous zone of the period, whitened and softened with various cosmetic washes, brushed with powder made from seed pearls – the nipples of court beauties were sometimes even painted pink with a mixture of cochineal and egg white.

This portrait in particular was to be 'read' as an image of woman as desirable object; even the hectic red of the rouged cheeks mimics sexual ardour. A less obvious portrayal of female charms may be seen in a painting, once also thought to be of Nell Gwyn (fig. 29.1), of a woman wearing a 'loose-bodied' gown (equated by contemporary moralists with loose morals) of yellow satin; her white linen shift spills over at the low neckline of the dress and surges out from under the short sleeves. This kind of generalised costume, based on the fashionable 'dishabill' (*déshabillé* – this is a period when many French words for modes and manners began to enter the English language), features prominently in Peter Lely's portraits, leading to a certain uniformity of image.

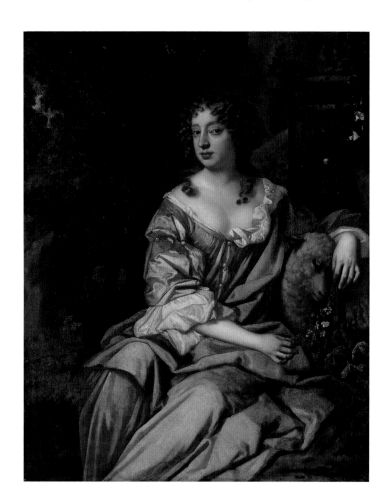

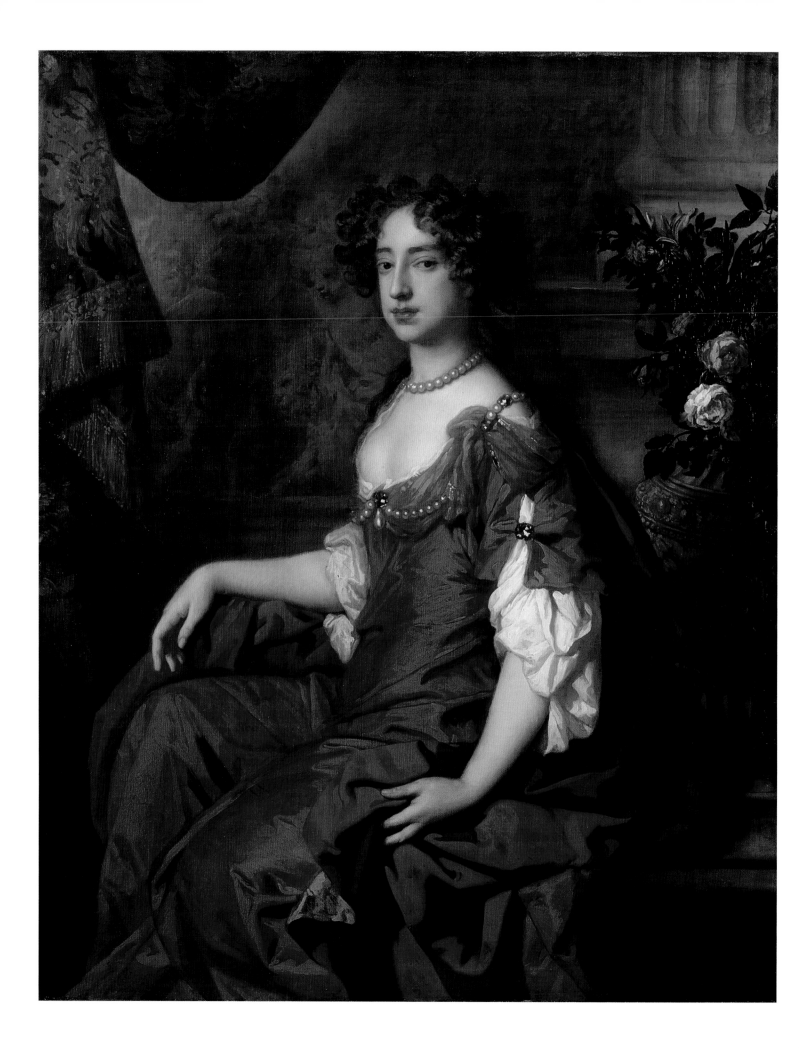

30 MARY II

(1662–94)

30 (opposite)
Queen Mary II
Sir Peter Lely, 1677
NPG 6214

30.1 (below)
Queen Mary II
Published by
Nicolaes Visscher II,
after Jan van der Vaart
c.1683–1729
NPG D31057

This portrait was probably painted to commemorate the marriage, in November 1677, of William of Orange to Mary Stuart, the tall, statuesque daughter of James II and Anne Hyde. Like so much costume of its kind, Mary's dress is a fiction based on the loose, informal gowns (with the implied presence of stays beneath) in vogue; it is little more than a piece of orange-red drapery pinned together with a few jewels. Only her hairstyle – bunches of curls described by the French noblewoman Madame de Sévigné in one of her famous letters to her daughter as a 'coiffure hurlubrelu' – is real, although the pearls round her neck may be those given by William of Orange to his bride on their marriage. The rich, luminous simplicity of pearls was the perfect accessory to every kind of female costume, real or imaginary.

If we wish to see portraits of Mary as a woman of fashion, it is necessary to turn away from Lely and look at the work of less well-known artists; for example a mezzotint, possibly by Nicolaes Visscher II, made shortly after Mary became Queen (fig. 30.1). Here she appears in a mantua, the formal gown of the period, made of striped-and-figured silk, with short sleeves (here at least the portrait by Lely follows the fashion), which are trimmed with ribbon bows on the shoulders. A large diamond brooch is pinned to the stomacher of her dress; Mary owned a number of diamond brooches, equal favourites with pearls in the jewel caskets of fashionable women.

Literally the most prominent part of Mary's costume in the later portrait is the towering headdress called a frelange. This consists of a cap (largely hidden), to which layers of lace (here *point de France*, a fine French needle-lace that Mary introduced into England in 1688) are attached, including the long lappets or streamers falling over the shoulders. Behind the lace are ribbon bows, the highest one known as the fontange. This elaborate confection (including the high-piled hair) was held up by a wire frame that was known as a commode; by the mid-1690s, the word commode was the term applied to the whole headdress.

31 ELEANOR JAMES

(*fl.*1685–1715)

31 (opposite)
Eleanor James
Unknown artist, c.1700
NPG 5592

31.1 (below, left)
Women's French fashion
c.1695

31.2 (below, right)
Dress (mantua) and stomacher
Dress c.1708;
stomacher c.1720s

In a period dominated by portraits of elite women in modish *déshabillé*, it is rare to come across an image of a fashionably dressed middle-class woman, particularly one of such independent spirit. Eleanor James, a redoubtable and strong-minded woman, ran her husband's printing firm in London, publishing pamphlets on political and religious subjects. The book open on the table refers to one of her most famous tracts, *Vindication of the Church of England* (1687), which provoked a satirical address from the Poet Laureate (and Catholic) John Dryden and for which she was imprisoned in Newgate by the Catholic James II.

Eleanor James's costume is a modest interpretation of the rich and convoluted fashions emanating from France (fig. 31.1); she wears the tall commode headdress and a mantua but not the elaborately decorated petticoat in vogue in high society. Her mantua is of golden-brown damask, worn with a matching petticoat (skirt), and laced over a yellow stomacher, very similar to a surviving example (fig. 31.2) of brocaded salmon-pink French silk damask, patterned with a so-called 'bizarre' design of abstract, foliate and floral motifs. The impressive commode is of fine French lace, with wide lappets falling over her shoulders. This kind of headdress reached its maximum height in the late 1690s, causing Joseph Addison to comment in the *Spectator* (22 June 1711): 'About Ten Years ago it shot up to a very great height ... I remember several Ladies who were once very near seven Foot high.' He marvelled at such 'Female Architects who raise such wonderful Structures out of Ribbons, Lace and Wire'.

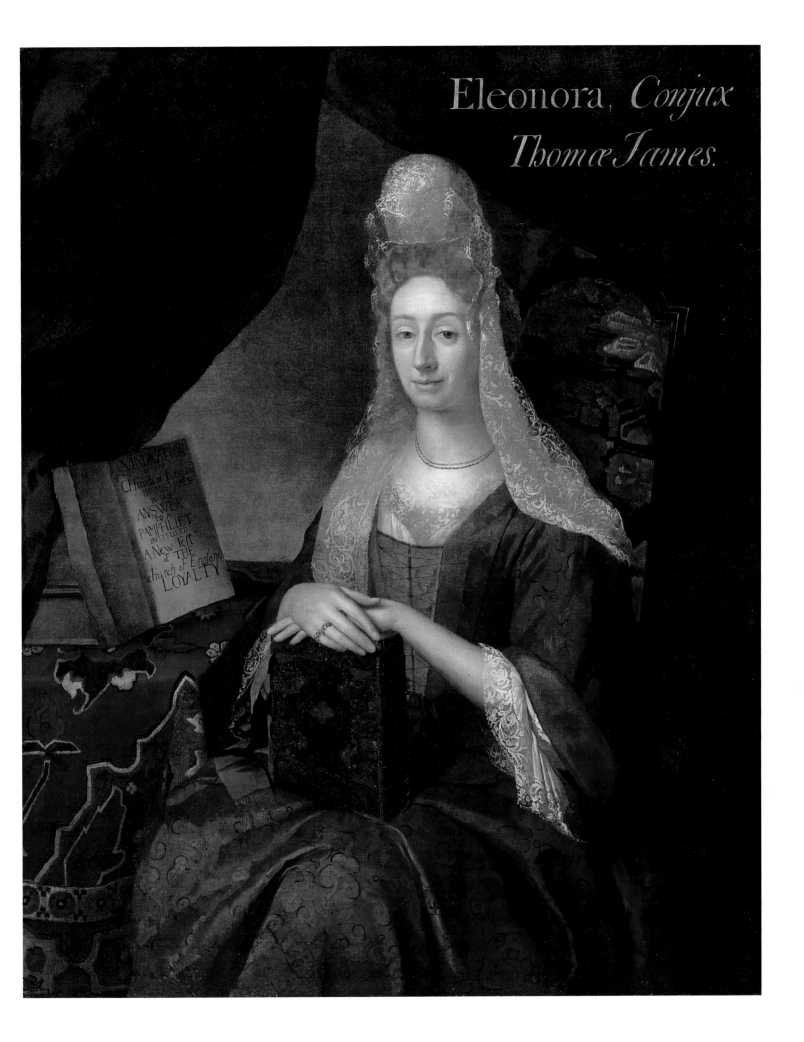

Eleonora, *Conjux*
Thomæ James.

VINDICATION
of the
Church of England
BY MRS. JAMES
IN AN
ANSWER
TO A
PAMPHLET
INTITULED
A New Test
of THE
church of England
LOYALTY

32 PRINCE JAMES FRANCIS EDWARD STUART and his sister PRINCESS LOUISA MARIA THERESA STUART

(1688–1766) and (1692–1712)

32 (opposite)
Prince James Francis Edward Stuart;
Princess Louisa Maria Theresa Stuart
Nicolas de Largillière, 1695
NPG 976

32.1 (below)
Princess Louisa Maria Theresa Stuart
Attributed to
Alexis Simon Belle,
c.1702–6
NPG 1658

As befits a portrait of royal children in exile (after the Revolution of 1688, James II and his family were given refuge in France), formality of pose and costume serves to underscore their status and their dynastic claims. The young Stuart prince (later to be known as the Old Pretender) wears a red velvet coat, with a gold brocade waistcoat, the cuffs of which turn over those of the coat. This coat, known as a *justaucorps* ('close to the body'), is cut tight to the figure in the French style, the stiffened skirts flaring out over the hips. The Prince's rank and social position are underlined both by the insignia of the Order of the Garter and by the formal pose he adopts – as taught by the dancing master – with one foot slightly in front of the other and a plumed hat carried under the arm. We see that one kid-gloved hand holds the other glove; this motif is ultimately derived from Renaissance portraiture, as is the appearance of a large dog (here a greyhound), which symbolises loyalty, a characteristic particularly appropriate in the political circumstances of the time. In close touch with the court at Versailles, the Prince's whole costume and demeanour are those of a miniature royal adult, from his curled wig and beribboned cravat, to his shoes of black leather with their red heels and diamond buckles.

The little Princess Louisa wears a costume that is a compromise between her age (she was 3 years old) and her rank. Her dress is of white satin, simple in style, with a back-fastening bodice, and long leading strings; white, the colour of innocence, is appropriate for a young girl, as is the orange blossom she holds, a symbol of virginity and traditionally carried by brides. Her royal status is emphasised by the long train to her dress (implying the presence of attendants to wait on her) and the rich lace (*point de France*) of her apron. Matching lace trims her boned bodice and her commode headdress, which follows the fashionable adult style.

Some ten years later Princess Louisa was painted in a fanciful dress of brocaded gold satin (fig. 32.1). Her hair is piled modishly high, two curls forming inverted commas on her forehead, and decorated with jasmine and carnations; a bunch of carnations is tied with a gold ribbon on her right shoulder. Carnations were admired for their smell and colour; they were traditionally linked with love and betrothal, a promise unfulfilled here, for the Princess, who inherited the Stuart grace and charm, died unmarried, of smallpox, in 1712.

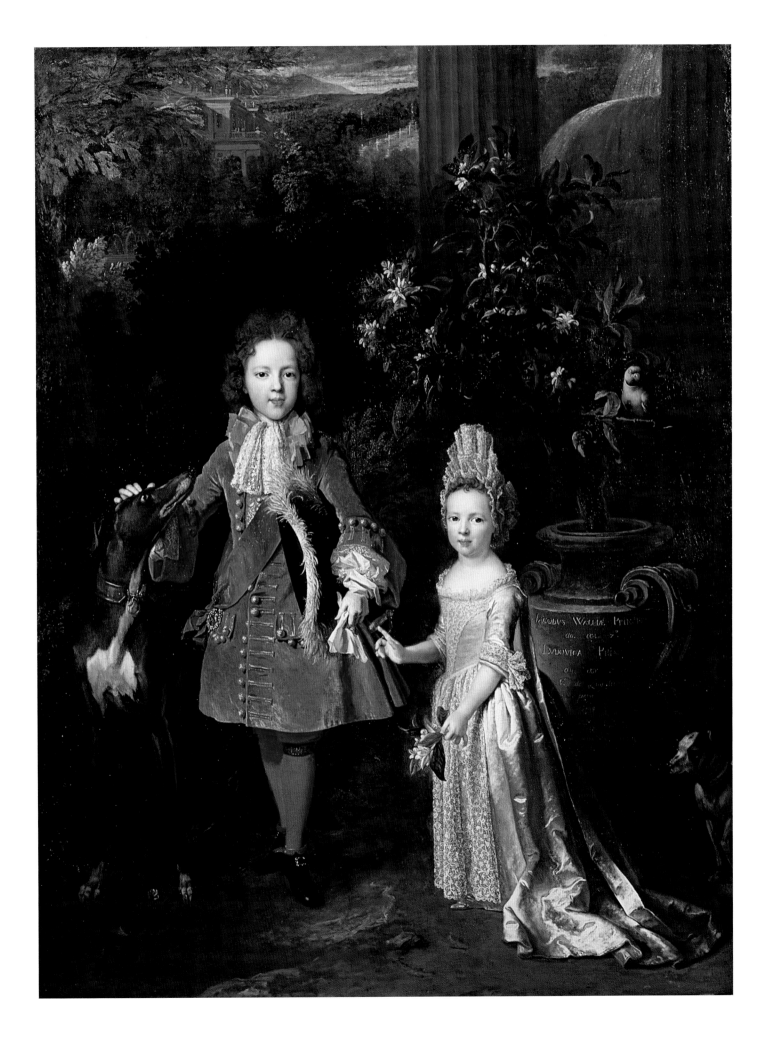

THE
EIGHTEENTH
CENTURY

TRANSFORMATIONS

During the eighteenth century, fashion was not chiefly dictated, as it had previously been, by the monarchy: one German visitor, somewhat ironically perhaps, described the Hanoverian court as 'the residence of dullness'. It was not until the handsome young Prince of Wales, later George IV, entered into society in the 1780s that royalty once again became a player on the fashionable scene; indeed, the tempestuous relationship that he maintained with his parents, George III and Queen Charlotte, was largely as a result of his extravagance, including in dress (fig. 47.2).

Hanoverian rule, which spanned almost the entire century, did provide political stability and a relatively democratic parliamentary constitution that set Britain apart from other European countries, notably from France, where an absolute monarchy reigned supreme until the Revolution in 1789. The difference in political and social climate between Britain and France (now firmly established as the leader of fashion) determined an entirely different approach to dress, from relative simplicity on one hand and extravagant formality on the other. The tensions that existed between the two countries were played out sartorially by constant rivalry and ambivalence. Strict codes of conduct and dress regulations imposed at Versailles by Louis XIV at the end of the previous century were emulated in all the European courts, including, up to a point, the English one. Yet despite the desirability of all types of French fashion, whether formal or informal, it was often perceived as effeminate in the case of men's wear and in the case of women's, as immoral in comparison to the more restrained English style. Nevertheless, French terminology was frequently affected as a mark of fashion consciousness, which, along with multiple, overlapping contemporary English terms for garments and types of textiles,

can cause much confusion. Ultimately, democracy triumphed in the form of the wave of Anglomania that swept through Europe in the last quarter of the century, providing a rare interlude of English dominance in fashion over French.

The most popular type of dress for women at the beginning of the century continued to be the mantua: this became increasingly formal until it was only worn at court. A bewildering variety of other garments was also available. There were closed gowns (often accessorised by a neckerchief, or tucker, and a sheer apron), or open-gowns, featuring a decorative stomacher between the bodice's front edges, and a skirt open from the waist down to display a matching or contrasting petticoat underneath. An open-gown was either fitted by pleating into the back (*robe à l'anglaise*), or hung from the back of the shoulders in a series of pleats (sack, *sacque* or *robe à la française*). There were also the separate jacket-and-skirt styles that included the perennially popular riding habit (figs vii and 46). For the first half of the century, from about 1710, all of these styles were worn over hooped petticoats of varying widths and shapes, from the bell-shaped variety of the 1720s to the wide bucket hoops of the 1740s (fig. 40.2). Hoops went out of fashion in the late 1750s but were retained for court wear until George IV banned them in 1820. The influence of French rococo style can be seen in the serpentine robings (ornamented borders sewn on in a decorative pattern to the sides of an open gown) and scalloped flounces (deep frills) that trimmed mid-century sack dresses (fig. 43.2), and in curvilinear motifs in textile design and lace, a commodity like jewellery, that was highly sensitive to changes in the fashionable aesthetic. These changes, along with innovations in trimmings and headdresses, were frequently relayed by dressed dolls, or *poupées*, such as that held by Christopher Anstey's daughter in fig. 44.

But it was the advent of the next artistic movement, neoclassicism, that finally brought a new simplicity to the female wardrobe, specifically in the shape of that most revolutionary of garments, the chemise dress, shocking in its

resemblance, as its name suggests, to women's underwear (fig. 48.2). Introduced from the West-Indian French colonies by Marie Antoinette, and into England through her friendship with Georgiana, Duchess of Devonshire (a fashion trendsetter whose innovative style was closely followed by the press), it became the signature garment of the last fifteen years of the century and continued as such into the next.

Men's wear also changed dramatically during the eighteenth century: although the basic three-piece suit was retained throughout, it evolved from the early bulky silhouette (produced by a knee-length coat with stiffened sword pleats and equally long waistcoat, accompanied by the unwieldy but essential marks of a gentleman, the sword and three-cornered hat, *chapeau bras*, held under the arm) to an image of athletic, almost naked, elegance, predicated on the look of classical statuary. The introduction of the informal frock coat, identifiable by its turned-down collar and slimline cut, in the 1730s, heralded the adoption of simpler, more practical styles, many of which, such as the caped greatcoat originally worn by coachmen, were taken from working dress. Heavy wigs were replaced by smaller powdered ones, then these were abandoned in favour of natural hair from the middle of the century. The English style in men's wear, appropriated largely from sporting and functional dress, when made from high-quality British wool or stout cotton fabric, became symbolic of patriotism and democracy. This style was disseminated across Europe, partly by those young gentlemen who went on the Grand Tour. Its spread was encouraged through the exchange of letters as well as the publication of fashion information and dedicated fashion plates in the newspapers and magazines that proliferated throughout the period. Reports of tourists who crossed the Channel to sample the sophisticated delights of shopping in London, the largest city in Europe with a population of just under a million by the end of the century, also helped its popularity.

Portrait painting flourished in Britain in the eighteenth century, boosted by demand from the rising middle classes, and this increasing social mobility could be facilitated, even determined, by the adoption of fashionable dress. Foreign visitors remarked on the high standards of dress and its cleanliness even among the working classes, as well as on their difficulty in distinguishing the ranks. Social acceptance was not as much predicated on noble birth as before but on the all-important characteristic of gentility: when Samuel Richardson's eponymous heroine, the lady's maid Pamela, finally marries into the gentry, it is because she has demonstrated her gentility not only through her virtuous behaviour but also through her good taste in clothes. Generally, however, for most people, it was still necessary to dress appropriately and according to one's station in life: it was only at the masquerade, the most popular form of entertainment during the eighteenth century, that people had the opportunity to assume disguise in order to subvert the sartorial conventions of society pertaining to gender, occupation and rank. **CB**

WILLIAM CONGREVE and RICHARD LUMLEY
(1670–1729) and (1688?–1740)

33 (opposite)
William Congreve
Sir Godfrey Kneller, Bt,
1709. NPG 3199

33.1 (below)
**Richard Lumley, 2nd Earl
of Scarborough**
Sir Godfrey Kneller, Bt,
1717. NPG 3222

In his play *Love for Love* (1695) Congreve praised Godfrey Kneller's ability to paint lifelike portraits. However, to a modern eye there can seem more uniformity than individuality in the artist's work, both in his strangely proportioned images of fashionable women with their heavy, costive faces and loose draperies, and his Kit-cat Club portraits of 'Whigs in wigs', two examples of which are illustrated here. The Kit-cat Club was an informal grouping of influential men – politicians, artists, writers and scholars – who had supported the Protestant succession and the 1688 Revolution. They met at Christopher Cat's tavern near Temple Bar in London, and included Kneller and Congreve, who held a number of government sinecures after his career as a playwright had ended.

Congreve is shown, in typical Kneller style, wearing an informal costume, a plain coat of murrey-coloured velvet over an open-necked shirt. As with the majority of Kit-cat Club portraits, the wig is the prevailing feature; here it is a large greyish-blond periwig. The wig was such a dominant feature of male appearance – men of fashion are described in Congreve's last play, *The Way of the World* (1700), as being 'beperiwigged' – that it comes as no surprise to find that there are more references to wigs than to any other item of clothing

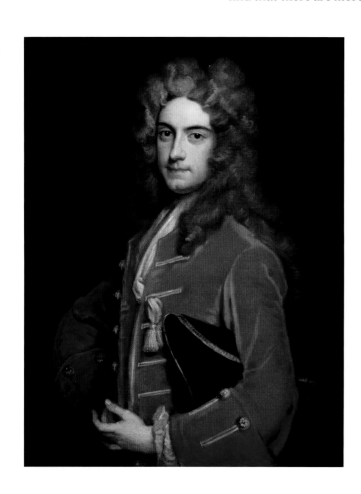

in the playwright's comedies of manners. The wig was an expensive arrangement of curled or frizzed hair (according to the French *encyclopédiste* Denis Diderot the best – strongest – hair came from beer-drinking countries). It was sewn on to a net cap and reached its maximum height and size towards the end of the first decade of the eighteenth century.

By the time that Kneller painted Richard Lumley, 2nd Earl of Scarborough, in 1717 (fig. 33.1), the wig had begun to be slightly reduced in size. Lumley, later Master of the Horse to George II, wears a red velvet coat with silver buttons and has pulled his fringed cravat through one of his overlarge decorative buttonholes. This way of arranging the cravat was known as *à la steinkirk* after the battle of Steinkerque (1692), when some French army officers, surprised by the enemy (soldiers of the Anglo-Dutch army) and with no time to tie their cravats, tucked the long ends through the buttonholes of their coats to keep them out of the way. Congreve refers to the popularity of the steinkirk cravat in *Love for Love*, and he himself is depicted thus attired in a portrait from the studio of Kneller of about 1709 (NPG 67). It became a popular fashion (even women adopted the style) that lasted well into the eighteenth century.

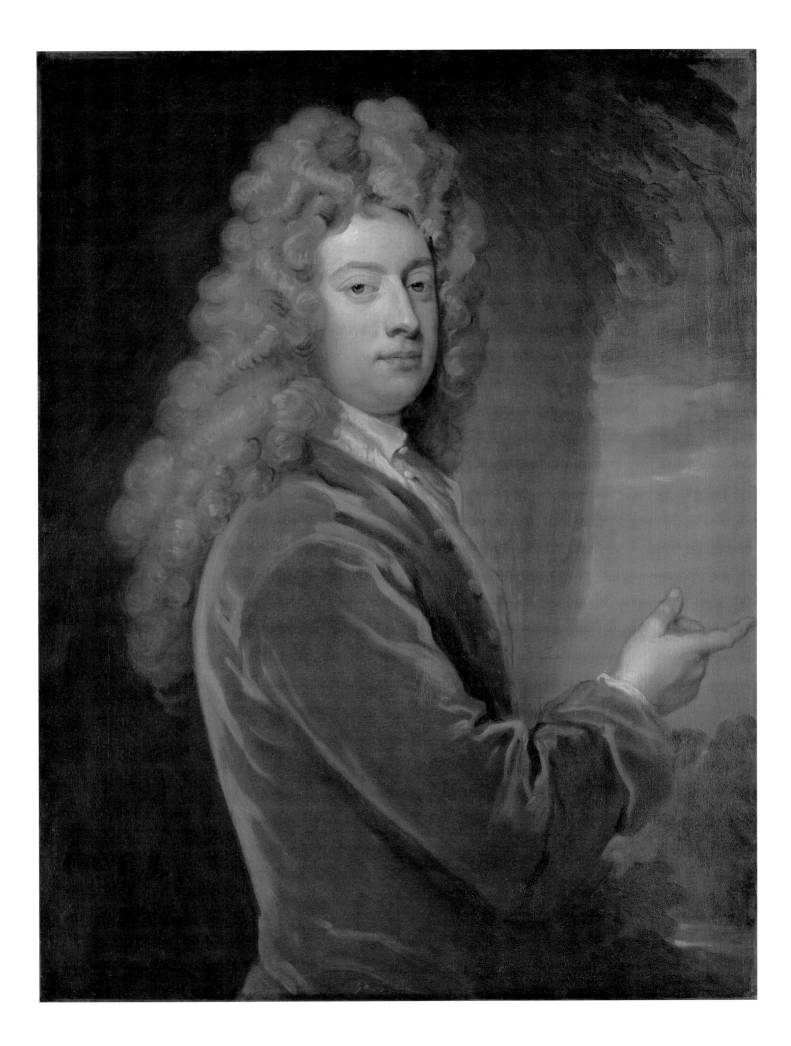

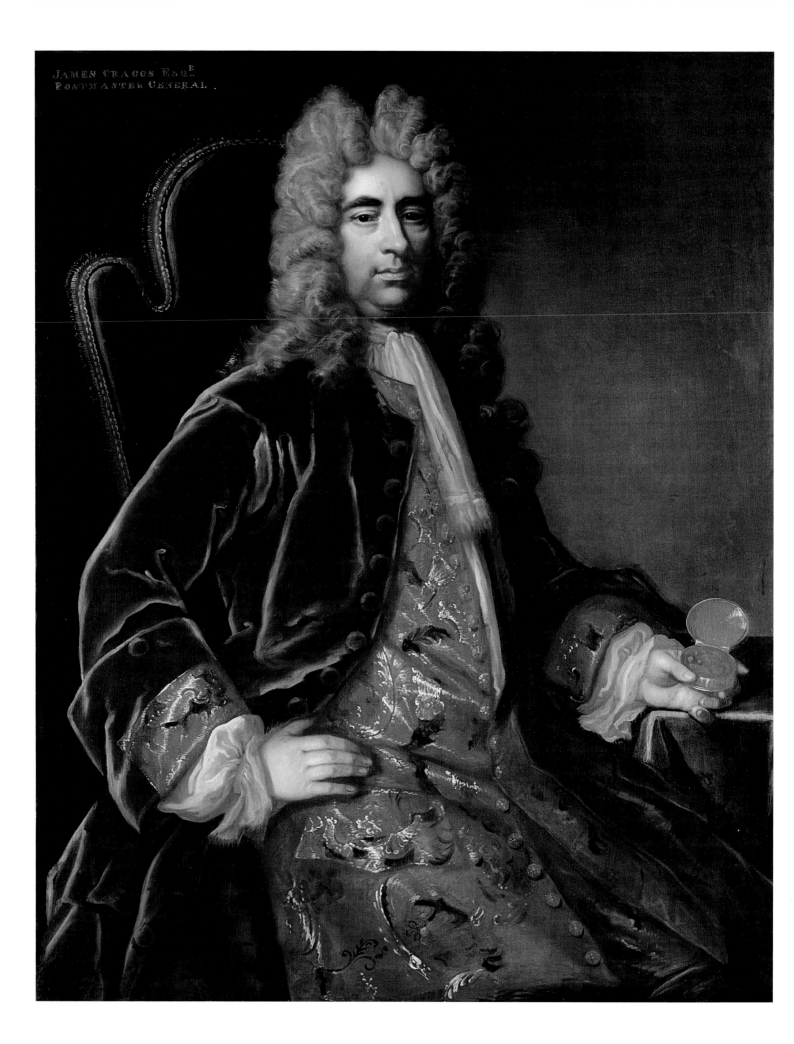

34 JAMES CRAGGS and JOSEPH COLLET
(1670–1729) and (1673–1725)

34 (opposite)
James Craggs the Elder
Attributed to
John Closterman, c.1710
NPG 1733

34.1 (below)
Joseph Collet
Amoy Chinqua, 1716
NPG 4005

Politician, administrator and speculator (he was one of the promoters of the South Sea Company, which crashed spectacularly in 1720), Craggs, who was a man of humble birth, is portrayed striking a genteel pose, hand on hip, and in rich and stylish costume. He wears a large light brown periwig, a fringed linen cravat (the cuffs of his shirt sleeves are also finely fringed), a brown velvet coat and a sumptuous gold-and-silver figured waistcoat – the waistcoat was increasingly the focal point of male costume.

The design of Craggs's waistcoat – a large woven pattern repeat with curving, fantastic shapes – is one of the so-called 'bizarre' styles, which appeared in silks from the 1690s to about 1710. These designs, often with strange and exotic elements, represent both a love of experimentation and a taste for Orientalism, which had become an inspiration for many art forms by the late seventeenth century. They may have been influenced by the popular Indian chintzes (painted or printed cottons) that were being imported into Europe and acted as a spur to the development of the domestic cotton industries, notably those of England and France, in the eighteenth century (see fig. 41.1).

Joseph Collet (1673–1725), Governor of Madras from 1717 to 1725, had this statuette (fig. 34.1) made by a Chinese artist from Amoy (a port in the south of the Fujian province of China frequented by European traders). It was a popular practice for Europeans in the East to commission such images of themselves; the diarist William Hickey, in Canton in 1769, visited 'a China man who took excellent likenesses in clay which he afterwards coloured'.

In a letter to his daughter in 1716, Collet described how the artist created: 'a sort of Picture or Image of my Self. The lineaments and the Features are Esteem'd very just, but the complexion is not quite so well hit; the proportion of my body and my habit is very exact.' Collet's 'habit' consists of a red coat embroidered in gold, buttoning from neck to hem, a flowered waistcoat and matching knee-breeches. The coat may be of silk, or of the woollen cloth that English merchants tried – largely unsuccessfully – to sell to China in return for silk, tea and porcelain. The artist, Amoy Chinqua, has taken great pains in the depiction of such details as the gold-braided hat carried under the arm, the fine pleats of the linen

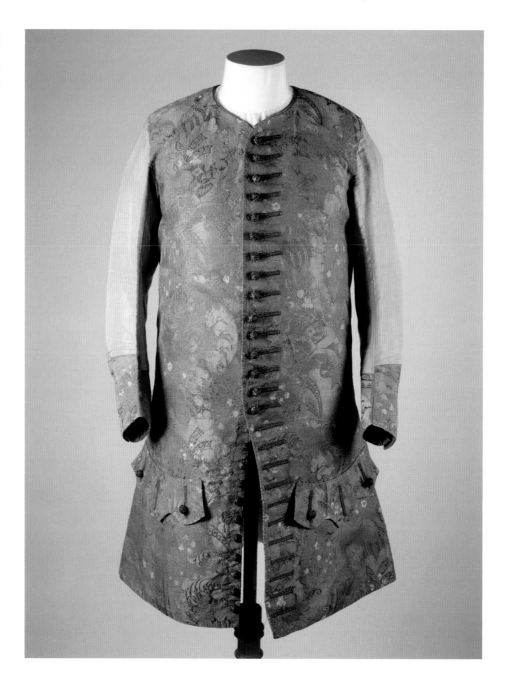

shirt and the metal studs and leather stitches on the heavy square-toed shoes.

A surviving sleeved waistcoat of bizarre silk (fig. 34.2), similar in design and cut to those worn by Craggs and Collet, demonstrates the economy with which these expensive textiles were used, the unseen parts of the garment being made in less costly plain silk.

WILLIAM TALMAN

(1650–1719) and his family

William Talman is portrayed with his family against an allegorical background that was probably intended to represent the gods' blessing on the marriage of his son John to Frances Cockayne in 1718. A full-bottomed periwig frames Talman's pop-eyed and choleric visage, that of a man conscious of his status and achievements – a famous architect (the dividers on the table allude to his profession), he had been Comptroller of the King's Works to William III.

The loose gown (Talman's is blue lined with white, a pink silk sash wound round the waist) continued to be the preserve of professional practitioners of the arts and sciences, but some younger men by this time chose to replace the heavy and cumbersome wig with a soft cap worn over a shaven head. In the portrait of Matthew Prior (1664–1721; fig. 35.1), the poet, diplomat and picture collector wears a black velvet cap trimmed with a red silk tassel; his red silk damask gown is lightly padded for extra warmth. A similar padded gown of dark pink silk damask, dating from about 1720, is also illustrated (fig. 35.2).

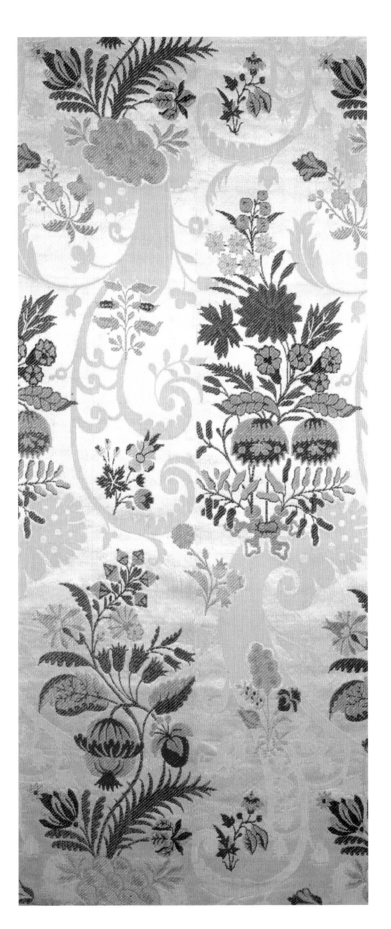

It is interesting to note that in the Giuseppe Grisoni portrait William Talman's wife, Hannah, occupies the greatest amount of space. Her white mantua, lined with gold (the bustle effect of the back drapery can clearly be seen), reveals a beautiful petticoat of flowered silk, worn over a hoop.

The design of the petticoat is similar to a surviving dress panel of white silk damask brocaded with semi-naturalistic flowers (fig. 35.3). Next to Hannah Talman stands her daughter-in-law Frances, in a rather subdued cross-over gown of plain red silk lined with blue, worn over a dark red skirt.

John Talman, who was a connoisseur of the arts (he invited Grisoni to England) and the first Director of the newly formed Society of Antiquaries, stands deferentially next to his father in a more up-to-date, shorter version of the full-bottomed wig.

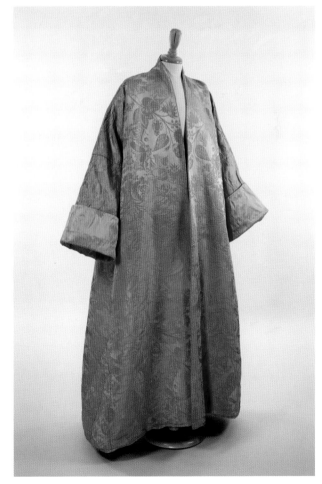

36
The Music Party
Philip Mercier, 1733
NPG 1556

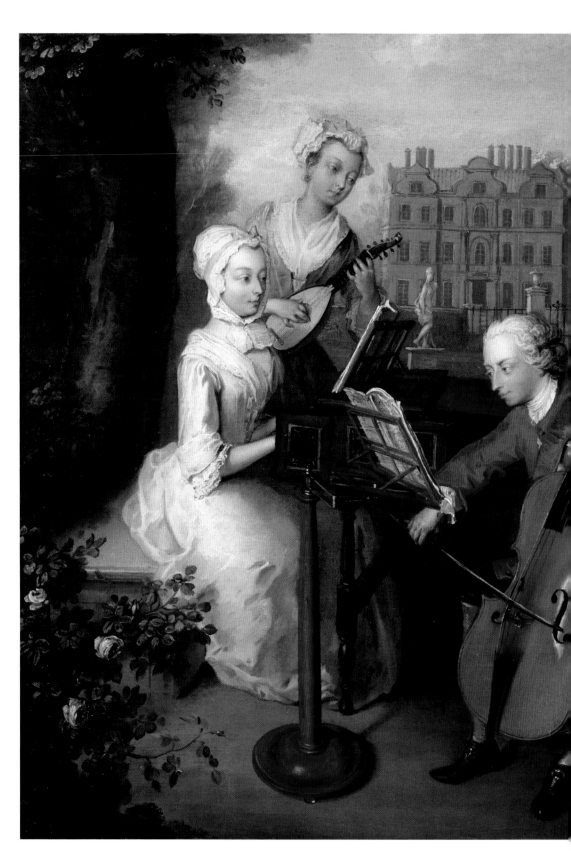

The setting for this informal group is the Dutch House at Kew, where Anne, Princess Royal (playing the harpsichord), lived before her marriage to Prince William of Orange in 1734.

Anne and her sisters – Caroline plays the lute and Amelia reads from Milton – are dressed with an almost bourgeois sobriety: they wear morning costume, simple 'closed gowns', that is, made all-in-one with a front-fastening bodice, white linen kerchief round the neck and plain caps with lappets that either pin on top, fall to the shoulders or fasten under the chin. From a contemporary collection of drawings by Bernard Lens (fig. 36.1), it is possible to see how such headdresses were arranged on the head: the cap holding the hair gathered up into a bun and the lappets arranged according to whim.

In contrast to the modest hausfrau look adopted by his sisters, Frederick's more formal clothes proclaim his status as heir to the throne (he died before his father, but his son became George III). The Prince wears a red coat and waistcoat, black knee-breeches and the insignia of the Order of the Garter. The fashionable tye wig (the back hair tied back either in a knot, a bag, a pigtail or a ribbon, see fig. 36.1) had by this time largely replaced the periwig, which was increasingly limited to the elderly, the conservative and professional men such as physicians, clerics and lawyers – it still exists in the formal costume of High Court judges and Queen's Counsel.

Unlike his father, George II, Frederick was a connoisseur of the arts – perhaps the most accomplished prince in this respect since Charles I, claimed the antiquary and engraver George Vertue, who was employed by the Prince to catalogue the royal collections. Prince Frederick patronised a number of artists, both English and foreign, including the painter of this portrait, the German-born Philip Mercier, who painted his portrait again a few years later

36.1 (right, top and below)
The Exact Dress of the Head
Bernard Lens, 1725–6

36.2 (opposite)
Frederick Lewis, Prince of Wales
Philip Mercier, c.1735–6
NPG 2501

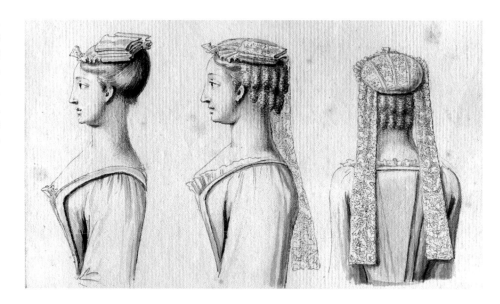

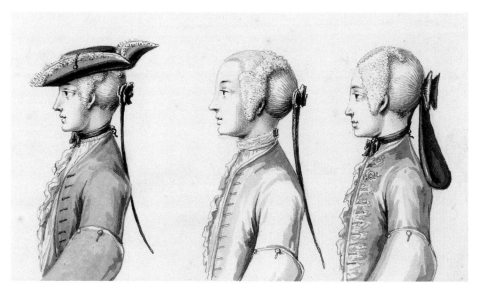

(fig. 36.2) in a formal gold-embroidered red velvet coat over a court waistcoat trimmed with gold fringe. He wears the most formal wig of the period, a heavily powdered bag wig, where the back hair is tied back in a black silk bag. The grandeur of this costume is reinforced by the pose that Prince Frederick adopts: right hand holding a cane; left hand (three-cornered hat kept in place under the arm) inserted in the side opening of the coat, on the hilt of his sword.

PRINCE HENRY BENEDICT MARIA CLEMENT STUART

Cardinal York (1725–1807)

37 (opposite)
Henry Benedict Maria
Clement Stuart,
Cardinal York
Louis Gabriel Blanchet, 1738.
NPG 5518

37.1 (below)
From *The Rudiments of
Genteel Behaviour*
François Nivelon, 1737

37.2 (right)
Silver metal lace on red velvet
Mid-eighteenth century

The young Prince, brought up with his elder brother Charles Edward (Bonnie Prince Charlie) in Rome, was a beautiful child, serious, studious, over-pious and music-loving, with a highly developed taste for luxury and splendour in costume – a trait that his career as a prince of the Church served only to enhance.

The young Stuart princes were brought up in the European tradition, that is, with more attention paid to ceremony and rank than was the case in England. This formal image shows Prince Henry with his left hand pointing towards the

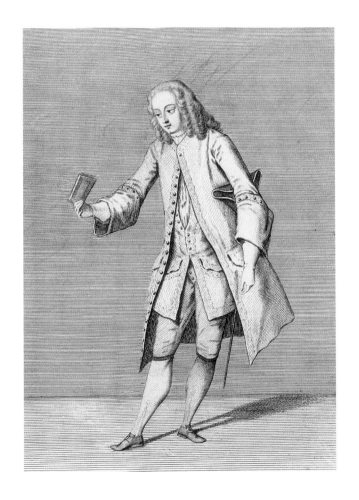

horizon and his right hand inserted at mid-chest level under the waistcoat. This pose, along with the equally conventional stance of one foot slightly in advance of the other, would have been taught by the dancing master, whose brief in the eighteenth century included not just lessons in dancing but also in elegance of manners, gesture and deportment, and general civility. Manuals such as François Nivelon's *Rudiments of Genteel Behaviour* (fig. 37.1), published in 1737, were also available as guides to comportment and etiquette.

As well as upholding the rank due to his birth, the young Prince's personal taste for formality and finery is reflected in his perfect poise, pride in the insignia of the Garter that he displays, his powdered wig (the long curls of which are tied back with black silk ribbon) and the richness and formality of his clothes. The most prominent part of his costume is his coat – literally so, for the side skirts are heavily stiffened (lined with layers of coarse wool, horsehair or buckram), creating an almost theatrical air, heightened by his dramatic gesture and balletic stance. This coat is of a deep red velvet liberally decorated with silver lace, as is his blue satin waistcoat. Such silver lace, made of strips of real silver foil (fig. 37.2), created a sumptuous effect, especially when set against velvet; a costume like this, worn on formal occasions, would glitter in candlelight.

38
The Shudi Family Group
Marcus Tuscher, c.1742
NPG 5776

Of Swiss origin, Burkat Shudi was a leading harpsichord maker; he is shown here with his wife Catherine and his sons Joshua and Burkat at their house in Great Pulteney Street, London. His elder son, Joshua, directs our attention to Shudi, who tunes a harpsichord, wearing an elegant blue-silk morning gown lined with pink; his ease chez soi is indicated by the fact that one of his red leather indoor shoes has been trodden down at the heel. A professional man of middling status, Shudi does not wear the tye or bag wig of high fashion, but a long bob wig (the modest

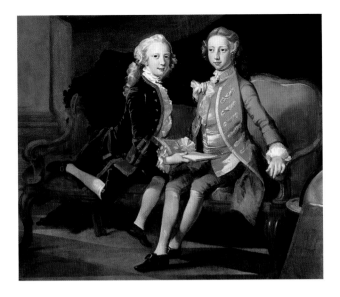

38.1
Francis Ayscough with the Prince of Wales (later King George III)
and Edward Augustus, Duke of York and Albany (detail)
Richard Wilson, c.1749. NPG 1165

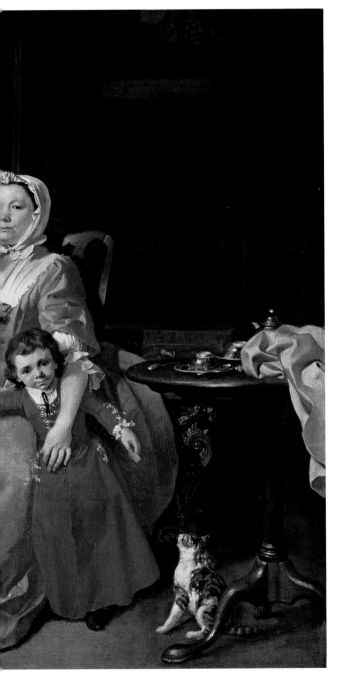

successor to the periwig), which is curled at the sides and reaches his shoulders.

Catherine Shudi's dress is a plain, middle-class version of the *sacque*, still fairly loose-fitting and with short, wide sleeves; it is lifted at the side to show her pink silk petticoat – perhaps in conscious harmony with the hem of her husband's gown that defies gravity by showing its pink lining. The informality of the family setting and notions of bourgeois propriety dictate her choice of accessories – a kerchief covering the low neckline of the dress and kept in place by a blue silk bow, and a white morning cap and hood tying under the chin.

The images of the two small boys show how even a slight difference in age is reflected in their clothing. The younger son, Burkat, born in 1737 (like his father, he became a harpsichord maker), still wears his baby clothes, a gown or long coat trimmed with gold loops; his hat – traditional symbol of masculinity – which he clutches in his right hand, is of pale brown beaver trimmed with silver lace and black feathers.

In the middle of the eighteenth century, boys were breeched at about the age of five, being put into a simplified version of adult male costume; this often took the form of a plain coat with practical slit cuffs of the kind that Joshua Shudi (b.1736) wears. His frilled shirt collar was a distinctively English style (it turned into the open collar, seen in Johann Zoffany's *The Sharp Family*, 1779–81; fig. 46). It was the custom for young boys to wear their own hair as it grew naturally. Richard Wilson's portrait of Prince George and Prince Edward (sons of Frederick, Prince of Wales) of about 1749 (fig. 38.1) depicts the young royal sitters wearing their own hair tied back with a ribbon. Prince George (the future George III) wears a grey silk suit trimmed with silver braid and a white satin waistcoat; Prince Edward (Duke of York and Albany) – his less elevated rank allows him to assume a livelier pose – is in blue velvet trimmed with gold. Instead of the usual adult male neckwear, the formal stock (a made-up neckcloth fastening at the back), the young princes have a black silk ribbon that ties at the neck and keeps the frilled shirt collar in place.

39 (opposite)
**Sir Thomas Robinson,
1st Bt**
Frans van der Mijn, 1750
NPG 5275

39.1 (below)
**Sleeve ruffles of
bobbin lace**
Mechelen, Belgium
c.1750

In the eighteenth century the pursuit of pleasure often went hand in hand with intellectual interests and informed connoisseurship. Sir Thomas Robinson, whose pose and costume indicate a man of refinement with a taste for luxury, was noted for his extravagant lifestyle. After an unsuccessful posting as Governor of Barbados (1742–7), he returned to England, where he helped to organise the entertainments – concerts and masquerades – held at Ranelagh Gardens in Chelsea, one of the great pleasure gardens of eighteenth-century London. Like many wealthy members of the elite, he was particularly knowledgeable about architecture; having made a study of Palladio's work in Italy, he rebuilt Rokeby, his house in Yorkshire.

Hand on hip, Robinson is painted wearing a stylish, informal ensemble. His coat is of blue satin lined with white, with the sleeve slit along the seam at the wrist and turned back to form a cuff; the effect is relaxed and unstructured without the stiffened side pleats of a more formal garment. His white satin waistcoat with its gold buttons is opened to the waist so that the fine lace on the shirt could be seen. Because of his pose, it is not possible to see what kind of lace it is, but it was customary for this to match that of the shirt ruffles – here they appear to be of Brussels. Very popular in the mid-eighteenth century were the fine bobbin laces of Flanders, such as Mechlin and Brussels (fig. 39.1). As part of the informality of his appearance, Robinson's black velvet breeches are unfastened at the knee, giving greater ease when seated, but causing the white silk stockings to wrinkle, no longer being held taut by the breech buckle. By this time, men's knee-breeches were fastened under the knee and over the hose, whereas before – especially in formal costume (see fig. 37) – the stockings were often worn rolled up over the breeches.

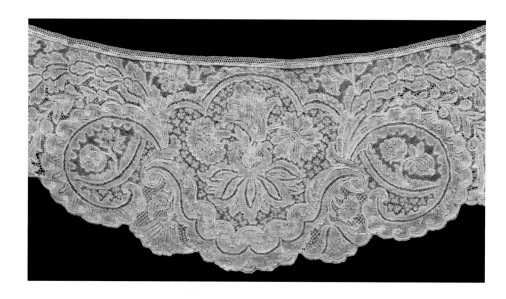

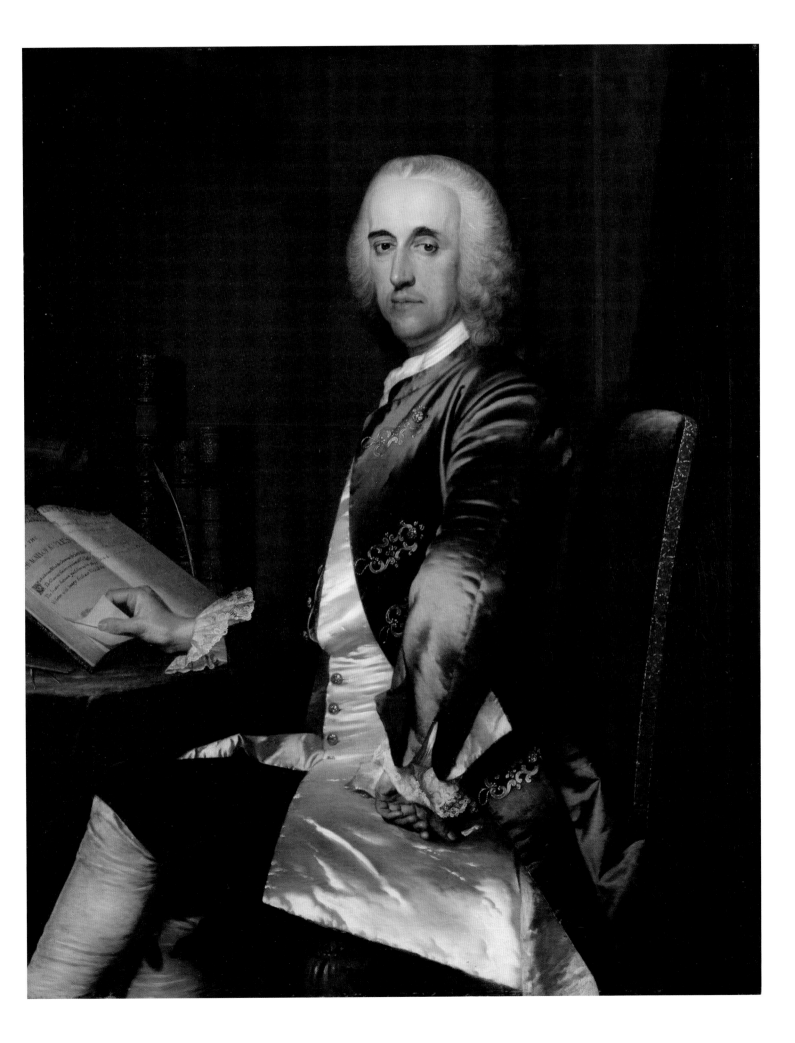

40 PEG WOFFINGTON
(1714?–60)

Peg Woffington was a celebrated Irish comic actress, famed for her wit and charm (David Garrick, illustrated in fig. 43, was among her lovers); she was particularly noted for her Shakespearian roles. This is an unusual portrait of an actress, for she is shown in neither a theatrical role nor as a woman of fashion (as the century progressed, many actresses set styles that elite women copied). Instead she is dressed informally, out of doors and painted with a directness and intimacy that engages the spectator.

By the early 1750s the prevailing influence in French fashion, the rococo, had crossed the Channel and affected English costume; the *sacque* gown was

40 (right)
Peg Woffington
John Lewis, 1753
NPG 5729

40.1 (opposite, top)
Unknown woman, formerly known as Peg Woffington
Attributed to Francis Hayman, c.1745
NPG 2177

40.2 (opposite, below)
Silk gown and cotton kerchief
Britain
1740; 1745–60

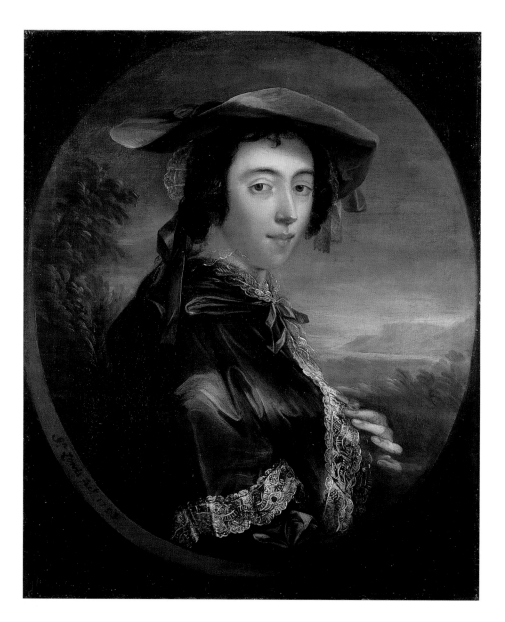

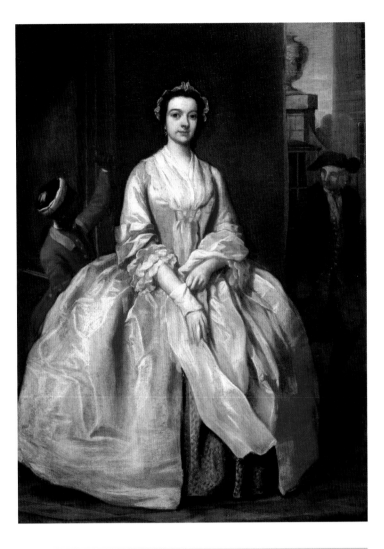

the most famous example, but there were also accessories, such as the delicate hooded shoulder-length mantle of blue silk trimmed with lace seen in this portrait. The hat, however, is English in style, a most insubstantial piece of silk decorated with blue ribbons; it is worn, as was customary, over an indoor cap of white linen edged with lace.

Also English (and Irish) was the vogue for women to wear their hair simply styled, curling to the shoulders and unpowdered. Frenchwomen tended to have their hair powdered and tightly curled like the fleece of a sheep (a style called *tête de mouton*); this kind of hairdressing was less frequently seen in England and then usually on more formal occasions, particularly later, in the 1760s.

An earlier painting in the Collection was once thought to be a portrait of Peg Woffington (fig. 40.1), but this identification is now questioned. However, it serves to show female fashion in the mid-eighteenth century: the young woman, in a salmon-pink silk gown and sea-green quilted petticoat, holds a white silk mantle over one arm as she pulls on a pair of gloves, while waiting for her black page boy to summon a sedan chair. Her silhouette is typical of this period, when the hoops that supported the skirts reached their maximum width. This is an image of discreet luxury – that she has a page at her disposal indicates some degree of wealth: scallops of lace edge her kerchief, or tucker, so-called because it was tucked behind the cords holding the front sides of her bodice together, and a delicate lace cap with its characteristic pinch pleat at the centre frames her lively expression. Her open gown, with its pleated, winged cuffs (soon to be replaced by the more decorative scalloped tiers typical of the rococo style in dress), closely resembles a surviving example from the collection at Colonial Williamsburg Museum, Virginia, USA (fig. 40.2)

Peg Woffington was stricken by palsy in 1757 and remained bedridden until her death. A portrait of her in her last years (NPG 650) by an unknown artist shows her in bed, only her head visible, and wearing a lace-edged cap tying under the chin; it is decorated with a blue ribbon, a defiant assertion, perhaps, of femininity and individuality in lamentable circumstances.

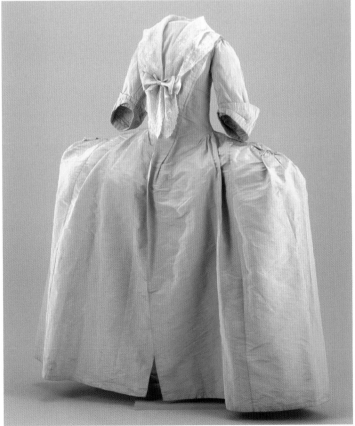

WARREN HASTINGS
(1732–1818)

41 (opposite)
Warren Hastings
Sir Joshua Reynolds,
1766–8. NPG 4445

41.1 (below)
Indian chintz waistcoat
Britain, nineteenth century

Warren Hastings joined the East India Company in 1750 and, through his talents as a great administrator, transformed it into a military and naval power as well as an important political force. Most portraits of Hastings (and there are more than sixty) show him later in his career, after his final return to England and the seven-year trial for corruption (1788–95) that nearly ruined him, even though he was acquitted. It is therefore something of a rarity to see the future Governor-General of India as a relatively young man, whose rather preoccupied look is emphasised by his thinning and slightly dishevelled hair, cut short on top for greater ease in the Indian climate.

By the later 1760s fashion itself had become less formal, and it was perfectly possible for men to wear coat, breeches and waistcoat of different colours and fabrics. A stylishly trimmed frock coat was, by now, acceptable as 'half-dress' or semi-formal attire, and this is what Hastings wears; it is made of a blue silk and woollen mixed cloth, with shining gold-thread buttons and buttonholes,

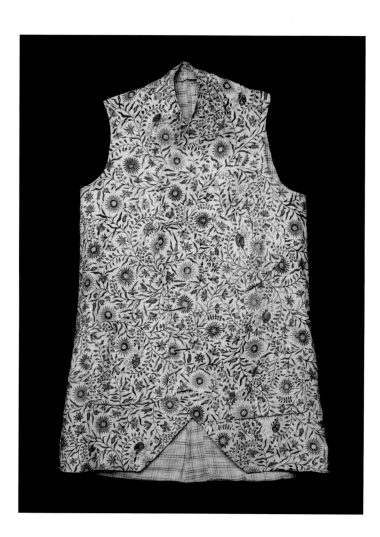

and has a velvet collar. His breeches are made of black velvet and fasten with a small gold buckle at the knee. As for the waistcoat, this is possibly of Indian manufacture, a printed cotton, similar to a surviving example of a slightly later date (see fig. 41.1). Hastings wished to promote Indian goods, for philanthropic reasons as well as for the purposes of trade (the Ashmolean Museum in Oxford, for example, has some knitted woollen hose and gloves that he brought back to England), and, like a number of British expatriates, he incorporated elements of native manufacture into his wardrobe.

In hot weather in India many men dispensed with the pleated linen stock round the neck, as the sitter does here, allowing us to see his shirt collar, turned down, and more of the frothy lace ruffle that edged the front opening of the shirt.

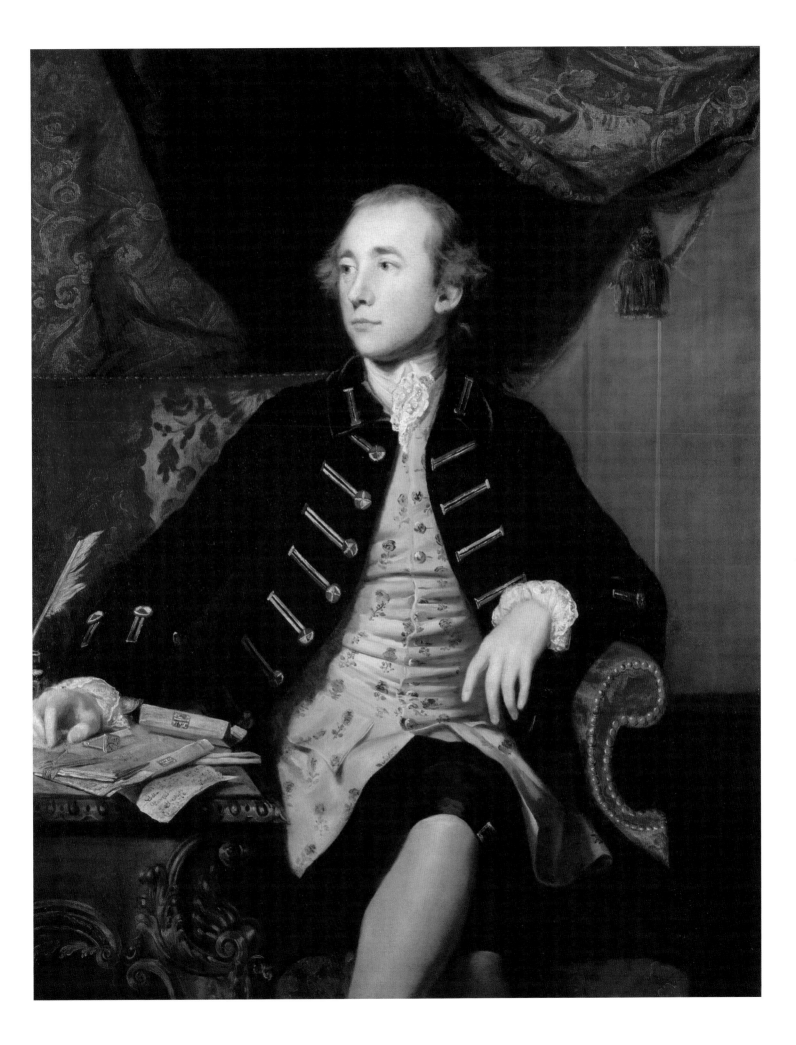

FRANCIS OSBORNE
5th Duke of Leeds (1751–99)

Youngest son of the 4th Duke of Leeds, Francis Osborne pursued the conventional path of a member of his caste – an education at Oxford (Christ Church), followed by a career in politics, serving under William Pitt the Younger in 1783; he also held office at court, as Lord Chamberlain of the Queen's Household, and succeeded his father as Duke of Leeds in 1789. In addition to his life as politician and courtier, he was a man of some cultivation in the arts and a writer of letters, comedies and political reminiscences. He was a member of the Society of Dilettanti, which had been formed in 1732 by a group of young men who had visited Italy on the Grand Tour and wished to promote the arts in general – in particular to foster an interest in the remains of classical antiquity through sponsoring archaeological research.

Elizabeth Montagu, famous bluestocking and writer, described Osborne as 'the prettiest man in his person, the most polite and pleasing in his manners' – traits of appearance and character that the artist tries to convey in this portrait. He is dressed for a masked ball; masquerades, held either in the public pleasure gardens of London or in private houses, were among the most popular forms of entertainment in the eighteenth century. He holds a mask by the silk frill that hid the chin and provided an effective incognito when worn with the three-cornered hat and the voluminous domino gown that covered the fashionable costume underneath. Osborne's domino is of white silk trimmed with gold

42.1
Draft trade card for Brackstone, a mercer
1773

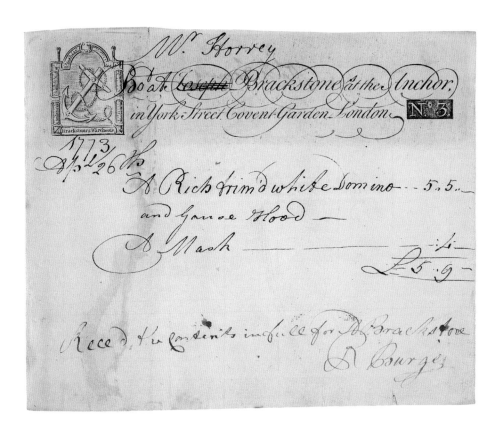

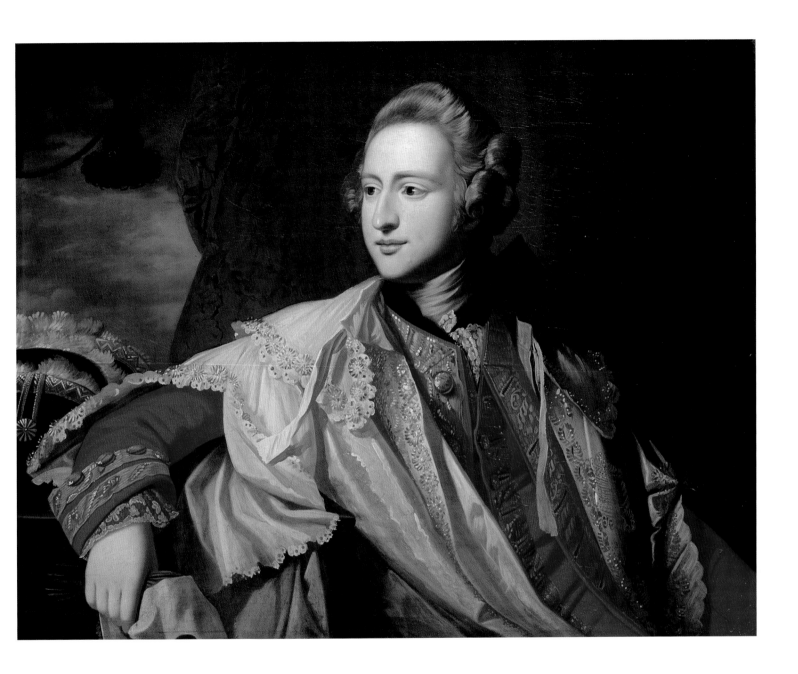

42 (above)
Francis Osborne,
5th Duke of Leeds
Attributed to Benjamin
West, c.1769
NPG 801

lace; it could either be his own or have been hired from the many theatrical costumiers in the Covent Garden area of London (see fig. 42.1). It is worn over a red silk suit decorated with gold lace, and on a table by his side is his black hat, decorated with gold braid and white ostrich feathers. By this time, many young men of fashion were beginning to wear their own hair, styled as a wig; even wigs themselves were meant to look more 'natural', and powder was reserved for formal occasions, such as attendance at court, the opera or grand balls. Although it is not always easy to distinguish real hair from a wig, it is probable that Osborne has adopted the former, the front hair combed over a roll into a toupee, or foretop, and tied at the back with black silk.

43 DAVID GARRICK and his wife EVA MARIA GARRICK

(1717–79) and (1724–1822)

43 (below)
David Garrick;
Eva Maria Garrick
Sir Joshua Reynolds,
1772–3. NPG 5375

The most famous actor of the eighteenth century – from his debut on the London stage in 1741 until his retirement in 1776 – is portrayed with his wife Eva, a Viennese dancer whom he married in 1749, in the garden (landscaped by Capability Brown) of their house by the Thames at Hampton.

The ageing actor – vain, rubicund and rather portly – wears a suit of red corded velvet, the coat and waistcoat lined with white. By this time it was rather old-fashioned to wear a suit where the three constituent garments were made of the same fabric, but it was a style favoured by Garrick as one that had been in

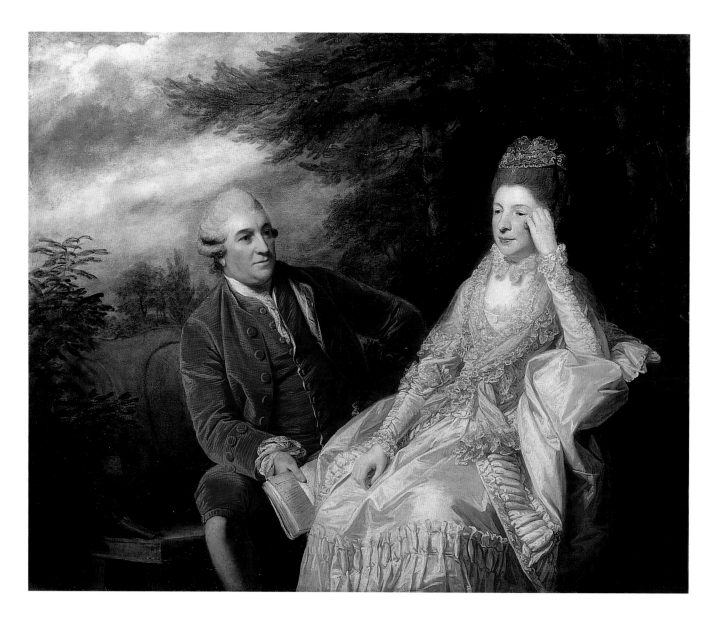

vogue in his youth. A suit belonging to Garrick (fig. 43.1) has coat, waistcoat and breeches made of reddish-brown velvet; the waistcoat is lined with cream silk, and the coat is lined with wool at the back, giving extra warmth to its wearer.

In keeping with the formality of his appearance, Garrick wears fine French needle-lace (possibly Alençon) and a powdered wig with high toupee and rigid side curls; such curls were called 'buckles' (from the French *boucle*, meaning 'curl'), and a 'well-buckled' wig was a contemporary term of approval.

By eighteenth-century standards Eva Garrick is still youthful-looking, perhaps because of the professional secrets of self-presentation gained from the theatre and the skilful use of cosmetics – her skin has been artificially whitened, rouge added to her cheeks and her lips reddened. She is dressed in white satin (an open gown, possibly with the fashionable looped-up overskirt – see fig. 45.3), with an informal, unstructured front-fastening bodice (*compère*, from the French word meaning 'intimate') and the recently introduced long sleeves to the wrist. Her appearance is almost too feminine, from her lightly powdered piled-up hair topped with a dainty lace cap, the 'butterfly' ruff under her chin and the embroidered scarf of silk gauze crossed over her breast, to the sumptuous satin of the dress with its padded 'robings' and large flounce on the skirt. A similar large flounce and a robing that forms a curving, serpentine line can be seen in a detail from a 1760s dress of white satin in the Museum of London (fig. 43.2).

43.1 (below, left) Theatrical costume ensemble associated with David Garrick 1758–61

43.2 (below, right) Detail of flounce and petticoat from satin sack-back dress 1760s

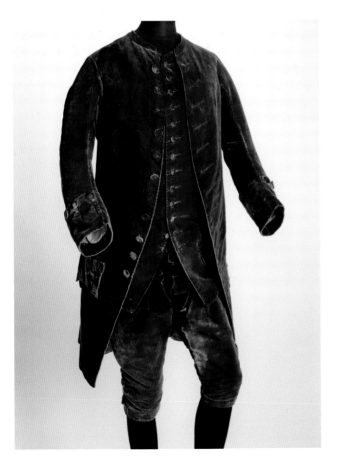

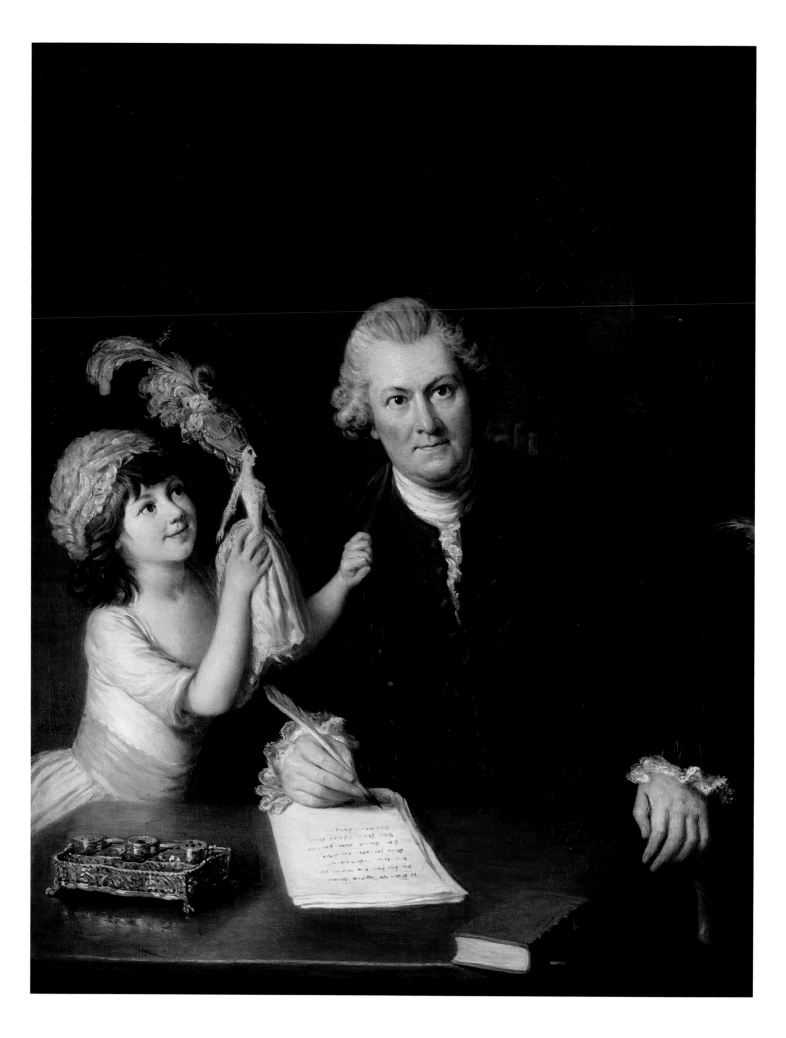

44 CHRISTOPHER ANSTEY

(1724–1805) with his daughter Mary

44 (opposite)
**Christopher Anstey
with his daughter**
William Hoare, c.1775
NPG 3084

44.1 (below)
Doll made of carved and
painted wood, in original
sack gown and petticoat of
silk and linen
1770–80

Christopher Anstey was a Cambridgeshire squire and the author of light verse, most successfully *The New Bath Guide* (1766), a humorous poetic satire on fashionable life in Bath. In his portrait by an artist resident in Bath (many artists, including Thomas Gainsborough, enjoyed lucrative stays in this fashionable resort, and Anstey himself moved there in 1770), we note a somewhat conventional frock suit of dark blue cloth. The lightly powdered hair is probably his own; by this time even middle-aged men were beginning to abandon the wig, except for formal occasions, and the rigid side curls of the early 1770s were giving way to a less structured and more 'natural' style. The new intimacy that characterises English family life in the late eighteenth century is reflected in portrait groups such as this, where open displays of affection between parent and child are recorded. Here, Mary Anstey tries to catch the attention of her father by holding up her doll; such dolls were known as 'babies' and often feature in portraits of young girls. She wears a simple white frock tied round the waist with a pink sash – a paradigm image of innocence. The word 'frock', hitherto used for a man's informal coat, encompasses the dress of young girls; in the same way that their clothing anticipates that of adult women at the end of the century, so the frock now is another word for dress.

A cap of ruched silk gauze is placed on Mary's naturally curling hair, cut with a fringe across the forehead; her simple hairstyle forms an amusing contrast to the towering coiffure sported by the doll, whose feathered hairstyle (women's headdresses reached their greatest heights in the late 1770s – see fig. 45.1) is possibly intended as a satire on the extreme fashion of the time, popularised by such society leaders as Georgiana, Duchess of Devonshire. Anstey himself poked fun at such plumed and elaborate female hairstyles in *An Election Ball* (1776) by likening them to those worn by the inhabitants of Tahiti, and the painting may have been inspired by this. The doll, dressed in a pink silk open gown and matching petticoat, copies the fashions of the late 1770s, possibly inspired by a fashion plate of the period. From the early 1770s illustrated fashion journals began to appear on a regular basis, largely replacing the dressed dolls costumed by metropolitan dressmakers and milliners as guidance for those who wished to appear à la mode (see fig. 44.1).

JOHN WILKES and his daughter MARY
(1727–97) and (1750–1802)

45 (opposite)
Mary Wilkes; John Wilkes
Johann Joseph Zoffany,
exhibited 1782
NPG 6133

45.1 (below)
*Twelve Fashionable Head-
dresses of 1778*

Wilkes was a well-known radical politician and champion of liberty, especially that of the press, founding in 1762 an anti-government newspaper, the *North Briton*. In the following year William Hogarth published a famous etching showing him as a squinting demagogue holding a cap of liberty on a staff.

Wilkes, a complex personality, was almost as notorious for his turbulent private life and spectacular ugliness as for his politics. Johann Zoffany has tactfully played down the squint, although Horace Walpole found the image still 'horridly like' and wondered, seeing the portrait in the artist's studio, 'why ... they are under a palm tree, which has not grown in a free country for some centuries'. Wilkes and his daughter were very close, and when he was Lord Mayor of London in 1774, she acted as his Lady Mayoress (he had separated from his wife, a rich heiress ten years older than himself, in 1756).

Wilkes wears a quasi-military riding costume, comprising a coat of blue woollen cloth lined with red, a striped waistcoat and breeches of nankeen (buff-coloured cotton); he wears top-boots (these were increasingly in fashion for indoors as well) and his own hair dressed like a wig, with a single side roll. The ruffles at his wrist are of Dresden work, embroidered linen or cotton (a cheaper and less formal alternative to lace), and the artist shows us clearly

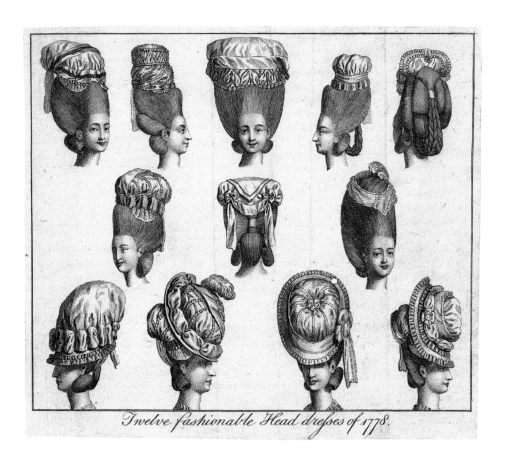

Twelve fashionable Head dresses of 1778.

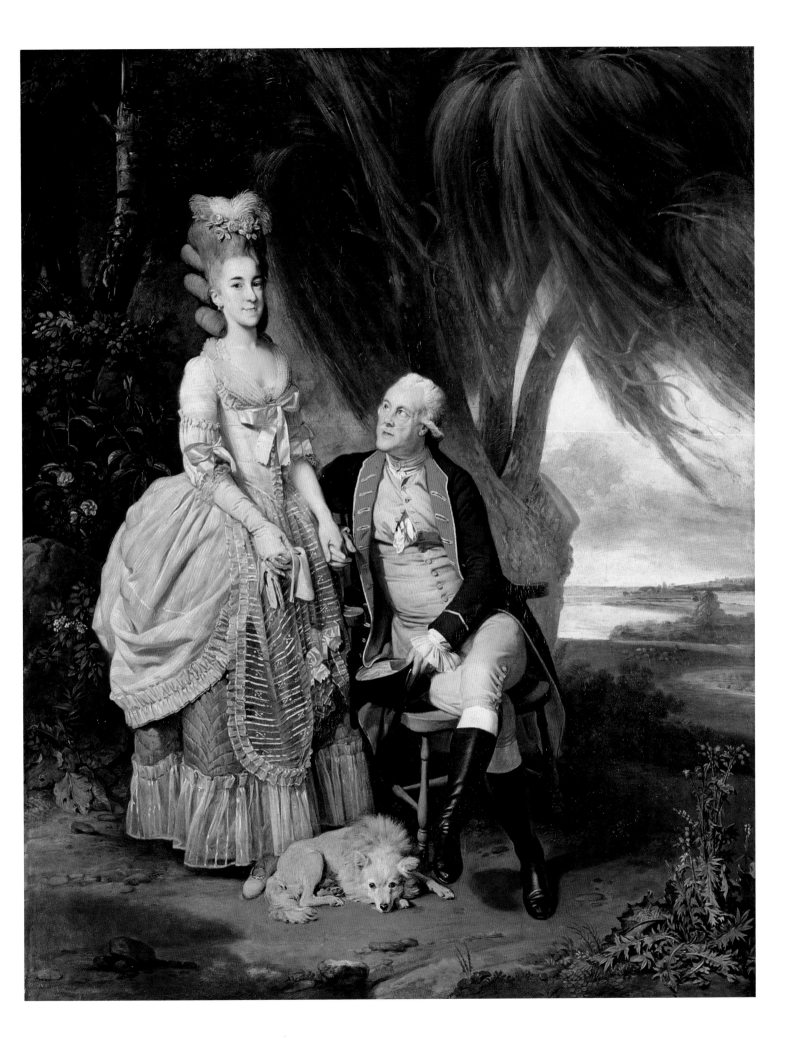

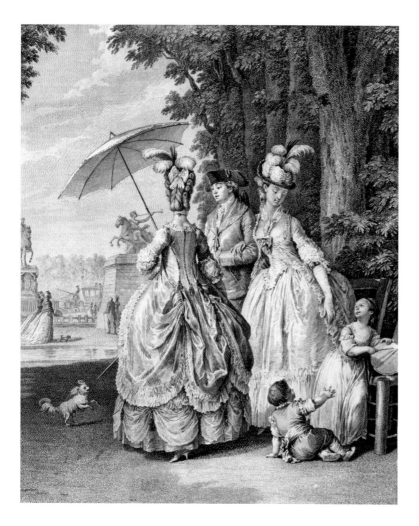

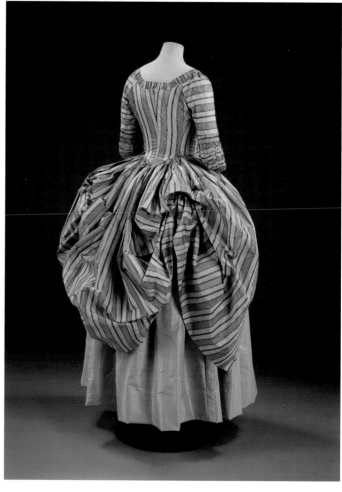

45.2 (above, left)
Le Rendez-vous pour Marly
Carl Güttenburg after a
drawing by Jean-Michel
Moreau le Jeune, 1777

45.3 (above, right)
Striped silk and linen robe
and petticoat
England, c.1775

how they attach to the shirt. Johann Zoffany was an artist who paid meticulous attention to all the details of costume, and his images of women, in particular, are as informative as fashion plates. Mary seems fussily overdressed and lacking in any innate sense of style. Her hair is arranged in the high-piled style with the stiff sausage-like side curls in vogue in the late 1770s (fig. 45.1); it is decorated with ostrich feathers, pink silk roses and foliage.

Unlike the more generalised interpretations of fashion seen in most portraits by British artists, Zoffany shows his sitter dressed in a very specific way. Her dress is a pink-and-white-striped silk polonaise gown, a style characterised by looped-up back drapery (figs 45.2 and 45.3); here it is worn over a green quilted-satin petticoat bordered with a flounce of striped silk gauze at the hem. All her accessories get equal billing with the dress, from the decorative apron of silk gauze embellished with similar pink satin bows to those on the bodice, to the net kerchief at the décolletage, the long kid gloves and the pink shoes with their silver buckles.

46 THE SHARP FAMILY

46
The Sharp Family
Johann Joseph Zoffany, 1779–81
NPG L169

The Sharp family, famous for their music-making on the Thames, perform a concert on William Sharp's yacht, *The Union*; old Fulham church can be seen in the background. As with many of Zoffany's paintings of large groups, some artistic licence is evident, both in the arrangement of the figures and in the fact that a

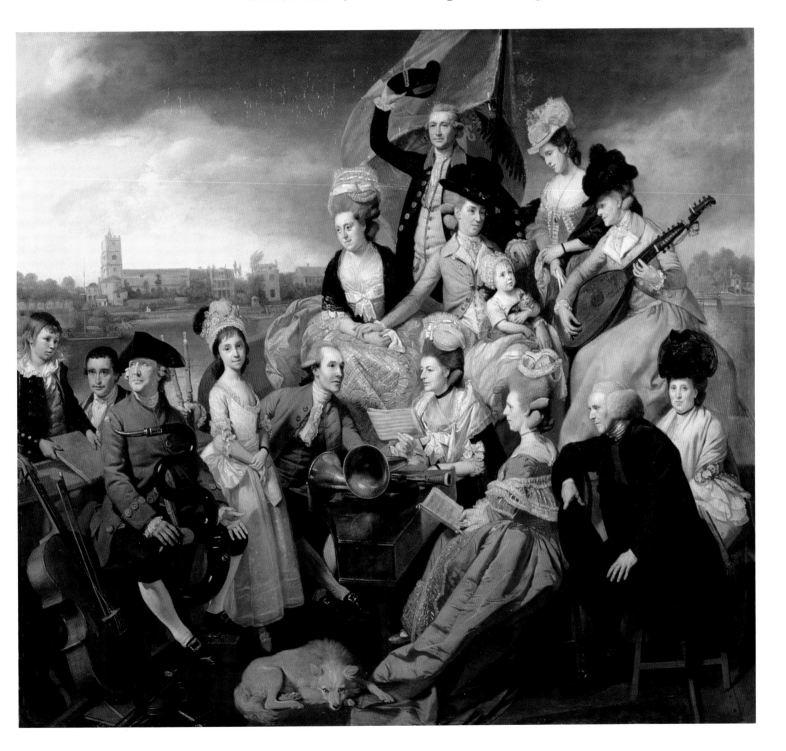

piano would be unlikely to be taken on board. What the artist wishes to convey – as well as recording the images of the individual musicians and their listeners – is the idea of a musical conversation piece. (Zoffany has, incidentally, included his dog in the foreground of the painting, as a kind of signature – it also appears, in the same pose, in his portrait of John Wilkes and his daughter Mary (fig. 45).)

The painting was commissioned by William Sharp, surgeon to George III, who stands at the tiller, wearing the Windsor uniform (established by the King in 1776 for members of the royal family and selected court officials). At the bottom right is his brother Dr John Sharp, in the black costume adopted by medical men and the 'physical' wig (a chin-length, frizzed powdered grey wig) that also denotes his profession. Seated by the piano is Granville Sharp, a well-known philanthropist, wearing a greenish-yellow coat and waistcoat, with black knee-breeches. To the left of the painting, holding a musical instrument called a serpent, is James Sharp, an engineer by profession, who is rather old-fashioned in dress, his hat firmly placed on his bewigged head, wearing a coat of brown woollen cloth with brass buttons. Behind him is the barge-master, distinguished from the rest of the men (their middle-class and professional status signified through their powdered hair or wigs) by his short, natural hair, which gives him a greater modernity of appearance. Next to him is a small boy, whose long hair waving naturally to the shoulders, dark blue coat and open, frilled shirt collar are all features of the clothing of young boys in the late eighteenth century.

46.1 (below) Detail showing Mrs James Sharp's quilted white satin petticoat

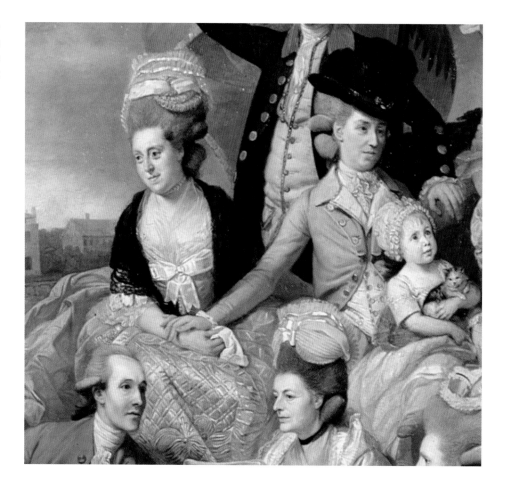

The three Sharp sisters also take part in the musical entertainment. Elizabeth, ready to play the piano, wears a *sacque* dress of rich reddish-brown (a colour known as 'carmelite') and a small, hooded white-satin shoulder mantle. To the right is Frances, music in her hand and perhaps about to sing, in a blue silk robe *à l'anglaise* (the dog places a paw on her train) and matching petticoat. Judith, playing the theorbo (a kind of lute) at the top right, is wearing a riding habit, a fashionable costume adapted from the male suit, popular for all kinds of outdoor activities. Just in front of William Sharp is his wife, who also wears a riding costume, consisting of a pale blue jacket and matching habit skirt, and a waistcoat of white silk trimmed with gold. She places her hand over that of Mrs James Sharp (fig. 46.1), whose pale lavender dress is almost eclipsed by her beautiful petticoat of quilted white satin. Quite a number of these quilted petticoats exist in museum collections (fig. 46.2); not only were they attractive, as well as being light and warm to wear, but they also helped to create the soft, rounded look that was such an essential part of women's fashion of the period.

Zoffany had an expert eye for the fabrics from which fashionable dress and accessories were created, as well as for the garments themselves. Through his eyes we appreciate, for example, the shine on satin and rustling silk taffeta, the soft, matte appearance of the sprigged white cotton worn by Catherine Sharp (standing next to her father, James), and the fine woollen shawl and Dresden sleeve ruffles worn by Mrs John Sharp (on the far right). We note the extraordinary variety of female headdresses, from the plumed and ribboned hats worn by the Amazons (as women in riding habits were often known, after the legendary female warriors) to the frilly confections of silk, gauze and net that perch on top of the powdered coiffures of the more formally dressed women in the painting.

46.2 (above)
Quilted satin petticoat
Mid-eighteenth century

GEORGE, PRINCE OF WALES
later King George IV (1762–1830)

In the golden age of satire in England, James Gillray reigned supreme. There can be no more effective indictment of royal dissipation than his caricature of the extravagant lifestyle of the gross Prince of Wales. Sitting in a first-floor room of his new palace, Carlton House, the Prince is surrounded by half-eaten food, empty bottles (an overflowing chamber pot behind him) and unpaid bills. To emphasise the point, above his head is Tintoretto's portrait of Luigi Cornaro, who lived to be ninety-one by repenting and reforming his youthful excesses.

Had the Prince lived earlier in the century, his corpulence would have gone unremarked, but at this time the fashionable male silhouette was slimmer. His embonpoint is cruelly recorded here, as he almost bursts out of his buff-coloured waistcoat and tight-fitting breeches; his blue coat, impossible to button across the chest, is cut away into tails at the back. Buff and blue were the colours associated with Charles James Fox, a Whig and a fellow crony in dissipated living, the Prince's association with whom was a source of irritation to King George III on both counts.

47.2 (below)
King George IV
Richard Cosway, c.1780–2
NPG 5890

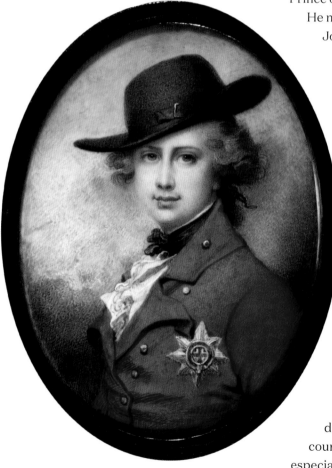

Gillray's image of the Prince of Wales as an obese dandy (the 'Prince of Whales') is probably not too far from the truth. He notes the beefy face that we also see in a fine sketch by John Russell 'drawn from the Life' in Brighton (a resort made fashionable by the Prince) in 1794 (fig. 47.1). In a few vigorous strokes, the artist has captured the Prince's mass of dishevelled, lightly powdered curls, the high collar of his coat, and the starched white cravat that increasingly distinguished a man of style from his lowlier fellows (see fig. 52.2).

From his earliest years, the Prince of Wales was interested in fashion. A miniature by Richard Cosway of the early 1780s (fig. 47.2) shows a handsome youth – his fleshy, voluptuous features already evident – wearing a well-cut red double-breasted frock coat with the Star of the Order of the Garter on the chest, a black military cravat and a rather dashing 'wide-awake' hat slightly tilted to one side. For everyday wear, this style of round uncocked hat with a wide brim had replaced the three-cornered hat – for so long an unchanging staple of the masculine wardrobe. By the 1780s men's clothes were becoming less flamboyant and more understated in colour and materials; silk fabrics and rich decoration were no longer the norm (the exception was court wear), and for everyday men wore fine woollen cloth, especially for their coats. All three portraits depict the Prince

47 (right)
A Voluptuary under the Horrors of Digestion (King George IV)
James Gillray, published by Hannah Humphrey 2 July 1792. NPG D33359

47.1 (below)
King George IV
John Russell, 1794

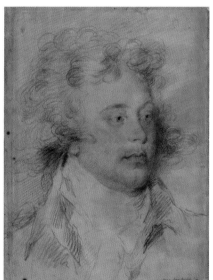

wearing a seemingly natural hairstyle, although he was known to augment his locks with hairpieces. Powdered wigs were now no longer in fashion, worn only at court and by certain professionals and elderly men.

In 1782 the Duchess of Devonshire noted: 'He is inclined to be too fat and looks too much like a woman in men's cloaths, but the gracefulness of his manner and his height certainly make him a pleasing figure.'

Later, in a more sarcastic vein, his estranged wife Caroline of Brunswick (see fig. 51) remarked on the Prince's fondness for clothes: 'He understands how a shoe should be made or a coat cut ... and would make an excellent tailor, or shoemaker, or hairdresser, but nothing else.'

(1759–97)

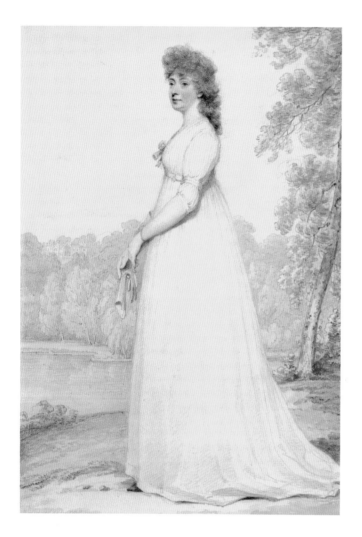

Feminist writer and thinker (author of *A Vindication of the Rights of Woman*, 1792) Mary Wollstonecraft is portrayed here with ostentatious simplicity, in a high-waisted white cotton dress, a muslin kerchief ensuring a modest neckline, and a soft hat worn over her plainly styled auburn hair. Wollstonecraft's feminist principles dictated that 'an air of fashion is but a badge of slavery', and in her *Thoughts on the Education of Daughters* (1787) she states:

> Dress ought to adorn the person, and not rival it. It may be simple, elegant and becoming, without being expensive ... The beauty of dress (I shall raise astonishment by saying so) is its not being conspicuous one way or the other, when it neither distorts nor hides the human form by unnatural protuberances.

Here she follows her own recommendation, for the dress reveals the body shape in a natural and discreet way; Mary Wollstonecraft, married to William Godwin, was pregnant at the time and died shortly after giving birth to a daughter, later Mary Shelley.

At the time of this portrait, women's dress, under the influence of neoclassicism, was 'simple, elegant and becoming'. This is evident in many contemporary images, such as the delicate portraits by Henry Edridge. His 1798 pencil-and-wash drawing of Anne Holroyd, Countess of Sheffield (fig. 48.1), shows the sitter in a white-muslin chemise dress, the folds of the airy fabric falling from a high waist to trail on the ground behind (a similar surviving example can be seen in fig. 48.2).

48 (opposite)
Mary Wollstonecraft
John Opie, c.1797. NPG 1237

48.1 (left, top)
Anne Holroyd, Countess of Sheffield
Henry Edridge, 1798. NPG 2185a

48.2 (left, below)
Muslin and cotton gown
England, early nineteenth century

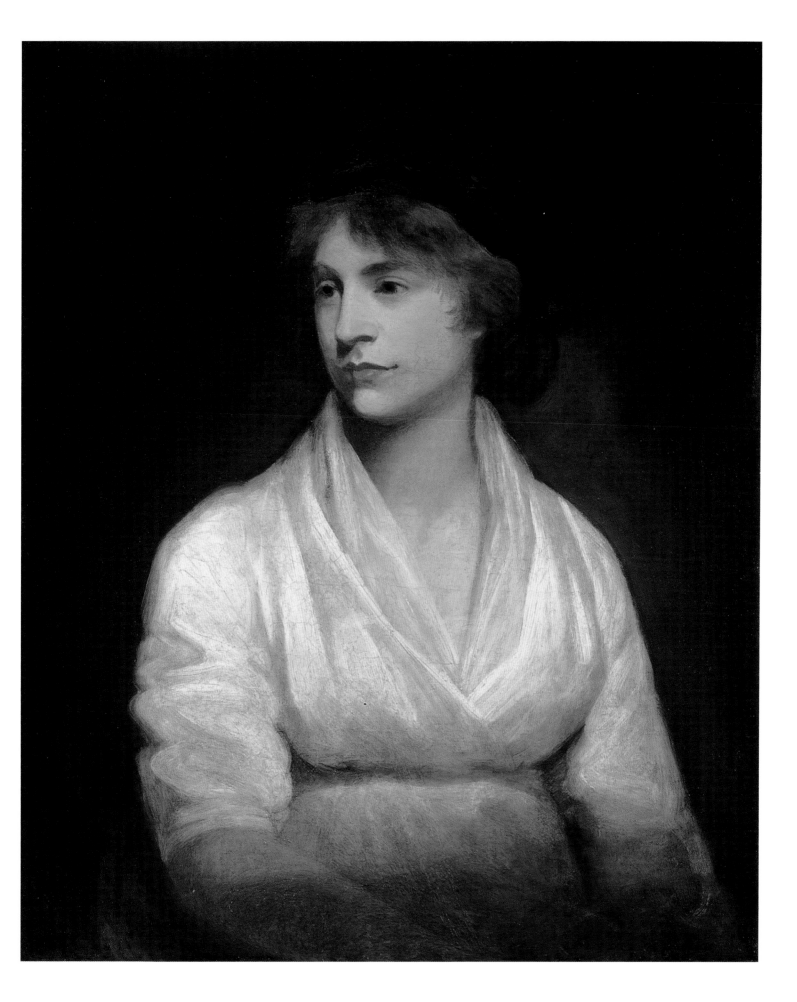

JOHN CONSTABLE and SAMUEL TAYLOR COLERIDGE (1776–1837) and (1772–1834)

49 (opposite)
John Constable
John Constable, c.1799–
1804. NPG 901

49.1 (below)
Samuel Taylor Coleridge
Peter Vandyke, 1795
NPG 192

Constable's sensitivity and his slightly melancholy disposition can easily be detected in the intensity of this self-portrait, drawn perhaps shortly after the time he entered the Royal Academy Schools, London, in 1799 or a few years later. The costume he wears is modest and unpretentious: a high-collared woollen coat over a waistcoat and the simplest white-linen cravat. At this time, although most men buttoned their clothes left over right (and women vice versa), there was no fixed rule about 'masculine' or 'feminine' custom in this respect, and it does not necessarily indicate, as some art historians have suggested, that this portrait was drawn by the artist looking in a mirror.

By the end of the eighteenth century there was little scope for flamboyance in male clothing. Individuality was expressed in the style of hair (wigs had disappeared) and in such minor details as the different ways of tying the cravat (see fig. 52.2). The visionary poet Samuel Taylor Coleridge, for example, in his portrait by Peter Vandyke (fig. 49.1), demonstrates his Romantic sensibility through his long, curled hair and rather fixed stare, but there is also a sense of incipient dandyism in his extravagantly bow-tied cravat and his white satin waistcoat with fashionably wide revers. Constable's demeanour is more conventional, with his hair cut short and slightly tousled in the fashionable neoclassical mode; his cravat is merely a long strip of linen wound round his neck and fastened in a loose knot.

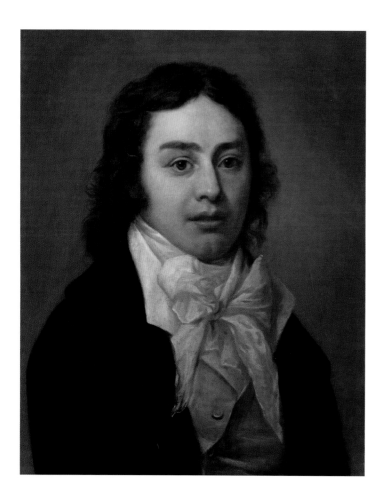

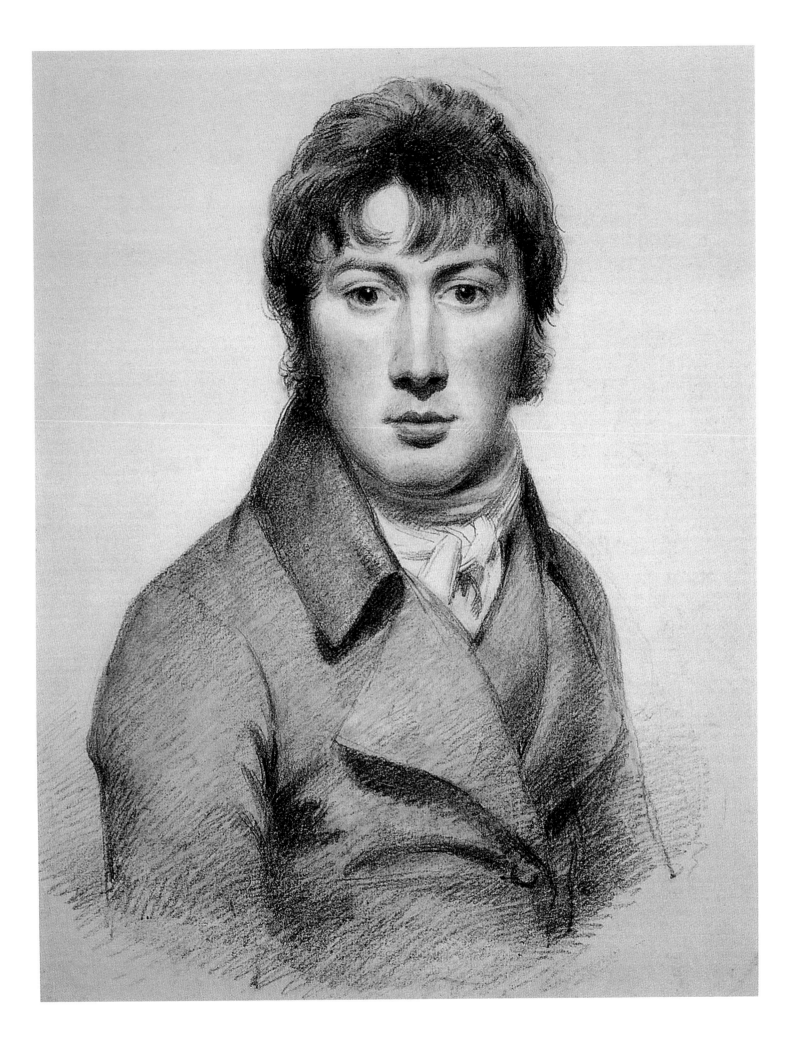

THE
NINETEENTH

CENTURY

INDUSTRY AND INVENTION

An unprecedented avalanche of technological developments speeded up the production and dissemination of fashion in the nineteenth century. The great inventions patented in the previous one, such as James Hargreaves's spinning jenny and Samuel Crompton's spinning mule, had already set in motion the driving force behind the Industrial Revolution, namely the manufacture of textiles, making the Victorian age one of the most significant periods in fashion's history. Production processes changed radically, from traditional, artisanal methods to machine-made, mass-produced ones; a shift from domestic, rural sites of production to urban factories and the giant cotton mills of the North, a shift that engendered the redistribution of the workforce from countryside to city. The increased consumption of cotton fabrics, now spun, woven and printed in Britain in vast quantities, not only provided more choice and greater affordability but also dramatically improved hygiene as cotton could be washed, unlike expensive silks, velvet and wool.

Numerous other innovations revolutionised fashion, including: a machine for making bobbin net in 1808; the sewing machine, invented in 1845; the sprung-steel cage crinoline and aniline dyes, introduced in 1856; steam-moulded corsets in the 1860s and paper dressmaking patterns by the 1870s. The impact of these advances on fashion and society was immeasurable, as were many others made in the century, for example, the bicycle, a truly liberating mode of transport, particularly for women, in the 1890s. The building of the canals and railways in the 1830s and improvements in roads and communications accelerated the rate at which commodities became available. The invention of photography in 1839 soon provided an affordable alternative to portraiture as a means of recording identity and appearance. In the second half of the century, *cartes de visite* (small-scale portrait photographs printed in multiples and used as a form of social currency) became immensely popular. They provide invaluable evidence of contemporary dress, with the caveat that, in most cases, the sitters wear their best clothes for the occasion and everyday, working dress is not generally represented.

The fashionable female silhouette fluctuated more dramatically than in any other period, from the high-waisted, narrow column of the early chemise dress to the increasingly embellished, neoclassical gown of the Regency; the wide, drooping shoulders and expanding skirts of the early Victorian period (fig. 55.1) to the vast, dome-shaped expanse of the 1860s crinoline (fig. 58); the rigid cuirass bodice (from the French *cuirasse*, meaning 'breastplate') and complex back drapery of the 1870s (fig. 59) and, finally, the figure-hugging sheath of the last decade. The distortion of the silhouette was achieved by rigidly boned corsets and bodices and complicated hooped and taped understructures that at different times freed and restricted the legs. The tea gown, an informal gown worn initially only at home from the 1870s, was relatively unstructured, yet it was still unthinkable, as far as most women were concerned, to do away with underpinnings as an uncorseted figure was equated with loose morals. The cult of mourning that arose after the death of Queen Victoria's husband and consort, Prince Albert, in 1861, ruled the lives of families of all classes, many of whose members fell victim to disease at home and in the colonies and high mortality rates prevailed, especially among children.

Ironically, despite the hegemony of France over fashion, it was an Englishman, Charles Frederick Worth, who became known as the first king of fashion and is usually credited with establishing the couture industry. Set up with his own *maison de couture*, or couture house, by 1858, he was the first designer, rather than just a dressmaker, in the sense that he dictated all aspects of his clients' toilettes, becoming in the process, immensely wealthy. Despite his exorbitant fees, high-society women from both sides of the

Atlantic flocked to him to order gowns for the numerous functions that made up the social season (fig. 62.1). Conspicuous consumption was the order of the day; yet this glamorous lifestyle masked the dirty side of the garment industry: a huge sweated labour force working in appalling conditions to meet ever-increasing consumer demand.

In men's fashion, the superb tailoring and plain, sparkling linen advocated at the turn of the century by that arbiter of style and master of understatement, Beau Brummell (fig. 52.1), gave way to the excesses of the Regency buck, a last hurrah before the almost universal sobriety of the black business suit took hold, although the figure of the dandy was still in evidence: Charles Dickens, a noted dandy in his youth, was criticised while on an American lecture tour for wearing fancy waistcoats 'somewhat in the flash order' (fig. 56). The three-piece suit was composed of a variety of styles of tailcoat, or a straight-fronted frock coat, both options worn with a waistcoat, stiff-collared shirt, cravat and, from the mid-1820s, trousers rather than breeches, although these continued to be worn for ceremonial dress and country pursuits. There was an increasing division between formal and informal styles and, within the latter, an expanding variety of garments such as the loose paletot coat and sack jacket that became the basis of the later informal lounge suit. As the popularity of sports gained hold, blazers, sweaters, knee-length knickerbockers and flannel trousers all became acceptable for leisure wear, yet even then some form of hat, such as a straw boater or peaked cap, was always retained.

Savile Row, in London's Piccadilly, established an international reputation as the epicentre of gentleman's tailoring during the nineteenth century; clustering around 'The Row' and wider St James's were bespoke shoemakers and hatters, outfitters supplying shirts and accessories, and wine and tobacco merchants as well as exclusive gentlemen's clubs. By the end of the century and well into the next, bespoke tailoring for women also became a speciality of the area.

Attempts were made to reform dress throughout the century, whether for reasons of equality, health or aesthetics. In 1851, Mrs Amelia Bloomer, an American proto-feminist, failed in her attempt to popularise her eponymous suit, consisting of a tunic worn over ankle-length trousers, because it was seen as too masculine. Tightly laced corsets, 'deforming' crinolines and high-heeled shoes were among the items rejected by members of the Rational Dress Society, established in 1881 by Viscountess Harberton. The beauty of historically inspired modes of dress was championed in avant-garde artistic circles such as the Pre-Raphaelite Brotherhood: William Morris wore an indigo-dyed suit and blue, soft-collared shirt, the badge of the working man, while his wife Jane made and wore flowing gowns, without a rigid corset underneath (fig. 60.2). In the 1880s, Oscar Wilde adopted 'Aesthetic dress' for a lecture tour of America (fig. 63), and Dr Jaeger developed his Sanitary Woolen System Co., in the belief that wearing wool expelled toxins from the body. The Aesthetes were catered for at Liberty's department store on London's Regent Street, opened in 1875, which imported Oriental wares such as blue-and-white china, Japanese fans and screens, as well as the soft silks in the muted 'greenery-yallery' colours lampooned by Gilbert & Sullivan in their 1881 operetta, *Patience*, yet beloved by those who saw themselves as a cut above the so-called Philistines.

The more practical needs of the 'New Woman' (who became a feature of *Punch* magazine throughout the 1890s), who may have attended university and worked for her living, were met by the 'tailor-made suit' that had evolved from the ever-popular riding habit. Made of wool in winter and cotton or linen in the summer, worn with a high-necked blouse or stiff-collared shirt and masculine tie and always a suitable hat, it was adopted universally as essential everyday wear. For cycling, the skirt could be divided, or even, perhaps in the case of a Rational dresser, replaced by a pair of bloomers, as the more generously cut female version of knee-length knickerbockers were named, after Mrs Bloomer. **CB**

50 MARY ANNE CLARKE
(1776–1852)

50 (opposite)
Mary Anne Clarke
Adam Buck, 1803
NPG 2793

50.1 (below)
Mary Anne Clarke
Lawrence Gahagan, 1811
NPG 4436

The sitter's main claim to fame is that she was the mistress (from 1803 to 1807) of Frederick, Duke of York (second son of George III), commander-in-chief of the British Army. In 1809 she was accused of trafficking in Army commissions, and the Duke was forced to resign. In this miniature by Adam Buck – a fashionable decorative artist and designer, who helped to popularise the vogue for the neo-classical – Mary Anne Clarke's nubile charms are on show in her high-waisted dress of white muslin, cut in a style that emphasises the shape of the body. A blue Wedgwood cameo (a popular mass-produced manifestation of neoclassical taste) fastens the dress under the bust, and our attention is drawn to the sitter's pretty arms by a similar cameo that holds up the short sleeve on the shoulder.

The fashionable neoclassical style of dress often displayed a considerable amount of flesh – to the alarm of moralists – and demanded a slim but 'feminine' figure, rounded arms and good skin. A long neck was also an asset, best to set off the 'classical' hairstyles in vogue: either cut short and curled (fashionable women could ring the changes with a wardrobe of wigs), or the hair lightly oiled (so-called 'huile antique' was a favourite) and gathered up in a loose bunch of curls at the back of the head.

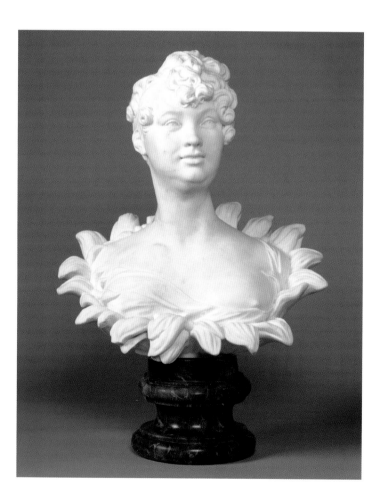

It is as a discarded mistress that we see Mary Anne Clarke in the marble bust of 1811 by Lawrence Gahagan (fig. 50.1), where she is depicted as Clytie (the deserted lover of Apollo, the sun god), who was changed into a sunflower so she could follow his progress across the sky. She appears as if arising naked from a sunflower (symbol of constancy and of royal favour), and the petals of the flower double up to suggest the frilled collar of the popular white muslin dress of the period.

Fifteen years later, the gradual widening of the silhouette across the shoulders can be seen in a portrait (fig. 50.2) of the adventurer and businesswoman Mary English (1789–1846), whose light silk evening dress is trimmed with a froth of net at the neckline and puffed sleeves (arms were usually bare in the evening). Neoclassical rigour, in painting and in dress, had given way to romantic sensibility, and the artist's sweeping brushstrokes beautifully express the ample folds of her red Kashmir shawl, edged in gold embroidery, the accessory of the moment, that she has gathered around her. A matching turban, a fashionable style for the evening at this period, sits atop her head, while a gold and turquoise brooch emphasises the separation of

50.2
Mary English
William Armfield Hobday,
1818. NPG 6964

her small, high breasts, moulded into the required shape by a 'divorce corset'. The portrait was painted a year before Mary English departed for South America, where she and her husband supported Simon Bolivar's struggle for the independence of the Spanish colonies on that continent. After her husband's death she became the representative of the bankers Herring and Richardson in Colombia and eventually bought a cacao plantation there.

CAROLINE OF BRUNSWICK and PRINCESS CHARLOTTE OF WALES
Princess of Wales (1768–1821) and (1796–1817)

This is a direct and honest portrait of the unruly – many called her vulgar – wife of the Prince of Wales; they married in 1795 and separated a year later. (This ambiguity over her marital status may be indicated by the shadow over her left hand, where her wedding ring is hardly visible.) She took up residence at Montagu House in Blackheath, on the edge of London (where this portrait was painted), which was far enough away from the Prince at Carlton House but close enough for both parents to share the upbringing of their only child, Princess Charlotte. This rather challenging image may indicate the sitter's possible dalliance with the artist, Sir Thomas Lawrence, and also (as she holds a sculpting implement) her own artistic interests: she took lessons in sculpture from Peter Turnerelli, an Irish sculptor recommended by Lawrence, and in the background is a clay bust of her father, the Duke of Brunswick.

Whatever the Princess's relationship with Lawrence, he has not flattered his sitter, drawing attention to her bold complexion (heightened both by a liberal use of cosmetics and by the colour of her dress) and to her fleshy arms, which the effect of 'rolled-up' sleeves emphasises. Her dress is of red velvet, tight over the bust, her solid flesh being kept firmly under control by a heavily whaleboned corset. The colour and fabric of her dress, along with the high collar, which supports a ruff of fine muslin, signal the popularity of the Renaissance as an influence on female costume of the period, as does the red velvet hat trimmed with bird-of-paradise plumes.

A Wooden Substitute,
or
Any Port in a Storm.

Soon after the birth of their daughter, and abandoned by her husband (who was already secretly married to Mrs Fitzherbert), Caroline spent several years perambulating around the Mediterranean, hence the subtitle of a caricature published in 1821 (fig. 51.1). Accompanying Caroline on her travels were various lovers, including Bartolomeo Pergami, pictured here. Despite her popularity with the public who mainly supported her in preference to the Prince during their divorce trial, the artist has mercilessly lampooned her overdressed appearance, even placing a locket with the images of two lovers strategically over her genitals.

Princess Charlotte's death in childbirth in 1817 plunged the nation into mourning. A portrait painted in the year of her death (fig. 51.2) depicts her as a handsome rather than beautiful young woman. Her statuesque figure, classical features and antique hairstyle (an early version of the 'Apollo' knot, a complicated arrangement of plaits and curls on top of the head in the shape of a bow, bound by a fillet or ornamental band) are imbued with gravitas by a column and a huge swag of drapery in the manner of Van Dyck, while the portfolio of drawings under her arm refers to her accomplishments as an amateur artist. She wears a two-piece blue silk 'Russian dress',

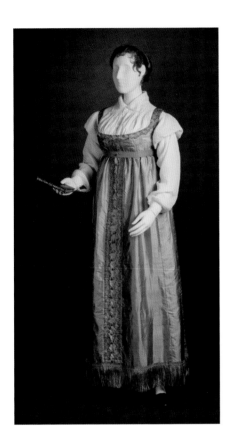

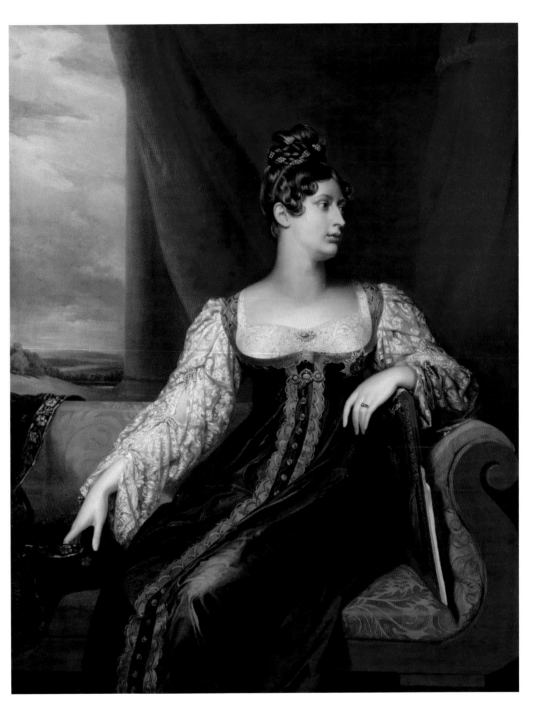

51.2 (right)
Princess Charlotte Augusta
of Wales
George Dawe, 1817
NPG 51

51.3 (above)
Princess Charlotte
Augusta's 'Russian Dress'

based on the traditional sarafan (a long, loose sleeveless dress worn over a
blouse, constituting part of the national costume of Russian women); the star
of the Order of St Catherine of Russia is on her left breast, a compliment to the
Tsar under whom Charlotte's husband, Prince Leopold of Saxe-Coburg-Gotha,
had served. This dress (fig. 51.3), minus its superlative lace sleeves and modesty-
piece, along with several other items from the Princess's wardrobe, are thought
to be the first substantial group of English royal clothing to survive.

52 ARTHUR WELLESLEY

1st Duke of Wellington (1769–1852)

This portrait was probably painted in Madrid, during the Peninsular War, when Wellington commanded the British troops against the French. Unusually for a military hero in wartime, Wellington wears civilian clothing, a fact that may be explained by his interest in fashionable dress; he was vain about his appearance, and particular about the cut, comfort (and cleanliness) of his costume. Wellington was a believer in the gospel according to George Bryan 'Beau' Brummell (fig. 52.1) (as expounded by Max Beerbohm in *Dandies and Dandies*, 1896) that the aim of male dress was to 'clothe the body that its fineness be revealed'. At the time of this portrait, Wellington's usual costume was a single-breasted frock coat, tightish fitting to show off his slim and well-proportioned figure, and pantaloons (a style of tight-fitting trouser that fastened with ribbons or buttons below the calf or by straps passing under the instep), which had largely superseded knee-breeches by the early nineteenth century and were generally worn with boots. Here Wellington's coat is dark blue with a velvet collar and with the extra-long sleeves characteristic of contemporary tailoring; with this he wears a high-collared white waistcoat, close-fitting pale grey pantaloons and black leather boots. These were the kind of boots that Wellington liked, for the back was cut away slightly, making it easier to bend the knee; the style most associated with him (then and now), however, was a boot coming to below the knee and cut straight around at the top.

Brummell was famous for advocating 'fresh linen, plenty of it, and country washed', a preference that must have put his laundry bills under some strain as he was known to discard many an imperfectly tied neckcloth ('our failures' as he called them) before he and his valet were satisfied. There were many ways of folding and tying starched neckcloths, as can be seen in Cruikshank's engravings from *Neckclothitania; or, Tietania: being an essay on Starchers, by one of the Cloth* (fig. 52.2).

The appearance of both men – short hair cut simply and brushed forward over the temples, and plain, unadorned clothes – is notable for its practicality and understatement, epitomising another of Brummell's favourite

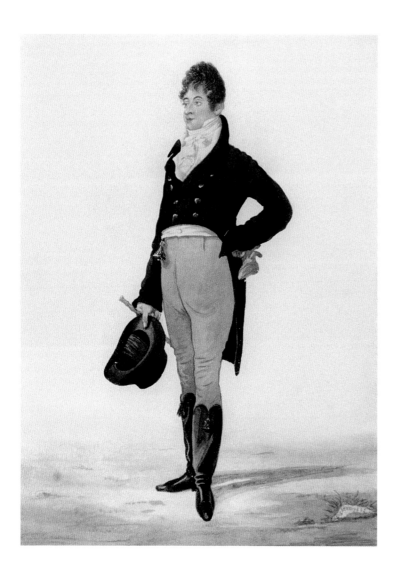

52.1 (below)
Beau Brummell
Richard Dighton, 1805

NECKCLOTHITANIA

52 (right)
Arthur Wellesley,
1st Duke of Wellington
Juan Bauzil, 1812–16
NPG 308

52.2 (above)
From *Neckclothitania*
1818

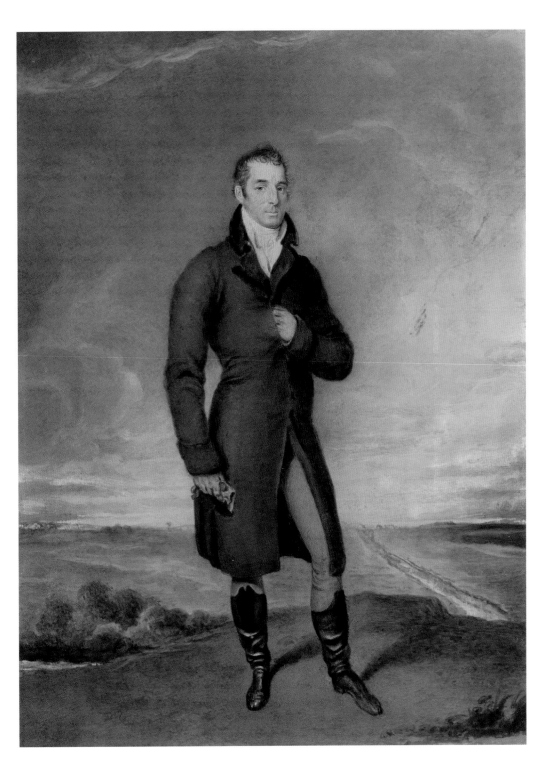

aphorisms that the 'severest mortification that a gentleman could incur was to attract observation in the street by his outward appearance'. It is also indicative of the increasing homogeneity of men's dress during the nineteenth century, a gradual process of sartorial democratisation, in which clothing was no longer dictated by social codes attached to class or rank, but rather by engagement with the wider world through a professional or business career – in other words, it reflected the rise of the self-made man and the middle classes.

53 WILLIAM COBBETT and JOHN CLARE
(1763–1835) and (1793–1864)

53 (opposite)
William Cobbett
John Raphael Smith,
engraved 1812
NPG 6870

53.1 (below)
John Clare
William Hilton, 1820
NPG 1469

Son of a tavern owner and smallholder, William Cobbett eventually became MP for Oldham in 1832, exemplifying social mobility in the nineteenth century. Having returned from the United States, where he rose through the ranks of the British Army, he became a controversial political agitator, radical pamphleteer, journalist (he published the weekly *Political Register* from 1802 until his death in 1835) and parliamentary reformer. His commentaries on the negative effects of the Industrial Revolution on the country in general and on traditional methods of farming in particular were published in the *Political Register* during the 1820s and finally compiled as a book, *Rural Rides*, in 1830, in which he described London as 'the great wen [cyst]'.

Smith's pastel drawing depicts Cobbett in his study at Newgate Prison, London, where he spent two years for libel: a desk littered with papers, above which hangs a portrait of John Hampden, a seventeenth-century advocate of parliamentary democracy, refer to Cobbett's lifelong efforts at political reform. He is wearing a drab-colour double-breasted frock coat in a thick wool, with a high collar and deep revers over a scarlet woollen waistcoat and buff breeches with plain linen and white worsted hose. In comparison to the dapper figure struck by Wellington at this date (fig. 52), Cobbett looks distinctly old-fashioned:

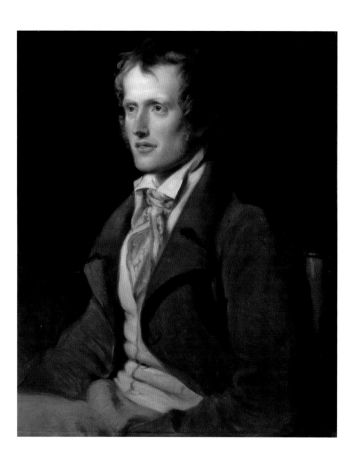

breeches were rapidly becoming elements of fossilised court dress, to be replaced by pantaloons and then by trousers by the 1820s. His almost flat black shoes, tied with ribbon bows (soon to become laces) are, however, very much in fashion, having replaced the eighteenth-century buckled shoe around the turn of the century.

A portrait of John Clare (1792–1864) (fig. 53.1), probably commissioned by John Taylor, Clare's editor and publisher, was painted after the poet's first book, *Poems Descriptive of Rural Life and Scenery*, came out in 1820. The artist has captured his sitter's almost unbearable sensitivity – Clare became insane in 1837 and was committed to Northampton Asylum. Clare's poetry was inspired by the Northamptonshire countryside, where he was brought up, the self-educated son of a cottage farmer, and where he worked as an agricultural labourer, living in great poverty with his wife and children. His poems caught the mood of the time, both in their subject – the countryside, which Romantic poets such as Wordsworth and Coleridge had used as inspiration and encouraged people to look at with new eyes, especially in light of the

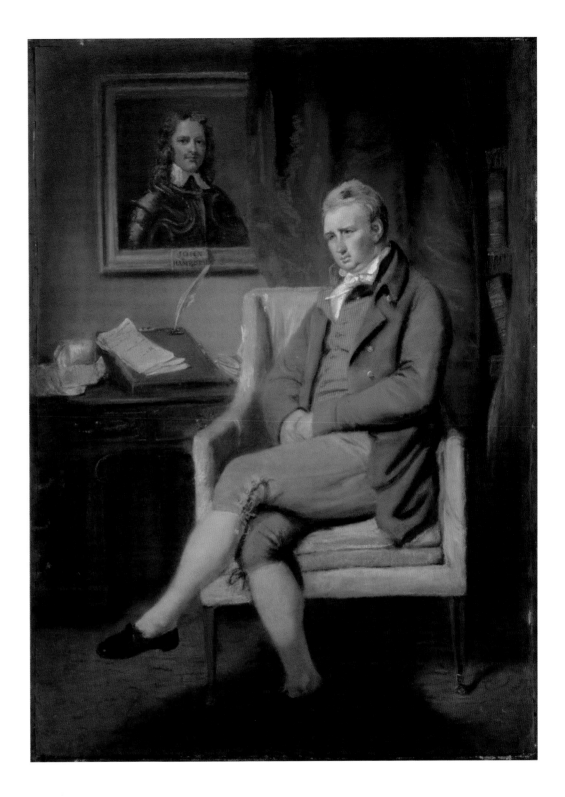

encroaching urbanisation generated by the Industrial Revolution – and in their treatment, which was intensely personal and moving.

Clare wears the Sunday-best clothes of a respectable workingman, not unlike those worn by Cobbett: a rough-textured brown woollen coat, greyish-brown trousers and a buff-coloured cotton waistcoat. His shirt collar is slightly rumpled, and, instead of the starched white-linen cravat that was part of fashionable men's wear, Clare has a printed silk scarf tied loosely round his neck, a fashion, incidentally, that was to be taken up by artists and intellectuals at the end of the nineteenth century.

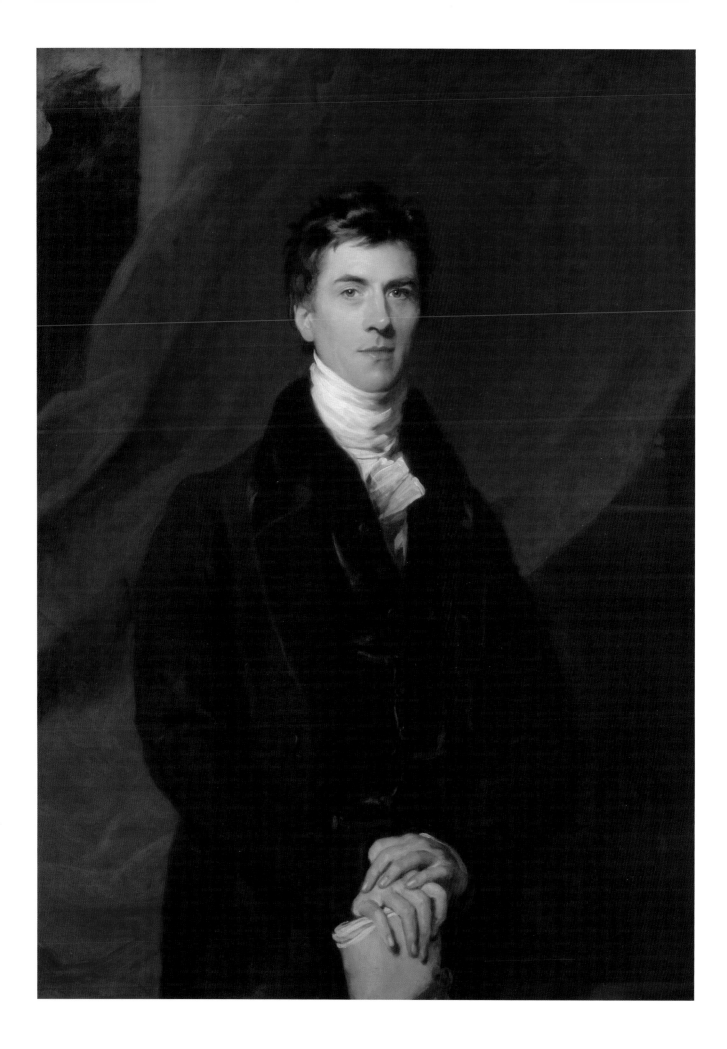

HENRY BROUGHAM and IRA ALDRIDGE
1st Baron Brougham and Vaux (1778–1868) and (1807–1867)

54 (opposite)
Henry Brougham, 1st Baron Brougham and Vaux
Sir Thomas Lawrence, 1825
NPG 3136

54.1 (below)
Ira Frederick Aldridge
After James Northcote,
c.1826. NPG L251

The glossiness and bravura of Thomas Lawrence's portrait captures the essence of the brilliant and mercurial Scottish lawyer who famously defended Queen Caroline at her trial for adultery in the House of Lords in 1820. A champion of legal and social reform, Brougham became Lord Chancellor in 1830 and had a leading role in passing the Reform Bill of 1832, an Act that redistributed parliamentary seats on a more rational basis and introduced a modest extension of the franchise.

Lawrence portrays Brougham both as a lawyer – holding a brief tied up with red ribbon – and a man of individuality and style, even within the constraints of the prevailing black and white of the upper-class professional; the only touch of colour is a blue ribbon at the waist, which holds his seals. His hair is cut short and slightly ruffled; it gives his face an air of vivacity and modernity, especially when set against his stiff, white starched-linen stock or neckcloth. Lawrence was an expert at depicting textiles, not just painting their appearance but their tactility as well. Not only does he record the details of the costume – Brougham's fine black-woollen morning coat and trousers, the rich black velvet of the coat collar and the waistcoat – but also the behaviour and feel of the fabrics – the sculptural qualities of the broadcloth, the pile of the velvet and the abrupt movement of the semi-transparent shirt ruffle. The painting of this ruffle, the hem clearly visible, is one of the many tours de force of this accomplished portrait.

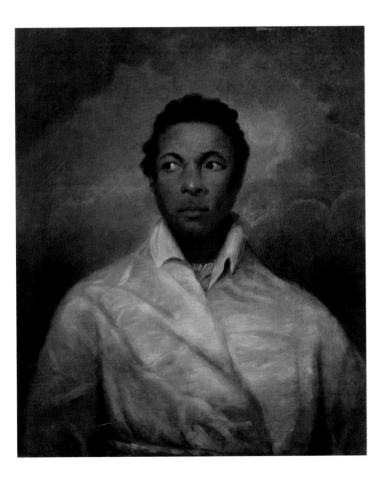

A passionate campaigner against slavery, Brougham would presumably have applauded the stage success of the black American actor Ira Frederick Aldridge (1807–67), who came to Britain from New York in 1824. (Northcote's original painting is in Manchester, a city with strong links to the anti-slavery movement.) In 1833, Aldridge made his West End debut as Othello, the role he is thought to represent here (fig. 54.1). As the Moor of Venice, he is wearing suitably exotic clothing: a pale gown wrapped across his chest, tied with a striped-silk sash around his waist. Despite the existence of a significant black presence in Britain since Roman times (in the eighteenth century there was thought to be a population of 10,000–15,000 people of African descent in the country), for some, the appearance of a black man in a leading Shakespearian role on the London stage was contentious; he achieved greater acceptance and success in Europe, eventually becoming one of the highest-paid actors in the world.

CLARA NOVELLO

(1818–1908)

55 (opposite)
Clara Novello
Edward Petre Novello, 1833
NPG 5685

55.1 (below)
*Elizabeth Knight by
Mr Gapp of Brighton*
1832

Clara Novello came from a famous musical family, the daughter of Vincent Novello, organist, composer and music publisher; she stands on his right as he plays the piano in a slightly earlier family group, also by Edward Novello (NPG 5686). Clara's soprano voice was praised by such composers as Mendelssohn and Schumann; she was the original soprano soloist in the first Italian performance of Rossini's *Stabat Mater* (1842) and was acclaimed all over Europe.

The 1830s was a decade of extremes in women's fashions, especially, perhaps, when compared to the neoclassical simplicities of the early nineteenth century. Dresses had tiny waists, widening skirts, and – the most characteristic feature of all – large, rounded sleeves, either padded or incorporating a framework of cane, and set well over the shoulder, making it difficult to raise the arms. Clara's dress (formal wear, possibly for a concert performance) is turquoise silk, fitted tightly over the torso, with a low neck and short puffed sleeves; a scarf of blonde (silk lace) floats over her shoulders.

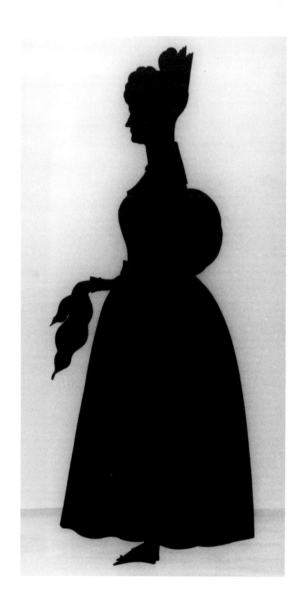

Hairstyles were particularly elaborate, the hair being gummed into gravity-defying shapes, and often trimmed with ribbons or combs. Silhouettes – like caricatures – are especially good at emphasising the salient forms of such exaggerated styles (fig. 55.1).

Clara has clearly followed these fashion dictates and adopted the Apollo-knot coiffure, very much à la mode, in which the hair was swept up into stiffened loops. Her forehead is adorned with a *ferronnière* of black silk; this was a band (or bands) of silk or jewellery, named after a style seen in a portrait called *La Belle Ferronnière*, attributed to Leonardo da Vinci (Paris, Louvre). These delicate forehead decorations were particularly popular in the 1820s and 1830s, part of the continuing vogue for sartorial inspiration taken from the Renaissance.

More informal dress of this period can be seen in William White's attractive watercolour of the Nightingale sisters (fig. i), engaged in the archetypally feminine pursuits of reading and sewing. It is hard to foresee the ferociously reforming spirit and steely determination of the future founder of the nursing profession created out of the battlefields of the Crimean War, in the young Florence seated at her embroidery.

Florence (1820–1910), in pink, and her sister Parthenope (d.1890), in yellow, wear modest versions

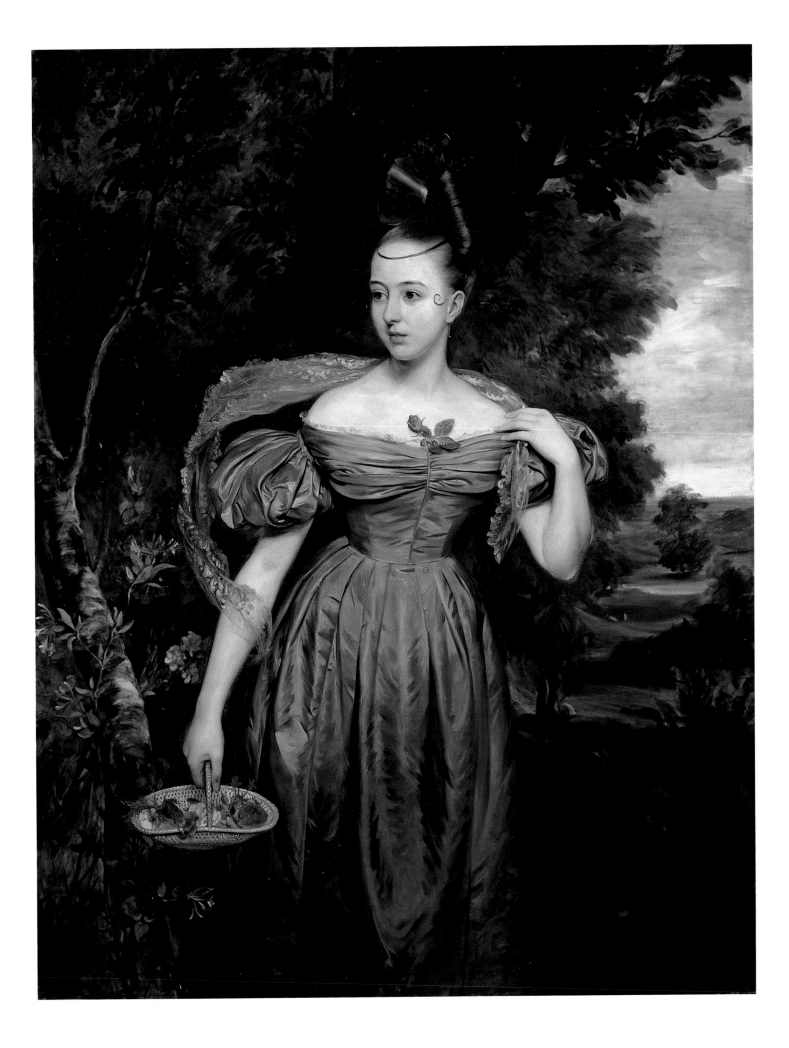

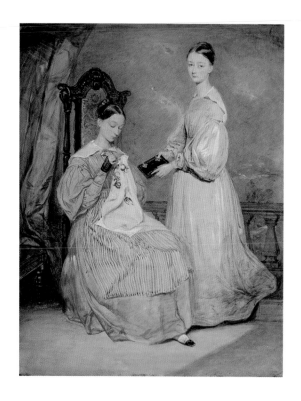

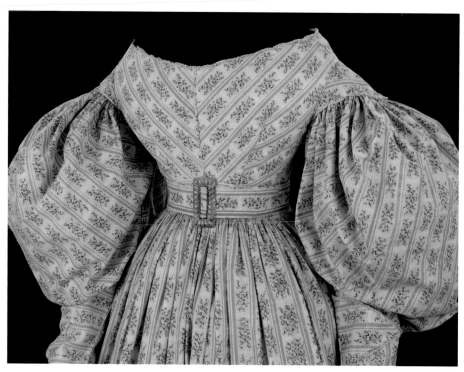

55.2 (above, left)
**Florence Nightingale
and her sister Frances
Parthenope, Lady Verney**
William White c.1836
NPG 3246

55.3 (above, right)
Printed-cotton day dress
England, 1830–5

of the contemporary paradoxical impulse for combining a kind of Biedermeier demureness and prettiness with body-deforming styles of high fashion (fig. 55.2). They wear similar day dresses, made all-in-one and fastening at the back. The plain, shining silks, large white collars and softly rounded sleeves help to create the effect of a portrait by Van Dyck, an artist who inspired later painters (such as Gainsborough and Lawrence) and was also an inspiration for fancy dress (especially in the eighteenth century), and for mainstream fashion in the 1820s and 1830s.

The Nightingale sisters' large gigot (leg-of-mutton) sleeves are typical of the decade; each style was given a name – sleeves full to the wrist (as Parthenope wears) were known as 'imbecile'; those full to the elbow (Florence's choice) were operatic in flavour, known as the 'Donna Maria' (fig. 55.3). Both Florence and Parthenope have styled their hair simply (no exaggerated Apollo-knot coiffures here), parting it in the centre and arranging it in a small, coiled bun towards the back of the head. These neat, smooth and modest hairstyles are echoed by the small, dainty feet clad in black leather, square-toed pumps. Such footwear emphasised an elegant instep and a slim ankle clad in knitted white stockings, just as the black-net mittens that Florence wears draw attention to the white skin of the hands. She is also wearing a striped apron.

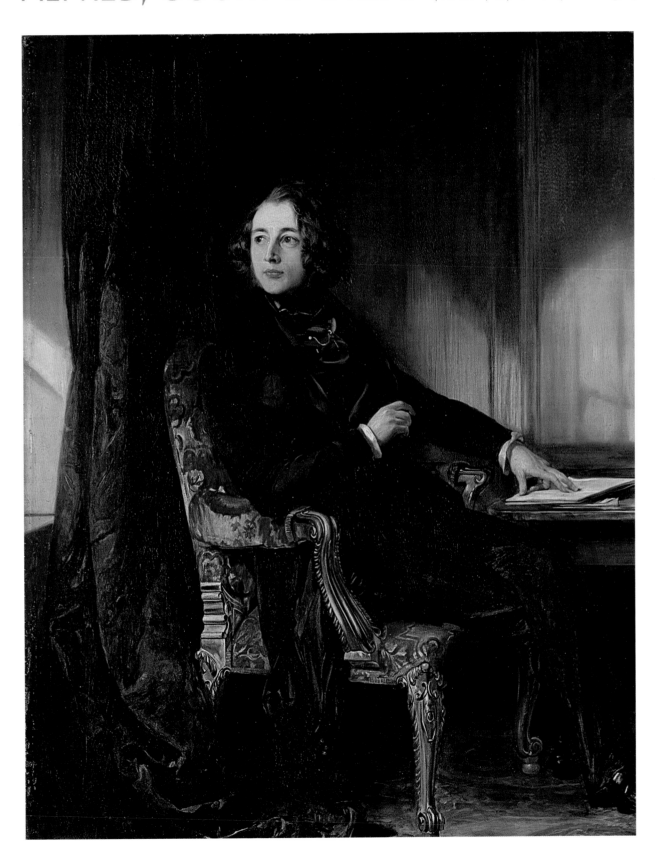

The young author (*Sketches by Boz*, 1836, and *The Pickwick Papers*, 1837, had already appeared) cultivates an almost flashy image here – Dickens's contemporaries remarked on his vanity – with shoulder-length wavy hair, wide-collared black coat and waistcoat, and trousers with foot-straps to preserve an unwrinkled line over his elegant and shining square-toed boots. His expansive black-satin cravat is kept in place with two diamond studs.

The artist has captured his sitter's penetrating intelligence and vivacity, as well as his nervous tension. Dickens liked the portrait, as did his friends and fellow-writers. Thackeray claimed that 'a looking glass could not render a better facsimile', and Carlyle, who met Dickens shortly after the portrait was finished, commented on his 'face of most extreme mobility' (he also remarked on the

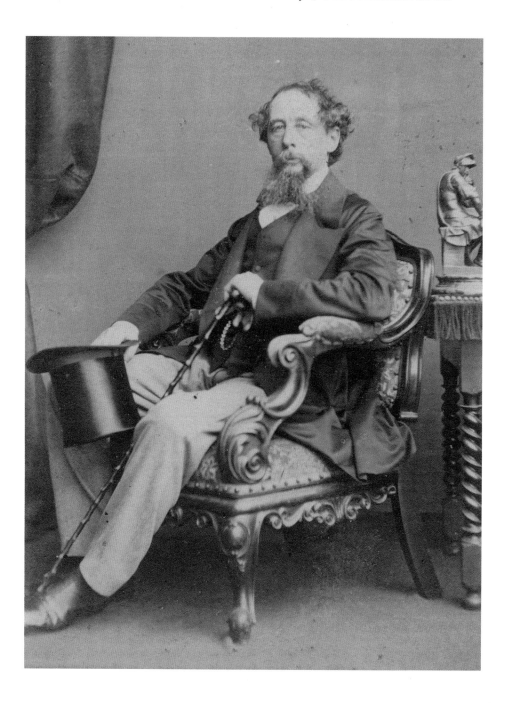

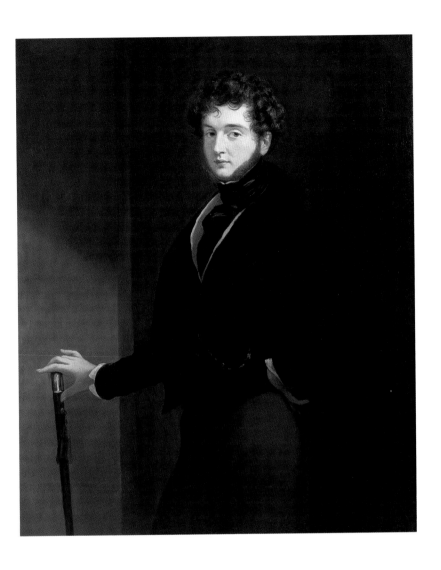

sitter's dandified costume). A dandyish air is still evident in a much later photograph of the author (fig. 56.1), whose generously cut frock coat, waistcoat, pale woollen trousers, polished boots, silk hat and knotted cane are all of the highest quality and style, but the effect of twenty or so years of frenetic activity since Daniel Maclise's portrait was painted can clearly be seen etched in Dickens's weary expression.

Maclise was one of Dickens's closest friends, part of a group that included the aesthete and amateur artist, Alfred, Count D'Orsay (1801–52), whose portrait by George Hayter (fig. 56.2) was painted in the same year as Dickens's. D'Orsay's costume consists of a cut-away black morning coat, two waistcoats (one white, one black), grey trousers and – like Dickens – a black satin cravat. His hair is curled, and his side-whiskers, which look theatrically unreal, reach almost to the middle of his chin.

Whereas, in the portrait of Dickens, the novelist assumes the guise of dandyish man of letters, D'Orsay's whole *raison d'être* was that of the dandy, a type described by Carlyle as a being 'whose trade, office and existence consists in the wearing of clothes'. His world revolved around fashion – the cut of

56.2 (above)
Alfred, Count D'Orsay
Sir George Hayter, 1838
NPG 5061

a coat lapel or a trouser leg, the perfection of patent-leather boots, the correct cravat for each occasion and to suit every mood, the best jasmine essence to perfume his primrose-coloured gloves. Such topics were elevated to works of art and discussed with the same seriousness in the salon that he held jointly with Margaret ('Marguerite') Power, Lady Blessington (famous hostess and writer of trashy novels), where high society mingled with artists and writers. Hayter's portrait, once owned by Lady Blessington, conveys D'Orsay's languid elegance and affectations of manner, as he poses, little finger crooked, with a silver-topped cane decorated with a red tassel.

57 ANGELA GEORGINA BURDETT-COUTTS

Baroness Burdett-Coutts (1814–1906)

Angela Georgina Burdett-Coutts inherited money from her mother, Sophia, daughter of Thomas Coutts (founder of the eponymous bank), and a sense of reforming zeal from her father, Sir Francis Burdett, a politician of liberal and progressive views. A great philanthropist, Burdett-Coutts used much of her wealth to aid good causes, for which she received a peerage in her own right in 1871. A hint of her educated tastes and good works can perhaps be seen in the book lying on the chair and the papers on her desk, but the overall image is that of a woman with a taste for luxury in dress (later in life she patronised the House of Worth); her costume is the reverse of saintly abnegation, and she led a liberated existence with a number of famous lovers, including the Duke of Wellington (fig. 52).

William Charles Ross, the last great miniaturist of the nineteenth century, famous for his fine draughtsmanship and colouring, has depicted a woman with a tall, slim and elegant figure (playing down her bad complexion – she suffered from eczema), in pale green silk. Her dress is demure (a characteristic of the 1840s), but with a carefully calculated touch of sexuality in the way that the neckline is cut to suggest it could slide easily off the shoulders. By the second quarter of the nineteenth century, lace was back in favour; it had never been ousted from the wardrobe of fashionable women, but it had suffered a decline during the period of neoclassical informality and simplicity. Both the traditional handmade needle- and bobbin laces were in vogue (Burdett-Coutts collected old lace), as well as the newer machine-made versions (fig. 57.1). In Ross's miniature, the sitter's dress is trimmed with a double lace flounce on the bodice and wound round her is a large stole, probably of blonde bobbin lace on a machine-net ground, one end of which falls over the back of the red cut-velvet chair, on which she leans.

Her dark, glossy hair ('like a raven's wing' was a popular phrase of approbation) is parted in the centre, looping over the ears and coiled at the back

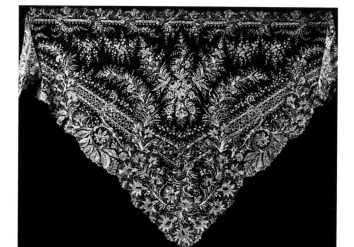

into a large plaited bun. The black velvet bracelets (the right one has a large pink topaz pinned to it) draw attention to her elegant hands; the fingers of her left hand touch her chin in the traditional gesture of contemplation.

Burdett-Coutts's dress looks as if it could be of green silk 'shot' with grey; certainly shot silk (where different coloured warp and weft yarns create a changeable effect) was very fashionable during the 1840s, and its effect can more clearly be seen in a hand-coloured daguerreotype (if this can be relied upon) of two celebrated opera singers of about the same date (fig. 57.2). Both women are in day dress: Jenny Lind, 'the Swedish Nightingale' (1820–87), on the left, 'at home' in a floral-print gown with

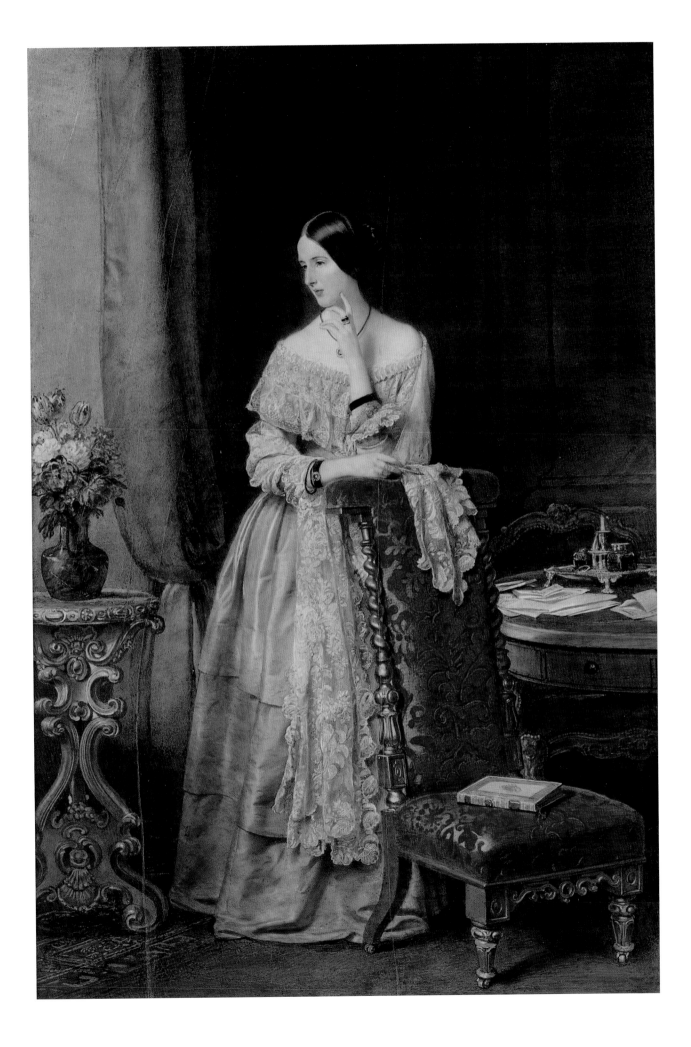

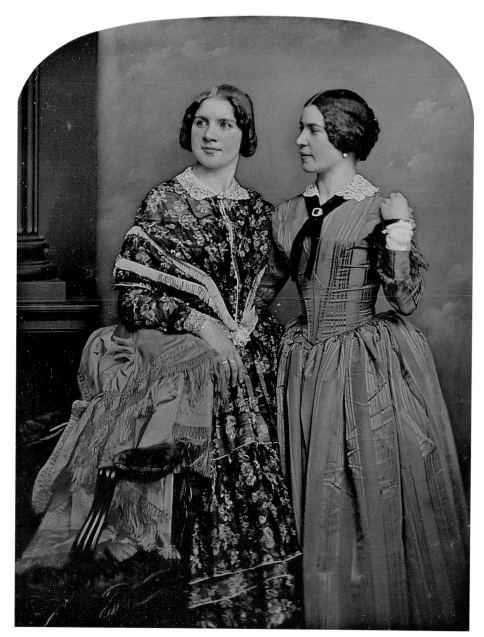

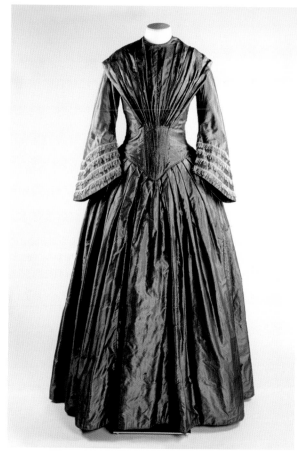

57.2 (above, left)
Jenny Lind; Marietta
Alboni, Countess Pepoli
(née Maria Anna Marzia)
William Edward Kilburn,
1848. NPG P956

57.3 (above, right)
Shot-silk day dress
1845–50

dark ground, the sloping effect of the dropped shoulder line emphasised by fringed trimming, 'receives' Marietta Alboni, Countess Pepoli (1823–94), who is dressed for visiting in a blue-and-pink shot-silk gown, stretched tightly over her corset; a matching mantle, or visite, is draped over the chair in the foreground. Alboni's dress relates closely in cut and colour to a surviving example from the same date in the collection at Chertsey Museum, Surrey (fig. 57.3). Both dresses display the influence of the Gothic style with strong vertical lines emphasised by stripes and pleating into a point at the waist or just below. This is just before the introduction of the sprung-steel cage crinoline, so the fashionable bell-shaped silhouette was achieved by pleating and gauging the fabric into the waist seam to create fullness over the hips; a number of petticoats would have been worn underneath as well, at least one stiffened with crin, a fabric made wholly or partly from horsehair (from the French *crin*, meaning 'horsehair'), which would have rustled when the wearer moved.

QUEEN VICTORIA and MARY SEACOLE

(1819–1901) and (1805–81)

58

The Secret of England's Greatness (Queen Victoria presenting a Bible in the Audience Chamber at Windsor)

Thomas Jones Barker, c.1863. NPG 4969

This is an imagined scene, with real historical figures, based on a popular but unfounded anecdote current in the 1850s. Queen Victoria is shown in the audience chamber at Windsor Castle receiving an ambassador from East Africa – probably based on Ali bin Nasr, governor of Mombasa –to whom she is presenting a Bible. On the left, we see Queen Victoria attended by Prince Albert and the distant figure of a lady-in-waiting; on the right, the shadowy figures of Lord John Russell and Viscount Palmerston in Royal Household levee dress.

The dominant figure – inevitably, in view of her regal dignity, and, literally, in terms of her vast crinolined costume – is that of Queen Victoria, wearing court dress. This consists of an evening dress of white satin liberally festooned

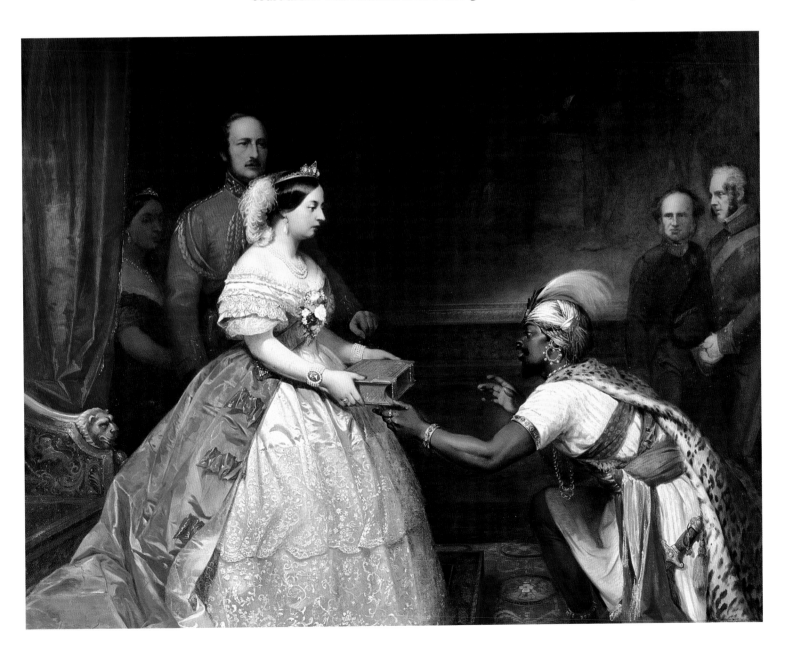

with lace (blonde on the bodice and two large flounces of bobbin appliqué on machine-made net on the skirt), to which is attached a court train of blue watered silk decorated with large ribbon bows down the sides. Feathers were traditionally worn with court dress, and Victoria has a white ostrich feather in her hair, held in place by a delicate opal tiara. Her other jewellery comprises the star of the Order of the Garter pinned to the blue sash of the Order, pearl earrings, necklace and bracelets – the one nearest to the viewer contains a miniature of the Prince Consort. Queen Victoria, although interested in clothes – at least, until she became a widow at the end of 1861 – had little sense of style, her personal taste being a mixture of the bourgeois and the grandiose; the bell-shaped skirts of the 1850s and 1860s, adorned with frills and flounces, did not suit her small and increasingly plump figure.

In Jerry Barrett's painting of the Queen (fig. 58.1), accompanied by Prince Albert and their two eldest sons, visiting soldiers wounded in the Crimea at the Brompton Hospital in Chatham, Kent, Victoria's style of dress is equally fussy and cluttered. She wears a flounced blue-taffeta day dress, striped in black and white, under a black velvet visite (a loose, sleeved mantle), and on her head is a cap of blonde lace from Caen beneath a pink silk bonnet.

As many people do, Queen Victoria became more critical of fashion as she grew older; in a letter to the Prince of Wales in 1858 she described it as 'a trifling matter', but she noted that 'it gives also the one outward sign from which people in general can and often do judge upon the inward state of mind'. These feelings

58.1
Queen Victoria's First Visit to Her Wounded Soldiers
Jerry Barrett, 1856
NPG 6203

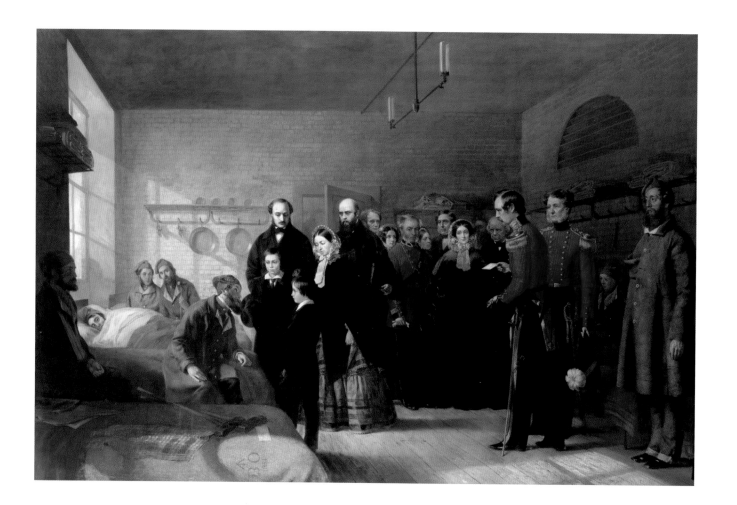

58.2 (right)
Mary Seacole
Albert Charles Challen,
1869. NPG 6856

58.3 (far right)
Mary Seacole
Maul & Co.
Date unknown

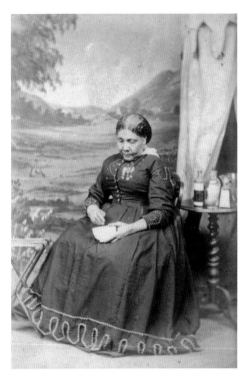

were reinforced by the death of Prince Albert in 1861 (there is some evidence that the Queen – both consciously and unconsciously – blamed her eldest son's love of extravagance and fashion for the early death of her husband), after which she wore mourning for the rest of her life.

The Jamaican nurse, adventurer and writer Mary Jane Seacole (1805–81; fig. 58.2) established her reputation during the Crimean War. Having been rejected as one of Florence Nightingale's nursing sisters, she set up the British Hotel halfway between the harbour at Balaclava and the British Army headquarters, where she dispensed food, alcohol and nursing care to the soldiers. She was subsequently thought to have been awarded the British Crimean Medal, the French Légion d'honneur and the Turkish Order of the Medjidie, and it is reasonable to assume that it is these that are depicted in Albert Charles Challen's portrait and other images of her after her return to England, such this *carte de visite* (fig. 58.3), the only known photograph of Seacole that shows her in a conventional gown with a tight bodice and full skirt trimmed with chequered braid. In Challen's portrait however, she presents a different image: her gown is indistinct but her bright scarlet neckerchief implies the dress of a practical working woman and may even represent identification with the uniform of British Army. Mary Seacole's name fell into obscurity until the 1970s, since when she has been recognised as an important figure in black British history. In 2005, Challen's portrait was used as one of a series of postage stamps, showing famous Britons, to commemorate the 150th anniversary of the National Portrait Gallery, and since 2007 her story has been included in the National Curriculum.

59 ALEXANDRA, PRINCESS OF WALES

(1844–1925)

Unlike many women of the British royal family, the Danish-born Princess Alexandra had a sense of style and enjoyed fashion. In this respect she anticipated a later Princess of Wales, Princess Diana; both women also knew instinctively how to pose for the camera, the results often being more appealing than their painted images.

At the time of this photograph, Princess Alexandra's clothes usually came from Elise in Regent Street, but from 1878 she also patronised Worth. Here she wears a day dress of spotted and plain silk, cut in the flattering style later known as *en princesse*, named by Worth in her honour in 1875. This was a dress consisting of a bodice cut in one with the skirt (there was no waist seam, the smooth fit being achieved by long darts from bust to hip), and with the back drapery looped up to create a bustle (a revival of the polonaise style seen in fig. 45.2). It was worn over another skirt, usually plain, as we can just see from the photograph. Here, the high pleated-cotton ruff (she had a scar on her neck that she wished to hide) and matching cuffs give a slight historical touch to the costume. In an unconscious echo, perhaps, of the bustle, women's hair in the

1870s was pulled back to reveal the ears, piled high on the head and gathered into a large chignon at the back. Women whose own hair was scanty wore false hair to achieve the desired height and bulk.

Again – like Princess Diana – Princess Alexandra was tall and slim, and looked good in all types of costume, formal and informal. In an age when photography ensured a more rapid dissemination of the latest modes than hitherto, Alexandra was the first member of the royal family to have fashions named after her and to set trends in informal wear, which (as noted earlier) is where novelties and experimental styles usually first appear. The Prince and Princess of Wales, who were the real leaders of London society (Queen Victoria taking on the role of the 'Widow of Windsor'), were fond of visiting Cowes on the Isle of Wight for the annual naval regatta. In a photograph of Princess Alexandra of about the same time (fig. 59.1), she wears a jacket and skirt inspired by naval uniform, and a beribboned straw hat like those worn by men for rowing. Her costume might have been made by the firm of Redfern, which began as a draper's in Cowes, and by the 1870s was making 'yachting and sea-side costumes'; they also made riding habits and the tailored suits that had become an essential part of the female wardrobe by the end of the century.

60 ANN MARY NEWTON
(1832–66)

60 (opposite)
Ann Mary Newton
Ann Mary Newton,
c.1862[?]. NPG 977

60.1 (below)
Emilia Francis, Lady Dilke
Pauline, Lady Trevelyan
(née Jermyn) and Laura
Capel Lofft (later Lady
Trevelyan), c.1864
NPG 1828a

Ann Mary Newton moved in artistic and intellectual circles. She came from an artistic background and was an artist herself, studying in Paris and exhibiting several times at the Royal Academy, London. She was married to the archaeologist Charles Newton, Keeper of Classical Antiquities at the British Museum. Her dress is made of embroidered dark peacock-blue silk, with shoulder 'epaulettes', in a style reminiscent of Renaissance costume; her hair is parted in the centre and combed back into a net, which is held in place by a ribbon; her jewellery is simple, comprising a jet necklace and a gold and garnet bracelet.

This is one of the earliest images of a woman artist in 'artistic' costume, a concept foreign to earlier periods, when female self-portraits either depict high fashion, in order to underline social and professional status, or show invented draperies. Artistic dress arose in the mid-nineteenth century in reaction to a materialistic age dominated by the overconsumption of finery, and such technological innovations as the chemical dyes of the late 1850s, which critics claimed made women's clothing a brightly coloured and vulgar display. Artistic dress was basically a simpler version of fashion, without its excessive artifice (omitting, for example, the wearing of the crinoline), and in more subtle, muted colours. It often incorporated 'historical' features, in the belief that the dress of the past was intrinsically more beautiful than that of the present. Under the influence of the Pre-Raphaelite artists in particular, many women moving in similar circles to Ann Mary Newton wore clothing inspired by the Middle Ages and the Renaissance.

In a similar vein, the portrait by Pauline, Lady Trevelyan (fig. 60.1), of her friend Emilia Pattison, who later married Sir Charles Dilke (see fig. 62.2), shows the sitter in a dress, the square neckline and large pattern of which (printed or embroidered in imitation of a cut velvet of the Renaissance) indicates the influence of sixteenth-century costume, as does her puffed hairstyle. The sitter's husband remarked that the costume in this portrait 'is that of the Venetian colour revival, inaugurated by Dante [Gabriel] Rossetti and his friends'.

In a series of photographs taken in Rossetti's garden at his house in Cheyne Walk, Chelsea, Jane Morris (1839–1914), in life as in art (she was painted many times by Rossetti in such a dress), epitomises

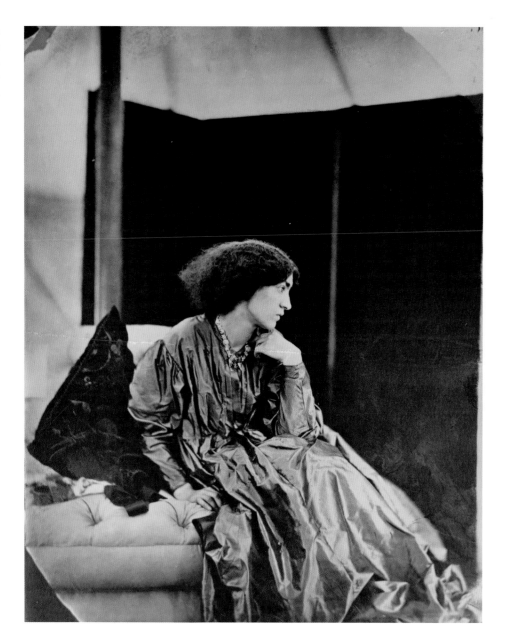

the Pre-Raphaelite ideal of 'truth and beauty in all things' (fig. 60.2). A talented needlewoman, she collaborated with her husband William on numerous embroideries and textile projects. She made her own and her daughters' clothes, according to the Brotherhood's credo that contemporary fashion, being ugly, should be rejected in favour of loose, flowing gowns (worn without corsets or crinoline underneath), a mass of crimped hair loosely tied at the back and an assortment of 'outlandish' ethnic beads at the neck. She continued to wear this rarefied style of dress for the rest of her life, despite having to put up with being the object of some amusement and derision: the artist W. Graham Robertson recalled that on holiday in France with her husband she was giggled at audibly by observers 'to the astonishment and rage of Morris, who was with difficulty restrained from throwing down his gage in the cause of his lady'.

61 LOUISE JOPLING
(1843–1933)

61
Louise Jopling
Sir John Everett Millais,
1st Bt, 1879. NPG 6612

As a leading female artist in Victorian London, Louise Jopling inhabited the most fashionable artistic circles of her time and included James McNeill Whistler and Sir John Everett Millais among her close friends, two of the most successful artists of the period, both of whom painted Jopling's portrait. In Millais's portrait, executed rapidly over five consecutive days as a gift for his godson Lindsay Millais Jopling, the couple's only child, Louise is dressed in the height of fashion, as she recalled in her memoirs, *Twenty Years of My Life* (1925): 'We had great discussions as to what I should wear. I had at that time a dress that was universally admired. It was black, with coloured flowers embroidered on it. It was made in Paris.' By 1879 the bustle had temporarily disappeared, and the fashionable silhouette was narrow and elongated. Louise's tightly fitted dress is of complex construction: seemingly, a plain black over-gown, draped over the hips to give some fullness, extends round to the back of her figure and is worn over a floral-patterned sleeved jacket and matching skirt. It creates the illusion of discrete layers, whereas the bodice and overskirt were in fact made as one unit, the false waistcoat sewn into the front edges of the over-gown and at the armholes. She wears no jewellery, the only embellishment being some carnations at her breast, bought early in the morning by her old housekeeper.

Despite the fact that Millais has not included the attributes of Louise's profession, such as an artist's brush and palette (she merely holds a fan behind her back), she appears supremely confident in her roles both as artist and model. She sat for him 'with all the knowledge of a portrait painter', and 'Of course I naturally made my expression as charming as I could.' Caught up in conversation, however, she 'forgot to keep on my designedly beautiful expression', and Millais captured instead her steady gaze, indicative of their mutual respect.

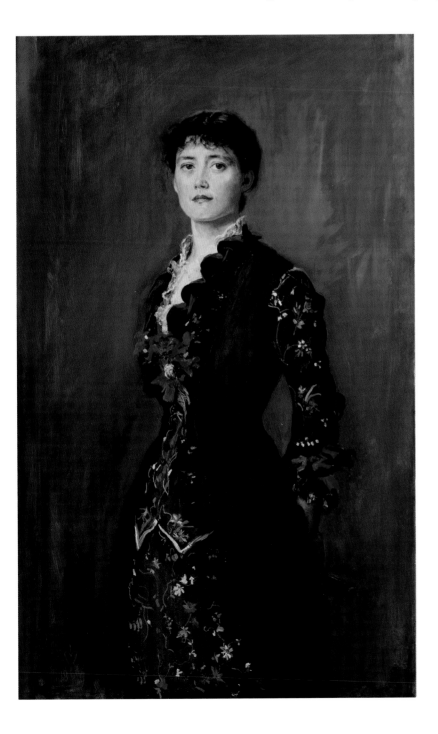

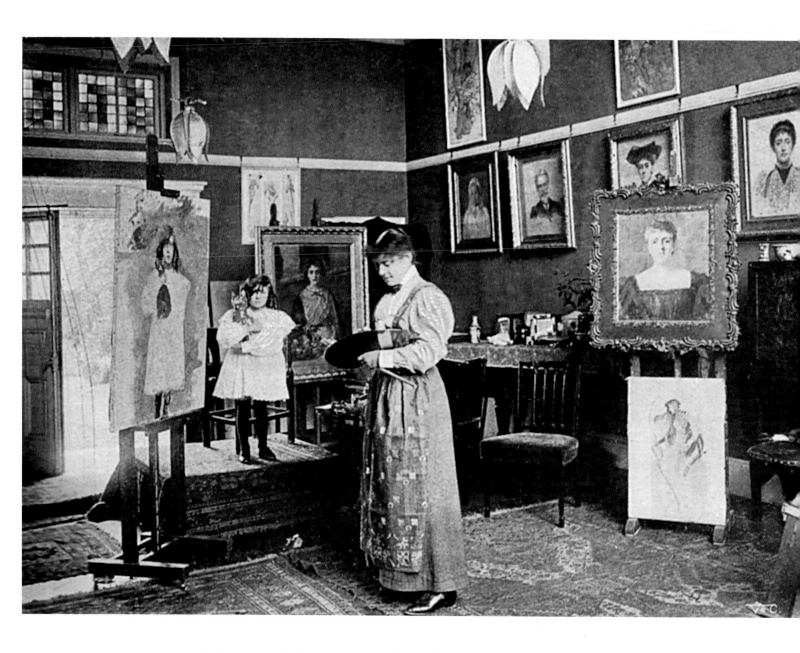

61.1 (above)
Louise Jopling in her studio
Unknown photographer
1906

In the late 1880s, Louise Jopling founded an art school and campaigned for female art students to be able to draw from nude life models; in 1901 she was one of the first women to be admitted to the Royal Society of British Artists. She supported women's suffrage and dress reform, becoming a vice-president of the Healthy and Artistic Dress Union, founded in 1890 for the propagation of 'sound ideas on dress'. When painting in her studio in Chelsea, she can be seen wearing a plain wool skirt and cotton blouse with leg-of-mutton sleeves and contrasting collar and cuffs; an embroidered apron is worn over the top for protection (fig. 61.1).

62 ADELINA PATTI and EMILIA FRANCIS, LADY DILKE

(1843–1919) and (1840–1904)

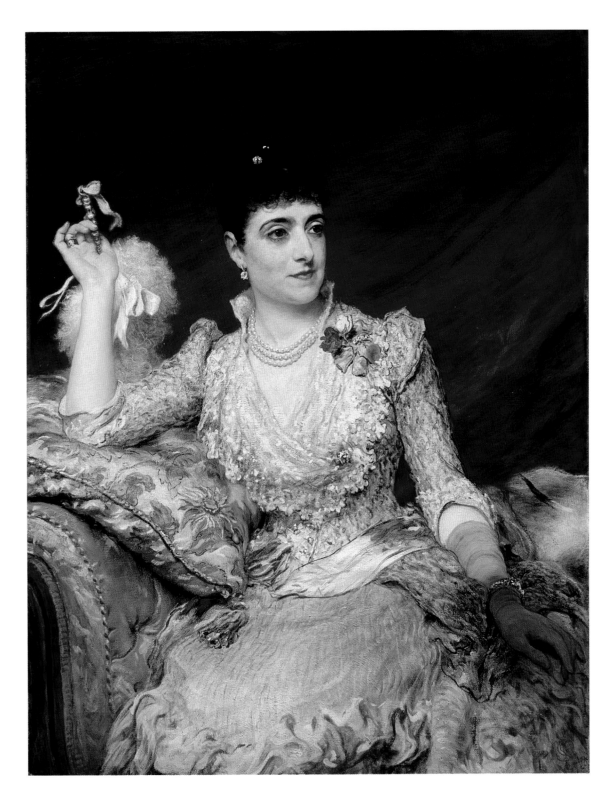

62 (previous page)
Adelina Patti
James Sant, exhibited
1886. NPG 3625

62.1 (below, left)
**Silk evening dress by
House of Worth**
c.1882

62.2 (below, right)
Emilia Francis, Lady Dilke
Sir Hubert von Herkomer,
1887. NPG 5288

The great Spanish-born coloratura soprano made her London debut at Covent Garden in 1861, in Bellini's *La Sonnambula*; she married three times, became a naturalised Briton in 1898 and retired to Wales. She was not famed for her looks (early photographs of her as a young woman show how plain she was); middle age and slight embonpoint suited her better. Here she is portrayed, not in an operatic role (although her gesture with the fan does have a slight touch of theatricality about it, and she is more heavily made up than was usual in England), but in a fashionable and luxurious ensemble of ruched-and-pleated chiffon. James Sant, a fashionable society artist, has skilfully captured the shifting, cobwebby feel of the fine silk and recorded the intricate dressmaking, with its convoluted layers and asymmetrical draperies.

Patti's whole appearance pays tribute to the conspicuous consumption of a very wealthy and fashionable woman, from the ermine wrap behind her, the dress itself and the harmonising pale pink swansdown fan to the jewellery she wears. There are pearls round her neck, and diamonds scattered liberally – in her ears, in her tightly curled hair, in the bracelet on her gloved wrist, in the brooch on her bodice and the clip that holds the small posy of flowers at her shoulder. She spent lavishly on clothes, both on and off the stage, and she was a valued customer of Worth, who may well have created the dress in the Sant portrait. Worth's signature-note at this time – a love of cunningly contrived,

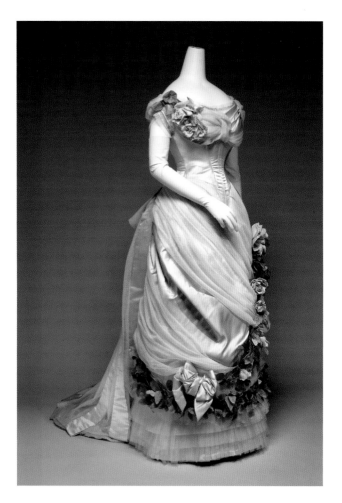

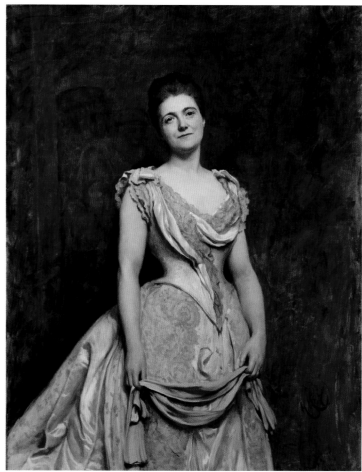

asymmetrical draperies – can also be seen in a surviving evening gown by him of about the same date, of cream satin embellished with diagonal swags of matching tulle across the skirt, trimmed with bows and festooned with a leafy garland of apricot silk roses and green ivy (fig. 62.1).

This gown also closely resembles in style that worn by Emilia Francis, Lady Dilke (1840–1904), whose portrait was painted shortly after her second marriage to the Liberal politician Sir Charles Dilke (fig. 62.2). Lady Dilke was a writer and art historian; she was also active in the reform of women's working conditions and in the movement for female suffrage. Here she has chosen to be painted neither in the kind of artistic costume of an earlier portrait (fig. 60.1), nor in the tailor-made suit that many progressive and professional women wore, but in a fashionable evening dress of heavy greyish-white satin trimmed with lace. Never a beautiful woman in the conventional sense, she is not flattered by the artist, but her intelligence and engaging personality are clearly shown. A middle-aged woman, her figure owes more to art than to nature, enhanced as it probably is by the new steam-moulded corset, which was advertised as giving the best fit and exceptionally curvaceous lines.

As in all fashionable female costume of the period, understructures of various kinds (known as 'dress-improvers') were worn under the skirt to help create the back fullness in vogue. Under her dress, Lady Dilke wears a bustle (referred to in the fashion magazines as a 'tournure') of wire and/or horsehair, which helps to create the heavy, sculptural folds characteristic of the formal toilette with its train. Hubert von Herkomer has solved the problem of what to do with the hands by making a feature of Lady Dilke's long pale-yellow evening gloves, which she holds in an echo of the pleated-and-swagged drapery on her bodice.

No doubt her art-historical knowledge would make her particularly aware and appreciative of the way in which – by the 1880s – the eighteenth century had begun to influence fashionable dress. It can be seen, very subtly, in the draping of the bodice and the lace decoration on her dress. It can also be seen in the costume that she wears in a miniature portrait by Charles Camino of 1882 (fig. 62.3). Here the sitter's velvet overdress is gathered up at the back in imitation of the polonaise gowns of the 1770s and 1780s (see fig. 45.3, for example), and the lace collar, large buttons of the dress, jabot (the ornamental frill on the bodice) and sleeve ruffles, as well as the diamond aigrette in her hair, all indicate a revival of interest in *ancien-régime* taste and luxury.

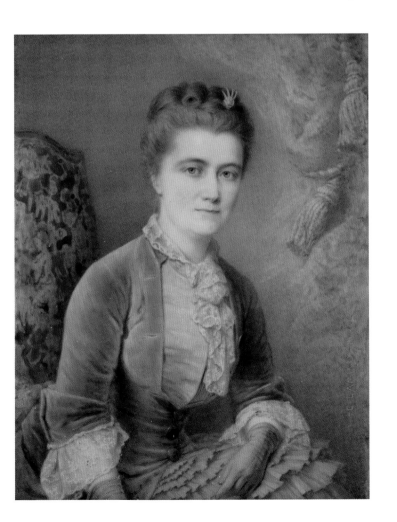

62.3 (below)
Emilia Francis, Lady Dilke
Charles Camino, 1882
NPG 1828

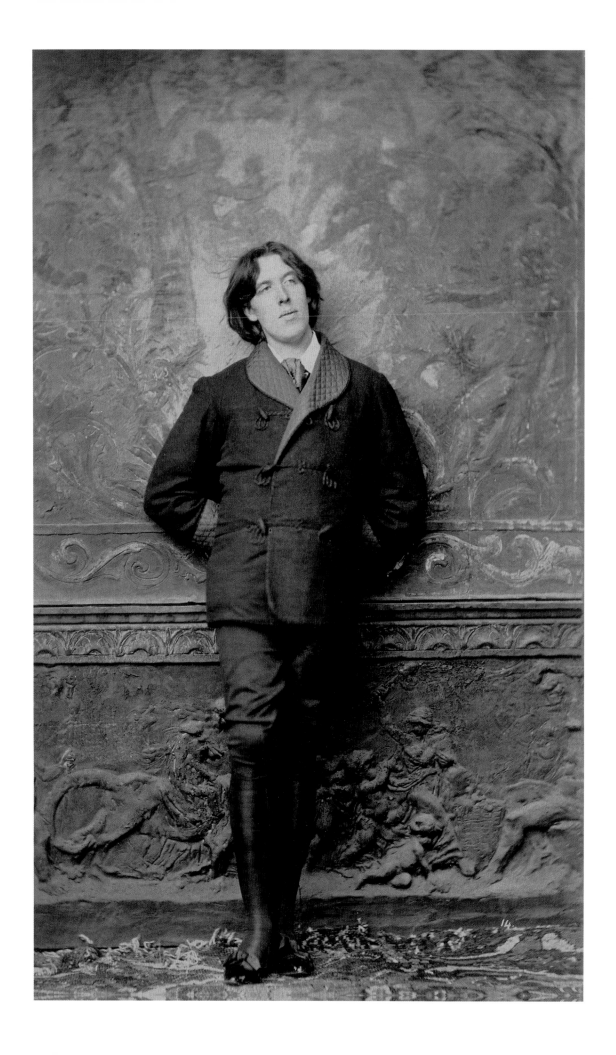

63 OSCAR WILDE

(1854–1900)

63 (opposite)
Oscar Wilde
Napoleon Sarony, 1882
NPG P24

63.1 (below)
Aubrey Beardsley
Jacques-Emile Blanche,
1895. NPG 1991

The late nineteenth-century preoccupation with artistic modes of dress, dress reform and aesthetic sensibility all merged in the shape of the young Irish writer Oscar Wilde, who arrived in New York in January 1882. Taken in Napoleon Sarony's studio as a publicity shot for his upcoming lecture tour, the photographer described Wilde as 'a picturesque subject indeed', dressed as he was in a double-breasted smoking jacket fastened with frogging and lined in quilted silk, with knee-breeches, silk stockings (these last two items especially bought for the tour from a theatrical costumier) and patent-leather pumps with ribbon bows; his long floppy hair framing his sensitive expression. Wilde famously once declared that 'One should either be a work of art or wear a work of art', and this supremely self-conscious image certainly adheres to those principles. It was an image he cultivated as a young man, and although he did not wear aesthetic dress for very long, he remained a notably flamboyant dresser.

One of the strands that made up the Aesthetic movement of this period was a love of the eighteenth century, a feature already noted in women's costume (see fig. 62.3). In Jacques-Emile Blanche's portrait of Aubrey Beardsley (1872–98)

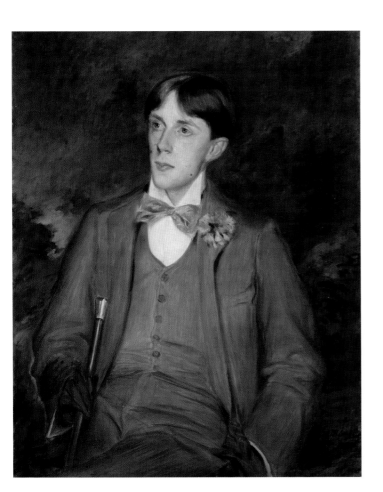

(painted in Dieppe, whence the sitter had fled in order to avoid the adverse publicity resulting from the trial of Oscar Wilde), the artist depicts not just the foppish figure of a Regency dandy but an aristocrat of the *ancien régime* as well (fig. 63.1).

Blanche thought that Beardsley looked like the young viscount in Hogarth's *Marriage A-la-Mode* series of engravings and, to underline this image of elegant depravity, has given him two black beauty spots (in the Hogarth painting these 'beauty spots' are patches covering the effects of venereal disease).

Beardsley's highly stylised graphic art – French eighteenth-century fashion plates were among the many influences on his work – and erotic imagery made him a prominent figure in the *fin-de-siècle* artistic and literary world. It was almost as if he had been invented by Oscar Wilde, and – like Wilde – his death was suitably 'artistic', even Romantic, for he died of consumption. Like Wilde, he liked to wear light colours – thus cocking a snook at the funereal clothes of the Establishment, and here he wears a suit of light grey with a matching waistcoat, a bow tie of shot silk and a pink carnation in his buttonhole; he always wore gloves and carried a cane, as dandies such as Count D'Orsay (fig. 56.2) had done.

Blanche records the costume and appearance

of his sitter, especially Beardsley's delicate bone structure, his fine floppy hair and his aesthetic manner, but it is left to Walter Sickert (fig. 63.2) to capture his personality, the thin, attenuated figure of the consumptive and his extraordinary gait. Sickert saw Beardsley at the – very appropriate – unveiling of a memorial to Keats in Hampstead Church in 1894, and painted him in 'semi-dress' wear appropriate for such an occasion – a black cut-away morning coat, grey trousers and a black-silk top hat. Close to a caricature, Sickert has exaggerated the tight line of the coat, the trouser legs, and the stiff high collar but succeeded in conveying the essence of his character, as his friends knew him. Among them was the writer and cartoonist Max Beerbohm, who found Beardsley 'more like a ghost than a living man', recalling:

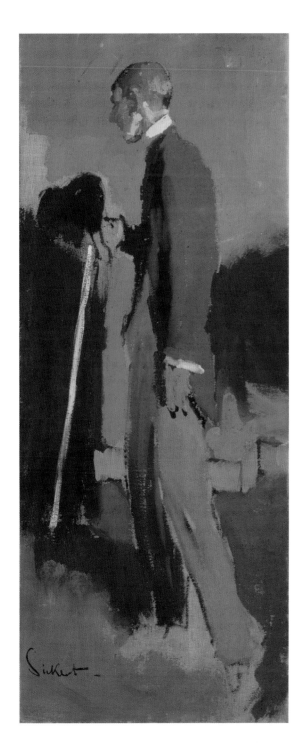

> the thin face, white as the gardenia in his coat,
> and the prominent harshly-cut features, the hair,
> that always covered his whole forehead in a
> fringe, and was of so curious a colour – a kind of
> tortoiseshell, the narrow angular figure, and the
> long hands that were so full of power.

Sir Max (Henry Maximilian) Beerbohm (1872–1956) was part of the artistic circle that included Oscar Wilde and Beardsley. His image, inspired by his hero Beau Brummell, was that of a dandy of taste and refinement. The artist William Rothenstein met him at Oxford in 1891 and noted:

> A baby face, with heavily lidded light grey eyes
> shaded by remarkably thick and long lashes,
> a broad forehead, and sleek black hair parted
> in the middle and coming to a queer curling point
> at the neck; a quiet and finished manner;
> rather tall, carefully dressed; slender fingered,
> with an assurance and experience unusual in
> one of his years.

In this portrait (fig. 63.3) William Nicholson has emphasised the bone structure of the head, with the hair plastered to the skull; he has caught the gleam on the top hat, the silver top of the cane and the shine on the patent-leather shoes. Beerbohm wears a long double-breasted Chesterfield coat, a slightly fitted overcoat, usually with a velvet collar, popular since the 1840s (it developed out of the frock coat), when it was named after the 6th Earl of Chesterfield, who was a fashionable society figure.

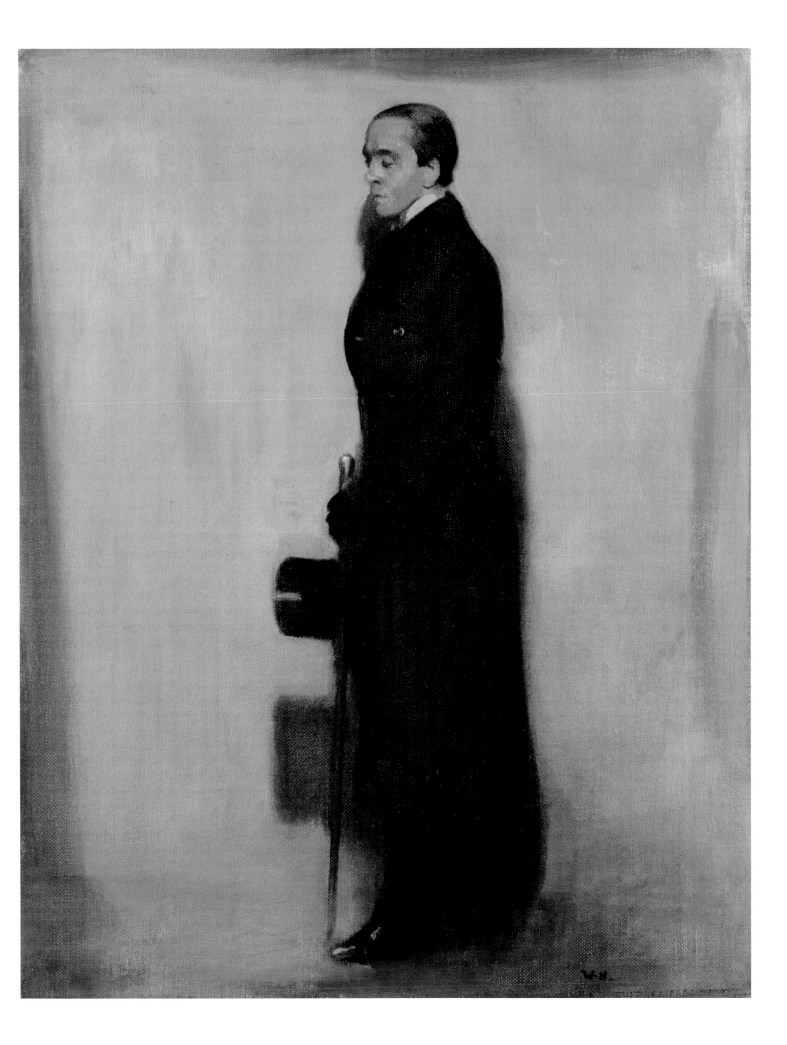

64 GERTRUDE ELIZABETH (NÉE BLOOD),
Lady Colin Campbell (1858–1911)

64 (opposite)
Gertrude Elizabeth,
Lady Colin Campbell
Giovanni Boldini
NPG 1630

64.1 (below)
Alice Helleu
Paul Helleu, c.1892

Giovanni Boldini's particular expertise lay in painting fashionably stylised images of *fin-de-siècle* society women, whose often rather risqué lives are epitomised here by Lady Colin Campbell. Divorced in 1886 by her husband on the grounds of her multiple adulteries, she counter-claimed adultery on his part; during the trial, which attracted immense publicity, she sat to Whistler in a white satin dress by Worth (the portrait, *Harmony in White and Ivory*, is either lost or destroyed). As a result of the scandal surrounding the divorce, Lady Colin was ostracised, resuming her place in society only after her ex-husband's death in 1895. She wrote books on etiquette and became an art critic for *Art Journal* and *The World*, bequeathing this portrait to the National Portrait Gallery. Sickert famously referred to Boldini's talents as 'the wriggle and chiffon school of portraiture', of which this must be a prime example. Lady Colin's impossibly attenuated anatomy is emphasised by her evening dress of black satin (doubtless, what contemporary fashion magazines called 'distinguée'), which clings to her body. Her figure and skin are set off by her dress, by the black chiffon scarf, by her black silk stockings and patent-leather shoes; the roses draw attention to her plunging décolletage and the long, pointed bodice shows off her tiny waist and curving hips. With such a costume, Lady Colin has little need of jewellery and wears only the simplest bangles, which emphasise the beauty of her arms. She is all curves and sinuous art-nouveau lines, stylishly exaggerated, like a fashion plate or a drawing by Paul Helleu (fig. 64.1).

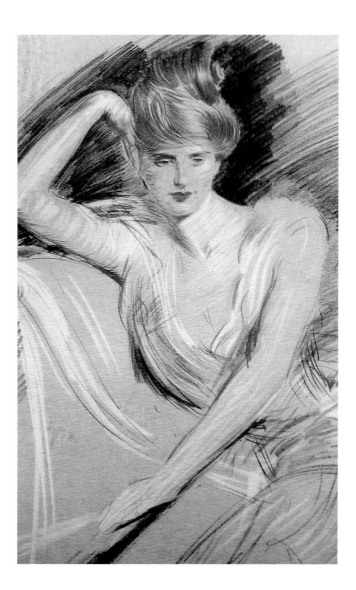

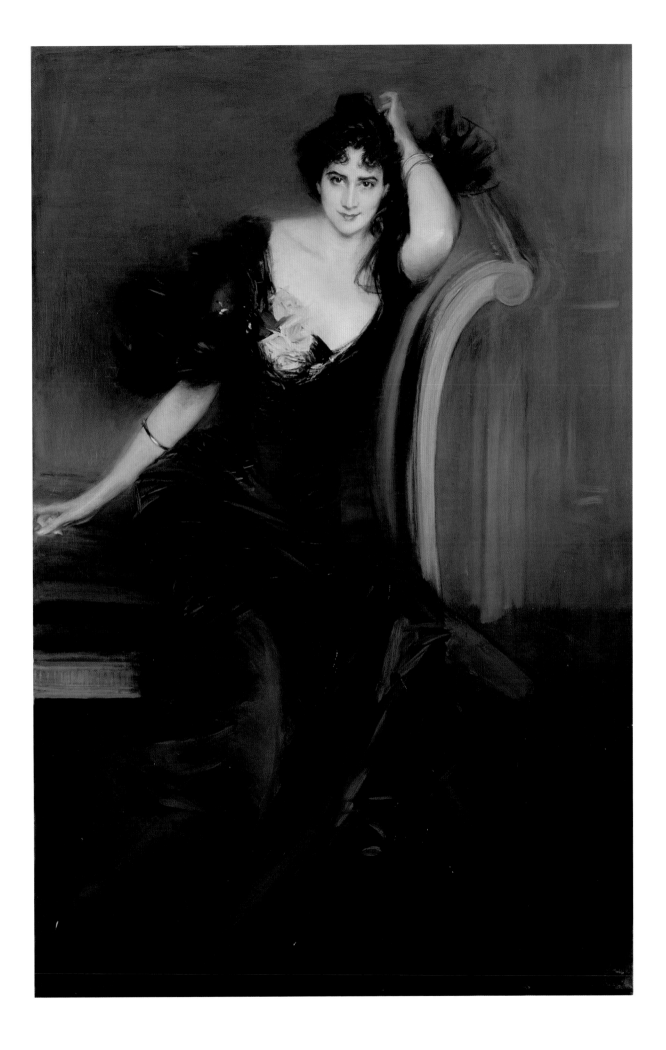

THE
TWENTIETH AND
TWENTY-FIRST

CENTURIES

FASHION
REVOLUTION

The death of Queen Victoria in 1901 did not bring a sudden end to either the opulent, upholstered nature of women's dress or the strict formality of men's, despite the accession of her pleasure-loving son, King Edward VII, who had introduced the tweed Norfolk suit as a roomy and comfortable alternative outfit for shooting and modified his own formal dress somewhat, if only to accommodate his increasing girth. Men's wear continued to be subject to strict codes of etiquette: a formal suit or frock coat for town wear, a lounge suit for informal wear; tweeds in the country and flannels (grey or white woollen trousers) for sports and leisure wear; white tie and tails or black tie and dinner jacket for the evening. Hats suitable for each occasion were always worn, and this stasis remained, except within the ranks of non-conformists and the avant-garde, until the 1960s.

At the start of the century, the fashionable S-bend corset engineered the female figure into a curvaceous, somewhat matronly silhouette with a large bosom, tiny waist and rounded posterior. Beading, chiffon frills, lace and a plethora of decorative trimmings were applied to evening gowns that were sleeveless and often startlingly décolleté. Daywear was more restrained, but even the tailor-made suit was set off by an enormous picture hat trimmed with artificial flowers, exotic bird-of-paradise plumes (fig. 65.1) or even their entire dead bodies. Furs of every kind were extremely fashionable.

Politics and dress reform sometimes go hand in hand, but the Suffragettes made a point of retaining a conventional appearance in order not to damage their cause; it was left to those with less serious concerns to push sartorial boundaries. New forms of popular culture came into vogue: ragtime, jazz and energetic dance crazes were imported from America and the sensational Ballets Russes arrived

in Paris in 1909, a city fermenting with artistic innovation and still the epicentre of high fashion. The supremacy of the House of Worth, by now one among many couture houses, was challenged by Paul Poiret, who dominated fashion from 1903 until the early 1920s. Poiret simplified the silhouette and mostly did away with complex construction, instead giving his designs impact through bold use of colour and decorative oriental motifs.

The outbreak of the First World War changed social and cultural life for good. The simplification of women's dress that had already started in the second decade of the century was accelerated by the functional requirements of wartime occupations such as munitions work, for which women adopted men's overalls; however, trousers were considered to be suitable only for very informal occasions right up until the 1960s. The reduced silhouette of interwar clothing revealed more naked flesh than ever before; the boyish, tubular dresses of the 1920s and the clinging bias-cut minimalism of the 1930s, coupled with the growing popularity of sports, demanded a svelte figure. Dietary and exercise regimes such as calisthenics became fashionable, as did sunworship – for the first time a tanned skin was a sign of leisure rather than of outdoor manual labour. A new generation of female couturières included Coco Chanel, Elsa Schiaparelli, Jeanne Lanvin and Madeleine Vionnet, all of whom in their different ways responded to the demands of the active modern woman, designing ski wear, beachwear, swimming costumes, golf and tennis outfits, daywear for town and glamorous evening ensembles.

The Second World War interrupted the narrative of fashion more brutally than the previous one; severe shortages of materials and strict rationing brought about an abrupt hiatus. However, after its liberation in 1945, Paris quickly re-established itself as the capital of couture, with Christian Dior at its centre. His 1947 collection, dubbed 'the New Look' by Carmel Snow, editor-in-chief of *Harper's Bazaar*, shocked the world with its luxury and lavish use of fabric. While for some women it was the epitome of romantic femininity; for many, Dior's nineteenth-century

silhouette represented an unwelcome return to impracticality and expense. But Dior's reign only lasted for ten years, by which time the power of the couture industry to dictate fashion was on the wane, challenged even by the master's own protégé, Yves Saint Laurent. From then on, high fashion became alive to the needs and desires of the young generation, rather than only to those of a few wealthy clients.

The so-called 'Youthquake' of the 1960s saw an upsurge of creative talent in art, design and enterprise in Britain, largely due to the strength of the art-school system. For the first time since the late eighteenth century, English style was in the vanguard of fashion; fresh, innovative designs by young British designers, sold in boutiques with blaring pop music and trendy assistants, revolutionised dress as well as the retail experience. Men's wear was finally liberated in the 'Peacock Revolution' generated by entrepreneurs such as John Stephen (fig. 79), the King of Carnaby Street. Youth subcultures, many affiliated to music genres, impacted on fashion through the second half of the century and into the new millennium: punk, for example, is a style that has had a lasting influence. Many designers continue to look to the past for inspiration, including the queen of punk herself, Dame Vivienne Westwood (fig. 84.2).

Since Charles Frederick Worth dressed Lillie Langtry in the 1880s, designers have capitalised on the ability of celebrity to sell fashion, an ability fully exploited later by the Hollywood studio system. In the first half of the twentieth century, the royal family also retained the ability to influence fashion: only Diana, Princess of Wales, continued to do this in the second half. From the 1960s onwards, through the medium of television, music became an even more significant force as a conduit of fashion, especially after the launch of the music-video channel MTV in America in 1981.

By the new millennium, fashion was inseparable from other expressions of popular culture and creative enterprise: fully integrated into the so-called 'art-celebrity-fashion nexus', an overlapping, constantly shifting, borderless creative universe that is mirrored by modern life. Models, artists, photographers and musicians contribute to and influence fashion almost as much as the couturiers and designers – many of whom are celebrities as famous as the clients they dress – who work within it. The cultural value of fashion is reflected by unparalleled media coverage and the popularity of sell-out exhibitions at major museums and art galleries in recent years. The economic value of the industry is immense, generating billions of dollars for the giant conglomerates who mostly control it, and who employ a vast global workforce. However, this growth has thrown up many ecological, environmental and ethical issues that are yet to be resolved.

Fashion as a discrete entity, dictated by a few couturiers and slavishly followed by many, no longer exists: it has fragmented into myriads of possibilities, yet this unprecedented choice too often results in the homogeneous 'sea of denim' that Coco Chanel so despised, or active-wear and trainers; it is indeed true that work-wear and sportswear have been the two most important influences on fashion since the early twentieth century.

Fashion is now disseminated through cyberspace: social media is an essential conduit for information. Online marketing platforms sell clothes from collections streamed live to mobile digital devices. The bewildering choice available is as limitless as the cyberspace through which it is delivered. It is increasingly difficult to predict in which direction designers will head next because fashion is, above all, now a matter of self-expression rather than conformity, the dictators of fashion are now its consumers.

Fashion is a word that encompasses many meanings and is frequently used negatively to connote superficiality. In spite of this, clothes remain powerful signifiers of our personalities, the coded meanings they contain no longer as easy to read as they were in the sixteenth century. The world and fashion are more complicated now, but for most of us, clothes still matter. **CB**

CAMILLE CLIFFORD and LILLIE LANGTRY
Mrs Lyndhurst Henry Bruce (1885–1970) and (1853–1929)

65 (opposite, right)
Camille Clifford
Draycott Galleries,
published by Davidson
Brothers, mid-1900s
NPG x27516

65.1 (opposite, left)
Lillie Langtry
Bassano Ltd, 22 May 1911
NPG x127699

65.2 (below)
Camille Clifford
Bassano Ltd, 22 May 1916
NPG x22156

Camille Clifford was a popular light-comedy actress, famous for her likeness to the American artist Charles Dana Gibson's handsome and statuesque women, whom she personified on the stage as the Gibson Girl.

The early years of the twentieth century saw the last gasp of exaggerated and body-deforming high fashion for women, as typified here by Camille Clifford. Her high-piled hair, crowned by a vast feathered hat, is counterbalanced by a spreading trumpet-shaped skirt, curving round from the knees to create a striking art-nouveau line. Her figure is formed into an hourglass, reliant on a corset that pushed the full bosom forward and the bottom to the back, producing what was called the S-bend shape. The resulting image of paradigmatic feminine curves – even allowing for the slight exaggeration of costume worn on the stage – is heightened by accessories such as the feathered fan, which is held up in a gesture of practised coquetry. In Aldous Huxley's novel Eyeless in Gaza (1936), the narrator opens the book by looking at old photographs, including one of his mother in 1901: 'Those swan-like loins. That long, slanting cascade of bosom – without any apparent relation to the naked body beneath. And all that hair, like an ornamental deformity on the skull.'

A decade or so later a gradual softening of the silhouette and new simplicity can be detected in the clean lines of actress and professional beauty Lillie

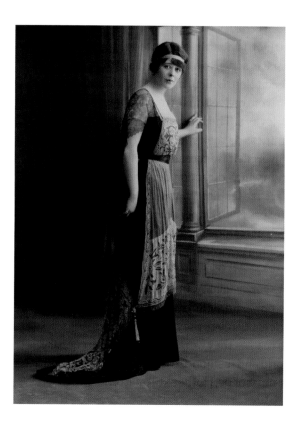

Langtry's summer toilette (fig. 65.1). A great celebrity of the day and one-time mistress of Edward, Prince of Wales, Langtry (1853–1929), known as 'the Jersey Lily', was often dressed by Worth for her stage appearances. The simplicity of Langtry's striped-linen tailor-made jacket, with its gleaming white facings and white silk blouse beneath, reflecting light upwards on to her face, is somewhat at odds, however, with the extravagant cartwheel of her plaited-straw hat and its magnificent panache of trimmed ostrich feathers.

Five years later, Bassano's portrait of Camille Clifford, taken in 1916, demonstrates that women's appearance and dress had completed its sea change, as a new mood of greater naturalism and simplicity was engendered by the First World War (fig. 65.2). Clifford's hair is simply styled, curled under at the back and sides, and held in place by a head-hugging ribbon bandeau. Her evening dress, although incorporating an embroidered, fringed and beaded over-tunic or tabard, follows the shape of the body, the ferocious corset having possibly been abandoned in favour of the lightly boned bust-bodice or brassière, which helps to create a slightly more relaxed posture.

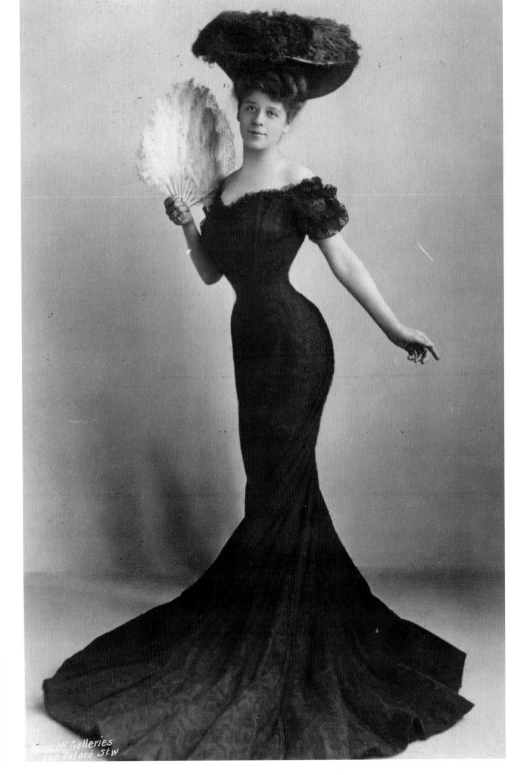

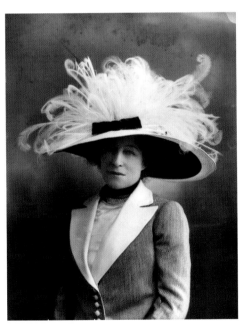

DAME CHRISTABEL PANKHURST

(1880–1958)

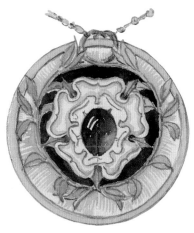

Christabel Pankhurst was the daughter of Emmeline Pankhurst (1858–1928), founder of the Women's Social and Political Union (WSPU), formed in 1903 to lobby for female suffrage. Christabel advocated militancy, and from 1905 she orchestrated a campaign of civil disobedience that included window-smashing, arson and bombing, eventually alienating some supporters, including her two sisters. Ethel Wright, a society portrait painter and fellow suffragette, depicts Pankhurst as a monumental figurehead of the Cause, striding towards future emancipation, dressed in the colours of the WSPU, a simple green-satin dress and purple-and-green sash across her chest (the colours that created the visual identity of the WSPU were chosen by Christabel's sister, Sylvia, who trained as an artist).

The suffragettes (the name given to militant suffragists by the *Daily Mail* in 1906 and subsequently adopted by the WSPU), faced with the challenge of dispelling the largely negative image of the late nineteenth-century feminist as a 'strong-minded' (that is, masculine) woman in 'spectacles and galoshes ... with a forty-five inch waist' (a stereotype frequently reproduced in Punch), used fashionable dress as a form of propaganda in the belief that 'eccentricity' would make the vote harder to obtain. The Union requested that members should be smartly dressed in public, with no overt signs of affiliation other than sashes, medals and discreet jewellery in the colours of the WSPU (fig. 66.1): the latter two items could be worn at all times, as symbols of membership, pride and to promote the movement. In 1908, an article in Votes for Women, a suffragette paper, titled 'The Suffragette and the Dress Problem', remarked that 'The suffragette of today is dainty and precise in her dress; indeed, she has the feeling that, for the honour of the cause she represents, she must "live up to" her highest ideals in all respects. Dress with her, therefore, is at all times a matter of importance.'

A postcard (fig. 66.2) shows Christabel Pankhurst attending a rally in Hyde Park, London, wearing the gown and mortarboard that signify her attainment of a degree in law from the University of Manchester, although as a woman she was not allowed to practise as a barrister. White clothing was worn by WSPU members on its parades and processions in order to create maximum visual impact; the coloured sashes alone declared their affiliation. This image of well-dressed femininity (the fashionable picture hat is retained), no doubt especially taken for publication as a promotional tool, is evidence of the realisation by the WSPU that to a large extent, the vote would eventually be won by social acceptability predicated on conformity in dress, rather than on sartorial affront.

66 (opposite)
Dame Christabel Pankhurst
Ethel Wright, exhibited
1909. NPG 6921

66.1 (above)
Design for pendant in
WSPU colours
c.1906–14

66.2 (below)
Emmeline Pethick-
Lawrence; Dame Christabel
Pankhurst
Unknown photographer,
21 June 1908. NPG x45194

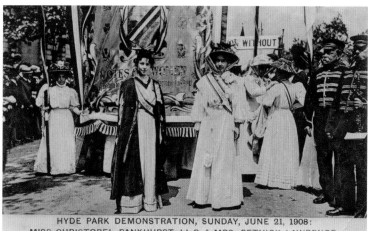

HYDE PARK DEMONSTRATION, SUNDAY, JUNE 21, 1908:
MISS CHRISTOBEL PANKHURST, LL.B. & MRS. PETHICK LAWRENCE.

67 GWEN JOHN and AUGUSTUS JOHN

(1876–1939) and (1878–1961)

The artist – principally famous for her quiet and almost obsessive still lifes, interiors and portraits – was trained at the Slade School of Fine Art in London from 1895 to 1898, and then studied in Paris until 1899, where she was taught by Whistler. She lived permanently in France after 1903 and was an intimate friend of Rodin.

This portrait was painted in London, the sitter depicting herself in a bronze-coloured 'Russian' blouse, belted at the waist over a black skirt. A soft black-silk bow at her neck complements the wide black belt and the mantle or shawl over her arm; her hair is gathered up into a large, loose bun that falls over the back of her head. It is a strong, challenging and self-confident image, with a bravura more typical of her brother Augustus John's portraits than her own work.

If any one figure symbolised the mythical land of bohemia in England in the early twentieth century, it was the painter Augustus John (1878–1961), whose rebellion against his middle-class background and his father's 'cult of the clothes brush', as he described it in his autobiography, was largely mediated through his appearance. Ottoline Morrell (see fig. 69), on meeting John for the first time, observed that 'He seemed intensely silent and rather méfiant. His hair cut like a Renaissance picture, gold earrings and a black sweater high to his neck and he looked at everyone very intensely…'. In a photograph taken in 1909 (fig. 67.1) he leans on the caravan in which he and his extended family travelled round England and southern France during the summer months, wearing an open-necked shirt and trousers tucked into high leather boots, which, along with his tanned skin, long (red) hair and beard, epitomise the romantic image of a wandering gypsy–artist he wished to project. The beard was the defining feature of the male bohemian; the sculptor Eric Gill regarded it as 'the proper clothing of the male chin, and the all-sufficing garment of differentiation'.

John was the self-appointed king of bohemian London, holding court at the Café Royal in Piccadilly and idolised by the younger generation of students at the Slade School of Fine Art, especially the so-called 'Slade cropheads' or 'Bloomsbury Bunnies', a 'little group of girls in corduroy trousers, coloured shirts, short hair,' as they were described by Ottoline Morrell. Dora Carrington, Barbara Bagenal and Dorothy Brett (fig. 67.2) were among this arty set and bobbed their hair well before the style became

67.2
Dora Carrington,
Barbara Bagenal,
Dorothy Brett
Unknown photographer,
c.1911

widespread. They are wearing fairly conventional clothes here – long skirts with
over-blouses and a painting smock in the case of Carrington, on the left – but
were usually more adventurous with their dress. Besides breeches and working-
men's trousers bought in Paris, they often wore coloured stockings and shoes of
two different colours.

LYTTON STRACHEY
(1880–1932)

68
Lytton Strachey
Dora Carrington, 1916
NPG 6662

Critic and biographer Lytton Strachey was a central figure in what became known as the Bloomsbury Group, described by Stephen Spender as 'the most constructive and creative influence on English taste between the two wars'. His seminal book *Eminent Victorians*, published in 1918, with iconoclastic essays on Florence Nightingale, Cardinal Manning, Thomas Arnold and General Gordon, set the standard for biography as a literary genre.

This unusual portrait (fig. 68) by Dora Carrington, a gifted artist who acted as Strachey's companion and housekeeper from 1917 until his death in 1932, was

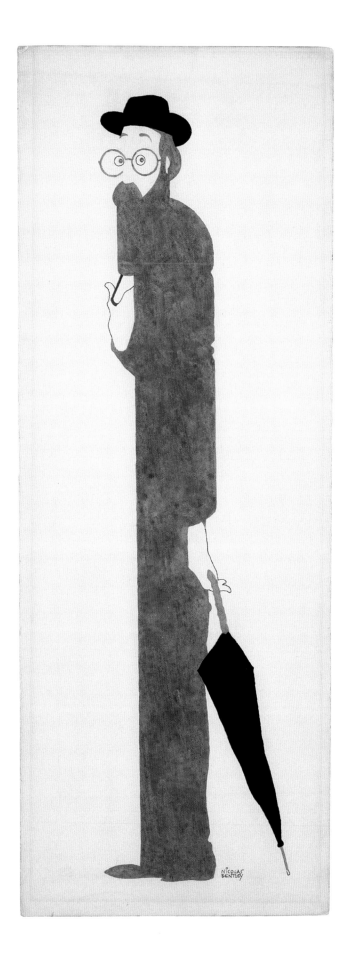

painted during the First World War, when he was a conscientious objector. The essence of Strachey's unmistakable myopic appearance is perfectly captured by Carrington, who depicts him in profile, lying on a couch with a red Kashmir shawl drawn up to his chest, his lank hair, horn-rimmed spectacles and reddish beard the epitome of bohemian style. She has paid equal attention to his elongated fingers, those 'long and beautiful antennae [that] could find passages in Racine or Dryden' as Ottoline Morrell described them. Carrington's unrequited love for Strachey, who was homosexual, was somewhat assuaged by painting him: 'I should like to go on painting you every week, wasting every afternoon loitering, and never, never showing you what I paint.' Soon after his death, she committed suicide by shooting herself.

Nicolas Bentley's affectionate caricature (fig. 68.1) imparts a more complete picture of this exquisite figure, whose soft shirt and velveteen jacket had been admired by Max Beerbohm at London's Savile Club in 1912. The male bohemians' fondness for comfortable textiles such as corduroy, rough tweeds and velvets as opposed to more conventional suiting fabrics anticipated, if not engendered, the revolution that would take place in men's wear later in the century and can be linked to the soft tailoring introduced in the 1980s by fashion designers such as Giorgio Armani.

68.1 (left)
Lytton Strachey
Nicolas Clerihew Bentley, c.1928–30
NPG 6842

69 LADY OTTOLINE MORRELL

(1873–1938)

69 (previous page)
Lady Ottoline Morrell
Augustus Edwin John, 1919

69.1 (below)
Lady Ottoline Morrell
Cecil Beaton, 1927
NPG x40290

This brilliant, idealistic and eccentric woman (wife to a Liberal Member of Parliament, who shared her aesthetic tastes and progressive views) was the patron of artists and writers at her home in Garsington, Oxfordshire, and at her London house in Gower Street, where this portrait was eventually displayed. Those attending her salon included Aldous Huxley, Lytton Strachey, Duncan Grant and Bertrand Russell.

Lady Ottoline was noted for her striking face – her large nose and jutting 'Habsburg' chin (a 1913 portrait by Duncan Grant, now in a private collection, originally had a wooden chin added to emphasise this prominent feature of her appearance) – and for her highly individual dress sense. She features as Hermione Roddice in D. H. Lawrence's novel *Women in Love* (1921) as 'a tall,

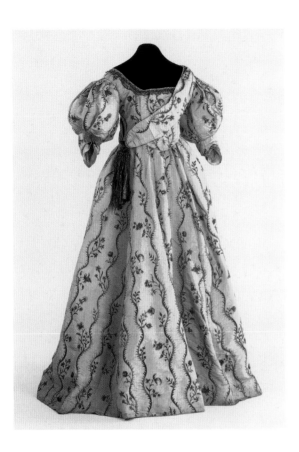

69.2 (above)
Lady Ottoline Morrell's
yellow silk dress
English school

slow, reluctant woman with ... a pale, long face', wearing eccentric garments in luxurious fabrics (some by Fortuny). In the same year, she appears as the 'dowagerish' and 'theatrical' Priscilla Wimbush in Aldous Huxley's *Crome Yellow*: 'Her voice, her laughter, were deep and masculine. Everything about her was manly. She had a large, square, middle-aged face, with a massive projecting nose and little greenish eyes, the whole surmounted by a lofty and elaborate coiffure of a curiously improbable shade of orange.'

Augustus John (with whom Lady Ottoline had a brief affair some ten years earlier) depicts her in a greenish-black velvet dress in 'Renaissance' style with a square neck and puffed upper sleeves; draped over her bosom are large ropes of pearls (painted with tooth-powder, creating a rather chalky effect), which give a somewhat Edwardian touch to the ensemble, as does her large black-velvet hat trimmed with feathers, placed firmly over her henna-ed hair. The artist was – understandably perhaps – worried about his sitter's reaction to the portrait, hoping that she would not find it 'ill-natured'. The critics were divided in their opinions, the *Star* (11 March 1920) attacking 'this grotesque travesty of aristocratic, almost imbecile hauteur', while the Manchester *Guardian* (1 March 1920) found it 'like one of the queer ancestral portraits you see in a scene on the stage ... done by a man of genius'.

Looking at contemporary photographs of Lady Ottoline, it is clear that John's portrait was not a caricature, but an honest, intelligent and perceptive image. In 1927, Cecil Beaton photographed Lady Ottoline for *Vogue* (fig. 69.1), supposedly 'in the Goya manner', emphasising her strong features and her penchant for the dramatic in dress and pose; he pulled down the shoulders of her dress for an 'historical' effect and to show off her necklace – what Huxley calls her 'customary' pearls. Ottoline Morrell collected exotic and historic fabrics, which were then made up by her maid into long, flowing 'artistic' dresses; in Beaton's portrait, her dress is of eighteenth-century-style silk – yellow with flowers embroidered in mauve and silver (fig. 69.2) – but hinting at the Renaissance in its cut and construction. Adding to the wondrous confusion of artistic influences in Beaton's photograph, the sitter is posed against a kind of swirling Vorticist backdrop (either fabric or wallpaper) and holds a Japanese paper fan, the abstract design of which also owes something to Cubism.

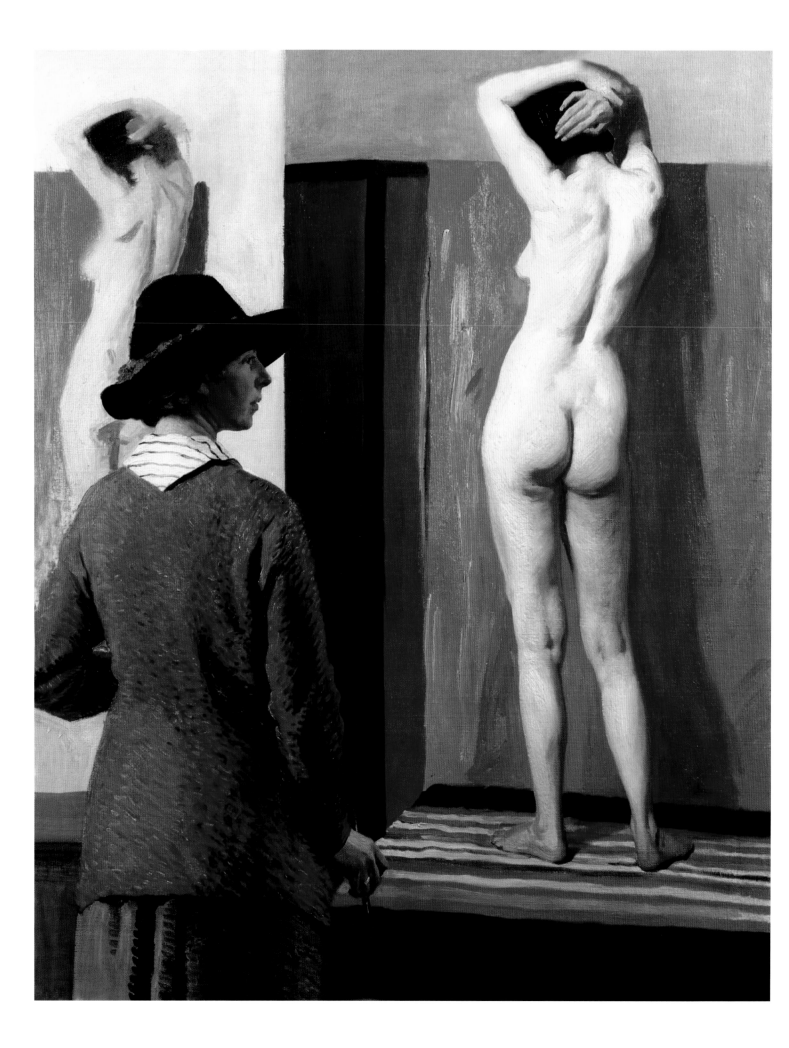

70 DAME LAURA KNIGHT and VANESSA BELL

(1877–1970) and (1879–1961)

70 (opposite)
Self-Portrait
Dame Laura Knight, 1913
NPG 4839

70.1 (below)
Vanessa Bell
Duncan Grant, c.1918
NPG 4331

Most famous for her scenes of gipsy life, the theatre and the circus, Laura Knight took the opportunity – hitherto denied to art students before the twentieth century – to paint nudes. The juxtaposition between the two back views, the nude figure of a fellow artist, Ella Naper, and the comfortable but shapelessly dressed figure of the artist, makes this a striking image. Knight wears a black felt hat decorated with a hatband made from brightly coloured twisted-wool braid and a striped black-and-white scarf round her neck, but the dominant feature of her costume is the scarlet knitted-woollen cardigan that she had bought in a jumble sale in Penzance for half a crown – this was a favourite garment and appears in a number of other paintings.

Bright colours, and red in particular, were popular with many women artists; this was possibly as a result of the impact made on the English art scene by such Fauve artists as Derain, Matisse and Dufy, in the years before the First World War. In Duncan Grant's portrait of Vanessa Bell (1879–1961) of about 1918 (fig. 70.1), bright red is the colour of her printed-cotton summer dress, the colours of its pattern being reflected in the opaque glass beads of her necklace. Grant (who lived with Vanessa Bell from 1913) painted her three times in this dress; one version (in a private collection) has a piece of the actual dress fabric attached to the portrait, at the bodice. Vanessa Bell complained that English people stared at her because of the bold colours of her clothes. This may have been one of the reasons for the failure of similar fabric designs and colours – clearly influenced by post-Impressionism – when they were made up into the dresses sold by the Omega Workshops, founded by Roger Fry in 1913. From 1915, Vanessa Bell designed dresses for the Omega Workshops; however, not only were they badly made but also – according to Virginia Woolf – the colours, 'reds and yellows of the vilest kind', were far too gaudy.

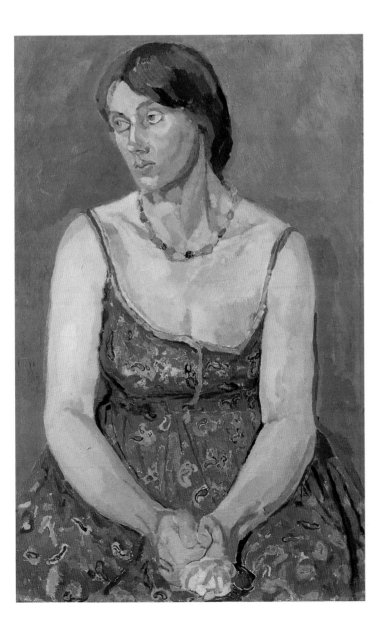

71 RADCLYFFE HALL
(1880–1943)

The famous lesbian author (her friends called her John) achieved notoriety when her book *The Well of Loneliness* (a *succès de scandale* at its publication in 1928) was banned in Britain. The largely autobiographical novel describes in some detail the masculine clothes worn by the protagonist, 'Stephen' (daughter of a wealthy couple who had longed for a boy), whose upbringing was sexually confused. Sometimes Stephen would appear in 'a suit of rough tweeds surreptitiously ordered from the excellent tailor in Malvern', or a flannel suit – 'grey with a little white pin stripe' – that she wore with a grey tie. Eventually, Stephen goes to London, becomes a novelist, wears men's clothes, cuts her hair

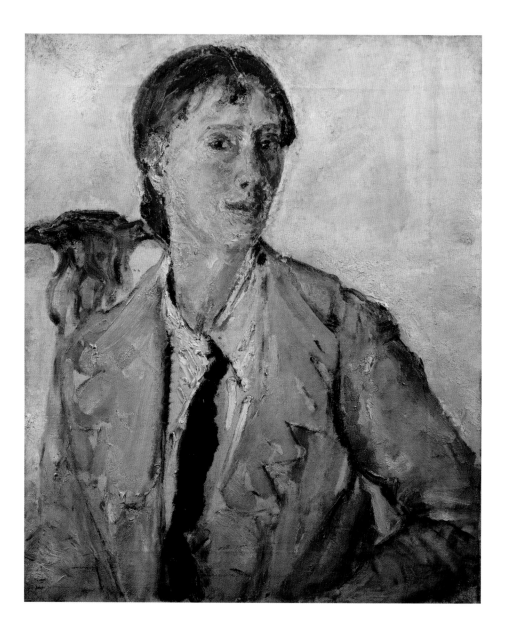

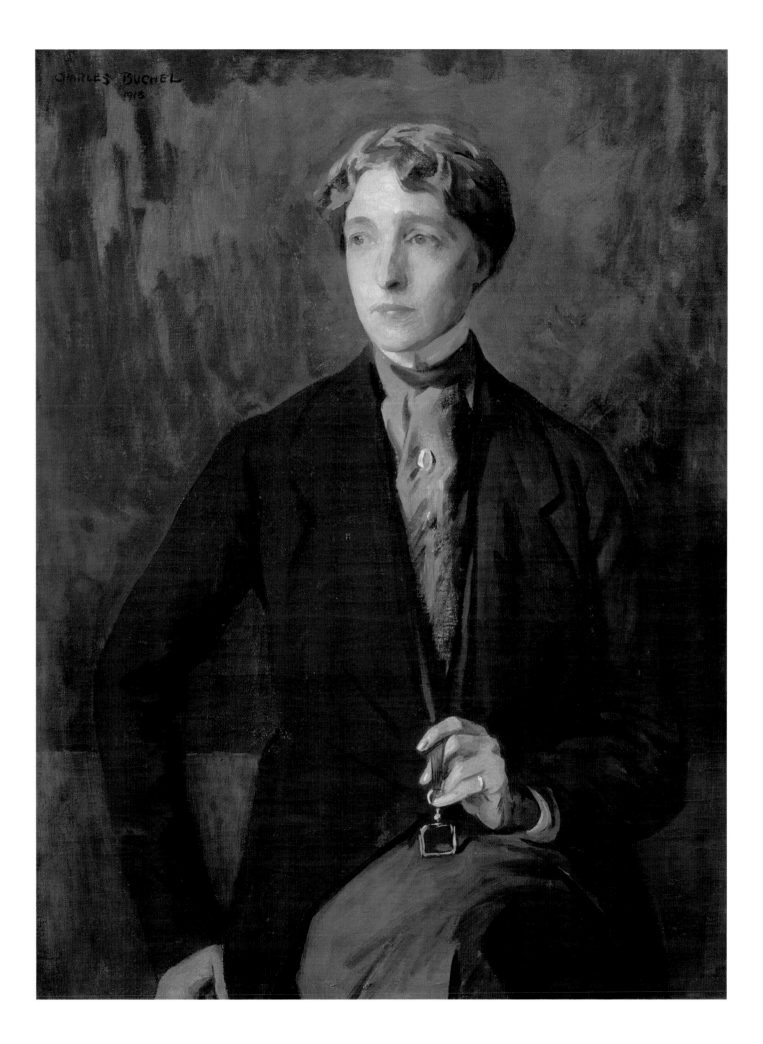

short like a man (Hall patronised gentlemen's outfitters and hairdressers herself) and smokes heavily (Hall, in fact, ordered smokers' requisites from Dunhill).

In Buchel's portrait (bequeathed by Hall's lover Una, Lady Troubridge), the sitter wears a black jacket cut along masculine lines, a grey silk cravat, kept in place with a gold and agate pin, and a grey skirt (she never carried a handbag and had pockets made in her skirts). Hanging from a black ribbon is a square gold-rimmed eyeglass. Although Hall's choice of costume is a statement of intent, a declaration of war against the constraints of convention, she is dressed in a way that would not be thought unusual at the time for progressive and intellectual women, who, since the late nineteenth century, had increasingly incorporated elements of the masculine wardrobe into their own, as being more practical and professional, and less fussily 'feminine'.

Two other examples of feminine adoption/adaption of male clothing are illustrated here. The masculinity of the shirt and tie, in Dame Ethel Walker's fine self-portrait of the mid-1920s (fig. 71.1), is offset by the zigzag collar of her yellow jacket and her long hair coiled into a bun at the nape of her neck. More overtly 'masculine' is the costume worn by the novelist and playwright Dorothy L. Sayers in William Hutchison's direct and honest portrait of the late 1940s (fig. 71.2). Here we see a large woman in a strictly tailored blue suit, white shirt and black tie, with a gold watch chain with a cornelian seal, but there are also slightly feminine touches – for example the rings she wears and the fringed blue scarf over her shoulders.

72 WINIFRED RADFORD and NOEL STREATFEILD

Mrs Douglas Illingworth (1901–92) and (1895–1986)

72 (opposite)
Winnifred Radford
Meredith Frampton, 1921
NPG 6397

72.1 (below)
Noel Streatfeild
Lewis Baumer,
exhibited 1926
NPG 5941

The artist was clearly attracted to the youthful charm of his subject – the portrait, with its heightened sense of reality, love of abstract beauty and fondness for material objects, is reminiscent in feeling of the Louvre's *Mademoiselle Rivière* of 1805 by Ingres, an artist whom Meredith Frampton greatly admired. The portrait of Winifred Radford was commissioned by her husband while she was a music student – she went on to have a distinguished singing career and to teach at the Guildhall School of Music & Drama in London. Her love of music is obviously alluded to here by the songbird.

As with the fashions of the early nineteenth century, the simple, unstructured styles of the 1920s were particularly suited to young women. Radford's costume (it has the look of home dressmaking about it) consists of a T-shaped top, possibly of rayon (the first synthetic fabrics were beginning to make an impact on women's fashions), trimmed with black net, and a plain pale skirt with unpressed pleats. The almost childish dress is in complete harmony with the short bobbed hairstyle that many young women adopted after the First World War, which we also see in Lewis Baumer's portrait of Noel Streatfeild (1895–1986; fig. 72.1), author of children's books, the most famous being *Ballet Shoes* (1936). Here the artist has caught the uncluttered simplicity of the low-waisted, sleeveless yellow dress, and the boyish front (created by a bandeau brassiere that flattened the bosom) gives the portrait a muted androgynous appeal, underlined perhaps by the slightly muscular arms, but mitigated by the delicate neck and the long string of pearls.

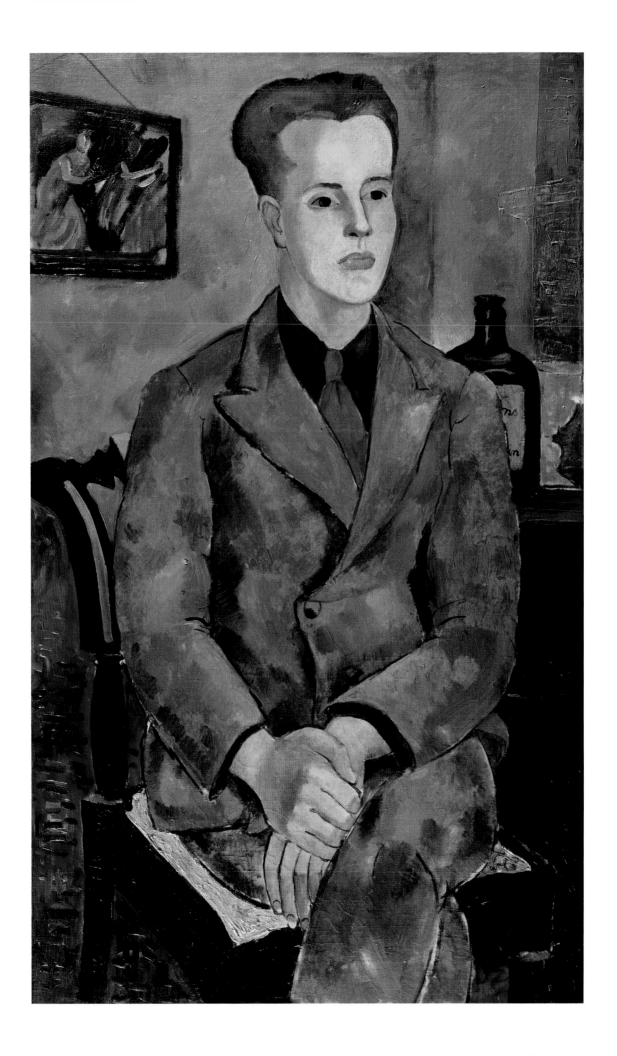

73 CONSTANT LAMBERT and HUMFRY PAYNE

(1905–51) and (1902–36)

73 (opposite)
Constant Lambert
Christopher Wood, 1926
NPG 4443

73.1 (below)
Humfry Gilbert Garth Payne
(Margaret) Ithell Colquhoun,
1934. NPG 5269

Artist and sitter met in Paris in 1925 and became close friends with similar views on art and music. They worked together on a ballet, *Romeo and Juliet*, commissioned by Serge Diaghilev, which was premiered in 1926.

Lambert was a composer, conductor and critic, a champion of modernism, who urged the incorporation of continental and jazz influences into English music, which was still in thrall to the symphonic tradition of Elgar and his followers; he was also knowledgeable about painting. Christopher Wood's artistic influences included Picasso, Cocteau and Modigliani, and his portraits – as here – are noted for both their study of character and abstract, decorative form.

Lambert's clothing, with its clashing, dissonant colours, would have been regarded as a sartorial affront to the sober formality of mainstream male fashion. He wears a high-waisted suit of greenish-yellowish fabric, which could either be wool or thick cotton, a blue shirt and a red tie. His slightly receding hair is quite bouffant on top, and his heart-shaped face and red lips present – along with his brightly coloured costume – a sexually ambivalent appearance consistent with the contemporary desire to 'épater le bourgeois' (meaning, shake up the hidebound).

From this time onwards, many men were increasingly portrayed in relatively simple and unstructured clothing, for the wearing of a formal three-piece suit, with a tailored jacket, stiff collar and tie, was regarded as too boring and conventional. Informal costume helped to create a relaxed body language, equally as revelatory of character as the depiction of the face in a portrait. A preparatory study (fig. 73.1) – sometimes known as 'The Man in the Doorway' – for the oil painting, also in the National Portrait Gallery (NPG 6230), shows the archaeologist Humfry Payne (1902–36), Director of the British School of Archaeology in Athens, dressed simply and informally in a blue open-necked cotton shirt and a leather belt round the waist of his turn-up slacks. Turn-ups, first appearing in sporting trousers in the 1860s, were in general use by the turn of the century and especially favoured in the 1920s by the Prince of Wales, the future Edward VIII, for both formal and informal wear. Blue became popular for men's shirts in the 1920s and 1930s; such garments were worn by men of liberal and progressive views, for the colour had been, since at least the eighteenth century, associated with working-class clothing.

74 HARRIET COHEN

(1896–1967)

Harriet Cohen was a well-known pianist, educated at the Royal Academy of Music, London, where she won many prizes. Her repertoire ranged from J. S. Bach to music composed for her by Constant Lambert and Arnold Bax.

74 (right)
Harriet Cohen
Ronald Ossory Dunlop,
c.1930. NPG 6165

74.1 (opposite, top)
Harriet Cohen
Joan Craven, c.1930–5
NPG x39244

74.2 (opposite, below)
**Detail of a pleated silk
Delphos gown by
Mario Fortuny, with
Murano glass beads**
1920–30

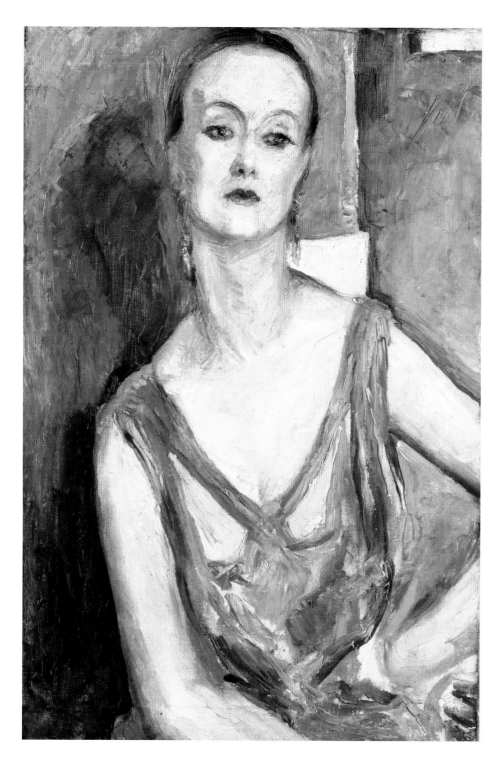

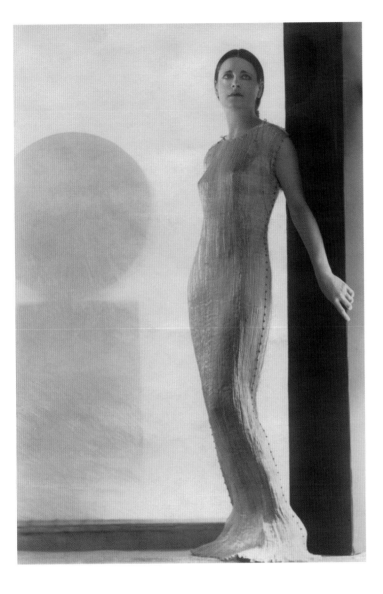

A beautiful, elegant woman with many friends in the literary and artistic world, she had a great sense of style in dress, and she is portrayed here in a gold-lamé evening gown of the kind she wore when giving public recitals. Such a low-necked, sleeveless dress not only shows off the figure but is also practical, for there are no frills, flounces or other superfluous ornamentation to hinder the movements of the arms when playing in public. In reaction to the short bob of the 1920s, many women grew their hair and wore it in a bun or a chignon at the back, as we can just see in a photograph of Cohen (fig. 74.1).

By the late 1920s women's clothing, especially for evening, had become more fitted to the shape of the body, and skirts were longer. Fabrics were often bias-cut (cut on the cross), which created a kind of elasticity, moulding the garment to the shape of the body and producing a sleek, smooth, streamlined look that emphasised a return to slightly more 'feminine' curves. For those too well upholstered, the newly invented elastic roll-on girdle proved essential. The 1930s saw a renewed interest in classical art, and the clinging draperies of antiquity could be fashionably re-created by bias-cut evening dresses or by wearing one of the multi-talented Spanish designer Mariano Fortuny's finely pleated silk gowns, such as the 'Delphos' model worn by Cohen in the photograph.

Fortuny's interpretations of classical Greek dresses in jewel-coloured silks, fastened with tiny glass beads, and gowns of velvet, hand-printed with

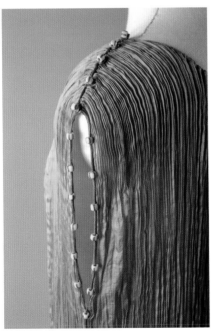

gold Renaissance and Persian-inspired motifs, were manufactured in Venice from 1906 in the factory from which the company continues to operate (fig. 74.2). Popular with women who moved in artistic and bohemian circles, they can be seen as a response to the craze for Orientalism that was sweeping through fashionable artistic circles in the early twentieth century; the greatest exponent of this aesthetic in the world of high fashion being the French couturier Paul Poiret.

Fortuny's gowns were (and still are) highly prized, collected by such women as Lady Diana Cooper (see figs 75.1 and 75.2), the American heiress and art collector Peggy Guggenheim, whose Venetian palazzo is now a museum, and the 1980s model and socialite Tina Chow. Combining timelessness and exoticism within a Western fashion vernacular, they are iconic garments, symbolic for Marcel Proust's narrator in *À la recherche du temps perdu* of Venice itself: 'The Fortuny gown that Albertine was wearing that evening seemed to me the tempting phantom of the invisible Venice. It was covered with Arab ornamentation, like the Venetian palaces hidden like sultan's wives behind a screen of pierced stone.'

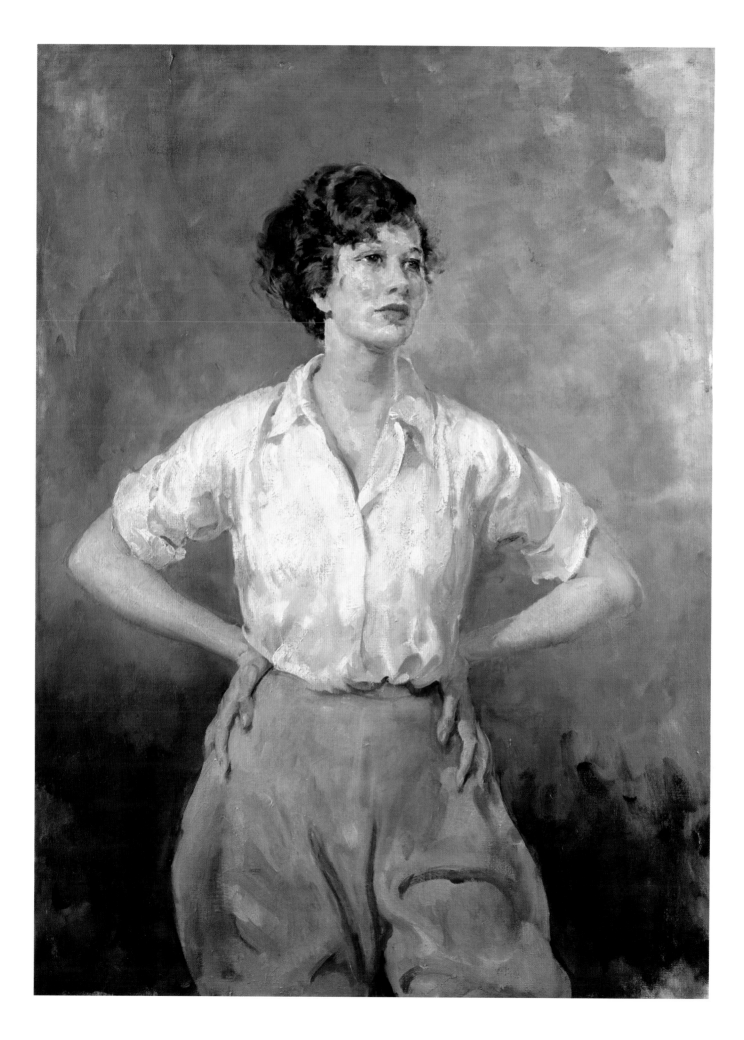

75 DAME WENDY HILLER
and LADY DIANA COOPER

(1912–2003) and (1892–1986)

75 (opposite)
Dame Wendy Hiller
Thomas Cantrell Dugdale,
c.1935. NPG 6656

As a Cheshire cotton-mill owner's daughter, Wendy Hiller was the perfect choice for the role of Sally Hardcastle in Ronald Gow's 1934 play, *Love on the Dole*, based on Walter Greenwood's novel of the same name, which launched her long career as a stage and screen actress. Sally is a Lancashire mill girl whose family's struggles with poverty and unemployment made a deep impression on critics and audiences, and brought public attention to social problems at the time. On stage, Hiller wore a pair of shorts in some scenes, but the artist depicts her here in riding breeches, perhaps heralding the gradual acceptance of trousers for women, although it was not until the 1960s that they were fully integrated into the fashionable mainstream.

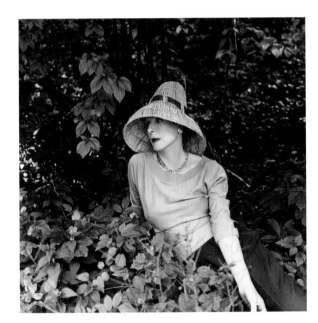

Lady Diana Cooper (1892–1986), described by Cecil Beaton as an 'artist in life' and 'one of England's great beauties', was a great fan of trousers, an attachment that was the source of much conflict between her and her husband, Duff Cooper, who did not wholly approve of them. They were obviously suitable for working on her three-acre smallholding during the Second World War, at Bognor Regis in West Sussex, where she was photographed in 1941 by Cecil Beaton in trousers, a sweater and a wide-brimmed straw 'coolie' hat (fig. 75.1). Earlier the same year she had spent the weekend at Ditchley, where Winston Churchill was also a guest, and wrote to her son: 'I look very funny in the country these days in brightly coloured trousers, trapper's fur jacket, Mexican boots and refugee headclothThey thought, no doubt, that I was a mad German assassin out of a circus.' However, when the occasion demanded it, she wore couture, such as the white and coffee-coloured Molyneux dress noted by an admirer at a lunch at the British Embassy in Washington in 1939; at the age of eighty-five, her beauty undimmed, Lady Diana wears a full-length, ombré-dyed dress by Gunyuki Torimaru (fig. 75.2), better known as Yuki, one of the earliest Japanese fashion designers to work in London (from 1972), which, with its fluid folds of draped jersey, echoes the Fortuny gowns that she collected and wore well into old age.

75.1 (left, top)
Diana, Viscountess Norwich (Lady Diana Cooper) Cecil Beaton, 1941
NPG x40065

75.2 (left, below)
Diana, Viscountess Norwich (Lady Diana Cooper)
Bernard Lee ('Bern') Schwartz, 1977. NPG P1224

ANNA and DORIS ZINKEISEN

(1901–76) and (1897–1991)

76 (opposite)
Anna Zinkeisen
Anna Katrina Zinkeisen,
c.1944
NPG 5884

76.1 (below)
Doris Zinkeisen
Doris Clare Zinkeisen,
exhibited 1929
NPG 6487

The artist Anna Zinkeisen was a well-known muralist, whose work decorated the great ocean liners of the inter-war period, the *Queen Mary* and the *Queen Elizabeth*. During the Second World War she worked as a medical artist in London at St Mary's Hospital, Paddington, her experience as an auxiliary nurse in the casualty department there standing her in good stead as she recorded operations, body parts and so on – the civilian victims of the bombing added to the normal workload of a busy hospital.

She is shown here in her working clothes as an artist, a blue smock (over a red dress), with her right sleeve rolled up. She holds her paintbrushes and cloth, and on her wrist is a bracelet with an enamelled Maltese cross, the Order of the Knights Hospitallers of St John of Jerusalem.

The most striking part of her appearance is her hair and face. During the war years, especially after the introduction of the Utility regulations in 1941, which drastically rationed clothes, one of the few ways in which women could vary the monotony of a limited wardrobe, and retain and enhance their femininity and self-esteem, was to arrange their hair in elaborate styles and wear cosmetics. Make-up, vastly improved as a result of the film industry, was seen as a boost to morale. Zinkeisen's long hair is carefully permed and set in waves to the shoulder and pinned in rolls above the brow, a style characteristic of the period. Her face is prominently made up – eyes enhanced with pencil and mascara, rouge applied to the cheeks and lipstick to the lips.

Anna's sister Doris (1898–1991) was also an artist, specialising in decorative scenes and designing for the theatre. Her talents as a costume designer for the stage are perhaps indicated in this theatrical self-portrait, exhibited in 1929 (fig. 76.1), where the prominent make-up of the period is stressed, and the eye is drawn, via the sitter's naked neck and bosom, to the dramatic sweep of an embroidered Chinese shawl.

CONVERSATION PIECE AT THE ROYAL LODGE, WINDSOR

77 (opposite)
Conversation piece at the Royal Lodge, Windsor
Sir (Herbert) James Gunn, 1950. NPG 3778

77.1 (below)
Wallis, Duchess of Windsor; Prince Edward, Duke of Windsor (King Edward VIII)
Dorothy Wilding, 7 February 1955
NPG x32656

In the re-designed Gothick setting of the Royal Lodge at Windsor (a portrait of George IV hangs above the fireplace), this informal image of the royal family taking tea is a deliberate echo of the conversation piece of the eighteenth century (see fig. 36, for example). King George VI (1895–1952) is the focus of attention of his wife and daughters, a corgi stretched out behind his chair. The King wears what had become the informal 'uniform' of most upper-class men of the time, a tweed lounge suit. With this he wears a pale blue shirt, a beige knitted pullover and highly polished brown lace-up shoes – such a costume would not look out of place more than sixty years later among elite men of a certain age.

The Queen (Queen Elizabeth, the Queen Mother; 1900–2002) wears a pale blue embroidered dress and high-heeled sling-back shoes, like her two daughters. Princess Elizabeth (later Queen Elizabeth II; b.1926) wears a tailored suit – very much the style of the 1940s – but her more fashion-conscious sister, Princess Margaret (1930–2002), has chosen a modest version of the New Look, introduced by Christian Dior in 1947. Her dress is a printed silk, with three-quarter-length sleeves and a long, full skirt that emphasises her small waist. Another minor signal, perhaps, of Princess Margaret's new sartorial independence is the absence of pearls, the conventional jewellery of the upper classes, even more than sixty years on. Both the Queen and her eldest daughter wear pearl necklaces, and, in addition, Princess Elizabeth – heir to the throne, and mother of the future heir – wears a sapphire-and-diamond brooch, which was a gift to Queen Victoria from Prince Albert on their marriage in 1840.

In contrast to the relatively modest appearance of the royal family, whose everyday clothing was much the same as that of any upper-middle-class family in Britain, there can have been few couples so united in their love of fashion and so stylish in appearance as the Duke of Windsor (1894–1972; briefly, in 1936, King Edward VIII) and the American divorcée Wallis Simpson (1896–1986), whom he married in 1937 (fig. 77.1).

As Prince of Wales and Duke of Windsor, Edward set a number of fashions – these included the Fair Isle jersey for playing golf, suede shoes, chalk-striped double-breasted suits, the backless waistcoat for formal morning

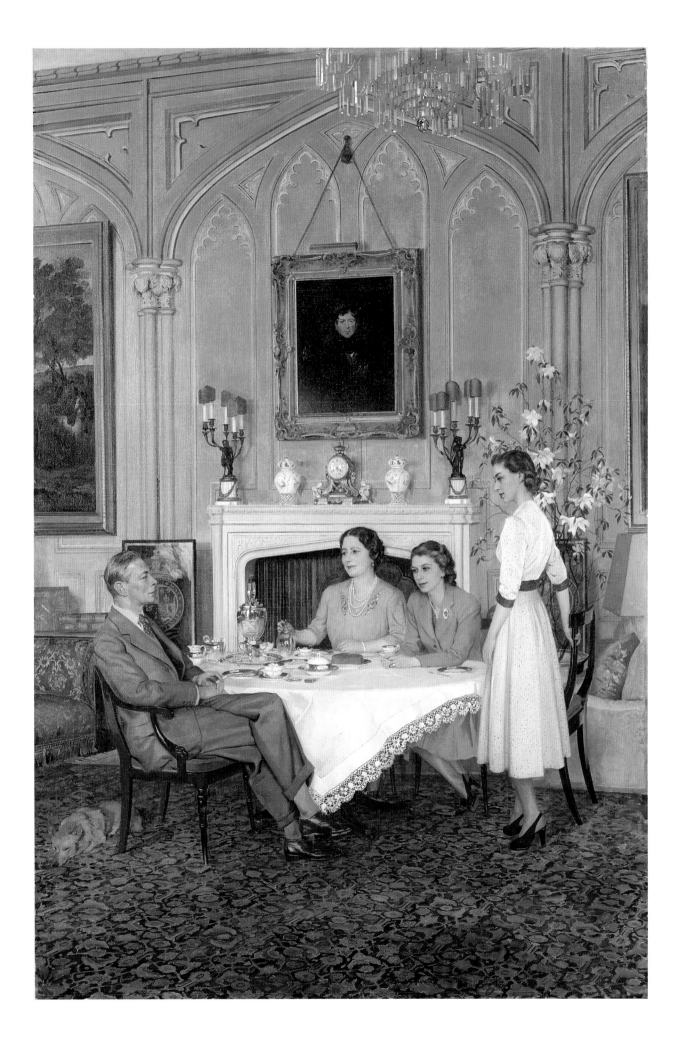

wear and the dark blue evening-dress tailcoat. On his visits to the United States, where he was very popular, he had been impressed by the informality, both in clothes and in manners, that he found there, and he attributed his guiding principles in dress – 'Comfort and Freedom' – to American influence. Such principles, he claimed, 'underlay the changes in male fashions throughout the freer and easier democratic age between the Wars'. The Duke of Windsor was interested in his appearance – he retained his slim and elegant figure throughout his life – and he had decided views on his clothes. During the Second World War, when he was Governor of the Bahamas, he started to have his trousers made in New York (the high-waisted, fuller styles, with a pleat front and turn-ups, were impossible to obtain in wartime London), but his jackets were tailored in Savile Row by Frederick Scholte. He kept swatches of fabric from his clothes, including a dark blue Highland wool with a white overcheck, which was made up into the jacket (part of a suit) that he wears in this photograph. The shirt has a soft, turned-down collar, and his tie is a printed silk with a small Paisley pattern.

The brittle elegance and cosmopolitan chic of the Duchess of Windsor is revealed in her well-groomed appearance and her dress. Her hair is centrally parted and carefully waved, and immaculate make-up enhances her beautiful complexion (Cecil Beaton said that her skin was as smooth as the inside of a shell). She wears a navy knitted cardigan with ivory zigzag grosgrain braid at the neck and wrists, possibly by Mainbocher, one of her favourite American designers. The Duchess was famous for her jewellery, preferring the contemporary to the antique. On her engagement-ring finger is a large, square table-cut yellow diamond, and at her wrist a Cartier diamond bracelet with jewelled crosses, each one inscribed on the back with the date of a significant event in the couple's relationship; even the pearls she wears – a choker necklace and clip-on earrings – look more up-to-date than the traditional styles favoured by the women of the royal family.

The Duchess's innate sense of style, her good bone structure and her ability to present herself well made her an excellent subject for the photographer, whether an undemanding and conventional society photographer such as Dorothy Wilding or a creative artist like Irving Penn, whose portrait (fig. 77.2) is a more dramatic image. Wearing a jersey dress with the calf-length skirt of the New Look and fitted at the waist with a belt and a wide band of contrasting colour, she stands hemmed in by threatening walls, as though in a cavern. Is she meant to be Ariadne, who gave Theseus the thread by which he could return safely from the labyrinth after having killed the Minotaur, and who was then abandoned by him on the island of Naxos?

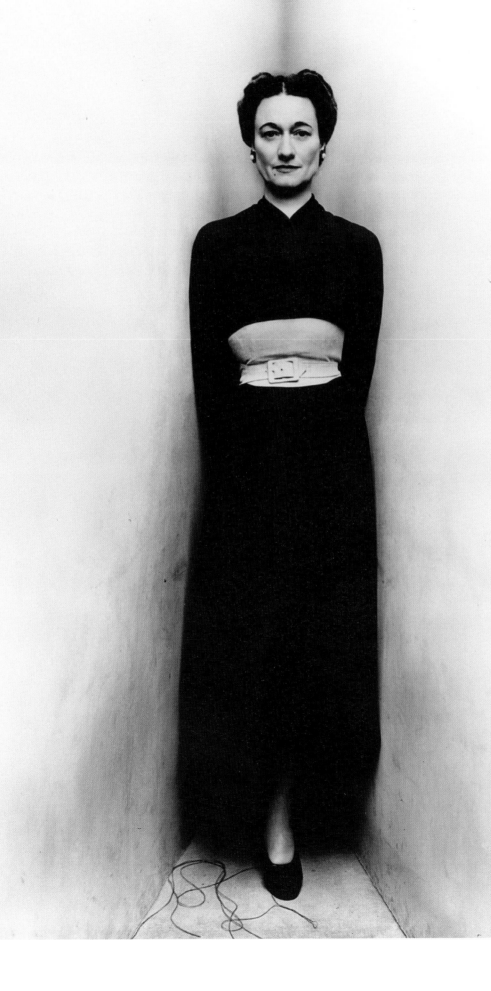

78 (opposite)
John Minton
(Edward) Russell
Westwood, 1951
NPG x35236

78.1 (below)
Harold Pinter
Cecil Beaton, 1962
NPG x26070

Regarded as one of the most promising artists of his generation, John Minton taught painting at the Royal College of Art from 1948 until his suicide in 1957. Charming and charismatic, he was a key figure in London's artistic community during the 1940s and 1950s, but his increasing alcoholism and isolation, owing in part to his advocacy of figurative over abstract painting, eventually brought about his death at the age of thirty-nine. He is perhaps best remembered as an illustrator whose work will be familiar to many from Elizabeth David's first two cookery books, *Mediterranean Food* (1950) and *French Country Cooking* (1951).

During the 1950s a variety of influences on men's clothing – working-class styles, popular music and film, as well as 'alternative' fashions – increasingly infiltrated the male wardrobe. Lee Cooper denim jeans were manufactured in Britain from 1946, but authentic Levi jeans, originally made as work wear for prospectors in the California gold rush in the mid-nineteenth century, were almost impossible to obtain until the late 1950s, except from a few specialist shops that sold imported American clothing. Minton wears a pair of baggy denim jeans with turn-ups and a striped short-sleeved jersey shirt (derived from sportswear) with a T-shirt underneath (derived from underwear), demonstrating the increasing adoption of casual American-style clothing, most of it based on sports- and work wear, among the younger generation.

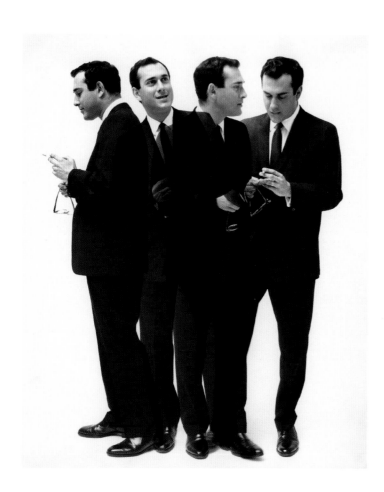

However, for many men the suit remained a staple of the male wardrobe; like other great classics such as the cardigan and the kilt, for example, it has the ability constantly to reinvent itself. Cecil Beaton's photograph of the playwright Harold Pinter (1930–2008; fig. 78.1), a clever overlapping of four images, shows a handsome young man in the kind of conventional dark suit that would be bought to signal a specific rite of passage – such as leaving school, going to university, gaining a job, marriage – or as a symbol of material success. Pinter claimed: 'I never had a suit until 1960,' the year of his first really successful play, *The Caretaker*, and this is the suit in the photograph, purchased from Austin Reed. It comprises a moderately fitted jacket with three buttons (only the middle one was to be fastened) and narrow-cut trousers with turn-ups. His hair, slightly receding at the temples, is cut short, and he holds a pair of spectacles as well as a cigarette – smoking featured widely in photography of this period.

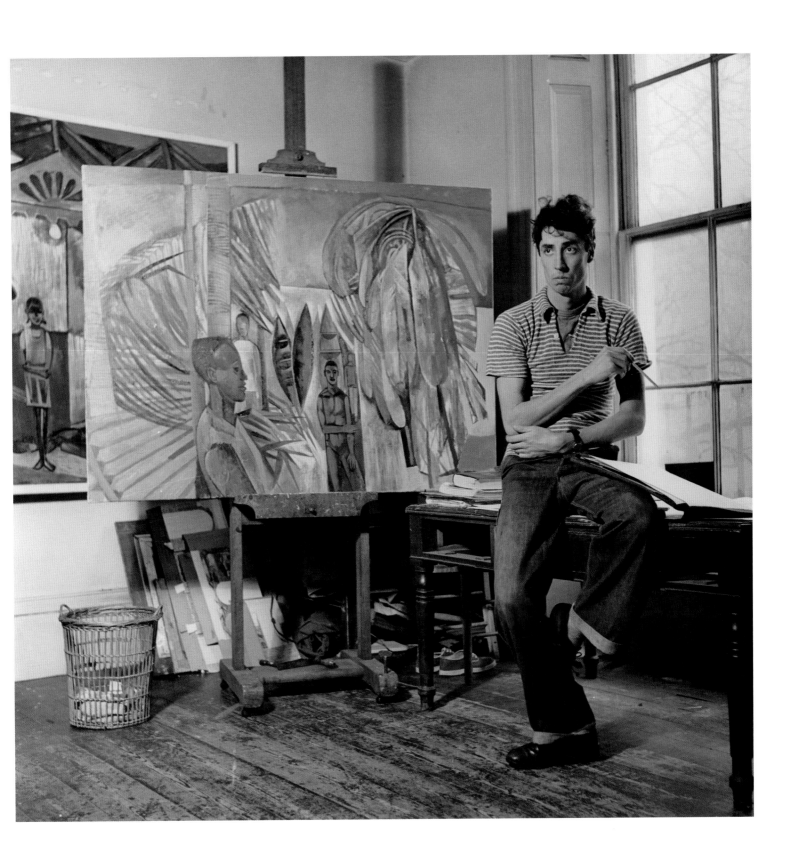

JOHN STEPHEN

(1934–2004)

79 (opposite)
John Stephen
Angela Williams, 1960s
NPG x125457

79.1 (below)
The Beatles
Harry Hammond, 1963
NPG x15550

The so-called Peacock Revolution in men's wear that began in the late 1950s was largely driven by the Glaswegian John Stephen, who became known as the King of Carnaby Street. One of the first fashion entrepreneurs to respond to the upsurge of youth culture in post-war Britain, he channelled the Continental tailoring beloved by the Mods (a term originally derived from Modernist bebop jazz fans), until then a style worn only by this small subcultural group, on to the high street. His string of boutiques (by 1963 he owned eighteen shops on Carnaby Street alone), with their blaring music and youthful assistants, changed the retail experience for good. Carnaby Street became synonymous with Swinging London, an agglomeration of boutiques specialising in fast-changing, affordable young fashions; the so-called London Look was exported further

afield by pop groups such as The Beatles and The Rolling Stones, both of which undertook tours of America in 1963.

The Beatles (fig. 79.1), the first British pop group with a truly international status and following, were transformed by their manager, Brian Epstein, from leather-clad rock and rollers into clean-cut Mods; they are seen here in their new Tonik mohair suits with collarless jackets made for them by Dougie Millings, a show-business tailor in London's Soho, just before their debut performance at the London Palladium. The Beatle haircut and Chelsea boots, from dance-and-theatrical footwear company Anello & Davide in London's Drury Lane, completed the uniform brand image that more or less lasted until they met Maharishi Mahesh Yogi in 1967.

The Rolling Stones's music was more firmly rooted in the blues than The Beatles's popularist style, and their edgier image was expressed through their various sartorial choices. Photographed in the same year as The Beatles (fig. 79.2), they all wear their hair longer than the Fab Four, but any uniformity among the members of the group ends there: separates are worn, or suits subverted by the addition of a leather jacket, in the cases of Bill Wyman and Brian Jones, while only the drummer, Charlie Watts, who continues to be regarded as an elegant and stylish dresser, wears a tie.

79.2
The Rolling Stones
Terry O'Neill, 1963
NPG x126149

80 JEAN SHRIMPTON and DAVID BAILEY

(b.1942) and (b.1938)

80 (above)
Jean Shrimpton;
David Bailey
Peter Rand, 1962
NPG x136000

It could be said that between them David Bailey and Jean Shrimpton, also known as The Shrimp, established both the early fashionable image of Swinging London and its visual representation. Having graduated from Lucie Clayton's modelling school at the age of seventeen in 1960, The Shrimp's early success as a model soon made her doe-eyed beauty, closer to beatnik than classical, the look to emulate, displacing previous notions of the feminine ideal typified by immaculately groomed, wasp-waisted models with haughty expressions. For his part, Bailey, one of the Terrible Trio of young East End boys that included Terence Donovan and Brian Duffy, rejected the autocratic style of the previous decade's photographers and breathed new life into fashion photography. They made a golden couple (Shrimpton became the world's highest-paid model by 1965), rarely out of the celebrity columns during their relationship; more significantly,

80.1 (right)
A Crate Full of Quant
(Dame Mary Quant,
Alexander Plunket Greene
and nine models)
John Adriaan, 1 April 1966
NPG x133068

80.2 (opposite)
Twiggy
Barry Lategan, 1966
NPG x133189

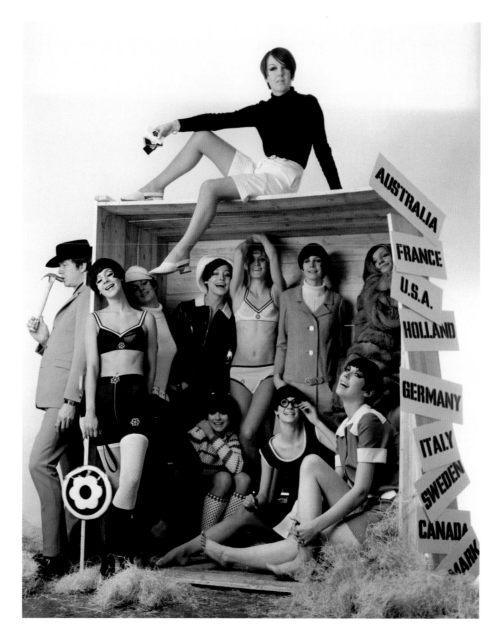

their creative collaboration on fashion shoots such as the fourteen-page spread, titled *Young Idea Goes West*, which appeared in British *Vogue* in April 1962, transmitted the buzz of London's so-called Youthquake to America. On seeing it, the current editor of American *Vogue*, Diana Vreeland, declared in typically abbreviated style: 'England. Has. Arrived.' Wearing an assortment of clothes by British brands and accompanied by her Neurosis teddy bear, Shrimpton posed against a backdrop of various gritty New York street scenes, shot by Bailey in the documentary style that became the inspiration for the 'straight-ups' used in fashion editorials in 1980s magazines such as *The Face* and *iD*.

After deciding to end her modelling career, Jean Shrimpton retreated to Cornwall to run a hotel. Bailey remains one of the most celebrated and active photographers and film makers of his generation: his first museum exhibition was held at the National Portrait Gallery in 1971; more recently, *Bailey's Stardust*,

a retrospective held in February 2014, was one of the largest-scale photography exhibitions ever held at the Gallery.

If Shrimpton and Bailey created the image of the London Look, it was the fashion designer Mary Quant (b.1934) who established its sartorial identity early in the decade and is widely associated with the introduction of the iconic

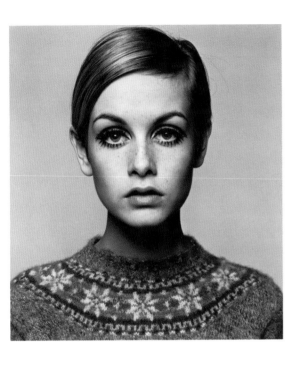

miniskirt, although this is debatable. Having opened her first boutique, Bazaar, in Chelsea in 1955, her sharp silhouettes and poster-paint colours, combined with a playful approach, gave new life to traditional garments such as the pinafore dress, transposing it from school uniform to trendy modernity. She applied her irreverence to a wide range of products, from zany plastic boots in bright colours to underwear, hosiery and cosmetics.

In 1966, at the launch of Quant's range of cosmetics, packaged in slick black and silver and branded with her daisy logo, fashion journalist Felicity Green's article for the *Daily Mirror* titled 'From rags to rouges' described the make-up as: 'in concept and appearance to most other beauty preparations what the first Quant clothes were to pre-Quant fashions'. The photograph, *A Crate Full of Quant*, that features in the article (fig. 80.1) shows the extent of her activity; combined with her husband Alexander Plunket Greene's business acumen, Quant became one of the most commercially successful British designers of the 1960s. There were impressive exports to Europe and lucrative deals with American manufacturers, bolstered by energetic promotional tours, featuring fashion shows with models dancing barefoot down the catwalk to the sound of pop music, which dispelled the stuffy atmosphere of the salon and gilded-chair protocol of previous years. Awarded an OBE in 1966, Mary Quant continued at the helm of her business until it was taken over by a Japanese company in 2000.

While Jean Shrimpton's vulnerable beauty epitomised the look of the early 1960s, it was a stick-thin teenager from north London who came to embody the dolly bird of the latter half of the decade. Hailed by the *Daily Express* newspaper as the face of 1966, by the following year Twiggy (Lesley Hornby, b.1949), under the Svengali-like guidance of her boyfriend and manager, Justin de Villeneuve, had become a household name, acquiring supermodel status after her first tour of the USA, during which the photographer Bert Stern made three documentaries, *Twiggy in New York, Twiggy In Hollywood* and *Twiggy, Why?*

Where Shrimpton exuded a kind of natural, seductive appeal, Twiggy's androgyny, heightened by her boyish crop cut by Leonard (fig. 80.2), was counterbalanced by cute painted-on eyelashes and freckles, and presented quite a different image, one of child-like innocence, underlined by her pigeon-toed stance, an image that gradually matured into a more sophisticated look based on fashion's nostalgia for Art Deco style. She retired from modelling in 1970 to pursue a career as an actress and singer, but she became a sought-after model again in the 1990s through photographer Steven Meisel's shoot of her for Italian *Vogue* in 1993; in 2005, she became the face of Marks & Spencer's high-profile advertising campaigns.

81 MARIANNE FAITHFULL and JANE BIRKIN
(b.1946)

81 (below)
Marianne Faithfull
Michael Ward, 26 July 1967
NPG x88843

Despite an ongoing career spanning five decades, singer and actress Marianne Faithful is all too often defined by her early rollercoaster personal life and relationship with The Rolling Stones's lead singer, Mick Jagger, between 1966 and 1970, during which she was a key member of the 'dissolute "Night-Watch" of mid-sixties Swinging London', as she described it in her autobiography. This group of beautiful people included members of the old aristocracy and the new pop aristocracy, gentlemen–tailors, boutique owners, antique dealers and interior designers, the *jeunesse dorée*, denizens of King's Road and Chelsea, rather than Carnaby Street or Soho. What bound them together was the burgeoning drug culture that flourished after the introduction of LSD into London in 1965; as Faithfull herself put it: 'The beautiful people had money. They were essentially an extension of Mary Quant's London, only with drugs.'

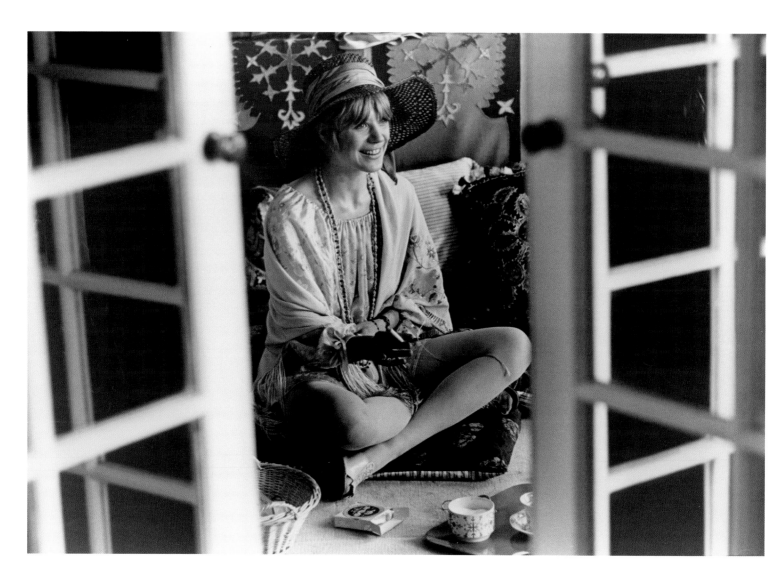

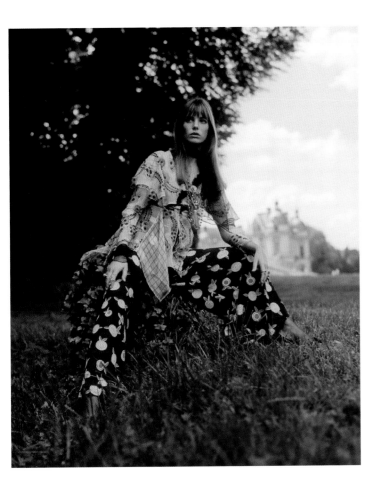

Photographed in 1967, in the Marylebone Road flat she shared with Jagger, the day before the result of the appeal against his conviction after the notorious Redlands (Keith Richards's house in Sussex) drugs bust, Marianne Faithfull is every inch the bohemian hippy chick as she sits cross-legged among cushions in her vintage, embroidered Chinese shawl, minidress, beads and floppy hat, items perhaps purchased from an antique market or high-end vintage boutique such as Granny Takes a Trip on the King's Road. Hippy style was eclectic; it required application (and money) to assemble the requisite 'bright plumage' associated with it: high fashion was combined with vintage, Victorian uniforms, ethnic robes, Indian fabrics, feather boas and Tibetan beads, all customised into outfits straight from the dressing-up box. As the owner of a stall in the Chelsea Antiques Market said, 'The King's Road was a fantasy promenade every day, a party. The sky was the limit'.

In a photograph for American *Vogue* (fig. 81.1), taken by Lord Lichfield (a member of the old aristocracy who moved seamlessly between royal and bohemian circles), the actress, singer and model Jane Birkin (b.1946) wears a floaty chiffon top and wide crêpe pants designed by Ossie Clark

81.1 (above)
Jane Birkin
Thomas Patrick John Anson,
5th Earl of Lichfield,
June 1969
NPG x128496

(1942–96). Clark's flattering cut and fluid fabrics, printed with his (then) wife, Celia Birtwell's Art Deco-inspired floral motifs, developed the romantic hippy aesthetic to match the late-1960s mood of decadence in high fashion. The garments they produced during their partnership, such as a crêpe evening coat and jacket in Birtwell's Mystic Daisy and Candy Flower prints (fig. 81.2), are much sought after by collectors; Birtwell continues to design capsule collections for high-street shops such as Uniqlo and John Lewis.

Jane Birkin achieved notoriety when she and her partner, the French singer-songwriter Serge Gainsbourg, recorded the raunchy 'Je t'aime ... moi non plus' in 1969, and she continues her career as a singer. She has become something of a fashion icon with an Hermès handbag named after her, as well as a popular figure in French culture; in 2001 she was awarded an OBE in recognition of her services to Anglo-French relations.

81.2 (left)
Detail of evening dress and coat by Ossie
Clark; print fabric by Celia Birtwell
1970–1

SIR ROY STRONG
(b.1935)

82 (opposite)
Sir Roy Strong
Bryan Organ, 1971
NPG 5289

82.1 (below)
Sir Roy Strong's suit
1968

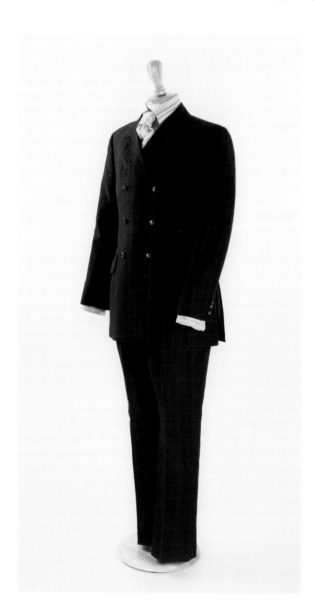

It is fitting that in this portrait by Bryan Organ (an artist taught by Graham Sutherland and painting in the realist tradition), Roy Strong, one of the most successful and dynamic directors (1967–73) of the National Portrait Gallery, should be posed in front of the Gallery's painting of the Somerset House Conference (1604; NPG 665). It was Strong's research and enthusiasm that established Elizabethan and Jacobean portraiture as a serious subject of study. With a slightly demure pose, he wears a dark blue suit with the waisted jacket and narrow shoulders typical of the tailoring of the early 1970s, as is the wide, patterned tie with a Windsor knot. Strong has the longish hair and moustache that many young men had begun to adopt in the late 1960s, and his intense stare is heightened by the round 'John Lennon' spectacles in vogue at that time.

Strong's talent for self-advertisement (which contributed to the high profile of the National Portrait Gallery during his 'reign') was linked to his flair for fashion. His diaries record, with a keen eye for detail and an acerbic wit, the clothes and appearance of the people he met; in his own outfits there were often appropriate historical touches – Regency-style frock coats, 1930s-style fedora hats – the kind of 'male sartorial display' that, he noted, was allowable in the late 1960s.

With the historian's love of the past (and an antiquarian zeal, for which dress historians are grateful) Sir Roy has either kept many of his clothes or donated them to museums with important costume collections, such as the Victoria and Albert Museum, in London, or the Fashion Museum, in Bath. In the latter museum there is a suit (fig. 82.1) that he bought in about 1968 from the fashionable tailor Blades (which opened in 1962 and specialised in Savile Row suits cut with a new flair and style). 'The best suit I ever had made,' he commented, describing it in his diaries in the following words:

It was blue, double-breasted with six buttons, tightly waisted and with side vents seemingly to the armpits, very narrow sleeves and straight-cut trousers ... With them went a black fedora hat from Herbert Johnson, a pair of glasses, a shirt and tie from Turnbull & Asser in raspberry ripple stripes and a pair of black shoes.

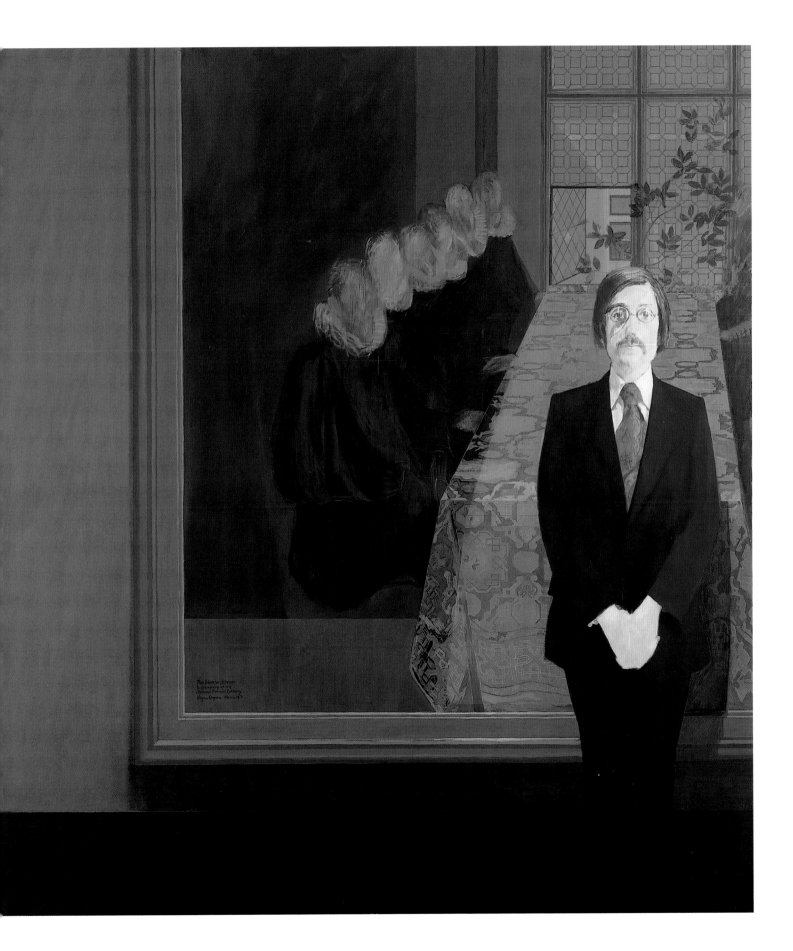

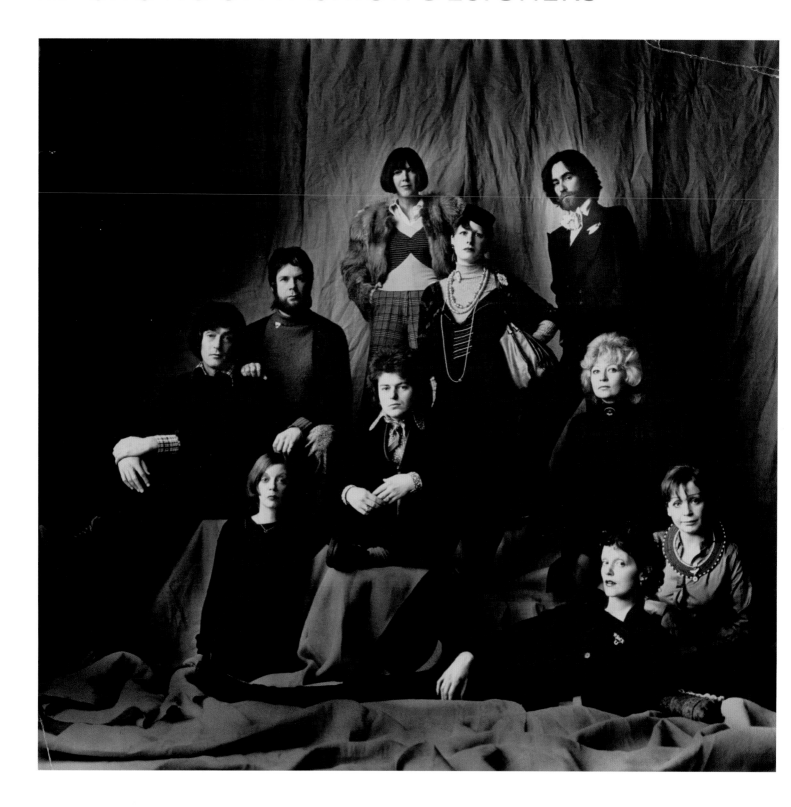

83 (opposite)
Fashion Designers
(clockwise from left:
John Bates; Bill Gibb;
Dame Mary Quant;
Dame Zandra Rhodes;
Ossie Clark; Gina Fratini;
Thea Porter; Alice Pollock;
Tim Gardner; Jean Muir)
Lord Snowdon, April 1973
NPG P1937

83.1 (below)
Princess Anne;
Mark Phillips
Norman Parkinson, 1973
NPG X30172

Taken for British *Vogue* in 1973, but unpublished, this photograph reflects Lord Snowdon's close relationship with fashion (and *Vogue* magazine) throughout his professional career since the 1960s. The rather formal poses that the group of designers adopt are somewhat at odds, however, with Snowdon's reputation as a photographer who brought movement and vitality to his images of fashion and a sense of informality to his portraits of the royal family.

The photograph depicts ten of the most successful British fashion designers of the day: an older generation that made their name in post-war Swinging London; among others, current favourites of the early 1970s scene, Ossie Clark and his design partner Alice Pollock, Zandra Rhodes and Bill Gibb, whose early death in 1988 cut short the career of one of the most promising talents in the business. Perhaps only one or two of these designers' names are familiar now to all but those involved in the fashion business; yet Zandra Rhodes has successfully maintained a long career, and it was in a dress by her that Princess Anne posed with her fiancé, Captain Mark Phillips, for an official engagement photograph taken by Norman Parkinson in the Long Gallery at Windsor Castle (fig. 83.1). The romantic froth of printed white on white chiffon and tulle is a continuation of the traditional royal patronage of British fashion designers, linking the gowns designed by previous royal dressmakers, Norman Hartnell and Hardy Amies, for the Queen and the Queen Mother, to those worn later by Diana, Princess of Wales.

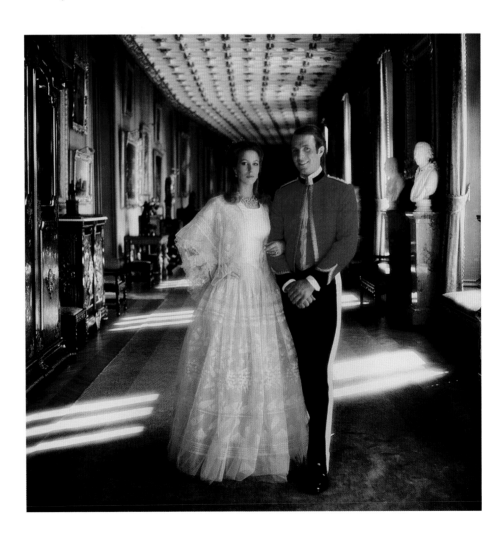

84 SID VICIOUS and VIVIENNE WESTWOOD

(1957–79) and (b.1941)

84 (below)
Sid Vicious
Bob Gruen, 1978
NPG P875

Never was music more intimately connected to fashion in Britain than when punk rock's challenge to effete hippy culture and the self-indulgent showmanship of 1970s prog rock was laid down with the release of the Sex Pistols's debut single 'Anarchy in the UK' in November 1976. Their notoriety was confirmed shortly afterwards with a live interview broadcast on the early-evening *Today* television show, during which members of the band launched a stream of invective at presenter Bill Grundy. For the short duration of the band's existence (it broke up in early 1978), its confrontational music, provocative dress and bad behaviour

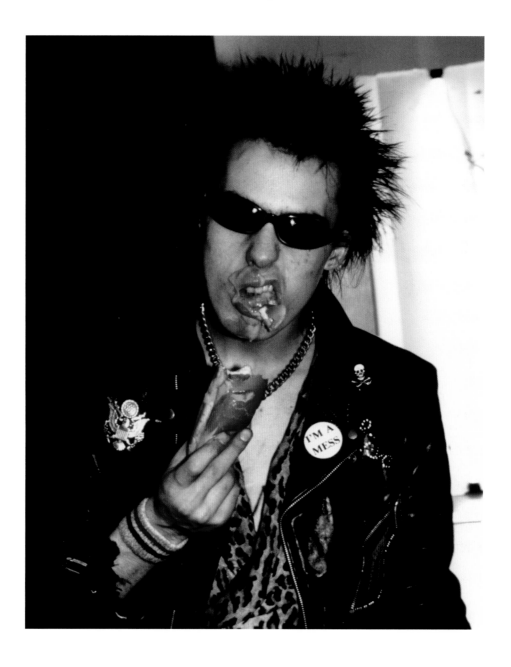

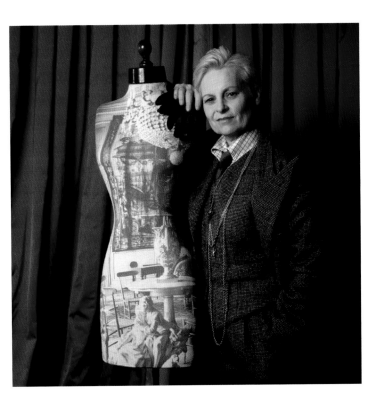

constantly hit the headlines, yet their aggression on stage and scathing lyrics chimed with disaffected youth at a time of political and economic instability. Aged twenty-one, Sid Vicious, the band's singer and bass player, who died of a heroin overdose a year later, shortly after his release on bail from a New York prison, having been charged with the murder of his girlfriend Nancy Spungen, is seen here in provocative 'doomed youth', anti-establishment style.

The anarchic vitality of punk and dynamism of London street style was channelled through the partnership (1970–83) of the Sex Pistols's manager, Malcolm McLaren, and Vivienne Westwood (b.1941), whose shop Let It Rock in the King's Road became the epicentre of the movement. Now a Dame of the British Empire and one of the UK's most respected designers, Westwood has based her career in fashion on shock tactics and a highly developed sense of the dramatic; after her punk and fetish designs of the 1970s, she began to show a softer edge, a New Romantic look (her Pirate collection of 1981–2 is

84.1 (above)
Dame Vivienne Westwood
David Secombe, 1992
NPG x68821

84.2 (below)
Dame Vivienne Westwood
Juergen Teller, 2014
NPG P1980

considered to be a seminal example), and became increasingly influenced by an eclectic historical revivalism. Westwood's solo career began in 1984, and she opened her shop in Mayfair in 1990, the year she was made British Designer of the Year by the British Fashion Council – an accolade she also received in 1991.

British designers are trained to look to the past in a creative way, and, in this regard, Vivienne Westwood is a pioneering force: her veneration for historic costume has inspired designs for both fashion and textiles. The dress-stand on which she leans (fig. 84.1) is printed with one of her textiles, incorporating scenes of an historic interior (the chateau of Compiègne, in northern France), with furniture, tapestry and porcelain in the grand style. She herself presents an image of jaunty masculinity, with her blonde hair cut short, checked shirt and tie, and a tweed three-piece suit with exaggerated lapels; imitation Victorian watch chains are draped over her waistcoat. The suit, jokey although it may appear, subverts and is a kind of homage to the long-established traditions of the English tailor and a reference to her own consummate tailoring skills.

Having turned seventy in 2012, she remains a globally respected figure still at the forefront of fashion and continues to disregard convention, as can be seen in a photograph by Juergen Teller (fig. 84.2), who has shot all of her campaigns since 2007. Taken in the garden of her London home, Westwood is wearing a dress that combines blue and beige striped and brown check cotton fabrics patched together, underneath a tangerine-coloured cardigan, her white hair cut in a very short crop and dark blue/black lipstick on her lips.

JEAN MUIR and GERMAINE GREER
(1928–95) and (b.1939)

85 (opposite)
Jean Elizabeth Muir
David Remfry, 1981
NPG 6556

85.1 (below)
Germaine Greer
Paula Rego, 1995
NPG 6351

The setting for this portrait was the designer's all-white flat near the Royal Albert Hall, Kensington, a suitably austere background to her costume, a shirt and culottes of navy jersey with matching tights and shoes. In the catalogue to an exhibition of Jean Muir's clothes in 1981, the historian Antonia Fraser wrote that she looked 'like a modish Puck dressed in navy blue'.

Miss Muir (it was regarded as a kind of *lèse-majesté* to be more familiar) believed in unity and harmony in clothing, referring to her work as 'architectural designing'. She created classic tailored-yet-fluid shapes, which were partly inspired by Chanel in the 1920s. In this portrait her hair is cut short and straight like a Twenties bob, and her make-up, which dramatises eyes and lips, owes much to that decade.

Jean Muir's clothes were very much in vogue during the 1970s and 1980s; they were noted for their simple, uncluttered lines and subtle, muted colours. Fabrics were carefully chosen – fine woollen crêpe, soft leather and suede, and – most typical of all – sleek silk or rayon jersey, because of the way it moved on the body. She paid meticulous attention to such details as top-stitching, on collars, cuffs and hems, and the right buckles and buttons – these last were particularly important and often hand-crafted.

Jean Muir's clothes, especially her dresses, flattered women of all shapes and sizes, and because of their almost 'timeless' styles, which combined elegance and comfort, they were usually kept for many years, as this writer can testify. In Paula Rego's impressively honest portrait of the academic and feminist writer Germaine Greer (fig. 85.1), a venerable Jean Muir dress (probably of early 1970s vintage) is shown – of red jersey, with characteristic top-stitching, and a large button at the neck and the cuffs. Greer says that it was the first decent dress she had ever bought and a favourite; she chose it for her portrait 'because of the colour and the texture and its classic shape, and because it was comfortable'. With it she wears rather battered gold lace-up shoes – 'the sole is coming off one of them', commented the artist – a choice dictated more by comfort than elegance, for the movement and swing of a Jean Muir dress was best achieved by the wearing of medium-high-heeled shoes, as the designer herself wears in the David Remfry portrait.

MARGARET THATCHER
Baroness Thatcher of Kesteven (1925–2013)

How does a portrait painter encompass on the canvas the distinguished life and achievements of the first woman to reach the highest elected office in the land (she was Prime Minister from 1979 to 1990)? Here, he resorts to an image of regal dignity (the artist claimed Van Dyck as one of his sources of inspiration) and paints his sitter in the official residence of the Prime Minister, 10 Downing

86 (right)
Margaret Thatcher
Rodrigo Moynihan, 1983–5
NPG 5728

86.1 (below)
Margaret Thatcher
Norman Parkinson, 1981
NPG P177

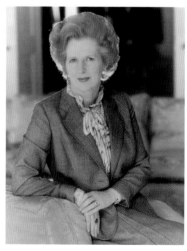

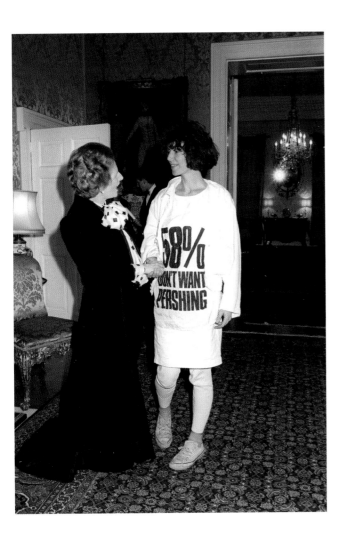

Street, the centre of political power. He depicts, as best he can through her features and pose, her authority, her inner strength and determination, but this is softened by the almost Edwardian femininity of her high-necked, full-sleeved pale grey blouse with its frilled collar and loose ribbon ties, her pearl jewellery and her carefully set dark blonde hair.

The portrait had a difficult gestation. The first version, completed in 1984, displeased Mrs Thatcher, as she felt that the artist had given her a squint (she had had an operation on her right eye just before the portrait was begun), so Rodrigo Moynihan aligned the eyes and slightly repainted the blouse, 'in order', he said, 'to reveal the structure of the body beneath'. It was finally approved by the sitter, who claimed 'his genius has shone through'.

Only a few years earlier Mrs Thatcher had been photographed by Norman Parkinson (fig. 86.1). This is a more flattering – even glamorous – image of the Prime Minister relishing the burden of office (this was before the Falklands War of 1982), even with a slight smile (unlike in Moynihan's portrait, where the artist complained that her face was too 'set' and that there was little movement except round the mouth). In the Parkinson photograph Mrs Thatcher looks like a successful professional woman (Businesswoman of the Year, perhaps), wearing the tailored suit, redolent of order and efficiency that we associate with her public image. In the 1980s 'power suits' (and 'power dressing') became a popular choice for women in a man's world. The grey suit (by Aquascutum) was the

86.2 (above)
Margaret Thatcher with Katharine Hamnett at 10 Downing Street
Unknown photographer, 1984

photographer's choice: he wanted her to look formal, but he liked the pearls as a contrast and to provide a touch of femininity.

Looking elegant in a velvet evening jacket and long skirt with another favourite pussy-bow blouse (fig. 86.2), the Iron Lady greeted Katharine Hamnett, chosen by the British Fashion Council as Designer of the Year in 1984, at a reception in 10 Downing Street. Known for her political activism, Hamnett's oversized T-shirt, emblazoned with an anti-nuclear slogan (Pershing was an American missile system based in Britain, despite the majority of the British public being opposed to it), spawned an item of clothing and a vehicle of protest that has never disappeared, but that is now more often used for self-referential rather than political statements. Teaming the T-shirt with a jacket, leggings and beaten-up Converse All Star trainers, Hamnett pioneers the down-dressing trend that would become known in the 1990s as Grunge. Hamnett continues to design ethical clothing and to champion environmental and anti-war causes, as well as fighting racism in the fashion arena. In 2011 she was awarded a CBE by the Queen for her services to the industry.

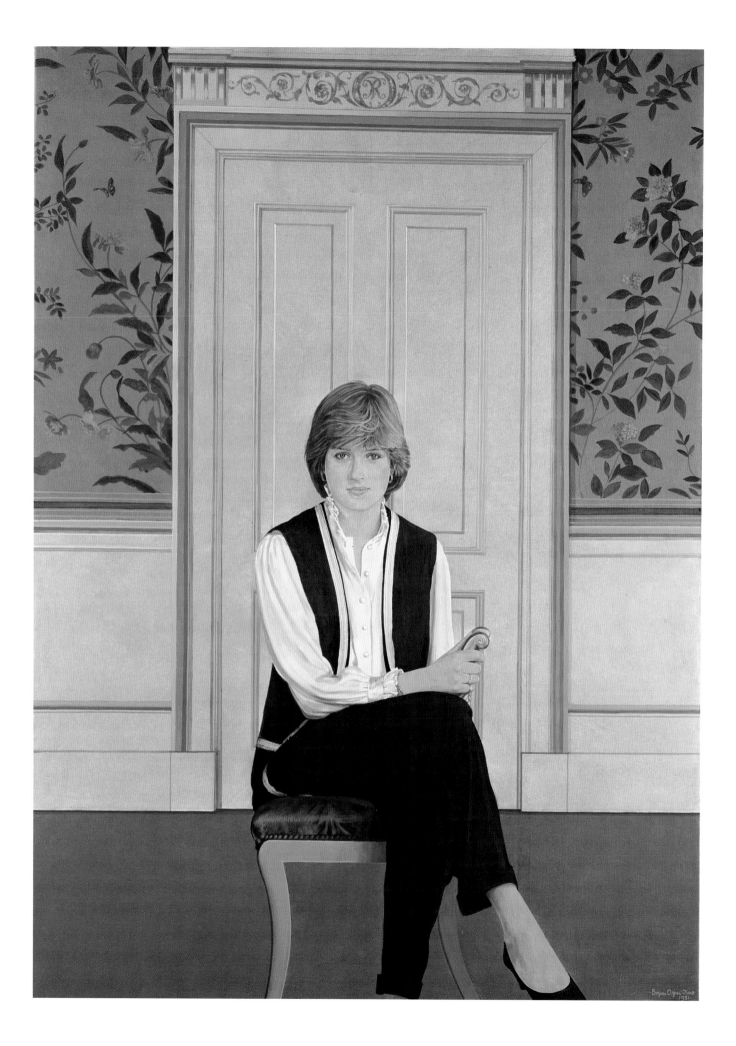

87 DIANA, PRINCESS OF WALES

(1961–97)

This portrait, painted at the time of her engagement to the Prince of Wales, shows Lady Diana Spencer in the Yellow Drawing Room at Buckingham Palace. Already her personal style is evident; her ability to catch and interpret the fashion mood of the time. Informality is the key word in this image, both her dress and her pose – seated sideways on a green Regency damask chair – almost

87 (opposite)
Diana, Princess of Wales
Bryan Organ, 1981
NPG 5408

87.1 (below)
Diana, Princess of Wales
Terence Donovan, 1990
NPG P716(12)

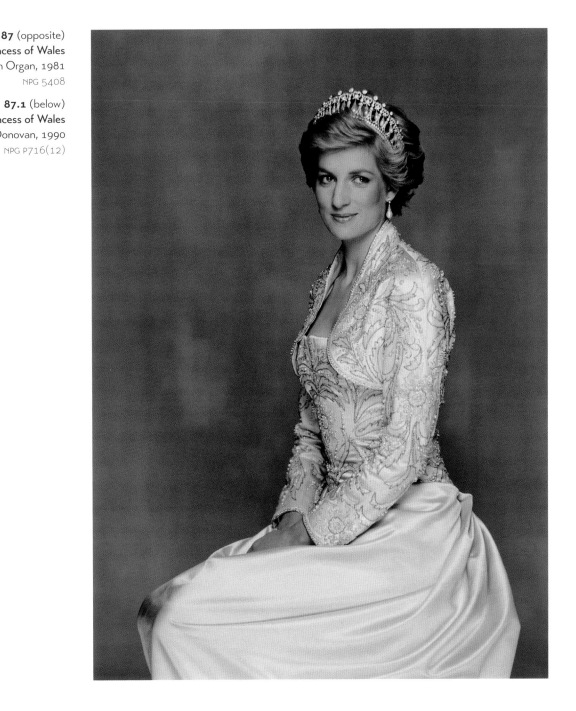

87.2 (above, left)
Beaded dress of black
velvet worn by Diana,
Princess of Wales in 1997
Designed by
Catherine Walker

subverting the grandeur of her surroundings. Her lightly streaked blonde hair is styled in a simple short bob with a full fringe, and her costume consists of a matching knit-jersey waistcoat and trousers. She wears a white blouse with a 'pie-crust' frilled collar, one of the earliest fashions she popularised. The trousers draw attention to the Princess's long legs and elegant ankles, black high-heeled shoes complementing her outfit. After her marriage the Princess amassed a considerable collection of fine jewellery, but all she wears here are simple gold-hoop earrings, a bracelet of coiled gold and inexpensive rings – opals set in silver and a gold signet ring on her little finger.

The Princess of Wales's love affair with the camera – she was a natural model – is well attested. In all but the most perceptive photographs, the camera did not delve into her character too much but projected a flattering image of her beauty and radiance that rises above the clothes she wears, as a portrait by Terence Donovan, taken in 1990 (fig. 87.1), indicates. In it she wears a formal ivory-satin evening dress with matching bolero-style jacket embroidered in foliate motifs in gold and pearls by Victor Edelstein, one of her favourite British couturiers. She also wears the Cambridge Lover's Knot tiara, given to her by the Queen as a wedding present.

After her divorce, Diana, Princess of Wales, as she then became known, adopted a more daring wardrobe by an international range of designers, including Giorgio Armani and Gianni Versace, yet she continued her patronage of Catherine Walker, a French designer based in London. It is a dress by Walker that she wears in one of a series of photographs taken in a single sitting at Kensington Palace by Mario Testino (NPG P1016), for which he asked her to take off her shoes and all her jewellery and dance, as he wanted her to feel and look as if she were at home. The black-glass bugle bead decoration on the black velvet halter-neck gown (fig. 87.2) was inspired by an antique picture frame, and, as recollected by Walker in her autobiography, it served as such to set off Diana's new-found confidence in one of the most informal and appealing photographs taken of her.

Testino's images caused a sensation when they were published by Vanity Fair one month before the Princess's death in 1997 and served as ideal publicity for the charity auction at which her dresses would be sold. Diana's wardrobe has indeed become something of a fetish for collectors, who pay fabulous sums for her garments, particularly those worn on significant occasions: the Catherine Walker dress worn in Testino's photograph was sold at auction in March 2013 for £90,000.

JOHN GALLIANO
(b.1960)

During the post-punk 1980s, the London underground-club scene flourished and nurtured a new generation of creative game-changers as well as being fertile ground for fashion designers looking for inspiration. One of the most elitist venues was the weekly Taboo club in Leicester Square, so-called by its founder and master of ceremonies, the Australian performance artist Leigh Bowery (1961–94), because 'there's nothing you can't do there'. Outlandish outfits and theatrical make-up, the more original and bizarre the better, were de rigueur, as can be seen in a photograph of Bowery and his friend the artist Trojan (Gary Barnes; 1966–86), who wears his painted 'Picasso face' (fig. 88). Bowery and Trojan used their own bodies as a canvas for creative expression, tempered nevertheless with irony and humour. In a wider sense, the upsurge of talent that emerged from the hedonistic milieu that they inhabited became highly influential in many areas of the arts, from Michael Clark's avant-garde ballet productions to Nick Knight's groundbreaking photographs, such as his portrait of John Galliano and friends published in *i-D* magazine's fifth-anniversary 'Grown Up' issue (fig. 88.1).

Galliano, whose graduate collection from Central Saint Martins in 1984 was bought in its entirety by Joan Burstein of the influential Browns fashion boutique in South Molton Street, was a product of the creative environment of art school as well as the febrile atmosphere of the underground-club scene in London. Applying a spirit of anarchy to his skill as a cutter and his love of historicism (his first collection was based on the dress of the Incroyables, the young dandies of the French Revolution), he struggled to achieve financial stability until he became the house designer at Givenchy in 1995. A year later he was appointed to the most coveted job in Paris, that of creative head at the House of Dior, where he remained from 1996 until 2011. Drawing inspiration from across the globe, he sampled ethnic, tribal and historical references in his work, as well as paying homage to Christian Dior through archival research at the *maison*. In the process, along with his loyal team, many of whom were from Britain, such as the hatter Stephen Jones, he created some of the most theatrical, colourful and beautiful

clothes seen in the couture industry, as well as some of the most spectacular catwalk shows. Never shy of looking the part, Galliano took his bow at the end of each show dressed in one of his many different flamboyant guises, a flavour of which can be seen in Mario Testino's portrait (fig. 88.2), taken for *Visionaire* magazine's '21 Deck of Cards Diamond' issue and styled by French fashion editor Carine Roitfeld. John Galliano has recently been appointed creative director at Maison Martin Margiela.

ALEXANDER MCQUEEN and ISABELLA BLOW (1969–2010) and (1958–2007)

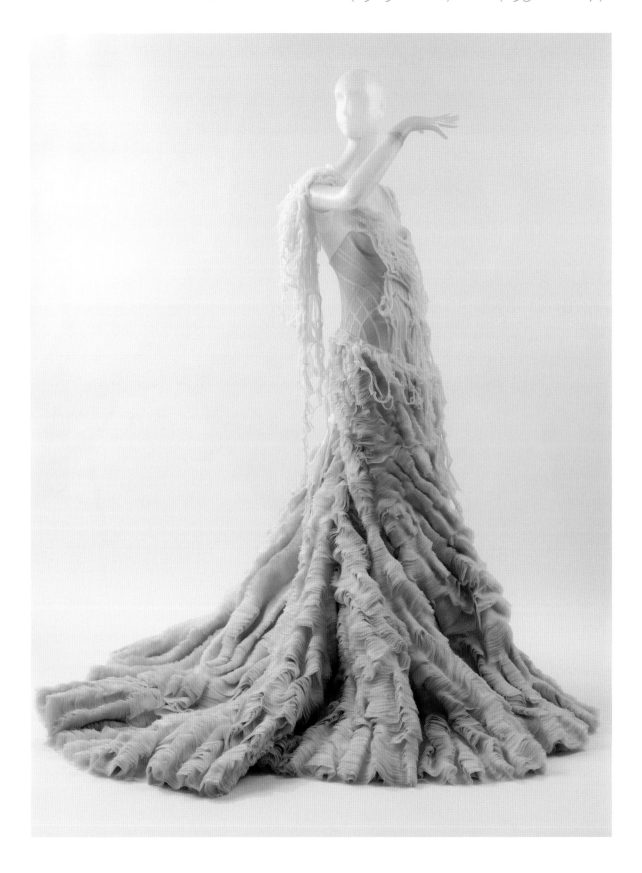

Alexander McQueen, who graduated from Central Saint Martins in 1992, had a darker vision than Galliano's, an iconoclastic spirit that led him to explore troubling political, sexual and sado-masochistic themes in his collections and to challenge and subvert conventional ideas of beauty. His spectacular fashion shows are legendary: from the 1999 Spring/Summer Collection No. 13 show that featured model Shalom Harlow as a dying swan, being sprayed with paint by two robots borrowed for the occasion from the Fiat motor factory, to the notorious finale of the Spring/Summer 2001 Voss show, when the writer Michelle Olley appeared on a couch, naked but for a fetish mask and covered in live moths. Yet McQueen's penchant for dramatic gesture was underpinned by hard-earned skill and craftsmanship, a talent for razor-sharp cutting and a love of artistry, evident in his iconic 'Oyster dress', a rippling millefeuille of sand-coloured organza resembling the undulations of the seashell.

Early on in his career McQueen was championed by the fashion editor Isabella Blow (1958–2007), in whom he recognised a kindred spirit and who purchased his entire graduate collection in instalments, as and when she found the funds. They can be seen together, camping it up (McQueen, with goatee beard, in corset and red vinyl gloves), in a photograph taken in 1996 by David LaChapelle at Hedingham Castle in Essex (fig. 89.1) for a Swinging London issue of *Vanity Fair*; the article that accompanied the double portrait named them 'The Provocateurs'. Blow's eccentric style (she always wore remarkable hats, as here, usually made for her by the Irish milliner Philip Treacy) was frequently reported on in the press; yet, like McQueen, she felt that she was something of a misfit and suffered from depression: they both ended their lives by committing suicide. In a portrait sculpture by Tim Noble and Sue Webster (fig. 89.2), commissioned for the Design Museum exhibition *When Philip Met Isabella*, her profile was created by a montage of found objects, some given to them by Blow – her trademark killer-red lipstick and Manolo Blahnik stilettos – and some sourced by the artists, such as a raven from the Tower of London and a black rat 'from the plague'. Silhouetted against the light, the sculpture evokes the gothic sensibility that Blow shared with McQueen.

89 (opposite)
'Oyster dress' by Alexander McQueen, in ivory silk georgette and organza, beige nylon, silk chiffon and white silk
Spring/summer 2003

89.2 (above)
Isabella Blow
Tim Noble and Sue Webster, 2002. NPG 6872

89.1 (left)
Alexander McQueen; Isabella Blow
David LaChapelle, 1996. NPG P1403

90 SIR PAUL SMITH and OZWALD BOATENG
(b.1946) and (b.1967)

90 (opposite)
Sir Paul Smith
James Lloyd, 1998
NPG 6441

90.1 (below)
Ozwald Boateng
Sal Idriss, 2002
NPG x125667

Paul Smith once said: 'You have to be 90 per cent business man and 10 per cent designer': that his fashion empire has expanded so successfully over the last forty years, while weathering assorted economic storms, is testament to his business acumen and ability to retain his brand's desirability through a reputation for combining high-quality traditional tailoring with playful humour and lightness of touch. His clothes are extremely popular in Japan, where he is held in great regard, yet he has channelled much of his energy into supporting young designers and finding ways to improve links between manufacturing and design in Britain. Not only has Smith changed perceptions of modern men's wear on a global level, he has also changed the retail experience: his shops have become destinations for those who share his fascination for quirky found objects, old or new, or his love of pursuits as varied as photography and cycling.

This colourful portrait, a symphony of yellow and green, shows him with a bolt of Japanese brocaded silk leaning against the chair in which he sits. The unusually wide check, loosely suggested by the artist's brushstrokes on the right side of his suit (worn with a denim shirt and white T-shirt underneath), indicates, but does not fully explain, the extent of his impact and influence. This was recognised when he was knighted in 2000 for his services to the British fashion industry.

While Sir Paul favoured upcoming offbeat locations such as Covent Garden and Notting Hill for his retail outlets, Savile Row, the portmanteau term for a

collection of tailors and outfitters operating in the small streets surrounding Piccadilly Circus, struggled to maintain its profile as the bastion of British bespoke tailoring in the latter part of the twentieth century. It took a new generation of young tailors such as Richard James and Ozwald Boateng to reinvigorate it and respond to the renaissance, from the 1980s, of the suit, surely one of the most successful garments ever invented. Boateng, an Anglo-Ghanaian, who opened his first premises on Vigo Street, just off Savile Row, in 1995, made his name with the slim fit and elegant cut of his suits with vibrantly coloured linings, a love of colour evident in a portrait photograph (fig. 90.1), in which he is wearing a shot blue-and-pink slub-silk shirt.

BRITISH MODELS DRESSED BY BRITISH DESIGNERS

Mario Testino's cover photograph for *Vogue* in January 2001 (it also took up an entire wall of his National Portrait Gallery exhibition the following year) was commissioned by fashion director Lucinda Chambers as 'a celebration of Britishness'. Eighteen fashion designers were sent Union Jacks and asked to create outfits from them that would be worn by eighteen of the best British models for the shoot. Erin O'Connor wore a Christian Dior corset by John Galliano, Liberty Ross sported Clements Ribeiro's hot-pants suit, Kate Moss donned a dress by Hussein Chalayan that had been previously buried in his back garden for three weeks, and Naomi Campbell modelled a tiny sequinned bikini by Julien Macdonald.

91
British Models dressed by British Designers
Mario Testino, 2001
NPG P1025

Many of the designers and models in Testino's photograph were a part of the cultural renaissance that took place in Britain from the mid-1990s, a renaissance in the arts, music and fashion, boosted by a wave of political optimism that would become known under the umbrella term as Cool Britannia. Kate Moss (b.1974) photographed in Los Angeles in a skin-tight T-shirt and a pair of boyish gingham shorts (fig. 91.1) and Naomi Campbell (b.1970; fig. 91, back row, third from left) photographed for Versace in Paris in nothing but a pair of Jackie O-style sunglasses, one nipple on display, both with long and successful careers on a global scale, perhaps best exemplify the social mobility and cultural diversity that Tony Blair envisaged for the country when his government came to power in 1997. The fashion industry continues to be regarded by many as exploitative, promoting unrealistic body size (as with the heroin chic of the 1990s), and prejudiced against ethnic minorities, a situation against which Campbell has long campaigned.

91.1
Kate Moss
Mario Testino, 1996
NPG P1020

92 (opposite, left)
Tracey Emin
Julian Broad, 26 April 2000
NPG x139553

92.1 (below)
Sam Taylor-Johnson
(*Self-Portrait in Single-breasted Suit with Hare*)
Sam Taylor-Johnson,
2014 (2001)
NPG P959

A generation of iconoclastic young British artists, or YBAs, as they became known, was an integral element of the Cool Britannia movement in the 1990s, and by the turn of the twenty-first century many of them had become commercially successful. Tracey Emin, along with Damien Hirst, *enfant terrible* of the YBAs, achieved notoriety through her work with her acutely honest and confrontational explorations of her own life, such as *My Bed* (1999), which featured dirty, rumpled sheets, condoms and stained underwear. Made a CBE in 2013, Emin was Eranda Professor of Drawing (2011–13) at the Royal Academy Schools, the bastion of the British art establishment. Emin has worn Dame Vivienne Westwood's designs for many years, because they are 'feminine and sexy'; this has blossomed into a sponsorship relationship that sees her wearing Westwood in advertisements and at social events.

Another successful female artist associated with the YBAs, who uses autobiographical references in her work, is Sam Taylor-Johnson (fig. 92.1),

whose self-portrait, taken in 2001 (when her name was Taylor-Wood), was a response to her battle with a second bout of cancer that had resulted in a mastectomy. An exercise in visual punning, she stands, literally holding on to a hare (symbol of lust and passion), with a full head of hair, in a single-breasted trouser suit (by the French designer Agnès B) and trainers, the camera shutter release in her other hand. A self-portrait that could almost be taken for a fashion photograph, her square-on stance reflects the introduction of the 'straight-up' shot initially featured in the new wave of independent magazines such as *iD* and *Arena*, published from the mid-1980s. Taylor-Johnson's work encompasses a diverse range of media including photography and film making. In 2004 she made an hour-long digital video of David Beckham, now in the National Portrait Gallery's collection (fig. 92.2), using a single take of the footballer after a training session in Madrid. The viewer is mesmerised, watching as one of the most recognisable faces in the world self-consciously adjusts his position from time to time, dressed, as far as one can see, only in leather bracelets, diamond ear studs and a silver chain hung with charms, including a cross and several coins.

The dependency between fashion and celebrity is perhaps nowhere better demonstrated than through the careers of David and Victoria Beckham

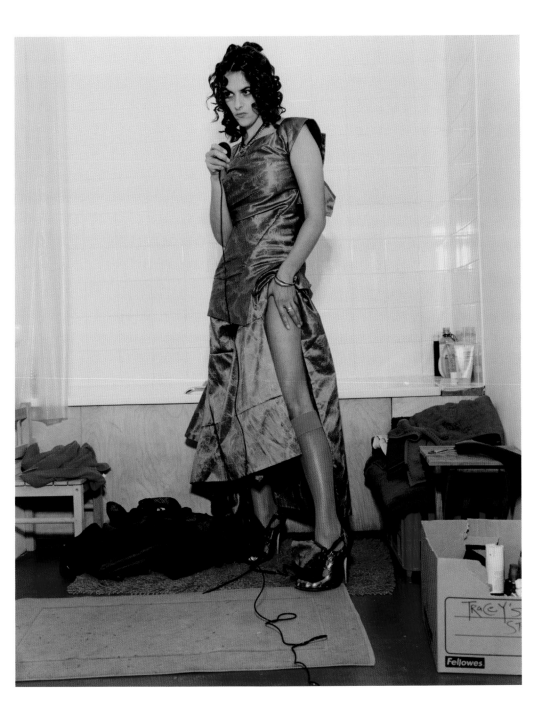

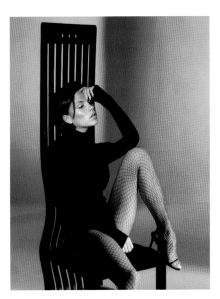

92.2 (above, top right)
David Beckham (*David*)
Sam Taylor-Johnson, 2004
NPG 6661

92.3 (above, top below)
Victoria Beckham
John Swannell, 2001
NPG x134782

one a footballer, the other a member of a short-lived girl band: both have successfully moulded themselves into world-class celebrities and money-spinning global brands. Seen here (fig. 92.3), in a black polo neck sweater, fishnet tights and high heels, her pared-down look foreshadows the signature sharply-cut style that her brand is known for. In the competitive world of the fashion industry her trajectory from 'Posh Spice' to (untrained) designer and head of her respected eponymous clothing label that reportedly doubled its turnover in 2014 to £30 million is especially noteworthy. Her skilful navigation of the fashion world has seen her appear on several front covers of American and British *Vogue*; her husband has also modelled extensively, appearing in campaigns for his own lines of underwear and perfume: together the Beckhams constitute a powerful force in popular culture and are one of the world's most influential and highly visible celebrity couples.

93 (below)
David Bowie
Steven Klein, 2003
NPG P1277

David Bowie's long career in music has been intimately connected with fashion, and his influence on it is still evident: he continues to be regarded as a style icon, his shape-shifting androgyny blending seamlessly with every new look. His most famous incarnation was Ziggy Stardust, whose sequinned garments, painted face and Japanese Kabuki-inspired lion's-mane hairstyle epitomised the self-conscious glamour of 1970s rock music. Since then, he has continued to be a revered cultural icon, his increasingly infrequent appearances always garnering media attention. In an editorial spread for *L'Uomo Vogue*, titled 'Is this concrete all around?' (a quote from Bowie's 1972 song 'All the Young Dudes'), photographer Steven Klein posed him as if in a cell, a grieving Madonna in a pietà composition with the Dior-clad model Natasha Vojnovic styled like Pris, a character from Ridley Scott's 1982 sci-fi film *Blade Runner*, played by Daryl Hannah, lying across his knees.

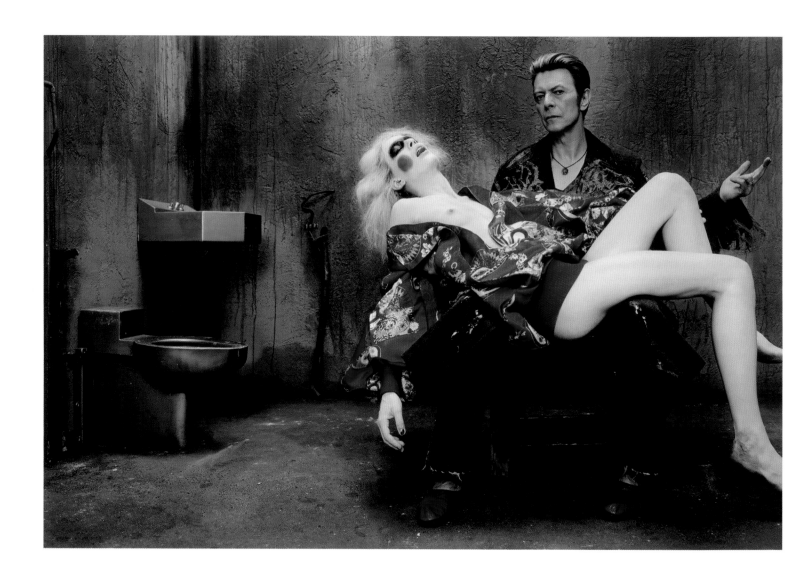

93.1 (above, left)
Amy Winehouse
Venetia Dearden, 2008
NPG x134361

93.2 (above, right)
Lily Allen
Nadav Kander, 2008
NPG x132588

The connection and overlap between music and fashion that began in the early twentieth century has continued to strengthen, particularly since the launch of MTV on American cable television in 1981 and the subsequent growth of digital technology and communication in cyberspace. Like models, artists and footballers, musicians initiate and disseminate fashions and style in the ever more complex and interconnected web of celebrity and popular culture. Now musicians influence fashion designers: Karl Lagerfeld based his pre-Fall 2008 collection for Chanel on Amy Winehouse's look (fig. 93.1), her tousled beehive and heavy, black cat's-eye make-up, which channelled a dark version of Brigitte Bardot. Winehouse's influence can still be seen on every high street, as can Lily Allen's more eclectic mash-up style, combining couture with trainers or Doc Martens, which has also caught the eye of Lagerfeld (fig. 93.2).

DAVID HOCKNEY and GRAYSON PERRY
(b.1937) and (b.1960)

94 (opposite)
David Hockney
(*Self-Portrait with Charlie*)
David Hockney, 2005
NPG 6819

94.1 (below)
Grayson Perry
Richard Ansett, 18
September 2013
NPG x139888

David Hockney, who was part of the Youthquake of the 1960s, has made a speciality of painting double portraits, including the monumental 1970–1 *Mr and Mrs Clark and Percy*, of his friends the fashion designers Ossie Clark and Celia Birtwell (see figs 81.1 and 81.2), one of the most viewed paintings in the Tate collection. The fact that he continues to be respected as one of the UK's foremost artists, whose exhibitions draw huge attendances, must in part be due to his willingness to explore different methods of working through new technology, from photography and early computer programmes such as Quantel Paintbox, to iPhone and iPad drawing-and-painting apps. However, for this large-scale portrait of New York art-curator Charlie Scheips, he returned to the traditional medium of oil paint, applying it directly to the canvas without any preparatory photography or sketching. The composition creates a triangular framework for the sitter, viewer and artist, similar to that in Velázquez's *Las Meninas*, a similarity

also echoed in the red of the braces, supporting his windowpane check trousers, which recalls the red symbol of the Order of Santiago emblazoned on the Spanish painter's chest. Hockney is surrounded by blue, including on his shoes – the colour of Californian skies and swimming pools, and the colour he is most closely associated with.

The 2003 Turner Prize-winning potter Grayson Perry has become one of the nation's favourite artists and commentators on contemporary culture and mores. His work is known for its semi-autobiographical exploration of themes surrounding childhood, sex and death, and he has curated major exhibitions, such as *The Tomb of the Unknown Craftsman* at the British Museum in 2011–12. He is also known for being a transvestite, frequently appearing as Claire, his cute, child-like alter ego. For more than a decade he has collaborated with the textile-print students at London's Central Saint Martins, who are briefed to design an outfit for Claire, several of which Perry goes on to purchase. In a portrait photograph taken just before Perry delivered one of his series of Reith Lectures for the BBC in 2013 (fig. 94.1), he wears a psychedelic Pucciesque smock dress designed by Angus Lai, a Central Saint Martins student, and featuring Alan Measles, his childhood teddy bear and life companion.

QUEEN ELIZABETH II and CATHERINE, DUCHESS OF CAMBRIDGE (b.1926) and (b.1982)

95
Queen Elizabeth II
(*Lightness of Being*)
Chris Levine, 2007
NPG 6963

Perhaps one of the greatest challenges an artist can be given is to make a portrait of a face that is so well known, so familiar that it would seem impossible to present a new perspective; yet Chris Levine's 2007 portrait of Queen Elizabeth II, in the form of a lenticular print on a light box, does just that. Perhaps the impact of this image is connected to the fact that the Queen, whose

face must be known by the majority of the world's population, is never seen with her eyes closed. Each of the multiple exposures required to create this portrait took 8 seconds, and between each shot the Queen briefly closed her eyes: it is this captured moment that makes the image unique. Glittering with the icy sparkle of the diamonds encrusting the George IV State Diadem, made for his coronation in 1821, and the moonlit sheen of her pearls, and swathed in snowy white Arctic fox, the three-dimensional quality the process has imparted to her face and figure gives her a chilling, spectral appearance.

Royal dress rarely has anything to do with fashion: it has its own particular requirements of visibility, functionality and tradition – it is a kind of uniform. Very few royal women can truly be said to have had an impact on fashion, the most recent example being Diana, Princess of Wales, who injected her royal wardrobe with a sense of novelty and experimentation, exerting a powerful influence on the public and demonstrating a spirited independence in her fashion choices after her divorce.

Her daughter-in-law, Catherine, Duchess of Cambridge (b.1982), has also had a significant influence on the fashion-buying public – the so-called 'Duchess effect' – although her clothing is more often than not obtained from high street and inexpensive online retailers than from couturiers or high-end designers. But for her wedding to Prince William in 2011 the Duchess chose Alexander McQueen's creative director, Sarah Burton (b.1974), who took over after McQueen's death in 2010, to design her dress. The ivory silk V-necked, long-sleeved gown with a two metre long train was overlaid with handmade British lace, made in Honiton in Devon, adhering to a long-established royal tradition (in place since Queen Victoria's marriage in 1840).

A portrait commissioned by the National Portrait Gallery in 2012, to mark the Duchess's patronage of the Gallery and her entry into public life (fig. 95.1), reflects her non-royal background and carries out her wish to be portrayed as her natural, rather than official, self, without the trappings of state. She has mediated her accessible image through a lack of ostentation and modest fashion choices, including dresses that cost as little as £35, enabling the public to buy into her style. Her luxuriant, layered hairstyle has also been widely emulated.

Except on ceremonial occasions, royalty no longer uses clothes to symbolise power – like fashion, it has become more accessible than ever before. The near-universal availability of fashionable dress, or democratisation of fashion, and its multifaceted nature mirrors changes in our society, changes that are visible through the images in this book that in turn reflect the enormous range and variety of sitters in the Gallery's Collection.

95.1 (below)
Catherine, Duchess
of Cambridge
Paul Emsley, 2012
NPG 6956

FURTHER READING

'Phrases and Philosophies for the Use of the Young' in *The Chameleon*, December 1894

Princely Magnificence: Court Jewels of the Renaissance, 1500–1630 (exh. cat., Debrett's Peerage Ltd. in association with the V&A, 1980)

Jane Ashelford, *Dress in the Age of Elizabeth I* (Batsford, 1988)

Jane Ashelford, *The Art of Dress: Clothes and Society 1500–1914* (The National Trust, 1996)

R.C. Bald, *John Donne: A Life* (Oxford University Press, revised edition 1986)

Cecil Beaton, *The Glass of Fashion* (Rizzoli, New York, 2014 reissue)

Max Beerbohm, 'Dandies and Dandies' in *The Works of Max Beerbohm* (Bodley Head, London, 1896)

Cally Blackman, *100 Years of Fashion Illustration* (Laurence King, London, 2007)

Cally Blackman, *100 Years of Fashion* (Laurence King, London, 2012)

Christopher Breward, Becky Conekin and Caroline Cox (eds), *The Englishness of English Dress* (Berg, Oxford & New York, 2002)

Richard Brilliant, *Portraiture* (Reaktion Books, London, 1991)

Penelope Byrde, *The Male Image: Men's Fashion in England 1300–1970* (Batsford, London, 1979)

William Camden, *The Life and Reign of Queen Elizabeth* (1706)

Lady Colin Campbell (ed.), *Etiquette of Good Society* (Cassell & Co., London, 1893)

D.J.H. Clifford (ed.) and Lady Anne Clifford, *The Diaries of Lady Anne Clifford* (The History Press, Stroud, Gloucestershire, 2009)

Valerie Cumming, Cecil Willett Cunnington and Phyllis Emily Cunnington, *The Dictionary of Fashion History* (Berg, Oxford & New York, 2010)

Marianne Faithfull, *Faithfull* (Penguin, London, 1994)

J.A. Franklin, Bernard Nurse and Pamela Tudor-Craig, *Catalogue of Paintings in the Collection of the Society of Antiquaries of London* (Harvey Miller Publishers, 2015)

R. Gathorne-Hardy (ed.), *Memoirs of Lady Ottoline Morrell* (Alfred Knopf, New York, 1964)

Robin Gibson, *20th Century Portraits* (National Portrait Gallery Publications, London, 1978)

Robin Gibson, *The Portrait Now* (National Portrait Gallery Publications, London, 1993)

Achsah Guibbory (ed.), *The Cambridge Companion to John Donne* (Cambridge University Press, 2006)

Avril Hart and Susan North, *Seventeenth- and Eighteenth-century Fashion in Detail* (V&A Publishing, 2009)

Karen Hearn, *Dynasties* (Tate Publishing, London, 1995)

Niklaus Wilhelm von Heideloff, *The Gallery of Fashion*, 1794–1803

Lloyd Lewis and Henry Justin Smith, *Oscar Wilde Discovers America* [1882] (New York, 1936)

Audrey Linkman, *The Victorians: A Photographic Portrait* (Tauris Parke, London, 1993)

Joel Lobenthal, *Radical Rags: Fashions of the Sixties* (Abbeville Press Inc., New York, 1990)

Jan Marsh, *Jane and May Morris: A Biographical Story, 1839–1938* (Pandora, London, 1986)

Christopher Newall, 'The Victorians, 1830–1880'; and Frances Spalding, 'The Modern Face, 1918–1960' in Roy Strong, Frances Spalding, John Wilson *et al.*, Strong, *The British Portrait, 1660–1960* (Antique Collectors' Club, Woodbridge, Suffolk, 1991)

Virginia Nicholson, *Among the Bohemians: Experiments in Living 1900–1939* (Penguin, London, 2003)

John Julius Norwich (ed.), *Darling Monster: The Letters of Lady Diana Cooper to her Son John Julius Norwich, 1939–1952* (Chatto & Windus, London, 2013)

David Piper, *The English Face*, M. Rogers (ed.) (National Portrait Gallery Publications, London, 1992)

Anna Reynolds, *In Fine Style: The Art of Tudor and Stuart Fashion* (Royal Collection Trust, London, 2013)

Aileen Ribeiro, 'If the slogan fits, wear it; the origins of activist fashion', *The Times*, 14 August 1984

Aileen Ribeiro, *Dress and Morality* (first published by B.T. Batsford, London 1986; republished and revised by Berg, Oxford & New York, 2003)

Aileen Ribeiro, *Fashion and Fiction: Dress in Art and Literature in Stuart England* (Yale University Press, New Haven & London, 2005)

Katrina Rolley, 'Fashion, Femininity and the Fight for the Vote' in *Art History* vol.13, no.1 (March 1990)

Valerie Steele, *Paris Fashion: A Cultural History* (Oxford University Press, 1988)

Roy Strong, 'The Elizabethan Malady: Melancholy in Elizabethan and Jacobean Portraiture' in *The Tudor and Stuart Monarchy: Pageantry, Painting, Iconography* (Vol. 2: Elizabethan) (Boydell Press, Woodbridge, 1995)

John L. Sweeney (ed.), *The Painter's Eye: Notes and Essays on the Pictorial Arts by Henry James* (University of Wisconsin Press, Madison, WI, 1989)

Sue Tilley, *Leigh Bowery: The Life and Times of an Icon* (Hodder & Stoughton, London, 1997)

Queen Victoria's Journal, 10 September 1839, vol.12: www.queenvictoriasjournals.org

Shearer West, *Portraiture* (Oxford University Press, 2004)

Andrew Wilton, *The Swagger Portrait* (Tate Publishing, London, 1992)

PICTURE CREDITS

Fig. i and 55.2. Florence Nightingale; Frances Parthenope, Lady Verney by William White, c.1836. Watercolour, 451 x 349mm. National Portrait Gallery, London (NPG 3246). Given by Sir Harry L. Stephen, Bt, 1945. © National Portrait Gallery, London.

Fig. ii. Florence Nightingale by Jerry Barrett, 1856. Pencil and watercolour, 165 x 102mm. National Portrait Gallery, London (NPG 3303). Given by wish of Miss H. T. Neild, 1946. © National Portrait Gallery, London.

Fig. iii. Florence Nightingale after S.G. Payne & Son, 1891. Bromide postcard print, 125 x 75mm. National Portrait Gallery, London (NPG x132535). © National Portrait Gallery, London.

Fig. iv. Princess Victoire of Saxe-Coburg-Gotha by Sir Edwin Landseer, 1839. Oil sketch on canvas. Royal Collection Trust (RCIN 400521). Royal Collection Trust/© Her Majesty Queen Elizabeth II 2015.

Fig. v. Sir Basil Henry Liddell Hart by Hein Heckroth, 1939. Oil on board, 768 x 514 mm. National Portrait Gallery, London (NPG 5907). © National Portrait Gallery, London.

Fig. vi. Samuel Pepys by John Hayls, 1666. Oil on canvas, 756 x 629 mm. National Portrait Gallery, London (NPG 211). © National Portrait Gallery, London.

Fig. vii. Henrietta Cavendish, Lady Huntingtower by Sir Godfrey Kneller, 1715. Oil on canvas. © National Trust Images

Fig. viii. Portrait of John Scott (?) of Banks Fee by Pompeo Girolamo Batoni, 1774. Oil on canvas. National Gallery, London (6308). Bequeathed by Mrs E.M.E. Commeline in memory of her husband, Col. C.E. Commeline, RE, 1960. © The National Gallery, London.

Fig. ix. Mary Moser by George Romney, c.1770–1. Oil on canvas, 763 x 642mm. National Portrait Gallery, London (NPG 6641). Purchased with help from the Heritage Lottery Fund and the Art Fund (with a contribution from the Wolfson Foundation), 2003. © National Portrait Gallery, London.

Fig. x. Edward Wortley Montagu by Matthew William Peters, 1775. Oil on canvas, 1162 x 862mm. National Portrait Gallery, London (NPG 4573). © National Portrait Gallery, London.

Fig. xi. Camila Batmanghelidjh by Dean Marsh, 2008. Oil on plywood panel, 763mm diameter. National Portrait Gallery, London (NPG 6845). Commissioned as part of the First Prize, BP Portrait Award, 2005. © National Portrait Gallery, London.

Fig. xii. Isambard Kingdom Brunel preparing the launch of the Great Eastern (also includes William Harrison; William Jacomb; Solomon Tredwell) by Robert Howlett, 1857. Albumen print, arched top, 276 x 241mm. National Portrait Gallery, London (NPG P663). © National Portrait Gallery, London.

Fig. xiii. Arthur James Balfour, 1st Earl of Balfour, by John Singer Sargent, 1908. Oil on canvas, 2600 x 1500mm. National Portrait Gallery, London (NPG 6620). Purchased through the Art Fund, Sir Christopher Ondaatje, the Lord Marcus Sieff bequest, the Wolfson Foundation through the Art Fund, Lord Rothschild, Sir Evelyn de Rothschild, the Headley Trust, the Linbury Trust, Sir Harry Djanogly, the Clore Duffield Foundation, the Ancaster Trust, the Sternberg Charitable Foundation and several other donations, 2002. © National Portrait Gallery, London.

Fig. xiv. John Elliott Burns by John Collier, 1889. Oil on canvas, 1245 x 921mm. National Portrait Gallery, London (NPG 3170). Given by the sitter's family, 1943. © National Portrait Gallery, London.

Fig. xv. Mrs Bischoffsheim by Sir John Everett Millais, Bt, 1873. Oil on canvas. Tate, London. © Tate, London 2015.

Fig. xvi. Joseph Edward Southall and Anna Elizabeth Southall by Joseph Edward Southall, 1911. Egg tempera on linen, 1003 x 503mm. National Portrait Gallery, London (NPG L215). Lent by Judith D. Smyth, 1998.
© Estate of Joseph Edward Southall; on loan to the National Portrait Gallery, London.

Fig. xvii. Lily Cole (Like a Painting) by Miles Aldridge, 2005. Lambda print, 506 x 380mm. National Portrait Gallery, London (NPG x131994). Given by Miles Aldridge, 2008. © Miles Aldridge.

1. King Henry VII by an unknown Netherlandish artist, 1505. Oil on panel, 425 x 305mm. National Portrait Gallery, London (NPG 416). © National Portrait Gallery, London.

1.1. Length of velvet, late fifteenth century. Silk, metal thread; width: 584mm, length: 3759mm. The Metropolitan Museum of Art. Rogers Fund, 1912 (Acc.n.: 12.49.8) © 2015. Image copyright The Metropolitan Museum of Art/Art Resource/Scala, Florence © Photo SCALA, Florence.

1.2. Bust of King Henry VII by Pietro Torrigiano, 1509–11. Painted and gilded terracotta. Victoria and Albert Museum, London. © Roxanne Peters for NEW PHO Invoicing/ Victoria and Albert Museum, London.

2. King Henry VIII, by an unknown Anglo-Netherlandish artist, c.1520. Oil on panel, 508 x 381mm. National Portrait Gallery, London (NPG 4690). © National Portrait Gallery, London.

2.1. Oval pendant set with a ruby, sapphires and pearls, one of nine designs for pendant jewels, from the 'Jewellery Book', drawn by Hans Holbein the Younger, c.1532–43. Pen and black ink, with grey and black wash and watercolour, touched with white bodycolour on paper. The British Museum, London. AN108812001. © The Trustees of the British Museum. All rights reserved.

2.2. King Henry VIII by an unknown artist, perhaps early 17th century (c.1542). Oil on panel, 889 x 667mm. National Portrait Gallery, London (NPG 496). © National Portrait Gallery, London.

3. Katherine of Aragon by an unknown artist, early 18th century. Oil on panel, 559 x 445mm. National Portrait Gallery, London (NPG 163). © National Portrait Gallery, London.

3.1. *Two views of a Woman wearing an English Hood* by Hans Holbein the Younger. The British Museum, London. 00031491001. © The Trustees of the British Museum. All rights reserved.

3.2. Unknown woman, formerly known as Catherine Howard, after Hans Holbein the Younger, late 17th century. Oil on panel, 737 x 495mm. National Portrait Gallery, London (NPG 1119). © National Portrait Gallery, London.

4 and 4.1. Katherine Parr, attributed to Master John, c.1545. Oil on panel, 1803 x 940mm. National Portrait Gallery, London (NPG 4451). Purchased with help from the Gulbenkian Foundation, 1965. © National Portrait Gallery, London.

4.2. Prophylactic pendant, England, c.1540–60. Gold enamelled in black and blue and set with a garnet, a peridot and hung with a sapphire. Victoria and Albert Museum, London. © Victoria and Albert Museum, London.

4.3. Katherine Parr by an unknown artist, late 16th century. Oil on panel, 635 x 508mm. National Portrait Gallery, London (NPG 4618). Purchased with help from The Art Fund, the Pilgrim Trust, H.M. Government and Gooden & Fox Ltd, 1968. © National Portrait Gallery, London.

5 and 5.1. King Edward VI by workshop associated with 'Master John', c.1547. Oil on panel, 1556 x 813mm. National Portrait Gallery, London (NPG 5511). © National Portrait Gallery, London.

6. Queen Mary I by Hans Eworth, 1554. Oil on panel, 216 x 169mm. National Portrait Gallery, London (NPG 4861). Purchased with help from The Art Fund, the Pilgrim Trust, H.M. Government, Miss Elizabeth Taylor and Richard Burton, 1972. © National Portrait Gallery, London.

6.1. The Peregrina necklace. Courtesy The Elizabeth Taylor Trust.

7, 7.1 and 7.2. Mary Neville, Lady Dacre; Gregory Fiennes, 10th Baron Dacre, by Hans Eworth, 1559. Oil on panel, 500 x 714mm. National Portrait Gallery, London (NPG 6855). Purchased with help from the National Heritage Memorial Fund, The Art Fund, the Portrait Fund, L.L. Brownrigg, John Morton Morris, Paul Dacre, and many other donations, 2008. © National Portrait Gallery, London.

8 and 8.1. Sir Henry Lee by Anthonis Mor (Antonio Moro), 1568. Oil on panel, 641 x 533mm. National Portrait Gallery, London (NPG 2095). Given by Harold Lee-Dillon, 17th Viscount Dillon, 1925. © National Portrait Gallery, London.

9. Queen Elizabeth I by an unknown Continental artist, c.1575. Oil on panel, 1130 x 787mm. National Portrait Gallery, London (NPG 2082). © National Portrait Gallery, London.

9.1 and 9.2. Queen Elizabeth I (the 'Ditchley' portrait) by Marcus Gheeraerts the Younger, c.1592. Oil on canvas, 2413 x 1524mm. National Portrait Gallery, London (NPG 2561). Bequeathed by Harold Lee-Dillon, 17th Viscount Dillon, 1932. © National Portrait Gallery, London.

10. Robert Dudley, 1st Earl of Leicester, by an unknown Anglo-Netherlandish artist, c.1575. Oil on panel, 1080 x 826mm. National Portrait Gallery, London (NPG 447). © National Portrait Gallery, London.

10.1. Robert Dudley, 1st Earl of Leicester, by an unknown English workshop, c.1575. Oil on panel, 965 x 686mm. National Portrait Gallery, London (NPG 247). © National Portrait Gallery, London.

11 and 11.1. Unknown woman, formerly known as Mary, Queen of Scots, by an unknown artist, c.1570. Oil on panel, transferred to canvas, 962 x 702mm. National Portrait Gallery, London (NPG 96). © National Portrait Gallery, London.

11.2. A pair of gloves with elongated fingers and separately worked gauntlets, c.1610–30. Leather, satin, silk and gold bobbin lace. The Fashion Museum, Bath. Fashion Museum, Bath and North East Somerset Council/The Glove Collection Trust/Bridgeman Images.

12. Sir Francis Drake by an unknown artist, c.1580. Oil on panel, 1813 x 1130mm. National Portrait Gallery, London (NPG 4032). © National Portrait Gallery, London.

12.1 Front of a crimson silk velvet cloak, 1560–75. Museum of London. © Museum of London.

12.2. Design for an aigrette with three plumes from an album of designs for jewellery by A. Lulls, c.1585–1640. Pencil, pen and ink, wash, body-colour and gold in a calf-skin album. Victoria and Albert Museum, London. © Victoria and Albert Museum, London.

12.3 and 12.4. Sir Walter Ralegh by an unknown English artist, 1588. Oil on panel, 914 x 746mm. National Portrait Gallery, London (NPG 7). © National Portrait Gallery, London.

13. Sir Christopher Hatton by an unknown artist, probably seventeenth century (1589). Oil on panel, 787 x 659mm. National Portrait Gallery, London (NPG 2162). © National Portrait Gallery, London.

13.1. Contemporary cameo showing a portrait of Sir Christopher Hatton. Private Collection. Photo © Christie's Images/Bridgeman Images.

14. John Donne by an unknown English artist, c.1595. Oil on panel, 771 x 625mm. National Portrait Gallery, London (NPG 6790). Purchased with help from the National Heritage Memorial Fund, the Art Fund, Lord Harris of Peckham, L.L. Brownrigg, the Portrait Fund, Sir Harry Djanogly, the Headley Trust, the Eva & Hans K. Rausing Trust, The Pidem Fund, Mr O. Damgaard-Nielsen, Sir David and Lady Scholey and numerous Gallery visitors and supporters, 2006. © National Portrait Gallery, London.

14.1. *A Young Man Seated Under a Tree* by Isaac Oliver, c.1590–5. Watercolour on vellum laid on card. Royal Collection Trust (RCIN 420639). Royal Collection Trust/© Her Majesty Queen Elizabeth II 2015.

15 and 15.1. Sir Henry Unton by an unknown artist, c.1596. Oil on panel, 740 x 1632mm. National Portrait Gallery, London (NPG 710). © National Portrait Gallery, London.

16. Sir Walter Ralegh; Walter Ralegh by an unknown artist, 1602. Oil on canvas, 1994 x 1273mm. National Portrait Gallery, London (NPG 3914). Given by Lennard family, 1954. © National Portrait Gallery, London.

16.1. Phineas Pett by an unknown artist, c.1612. Oil on panel, 1187 x 997mm. National Portrait Gallery, London (NPG 2035). © National Portrait Gallery, London.

16.2. Man's nightcap of fine linen embroidered with silks, silver gilt thread and silver gilt spangles, 1600–20. Chertsey Museum. © The Olive Matthews Trust Collection, Chertsey Museum. Photograph by John Chase.

17 and 17.2. Henry, Prince of Wales by Robert Peake the Elder, c.1610. Oil on canvas, 1727 x 1137mm. National Portrait Gallery, London (NPG 4515). Purchased with help from The Art Fund, 1966. © National Portrait Gallery, London.

17.1. The Lesser George, badge of the Order of the Garter. Enamelled gold. England, c.1610. Victoria and Albert Museum, London. © Victoria and Albert Museum, London.

18. Anne of Denmark by John De Critz the Elder, c.1605–10. Oil on canvas, 2016 x 1265mm. National Portrait Gallery, London (NPG 6918). © National Portrait Gallery, London.

18.1. Elizabeth, Queen of Bohemia by an unknown artist, 1613. Oil on panel, 784 x 622mm. National Portrait Gallery, London (NPG 5529). © National Portrait Gallery, London.

18.2. Breast ornament. Enamelled gold, set with 208 table-cut and triangular point-cut diamonds. Netherlands, c.1630. Victoria and Albert Museum, London. © Victoria and Albert Museum, London.

19. Anne, Countess of Pembroke (Lady Anne Clifford) by William Larkin, c.1618. Oil on panel, 575 x 435mm. National Portrait Gallery, London (NPG 6976). Purchased with help from the Art Fund, the Portrait Fund, the American Friends of the National Portrait Gallery in memory of David Alexander (President 2003 to 2010), Richard Aylmer, Sir Harry Djanogly CBE, the Golden Bottle Trust, Terry and Maria Hughes, Lady Rose Monson, Sir Charles and Lady Nunneley, Sir David Scholey CBE and Lady Scholey, and two anonymous supporters, 2013. © National Portrait Gallery, London.

19.1. Collar, detail. Needle lace. Genoa, Italy, c.1620–30. Victoria and Albert Museum, London. © Victoria and Albert Museum, London.

20 and 20.1. Probably Mary (née Throckmorton), Lady Scudamore by Marcus Gheeraerts the Younger, 1615. Oil on panel, 1143 x 826mm. National Portrait Gallery, London (NPG 64). © National Portrait Gallery, London.

20.2. Woman's close-fitting long-sleeved jacket, 1610–20. Museum of London. © Museum of London.

21. King Charles I by Daniel Mytens, 1631. Oil on canvas, 2159 x 1346mm. National Portrait Gallery, London (NPG 1246). © National Portrait Gallery, London.

21.1. King Charles I by Gerrit van Honthorst, 1628. Oil on canvas, 762 x 641mm. National Portrait Gallery, London (NPG 4444). Purchased with help from The Art Fund, 1965. © National Portrait Gallery, London.

22. Queen Henrietta Maria by Hendrik van Steenwyck, background by an unknown artist, c.1635. Oil on canvas, 2159 x 1352mm. National Portrait Gallery, London (NPG 1247). Given by Henry Louis Bischoffsheim, 1899. © National Portrait Gallery, London.

22.1. Queen Henrietta Maria with Sir Jeffrey Hudson by Sir Anthony van Dyck, 1633. Oil on canvas, 2191 x 1348mm. Samuel H. Kress Collection. Courtesy National Gallery of Art, Washington.

23. John Belasyse (Bellasis), 1st Baron Belasyse of Worlaby by Gilbert Jackson, 1636. Oil on canvas, 1892 x 1295mm. National Portrait Gallery, London (NPG 5948). Purchased with help from the National Heritage Memorial Fund and The Art Fund, 1987. © National Portrait Gallery, London.

23.1. Doublet and breeches. White satin handsewn with silk braid and silk ribbon. England, 1630–40. Victoria and Albert Museum, London. © Victoria and Albert Museum, London.

24. Sir Anthony van Dyck, by Sir Anthony van Dyck, c.1640. Oil on canvas, 560 x 460mm oval. National Portrait Gallery, London (NPG 6987). Purchased with support from the Heritage Lottery Fund, the Art Fund in honour of David Verey CBE (Chairman of the Art Fund 2004–14), the Portrait Fund, The Monument Trust, the Garfield Weston Foundation, the Aldama Foundation, the Deborah Loeb Brice Foundation, Sir Harry Djanogly CBE, Mr and Mrs Michael Farmer, Matthew Freud, Catherine Green, Dr Bendor Grosvenor, Alexander Kahane, the Catherine Lewis Foundation, the Material World Foundation, The Sir Denis Mahon Charitable Trust, Cynthia Lovelace Sears, two major supporters who wish to remain anonymous, and many contributions from the public following a joint appeal by the National Portrait Gallery and the Art Fund, 2014. © National Portrait Gallery, London.

24.1. Thomas Killigrew and William, Lord Crofts (?) by Sir Anthony van Dyck, 1638. Oil on canvas. Royal Collection Trust (RCIN 407426). Royal Collection Trust/© Her Majesty Queen Elizabeth II 2015.

24.2. Darmstadt doublet. Hessisches Landesmuseum Darmstadt. Photo: Christoph von Viràg, Abegg-Stiftung, Riggisberg (CH).

24.3. Thomas Killigrew by William Sheppard, 1650. Oil on canvas, 1245 x 965mm. National Portrait Gallery, London (NPG 3795). © National Portrait Gallery, London.

25. The Capel Family (Arthur Capel, Earl of Essex; Charles Capel; Arthur Capel, 1st Baron Capel; Elizabeth, Lady Capel; Henry Capel, Baron Capel of Tewkesbury; Mary Capel, Duchess of Beaufort; Elizabeth, Countess of Carnarvon) by Cornelius Johnson (Jonson or Jonson van Ceulen), c.1640. Oil on canvas, 1600 x 2591mm. National Portrait Gallery, London (NPG 4759). Purchased with help from The Art Fund, 1970. © National Portrait Gallery, London.

25.1. Man's collar. Linen edged with bobbin lace and tassles of knotted line thread.

Honiton, Devon, England, c.1630–50. Victoria and Albert Museum, London. © Victoria and Albert Museum, London.

25.2. Rattle, whistle and bells, silver and coral, marked by Jane Dorrell and Richard May, London, active 1766–71. The Colonial Williamsburg Foundation (Museum purchase), Accession #1970-122.

25.3. *English Noblewoman* by Wenceslaus Hollar, 1643. Etching, 950 x 630mm. Fine Arts Museum of San Francisco. Achenbach Foundation for Graphic Arts, 1963.30.17865.

26. Frances Talbot (née Jenyns (Jennings)), Duchess of Tyrconnel (formerly Lady Hamilton) by Samuel Cooper, c.1665. Watercolour on vellum, 73 x 61mm oval. National Portrait Gallery, London (NPG 5095). © National Portrait Gallery, London.

26.1. Watered silk bodice, English, 1645–55. Museum of London. © Museum of London.

27. The Family of Sir Robert Vyner (Viner), Bt (Bridget, Duchess of Leeds; Mary (née Whitchurch), Lady Vyner; Charles Vyner; Sir Robert Vyner (Viner), Bt) by John Michael Wright, 1673. Oil on canvas, 1448 x 1956mm. National Portrait Gallery, London (NPG 5568). © National Portrait Gallery, London.

27.1. Italian brown figured silk brocaded in silver, late seventeenth century. Image Courtesy Yale University Press.

28. John Dryden by James Maubert, c.1695. Oil on canvas, 572 x 502mm. National Portrait Gallery, London (NPG 1133). © National Portrait Gallery, London.

28.1. Unknown man, formerly known as Daniel Purcell, attributed to an unknown artist, 1690s. Oil on canvas, 559 x 470mm. National Portrait Gallery, London (NPG 1463). Given by Charles Burney, 1907. © National Portrait Gallery, London.

29. Eleanor ('Nell') Gwyn by Simon Verelst, c.1680. Oil on canvas, feigned oval, 737 x 632mm. National Portrait Gallery, London (NPG 2496). Bequeathed by John Neale, 1931. © National Portrait Gallery, London.

29.1. Unknown woman, formerly known as Nell Gwyn, studio of Sir Peter Lely, c.1675. Oil on canvas, 1270 x 1016mm. National Portrait Gallery, London (NPG 3976). © National Portrait Gallery, London.

30. Queen Mary II by Sir Peter Lely, 1677. Oil on canvas, 1254 x 1019mm. National Portrait Gallery, London (NPG 6214). © National Portrait Gallery, London.

30.1. Queen Mary II, published by Nicolaes Visscher II, after Jan van der Vaart, c.1683–1729. Mezzotint, 335 x 255mm. National Portrait Gallery, London (NPG D31057). Given by the daughter of compiler William Fleming MD, Mary Elizabeth Stopford, 1931. © National Portrait Gallery, London.

31. Eleanor James by an unknown artist, c.1700. Oil on canvas, 1268 x 1035mm. National Portrait Gallery, London (NPG 5592). © National Portrait Gallery, London.

31.1. Women's French fashion, c.1695. By permission of the Pepys Library, Magdalene College, Cambridge.

31.2. Dress (Mantua), c.1708 and stomacher, c.1720s. Silk, metal; length at centre back 2650mm. The Metropolitan Museum of Art. Purchase, Irene Lewisohn Bequest, Rogers Fund, and Isabel Shults Fund, 1991 (Acc.n.1991.6.1ab, 1991.6.2). © 2015. Image copyright The Metropolitan Museum of Art/Art Resource/Scala, Florence © Photo SCALA, Florence.

32. Prince James Francis Edward Stuart and Princess Louisa Maria Theresa Stuart by Nicolas de Largillière, 1695. Oil on canvas, 1928 x 1457mm. National Portrait Gallery, London (NPG 976). Bequeathed by Horatio William Walpole, 4th Earl of Orford, 1895. © National Portrait Gallery, London.

32.1. Princess Louisa Maria Theresa Stuart, attributed to Alexis Simon Belle, c.1702–6. Oil on canvas, 753 x 625mm. National Portrait Gallery, London (NPG 1658). Given by George Harland Peck, 1912. © National Portrait Gallery, London.

33. William Congreve by Sir Godfrey Kneller, Bt, 1709. Oil on canvas, 914 x 711mm. National Portrait Gallery, London (NPG 3199). Given by the Art Fund, 1945. © National Portrait Gallery, London.

33.1. Richard Lumley, 2nd Earl of Scarbrough by Sir Godfrey Kneller, Bt, 1717. Oil on canvas, 914 x 711mm. National Portrait Gallery, London (NPG 3222). Given by the Art Fund, 1945. © National Portrait Gallery, London.

34. James Craggs the Elder, attributed to John Closterman, c.1710. Oil on canvas, 1270 x 1016mm. National Portrait Gallery, London (NPG 1733). © National Portrait Gallery, London.

34.1. Joseph Collet by Amoy Chinqua, 1716. Painted unfired clay statuette, 838mm high. National Portrait Gallery, London (NPG 4005). Given by the sitter's descendant, W.P.G. Collet, 1956. © National Portrait Gallery, London.

34.2. Sleeved waistcoat of figured silk with button and buttonholes embroidered in metal thread, 1718–22. Museum of London. © Museum of London.

35. The Talman Family Group (William Talman; John Talman; Frances Cockayne; Hannah Talman) by Giuseppe Grisoni, c.1718–19. Oil on canvas, 1024 x 724mm. National Portrait Gallery, London (NPG 5781). © National Portrait Gallery, London.

35.1. Matthew Prior by Jonathan Richardson after Thomas Hudson, c.1718. Oil on canvas, 1022 x 872mm. National Portrait Gallery, London (NPG 562). Transferred from British Museum, 1879. © National Portrait Gallery, London.

35.2. Man's nightgown. Silk damask, 1715. Fashion Museum, Bath and North East Somerset Council/Acquired with the assistance of The Art Fund and V&A/Purchase Grant Fund/Bridgeman Images.

35.3. Silk dress panel, 1707–8. Museum of London. © Museum of London.

36. *The Music Party* (Frederick Lewis, Prince of Wales, and his sisters, Anne, Princess Royal and Princess of Orange; Princess Caroline Elizabeth; Princess Amelia Sophia Eleanora) by Philip Mercier, 1733. Oil on canvas, 451 x 578mm. National Portrait Gallery, London (NPG 1556). © National Portrait Gallery, London.

36.1. *The Exact Dress of the Head* by Bernard Lens, 1725–6. Pen and ink and watercolour on paper pasted into a sketchbook. Victoria and Albert Museum, London. © Victoria and Albert Museum, London.

36.2. Frederick Lewis, Prince of Wales by Philip Mercier, *c*.1735–6. Oil on canvas, 1238 x 1003mm. National Portrait Gallery, London (NPG 2501). Bequeathed by Miss Lillie Belle Randell, 1931. © National Portrait Gallery, London.

37. Henry Benedict Maria Clement Stuart, Cardinal York by Louis Gabriel Blanchet, 1738. Oil on canvas, 1886 x 1403mm. National Portrait Gallery, London (NPG 5518). © National Portrait Gallery, London.

37.1. From *The Rudiments of Genteel Behaviour* by F.Nivelon, 1737. Victoria and Albert Museum, London. © Victoria and Albert Museum, London.

37.2. Silver metal lace on red velvet, eighteenth century. 114mm (at widest point) x 335mm. © reserved.

38. The Shudi Family Group (Burkat Shudi; Joshua Shudi; Catherine Shudi (née Wild); Burkat Shudi) by Marcus Tuscher, *c*.1742. Oil on canvas, 834 x 1415mm. National Portrait Gallery, London (NPG 5776). Purchased with help from the National Heritage Memorial Fund, 1985. © National Portrait Gallery, London.

38.1 (detail). Francis Ayscough with the Prince of Wales (later King George III) and Edward Augustus, Duke of York and Albany by Richard Wilson, *c*.1749. Oil on canvas, 2070 x 2578mm. National Portrait Gallery, London (NPG 1165). Given by Thomas Agnew & Sons Ltd, 1900. © National Portrait Gallery, London.

39. Sir Thomas Robinson, 1st Bt by Frans van der Mijn (or Myn), 1750. Oil on canvas, 1267 x 1019mm. National Portrait Gallery, London (NPG 5275). © National Portrait Gallery, London.

39.1. Sleeve ruffles. Bobbin lace worked in linen thread. Mechelen, Belgium, *c*.1750. Victoria and Albert Museum, London. © Victoria and Albert Museum, London.

40. Peg Woffington by John Lewis, 1753. Oil on canvas, feigned oval, 760 x 633mm. National Portrait Gallery, London (NPG 5729). © National Portrait Gallery, London.

40.1. Unknown woman, formerly known as Peg Woffington, attributed to Francis Hayman, *c*.1745. Oil on canvas, 622 x 448mm. National Portrait Gallery, London (NPG 2177). © National Portrait Gallery, London.

40.2. Gown and kerchief. Gown, Britain, 1740, ribbed silk, bodice lined with linen, skirt lined with silk, reproduction petticoat. Kerchief, Britain, 1745–60, cotton embroidered with linen. Accession # 1994-87 & 1971-170. The Colonial Williamsburg Foundation. Museum Purchase.

41. Warren Hastings by Sir Joshua Reynolds, 1766–8. Oil on canvas, 1264 x 1010mm. National Portrait Gallery, London (NPG 4445). Accepted in lieu of tax by H.M. Government and allocated to the Gallery, 1965. © National Portrait Gallery, London.

41.1. Waistcoat. Indian chintz. Britain, nineteenth century. Victoria and Albert Museum, London. © Victoria and Albert Museum, London.

42. Francis Osborne, 5th Duke of Leeds, attributed to Benjamin West, *c*.1769. Oil on canvas, 692 x 889mm. National Portrait Gallery, London (NPG 801). Given by Walter John Pelham, 4th Earl of Chichester, 1888. © National Portrait Gallery, London.

42.1. Draft trade card for Brackstone, a mercer. The British Museum. © The Trustees of the British Museum.

43. David Garrick and Eva Maria Garrick (née Veigel) by Sir Joshua Reynolds, 1772–3. Oil on canvas, 1403 x 1699mm. National Portrait Gallery, London (NPG 5375). © National Portrait Gallery, London.

43.1. Theatrical costume ensemble: brown velvet suit, coat, waistcoat and breeches associated with David Garrick, 1758–61. Museum of London. © Museum of London.

43.2. Detail of flounce and petticoat from satin sack-back dress, 1760s. Museum of London. © Museum of London.

44. Christopher Anstey with his daughter, by William Hoare, *c*.1775. Oil on canvas, 1265 x 1010mm. National Portrait Gallery, London (NPG 3084). Bequeathed by Mrs C.M. Sambourne-Palmer, 1940. © National Portrait Gallery, London.

44.1. Doll in original sack gown and petticoat. Carved and painted wood, silk, linen, wool, 1770–80. Presented in memory of Miss Monkhouse, 1937. TBM Toy.302. The Bowes Museum, Barnard Castle, County Durham, England.

45. Mary Wilkes and John Wilkes by Johann Joseph Zoffany, exhibited 1782. Oil on canvas, 1264 x 1003mm. National Portrait Gallery, London (NPG 6133). Purchased with help from the National Heritage Memorial Fund and The Art Fund, 1991. © National Portrait Gallery, London.

45.1. *Twelve Fashionable Head-dresses of 1778*. John Johnson Collection: Women's Clothes and Millinery 5 (35a), The Bodleian Library, University of Oxford.

45.2. *Le Rendez-vous pour Marly*, Carl Güttenberg after a drawing by Jean-Michel Moreau the Younger, 1777. Private Collection/The Stapleton Collection/Bridgeman Images.

45.3. Striped robe and petticoat. Silk and linen. England, *c*.1775. Victoria and Albert Museum, London. © Roxanne Peters for NEW PHO Invoicing/Victoria and Albert Museum, London.

46 and 46.1. The Sharp Family (includes Mary Lloyd-Baker (née Sharp); Elizabeth Prowse (née Sharp); Anna Jemima Sharp; Catherine Sharp (née Barwick); Catherine Sharp; Frances Sharp; Granville Sharp; James Sharp; Mrs James Sharp (née Lodge); John Sharp; Judith Sharp; Mary Sharp (née Dering); William Sharp) by Johann Joseph Zoffany, 1779–81. Oil on canvas, 1156 x 1257mm. National Portrait Gallery, London (NPG L169). Lent by Trustees of the Lloyd-Baker Settled Estates, 1978. Private collection; on loan to the National Portrait Gallery, London.

46.2. Quilted satin petticoat, mid-eighteenth century. Museum of London. © Museum of London.

47. *A Voluptuary under the Horrors of Digestion* (King George IV) by James Gilray, published by Hannah Humphrey on 2 July 1792. Hand-coloured stipple engraving, 361 x 288mm. National Portrait Gallery, London (NPG D33359). © National Portrait Gallery, London.

47.1. The Prince Regent, later George IV by John Russell, 1794. Chalk (black and red) on paper, 344 x 485mm. The Samuel Courtauld Trust, The Courtauld Gallery, London.

47.2. King George IV by Richard Cosway, *c*.1780–2. Watercolour on ivory, 98 x 73mm oval. National Portrait Gallery, London (NPG 5890). © National Portrait Gallery, London.

48. Mary Wollstonecraft by John Opie, *c*.1797. Oil on canvas, 768 x 641mm. National Portrait Gallery, London (NPG 1237). Bequeathed by Jane, Lady Shelley, 1899. © National Portrait Gallery, London.

48.1. Anne Holroyd (née North), Countess of Sheffield by Henry Edridge, 1798. Pencil and wash, 267 x 184mm. National Portrait Gallery, London (NPG 2185a). © National Portrait Gallery, London.

48.2. Gown. Muslin and cotton. England, early nineteenth century. Victoria and Albert Museum, London. © Victoria and Albert Museum, London.

49. John Constable by John Constable, *c*.1799–1804. Pencil and black chalk heightened with white and red chalk, 248 x 194mm. National Portrait Gallery, London (NPG 901). © National Portrait Gallery, London.

49.1. Samuel Taylor Coleridge by Peter Vandyke, 1795. Oil on canvas, 559 x 457mm. National Portrait Gallery, London (NPG 192). © National Portrait Gallery, London.

50. Mary Anne Clarke (née Thompson) by Adam Buck, 1803. Watercolour and bodycolour on ivory, 102 x 83mm. National Portrait Gallery, London (NPG 2793). © National Portrait Gallery, London.

50.1. Mary Anne Clarke (née Thompson) by Lawrence Gahagan, 1811. Marble bust, 641mm high. National Portrait Gallery, London (NPG 4436). © National Portrait Gallery, London.

50.2. Mary English (née Ballard, later Greenup) by William Armfield Hobday, 1818. Oil on canvas, 760 x 630mm. National Portrait Gallery, London (NPG 6964). Given by members of the sitter's family in memory of Drusilla Scott, the sitter's great-great granddaughter, 2013. © National Portrait Gallery, London.

51. Caroline Amelia Elizabeth of Brunswick by Sir Thomas Lawrence, 1804. Oil on canvas, 1403 x 1118mm. National Portrait Gallery, London (NPG 244). © National Portrait Gallery, London.

51.1. *A Wooden Substitute, or Any Port in a Storm* (Bartolomeo Pergami; Caroline Amelia Elizabeth of Brunswick; Sir Matthew Wood, 1st Bt) attributed to Theodore Lane, published by George Humphrey on 19 January 1821. Coloured etching, 271 x 201mm. National Portrait Gallery, London (NPG D10847). © National Portrait Gallery, London.

51.2. Princess Charlotte Augusta of Wales by George Dawe, 1817. Oil on canvas, 1397 x 1080mm. National Portrait Gallery, London (NPG 51). © National Portrait Gallery, London.

51.3. Princess Charlotte Augusta's 'Russian Dress'. Royal Collection Trust/ © Her Majesty Queen Elizabeth II 2015.

52. Arthur Wellesley, 1st Duke of Wellington by Juan Bauzil (or Bauziel), 1812–16. Watercolour, 330 x 248mm. National Portrait Gallery, London (NPG 308). Given by William Smith, 1870. © National Portrait Gallery, London.

52.1. Portrait of George 'Beau' Brummell by Robert Dighton, 1805. Colour litho, later colouration. Private Collection/Bridgeman Images.

52.2. *Neckclothitania*. From https://commons.wikimedia.org/

53. William Cobbett by John Raphael Smith. Chalk, engraved 1812. 635 x 457mm. National Portrait Gallery, London (NPG 6870). © National Portrait Gallery, London.

53.1 John Clare by William Hilton, 1820. Oil on canvas, 762 x 635mm. National Portrait Gallery, London (NPG 1469). © National Portrait Gallery, London.

54. Henry Brougham, 1st Baron Brougham and Vaux by Sir Thomas Lawrence, 1825. Oil on panel, 1143 x 819mm. National Portrait Gallery, London (NPG 3136). Purchased with help from The Art Fund, 1943. © National Portrait Gallery, London.

54.1. Ira Frederick Aldridge, after James Northcote, *c*.1826. Oil on canvas, 763 x 632mm. National Portrait Gallery, London (NPG L251). Lent by a private collection, 2012. Private Collection; on loan to the National Portrait Gallery, London.

55. Clara Novello by Edward Petre Novello, 1833. Oil on canvas, 1425 x 1126mm. National Portrait Gallery, London (NPG 5685). © National Portrait Gallery, London.

55.1. *Elizabeth Knight by Mr Gapp of Brighton*, 1832. Cut silhouette, height 242mm; paper on card 279 x 146mm. Private Collection. © reserved.

55.2. See fig. i.

55.3. Day dress. Printed cotton. England, 1830–5. Victoria and Albert Museum, London. © Victoria and Albert Museum, London.

56. Charles Dickens by Daniel Maclise, 1839. Oil on canvas, 914 x 714mm. NPG 1172. Lent by Tate Gallery: London: UK, 1954. Tate 2015; on loan to the National Portrait Gallery, London.

56.1. Charles Dickens by John & Charles Watkins, 1861. Albumen *carte-de-visite*, 89 x 55mm. National Portrait Gallery, London (NPG Ax16252). Given by Algernon Graves, 1916. © National Portrait Gallery, London.

56.2. Alfred, Count D'Orsay by Sir George Hayter, 1839. Oil on canvas, 1273 x 1016mm. National Portrait Gallery, London (NPG 5061). © National Portrait Gallery, London.

57. Angela Georgina Burdett-Coutts, Baroness Burdett-Coutts by Sir William Charles Ross, *c*.1847. Watercolour on ivory, 419 x 292mm. National Portrait Gallery, London (NPG 2057). Transferred from Tate Gallery: London: UK, 1957. © National Portrait Gallery, London.

57.1. Shawl of appliqué bobbin lace on machine-net ground, Brussels, *c*.1850. Victoria and Albert Museum, London. © Victoria and Albert Museum, London.

57.2. Jenny Lind; Marietta Alboni, Countess Pepoli (née Maria Anna Marzia) by William Edward Kilburn, 1848. Hand-coloured, half-plate daguerreotype, arched top, 115 x 89mm. National Portrait Gallery, London (NPG P956). © National Portrait Gallery, London.

57.3. Day dress of shot silk, 1845–50. © The Olive Matthews Trust Collection, Chertsey Museum. Photograph by John Chase.

58. *The Secret of England's Greatness* (Queen Victoria presenting a Bible in the Audience Chamber at Windsor) (Elizabeth Wellesley (née Hay), Duchess of Wellington; Prince Albert of Saxe-Coburg-Gotha; Queen Victoria; Henry John Temple, 3rd Viscount

Palmerston; John Russell, 1st Earl Russell) by Thomas Jones Barker, c.1863. Oil on canvas, 1676 x 2138mm. National Portrait Gallery, London (NPG 4969). © National Portrait Gallery, London.

58.1. *Queen Victoria's First Visit to Her Wounded Soldiers* (includes Prince Albert of Saxe-Coburg-Gotha; Prince George William Frederick Charles, 2nd Duke of Cambridge; Charlotte Canning (née Stuart), Countess Canning; George Russell Dartnell; Prince Alfred, Duke of Edinburgh and Saxe-Coburg and Gotha; King Edward VII; Sir Charles Grey; Henry Hardinge, 1st Viscount Hardinge of Lahore; Sir Charles Beaumont Phipps; Henry Cooper Reade; Queen Victoria and 11 others) by Jerry Barrett, 1856. Oil on canvas, 1419 x 2133mm. National Portrait Gallery, London (NPG 6203). Purchased with help from the National Heritage Memorial Fund and The Art Fund, 1993. © National Portrait Gallery, London.

58.2. Mary Jane Seacole (née Grant) by Albert Charles Challen, 1869. Oil on panel, 240 x 180mm. National Portrait Gallery, London (NPG 6856). Purchased with help from the National Lottery through the Heritage Lottery Fund, and Gallery supporters, 2008. © National Portrait Gallery, London.

58.3. Mary Jane Seacole, by Maull & Co. © 2015 Amoret Tanner Collection/fotoLibra.

59. Queen Alexandra by Maull & Co, 1873. Albumen cabinet card, 138 x 90mm. National Portrait Gallery, London (NPG x33252). Given by Theatre Museum, 1970. © National Portrait Gallery, London.

59.1. Photograph of Queen Alexandra when Alexandra, Princess of Wales, with a dog, Russell & Sons, Chichester, 1860s. Albumen photographic print *carte de visite*. Royal Collection Trust/© Her Majesty Queen Elizabeth II 2015.

60. Ann Mary Newton (née Severn) by Ann Mary Newton (née Severn), c.1862[?]. Oil on canvas, 610 x 521mm. National Portrait Gallery, London (NPG 977). Bequeathed by the sitter's husband, Sir Charles Thomas Newton, 1895. © National Portrait Gallery, London.

60.1. Emilia Francis (née Strong), Lady Dilke by Pauline, Lady Trevelyan (née Jermyn) and Laura Capel Lofft (later Lady Trevelyan), c.1864. Oil on millboard, 254 x 181mm. National Portrait Gallery, London (NPG 1828a). Bequeathed by the sitter's husband, Mark Pattison, 1919. © National Portrait Gallery, London.

60.2. Jane Morris (née Burden) by John Robert Parsons, copied by Emery Walker Ltd., July 1865. Bromide print, 208 x 155mm. National Portrait Gallery, London (NPG x137525). Given by Emery Walker Ltd, 1956. © National Portrait Gallery, London.

61. Louise Jane Jopling (née Goode, later Rowe) by Sir John Everett Millais, 1st Bt, 1879. Oil on canvas, 1240 x 765mm. National Portrait Gallery, London (NPG 6612). Purchased with help from the Art Fund and the Heritage Lottery Fund, 2002. © National Portrait Gallery, London.

61.1. Louise Jopling in her studio, 1906. Courtesy Dr Patricia de Montfort.

62. Adelina Patti by James Sant, exhibited 1886. Oil on canvas, 1099 x 851mm. National Portrait Gallery, London (NPG 3625). Bequeathed by Rolf, Baron Cederström, 1948. © National Portrait Gallery, London.

62.1. Evening dress by Charles Frederick Worth, House of Worth c.1882. Silk, length at centre back a) 635mm; b) 1270mm. The Metropolitan Museum of Art Costume Collection at The Metropolitan Museum of Art, Gift of the Brooklyn Museum, 2009; Gift of the Princess Viggo in accordance with the wishes of the Misses Hewitt, 1931 (2009.300.635a,b) © 2015. Image copyright The Metropolitan Museum of Art/Art Resource/Scala, Florence © Photo SCALA, Florence.

62.2. Emilia Francis (née Strong), Lady Dilke by Sir Hubert von Herkomer, c.1864. Oil on canvas, 1397 x 1092mm. National Portrait Gallery, London (NPG 5288). © National Portrait Gallery, London.

62.3. Emilia Francis (née Strong), Lady Dilke by Charles Camino, 1882. Watercolour on ivory, 140 x 95mm. National Portrait Gallery, London (NPG 1828). Bequeathed by the sitter's husband, Mark Pattison, 1919. © National Portrait Gallery, London.

63. Oscar Wilde by Napoleon Sarony, 1882. Albumen panel card, 305 x 184mm. National Portrait Gallery, London (NPG P24). © National Portrait Gallery, London.

63.1. Aubrey Vincent Beardsley by Jacques-Emile Blanche, 1895. Oil on canvas, 926 x 737mm. National Portrait Gallery, London (NPG 1991). © National Portrait Gallery, London.

63.2. Aubrey Beardsley by Walter Richard Sickert, 1894. Tempera on canvas. © Tate, London 2015.

63.3. Sir Max Beerbohm by Sir William Newzam Prior Nicholson, 1905. Oil on canvas, 502 x 400mm. National Portrait Gallery, London (NPG 3850). Bequeathed by Mrs G. Kinnell, 1953. © Desmond Banks.

64. Gertrude Elizabeth (née Blood), Lady Colin Campbell by Giovanni Boldini, c.1897. Oil on canvas, 1843 x 1202mm. National Portrait Gallery, London (NPG 1630). Given by Winifred Brooke Alder by wish of the sitter, 1911. © National Portrait Gallery, London.

64.1. Alice Helleu by Paul Helleu, c.1892. Three-colour crayon drawing. Private Collection. © reserved.

65. Camille Clifford (Camilla Antoinette Clifford) by Draycott Galleries, published by Davidson Brothers, mid 1900s. Postcard print, 124 x 80mm. National Portrait Gallery, London (NPG x27516). Given by Philip Barraud, 1986. © National Portrait Gallery, London.

65.1. Lillie Langtry by Bassano Ltd, 22 May 1911. Whole-plate glass negative. National Portrait Gallery, London (NPG x127699). Given by John Morton Morris, 2004. © National Portrait Gallery, London.

65.2. Camille Clifford (Camilla Antoinette Clifford) by Bassano Ltd, 22 May 1916. Whole-plate glass negative. National Portrait Gallery, London (NPG x22156). Given by Bassano & Vandyk Studios, 1974. © National Portrait Gallery, London.

66. Dame Christabel Pankhurst by Ethel Wright, exhibited 1909. Oil on canvas, 1625 x 967mm. National Portrait Gallery, London (NPG 6921). Bequeathed by Elizabeth Ruth Dugdale Weir, 2011. © National Portrait Gallery, London.

66.1. Design for a pendant, with centre stone purple in colour and surrounded by a foliate

design, drawn by Francis Derwent Wood, c.1906–14. Watercolour over graphite on paper. The British Museum, London. © The Trustees of the British Museum. All rights.

66.2. Emmeline Pethick-Lawrence; Dame Christabel Pankhurst by an unknown photographer, 21 June 1908. Postcard print, 77 x 137mm. National Portrait Gallery, London (NPG x45194). © National Portrait Gallery, London.

67. Gwen John by Gwendolen Mary ('Gwen') John, c.1900. Oil on canvas, 610 x 378mm. National Portrait Gallery, London (NPG 4439). Given by the Art Fund to mark Sir Alec Martin's 40 years' service to the fund, 1965. © National Portrait Gallery, London.

67.1. Augustus John possibly by (Charles) John Hope-Johnstone, 1909. Vintage snapshot print, 87 x 67mm. National Portrait Gallery, London (NPG Ax13021). © reserved; collection National Portrait Gallery, London.

67.2. Dora Carrington, Barbara Bagenal, Dorothy Brett by an unknown photographer. Black-and-white negative, c.1911. © Tate, London 2015.

68. Lytton Strachey by Dora Carrington, 1916. Oil on panel, 508 x 609mm. National Portrait Gallery, London (NPG Ax13021). Bequeathed by Frances Catherine Partridge (née Marshall), 2004. © National Portrait Gallery, London.

68.1. Lytton Strachey, by Nicolas Clerihew Bentley, c.1928–30. Ink and watercolour on artist's board, 364 x 134mm. National Portrait Gallery, London (NPG 6842). Given by Richard Digby Day, 2008. © reserved; collection National Portrait Gallery, London.

69. Lady Ottoline Morrell by Augustus Edwin John, 1919. Oil on canvas, 690 x 511mm. National Portrait Gallery, London (NPG 6095). Accepted in lieu of tax by H.M. Government and allocated to the Gallery, 1990. © Estate of Augustus John/Bridgeman Images.

69.1. Lady Ottoline Morrell by Cecil Beaton, 1927. Bromide print on white card mount, 266 x 189mm. National Portrait Gallery, London (NPG x14149). Given by Cecil Beaton, 1968. © The Cecil Beaton Studio Archive, Sotheby's, London.

69.2. Lady Ottoline Morrell's dress, English school. Silk. Fashion Museum, Bath and North East Somerset Council/Acquired with the assistance of The Art Fund and V&A/Purchase Grant Fund/Bridgeman Images.

70. *Self-Portrait* by Dame Laura Knight, 1913. Oil on canvas, 1520 x 1270mm. National Portrait Gallery, London (NPG 4839). © Reproduced with permission of The Estate of Dame Laura Knight DBE RA, 2015. All rights reserved.

70.1. Vanessa Bell (née Stephen) by Duncan Grant, c.1918. Oil on canvas, 940 x 606mm. National Portrait Gallery, London (NPG 4331). © National Portrait Gallery, London.

71. Radclyffe Hall by Charles Buchel (Karl August Büchel), 1918. Oil on canvas, 914 x 711mm. National Portrait Gallery, London (NPG 4347). Bequeathed by Una Elena Vincenzo (née Taylor), Lady Troubridge, 1963. © National Portrait Gallery, London.

71.1. Dame Ethel Walker by Dame Ethel Walker, c.1925. Oil on canvas, 613 x 508mm. National Portrait Gallery, London (NPG 4347). © National Portrait Gallery, London.

71.2. Dorothy Leigh Sayers by Sir William Oliphant Hutchison, c.1949–50. Oil on canvas, 762 x 667mm. National Portrait Gallery, London (NPG 5146). © National Portrait Gallery, London.

72. Winifred Radford by Meredith Frampton, 1921. Oil on canvas, 892 x 746mm. National Portrait Gallery, London (NPG 6397). © National Portrait Gallery, London.

72.1. Noel Streatfeild by Lewis Baumer, exhibited 1926. Oil on canvas, 762 x 635mm. National Portrait Gallery, London (NPG 5941). Bequeathed by (Mary) Noel Streatfeild, 1987. © National Portrait Gallery, London.

73. Constant Lambert by Christopher Wood, 1926. Oil on canvas, 914 x 559mm. National Portrait Gallery, London (NPG 4443). © National Portrait Gallery, London.

73.1. Humfry Gilbert Garth Payne by (Margaret) Ithell Colquhoun, 1934. Pen and ink, pencil and watercolour on tracing paper, 641 x 305mm. National Portrait Gallery, London (NPG 5269). © National Portrait Gallery, London.

74. Harriet Cohen by Ronald Ossory Dunlop, c.1930. Oil on canvas, 760 x 507mm. National Portrait Gallery, London (NPG 6165). Given by the sitter's sister, Myra Verney, 1992. © reserved; collection National Portrait Gallery, London.

74.1. Harriet Cohen by Joan Craven, c.1930–5. Cream-toned bromide print on cream card and black and white tint mount, 202 x 135mm. National Portrait Gallery, London (NPG x39244). Given by the sitter's sister, Myra Verney, 1992. © National Portrait Gallery, London.

74.2. Detail of a pleated silk Delphos gown by Mariano Fortuny, with Murano glass beads. 1920–30. © The Olive Matthews Trust Collection, Chertsey Museum. Photograph by John Chase.

75. Dame Wendy Margaret Hiller by Thomas Cantrell Dugdale, c.1935. Oil on canvas, 1117 x 815mm. National Portrait Gallery, London (NPG 6656). Given by the sitter's son and daughter, Anthony Hiller Gow and Ann Gow, 2003. © National Portrait Gallery, London.

75.1. Diana, Viscountess Norwich (Lady Diana Cooper) by Cecil Beaton, 1941. Bromide print, 201 x 192mm. National Portrait Gallery, London (NPG x40065). Accepted in lieu of tax by H.M. Government and allocated to the Gallery, 1991. © The Cecil Beaton Studio Archive, Sotheby's, London.

75.2. Diana, Viscountess Norwich (Lady Diana Cooper) by Bernard Lee ('Bern') Schwartz, 1977. Dye transfer print, 343 x 349mm. National Portrait Gallery, London (NPG P1224). Given by Bernard Lee Schwartz Foundation, 2007. © National Portrait Gallery, London.

76. Anna Zinkeisen by Anna Katrina Zinkeisen, c.1944. Oil on canvas, 752 x 625mm. National Portrait Gallery, London (NPG 5884). © National Portrait Gallery, London.

76.1. Doris Zinkeisen by Doris Clare Zinkeisen, exhibited 1929. Oil on canvas, 1072 x 866mm. National Portrait Gallery, London (NPG 6487). © Estate of Doris Clare Zinkeisen.

77. Conversation Piece at the Royal Lodge, Windsor (King George VI; Queen Elizabeth, the Queen Mother; Queen Elizabeth II; Princess Margaret) by Sir (Herbert) James Gunn, 1950. Oil on canvas, 1511 x 1003mm. National Portrait Gallery, London (NPG 3778). Commissioned 1950. © National Portrait Gallery, London.

77.1. Wallis, Duchess of Windsor; Prince Edward, Duke of Windsor (King Edward VIII) by Dorothy Wilding, 7 February 1955. Half-plate film negative. National Portrait Gallery, London

(NPG x32656). Given by the photographer's sister, Susan Morton, 1976. © National Portrait Gallery, London.

77.3. Wallis, Duchess of Windsor by Irving Penn, 1948. Bromide print, 241 x 181mm. National Portrait Gallery, London (NPG P604). Duchess of Windsor (1 of 2), New York, 1948. Copyright © The Irving Penn Foundation.

78. John Minton by (Edward) Russell Westwood, 1951. Glazed bromide print, 241 x 242mm. National Portrait Gallery, London (NPG x35236). Acquired British Film Institute. © Estate of Russell Westwood/National Portrait Gallery, London.

78.1. Harold Pinter by Cecil Beaton, 1962. Bromide print, 294 x 244mm. National Portrait Gallery, London (NPG x26070). © National Portrait Gallery, London.

79. John Stephen by Angela Williams (Angela Coombes), 1960s. Cibachrome print, 395 x 257mm. National Portrait Gallery, London (NPG x125457). Given by Angela Coombes, 2001. © Angela Williams/National Portrait Gallery, London.

79.1. The Beatles (George Harrison; Paul McCartney; Ringo Starr; John Lennon) by Harry Hammond, 1963. Bromide print, 365 x 302mm. National Portrait Gallery, London (NPG x15550). © Harry Hammond/Victoria and Albert Museum.

79.2. The Rolling Stones (Mick Jagger; Keith Richards; Bill Wyman; Brian Jones; Charlie Watts) by Terry O'Neill, 1963. Digital R type colour print from original transparency, 490 x 493mm. National Portrait Gallery, London (NPG x126149). Given by Terry O'Neill, 2003. © Iconic Images/Terry O'Neill.

80. David Bailey and Jean Shrimpton by Peter Rand, 1962. Bromide print, 269 x 400mm. National Portrait Gallery, London (NPG x136000). © Peter Rand.

80.1. A Crate Full of Quant (Dame Mary Quant, Alexander Plunket Greene and nine models) by John Adriaan, 1 April 1966. Fibre based lambda print, 459 x 358mm. National Portrait Gallery, London (NPG x133068). Given by Sally Passmore, 2009. © John Adriaan.

80.2. Twiggy (née Lesley Hornby) by Barry Lategan, 1966. Bromide print, 428 x 382mm. National Portrait Gallery, London (NPG x133189). © Barry Lategan.

81. Marianne Faithfull by Michael Ward, 26 July 1967. Bromide print, 238 x 353mm. National Portrait Gallery, London (NPG x88843). © Michael Ward Archives/National Portrait Gallery, London.

81.1. Jane Birkin by Thomas Patrick John Anson, 5th Earl of Lichfield, June 1969. Giclée colour print, 372 x 304mm. National Portrait Gallery, London (NPG x128496). Given by Thomas Patrick John Anson, 5th Earl of Lichfield, 2003 in conjunction with the exhibition Lichfield: The Early Years 1962–82. © Lichfield.

81.2. Evening dress and coat, detail, by Ossie Clark, 1970–1. Print fabric, by Celia Birtwell. Rayon crêpe with flower print with chiffon inserts. Victoria and Albert Museum, London. © Victoria and Albert Museum, London.

82. Sir Roy Strong by Bryan Organ, 1971. Oil on canvas, 1775 x 1775mm. National Portrait Gallery, London (NPG 5289). © National Portrait Gallery, London.

82.1. Sir Roy Strong's suit, 1968. Textile. Fashion Museum, Bath and North East Somerset Council/Gift of Sir Roy Strong/Bridgeman Images.

83. Fashion Designers by Lord Snowdon, April 1973. Gelatin silver print, 377 x 393mm. National Portrait Gallery, London (NPG P1937). Given by Lord Snowdon, 2013. Photograph by Snowdon/Trunk Archive.

83.1. Princess Anne; Mark Phillips by Norman Parkinson, 1973. Cibachrome print, 306 x 305mm. National Portrait Gallery, London (NPG x30172). Given by Norman Parkinson, 1981, in conjunction with the NPG exhibition Norman Parkinson: 50 Years of Portraits and Fashion. © Norman Parkinson Archive.

84. Sid Vicious by Bob Gruen, 1978. Cibachrome print, 508 x 406mm. National Portrait Gallery, London (NPG P875). Purchased, 2001, in conjunction with the Millennium exhibition Faces of the Century. © Bob Gruen.

84.1. Dame Vivienne Isabel Westwood by David Secombe, 1992. Cibachrome print, 263 x 268mm. National Portrait Gallery, London (NPG x68821). © David Secombe.

84.2. Dame Vivienne Isabel Westwood by Juergen Teller, 2014. C-type colour print, 1219 x 812mm. National Portrait Gallery, London (NPG P1980). Commissioned; made possible by J.P. Morgan through the Fund for New Commissions, 2014. © National Portrait Gallery, London/Photo: Jurgen Teller.

85. Jean Elizabeth Muir by David Remfry, 1981. Watercolour, 1026 x 689mm. National Portrait Gallery, London (NPG 6556). © David Remfry/National Portrait Gallery, London.

85.1. Germaine Greer by Paula Rego, 1995. Pastel on paper laid on aluminium, 1200 x 1111. National Portrait Gallery, London (NPG 6351). Commissioned, 1995. © National Portrait Gallery, London.

86. Margaret Thatcher by Norman Parkinson, 1981. Colour print, 1265 x 1015mm. National Portrait Gallery, London (NPG 5728). Commissioned, 1984. © Norman Parkinson Ltd./Courtesy Norman Parkinson Archive.

86.1. Margaret Thatcher by Norman Parkinson, 1981. Colour print, 492 x 394mm. National Portrait Gallery, London (NPG P177). Given by Norman Parkinson, 1981. © Norman Parkinson Ltd./Courtesy Norman Parkinson Archive.

86.2. Prime Minister Margaret Thatcher greets fashion designer Katharine Hamnett, who wears a T-shirt with a nuclear missile protest message, at 10 Downing Street, where Thatcher hosted a reception for British Fashion Week designers. Courtesy Press Association Images.

87. Diana, Princess of Wales by Bryan Organ, 1981. Acrylic on canvas, 1778 x 1270mm. National Portrait Gallery, London (NPG 5408). Commissioned, 1981. © National Portrait Gallery, London.

87.1. Diana, Princess of Wales by Terence Daniel Donovan, 1990. Colour print, 291 x 211mm. National Portrait Gallery, London (NPG P716(12)). Given by the photographer's widow, Diana Donovan, 1998. Photo: Terence Donovan © The Terence Donovan Archive.

87.2. Beaded dress of black velvet worn by Diana, Princess of Wales in 1997, designed by Catherine Walker. Courtesy Kerry Taylor Auctions.

88. Trojan and Leigh Bowery by David Gwinnutt, 1983. Bromide fibre print, 480 x

342mm. National Portrait Gallery, London (NPG x131399). © David Gwinnutt/National Portrait Gallery, London.

88.1. Sibylle de Saint Phalle, John Flett, John Charles Galliano and Barry Metcalf by Nick Knight, 1985. Bromide fibre print, 441 x 460mm. National Portrait Gallery, London (NPG x26094). © Nick Knight/Trunk Archive.

88.2. John Charles Galliano by Mario Testino, 1997. C-type colour print, 510 x 407mm. National Portrait Gallery, London (NPG P1017). © Mario Testino.

89. 'Oyster' dress by Alexander McQueen, spring /summer 2003. Ivory silk georgette and organza, beige nylon and silk chiffon, white silk; length at centre back 1829mm. The Metropolitan Museum of Art. N.inv.:2003.462 © 2015. Image copyright © The Metropolitan Museum of Art/Art Resource/Scala, Florence © Photo SCALA, Florence.

89.1. Alexander McQueen and Isabella Blow by David LaChapelle, 1996. C-type colour print, 734 x 1012mm. National Portrait Gallery, London (NPG P1017). © David LaChapelle. Courtesy Fred Torres Collaborations.

89.2. Isabella Blow by Tim Noble, Sue Webster, 2002. Taxidermy, wood, fake moss, light projector and installation template, 1550 x 500mm. National Portrait Gallery, London (NPG 6872). Given by Tim Noble, Sue Webster and the estate of Isabella Blow, 2009. Photograph by Andy Keate, © National Portrait Gallery, London; sculpture © Tim Noble and Sue Webster/DACS, London 2015.

90. Sir Paul Brierley Smith by James Lloyd, 1998. Oil on canvas, 1624 x 1451mm. National Portrait Gallery, London (NPG 6441). Commissioned as part of the First Prize, BP Portrait Award 1997, 1998. © National Portrait Gallery, London.

90.1. Ozwald Boateng by Sal Idriss, 2002. C-type colour print, 391 x 393mm. National Portrait Gallery, London (NPG x125667). © Sal Idriss/National Portrait Gallery, London.

91. British Models dressed by British Designers (left to right, standing: Stella Tennant; Erin O'Connor; Naomi Campbell; Kate Moss; Rosemary Fergusson; Jasmine Leonora Guiness; Karen Elson; Georgina Cooper; Sophie Dahl; Jodie Kidd; left to right, seated: Cecilia Chancellor with her son, Lucas; Jacquetta Wheeler; Liberty Ross; Elizbaeth Scarlett Jagger; Jade Parfitt; Lisa Ratcliffe; Alek Wek; Vivien Solari) by Mario Testino, 2001. C-type colour print on aluminium, 414 x 516mm. National Portrait Gallery, London (NPG P1025). © Mario Testino.

91.1. Kate Moss by Mario Testino, 1996. Durst and Lambda bromide print, 515 x 408mm. National Portrait Gallery, London (NPG P1020). © Mario Testino.

92. Tracey Emin by Julian Broad, 26 April 2000. C-type colour print, 443 x 355mm. National Portrait Gallery, London (NPG x139553). Given by Julian Broad, 2014. © Julian Broad/National Portrait Gallery, London.

92.1. Sam Taylor-Johnson (Self-portrait in Single-breasted Suit with Hare) by Sam Taylor-Johnson 2014 (2001). C-type colour print, 1521 x 1046mm. National Portrait Gallery, London (NPG P959). Purchased with help from the artist and the Art Fund, 2002. © Sam Taylor-Johnson.

92.2. David Beckham (David) by Sam Taylor-Johnson, 2004. Digital video displayed on plasma screen. National Portrait Gallery, London (NPG 6661). Commissioned; made possible by J.P. Morgan through the Fund for New Commissions, 2004. © Sam Taylor-Johnson. All rights reserved, DACS 2015.

92.3. Victoria Beckham (née Adams) by John Swannell, 2001. Archival digital print, 516 x 389mm. National Portrait Gallery, London (NPG x134782). Given by John Swannell, 2011. © John Swannell/Camera Press.

93. David Bowie by Steven Klein, 2003. C-type colour print, 762 x 1130mm. National Portrait Gallery, London (NPG P1277). Purchased with help from the proceeds of the 150th anniversary gala, 2007. © Steven Klein.

93.1. Amy Winehouse by Venetia Dearden, 2008. Giclée print, 594 x 466mm. National Portrait Gallery, London (NPG x134361). © Venetia Dearden/National Portrait Gallery, London.

93.2. Lily Allen by Nadav Kander, November 2008. Archival pigment print, 558 x 465mm. National Portrait Gallery, London (NPG x132588). Given by Nadav Kander, 2009. © Nadav Kander; courtesy Flowers Galleries.

94. David Hockney (Self-Portrait with Charlie) by David Hockney, 2005. Oil on canvas, 1829 x 914mm. National Portrait Gallery, London (NPG 6819). Purchased with help from the proceeds of the 150th anniversary gala and Gift Aid visitor ticket donations, 2007. © David Hockney. Photo: Richard Schmidt. Collection National Portrait Gallery, London.

94.1. Grayson Perry by Richard Ansett, 18 September 2013. C-type colour print, 555 x 392mm. National Portrait Gallery, London (NPG x139888). By Richard Ansett. Commissioned for BBC Radio 4's Reith Lectures 2013 by Anna Lenihan, BBC Pictures.

95. Queen Elizabeth II (Lightness of Being) by Chris Levine, 2007. Lenticular print on lightbox. National Portrait Gallery, London (NPG 6963). © Chris Levine.

95.1. Catherine, Duchess of Cambridge by Paul Emsley, 2012. Oil on canvas, 1152 x 965mm. National Portrait Gallery, London (NPG 6956). Commissioned and given by Sir Hugh Leggatt in memory of Sir Denis Mahon through the Art Fund, 2012. © National Portrait Gallery, London.

INDEX

Published in Great Britain by National Portrait Gallery Publications,
St Martin's Place, London WC2H 0HE

Sold to support the National Portrait Gallery, London. For a complete
catalogue of current publications, please write to the National Portrait Gallery
at the address above, or visit our website at www.npg.org.uk/publications

ISBN 978 1 85514 556 6

A catalogue record for this book is available from the British Library.

10 9 8 7 6 5 4 3 2 1

Printed in Italy

Managing Editor Christopher Tinker
Senior Editor Sarah Ruddick
Production Manager Ruth Müller-Wirth
Picture research and production Kathleen Bloomfield
Design Lizzie B Design
Origination DL Imaging Ltd

FSC
www.fsc.org
MIX
Paper from
responsible sources
FSC® C015829

p.2 Henry Brougham, 1st Baron Brougham and Vaux by Sir Thomas Lawrence, 1825
(detail of fig. 54).
pp.6–7 The Shudi Family Group by Marcus Tuscher, c.1742 (detail of fig. 38).
p.8 Ann Mary Newton by Ann Mary Newton, c.1862[?] (detail of fig. 60).

The National Portrait Gallery would like to
thank Furthermore: a program of the J.M. Kaplan
Fund for their help with funding the reproduction
of a number of images in this publication.

Furthermore:
a program of the J.M. Kaplan Fund